The Edwardians: Secrets and desires

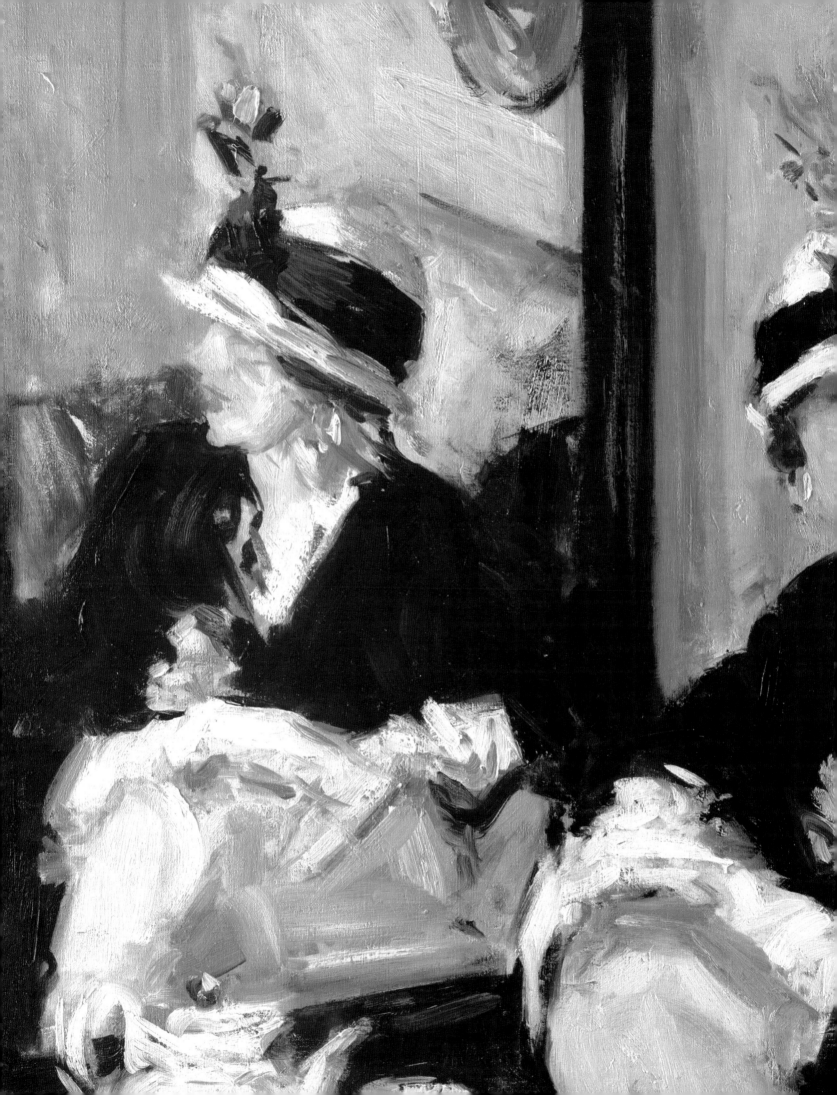

Anne Gray
with essays by Ann Galbally, Kenneth McConkey,
Benedict Read and Christine Riding

The Edwardians
SECRETS AND DESIRES

■ national gallery of **australia**

Produced by the Publications Department
of the National Gallery of Australia

nga.gov.au

The National Gallery of Australia is an Australian
Government Agency.

Editor: Susan Hall
Rights and Permissions: Leanne Handreck
Designer: Sarah Robinson
Printer: Lamb Printers Pty Ltd

Cataloguing-in-Publication-data

The Edwardians: secret and desires.

Bibliography.
Includes index.
ISBN 0 642 54149 3.

1. Painting, Edwardian – Exhibitions.
I. Gray, Anne, 1947– .II. National Gallery of. III. Title.

759.20749471

Published on the occasion of the exhibition:
The Edwardians: Secrets and desires

National Gallery of Australia, Canberra
12 March 2004 – 14 June 2004

Art Gallery of South Australia, Adelaide
9 July – 12 September 2004

The exhibition was organised by the National Gallery
of Australia, Canberra.

The exhibition was curated in Canberra by:
Anne Gray, Assistant Director, Australian Art
Administration: Liz Wilson, Executive Assistant

Distributed in Australia by
Thames and Hudson
11 Central Boulevard Business Park
Port Melbourne, Victoria 3207

Distributed in the United Kingdom by
Thames and Hudson
181A High Holborn
London WC1V 7QX, UK

Distributed in the United States of America by
University of Washington Press
1326 Fifth Avenue, Ste 555
Seattle, WA 98101-2604

Front cover: **John Singer Sargent** *The fountain, Villa Torlonia,
Frascati, Italy* 1907 (detail) [**cat. 120**]

Back cover: **William Strang** *Bank holiday* 1912 [cat. 131]

Frontispiece: **F.C.B. Cadell** *Reflections* c.1915
(detail) [**cat. 16**]

Contents

In or about December, 1910, human character changed.

Virginia Woolf, 'Mr Bennett and Mrs Brown' (1924) *Collected essays*

Minister's foreword

Over the years Australians have witnessed many remarkable art exhibitions. The latest in a long line of significant exhibitions assembled for our pleasure is *The Edwardians: Secrets and desires*.

The Edwardian era was a time of dramatic change. It was a period when established order began to give way to the beginnings of a more modern world. Social reform, technological invention and artistic exploration were features of this age.

Many Australian artists went to Europe at the turn of the 20th century to study and live. This exhibition places the work of these Australian artists in the context of the British, Irish and American artists of the time. They produced images that reveal changes in society, and the variety of experiences that became possible with the advent of the motor car and the changing roles of the social classes.

This outstanding display is the result of highly experienced gallery staff, among them curators, registration staff, art handlers, couriers and packers, who have researched, negotiated and brought this collection together for our enjoyment and education.

The exhibition is also made possible by the Australian Government's indemnification scheme — Art Indemnity Australia. Without Art Indemnity Australia the high cost of commercial insurance would prohibit major exhibitions from touring Australia.

The Australian Government is proud to support this magnificent exhibition, arranged by the National Gallery of Australia in association with the Art Gallery of South Australia, and looks forward to successful seasons in Canberra and Adelaide.

Senator Rod Kemp
Minister for the Arts and Sport

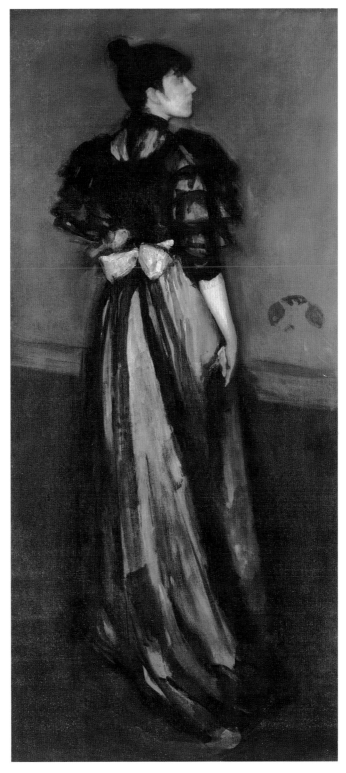

James McNeill Whistler *Mother of pearl and silver: The Andalusian* 1888(?)–1900 [cat. 144]

Director's foreword

In recent years, the National Gallery of Australia has made it one of its programming aims to reassess certain overlooked movements and artists in Australian art. This has brought some notable successes such as *Islands in the sun*; *Douglas Annand: The Art of Life*; *Joy Hester and friends*; *Transparent Things — Expressions in Glass*; *Seeing the Centre: The art of Albert Namatjira 1902–1959* and *Tactility: Two centuries of Indigenous objects, textiles and fibre*. Our current exhibition, *The Edwardians: Secrets and Desires* adds significantly to this record.

The Edwardians: Secrets and desires focuses on connections between Australian, British, Irish, American and French artists, all drawn to London, the magnet capital of the British Empire. Many Australian artists at the turn of the century — then as now — wanted to be 'the best', not only in Australia but also on the world stage. They travelled to London and also Paris — at that time the centres of the art world — and studied and worked there. So too did artists from Ireland, Scotland, America and New Zealand. Artists moved regularly between these two cities, and were keen to have their works included in exhibitions in both centres. The overriding supremacy of London and Paris, however, meant that to obtain reputation outside their place of origin most Irish, Scottish, American and Australian artists found it necessary to exhibit and live in, or near, either city.

This is the first time that Australians have had an opportunity to view these Australian works of the Edwardian period in their international context and to appreciate the environment, both aesthetic and historical, in which artists such as Bunny, Carrick, Conder, Davidson, Fox, Lambert, O'Connor and Preston were working.

A number of Irish-born artists also achieved considerable success. Perhaps the most successful of them all was William Orpen, although John Lavery also had a large following as a society portrait painter. Likewise, Scottish artists such as F.C.B. Cadell

and J.D. Fergusson came into prominence. Augustus and Gwen John, brother and sister artists who were born in Wales, also became major figures during this time.

One hundred years after the Edwardian era is an appropriate time to stage an exhibition of Edwardian art drawn from museums throughout the former British colonies of Australia, New Zealand, Singapore, Canada, Ireland and America, as well as from the former colonial powers, Britain and France. The art museums in the Australian state capitals of Melbourne, Sydney and Adelaide bought a number of major Edwardian paintings and sculptures in the 1900s. This was also true of the larger New Zealand cities. Two of the artists included in this exhibition, the Briton George Clausen and the Australian Margaret Preston (Rose McPherson), acted as buyers for the National Gallery of Victoria and the Art Gallery of South Australia respectively. Preston made a daring purchase: an innovative work by the Irish artist, William Orpen, *Sowing new seed*. It was a controversial acquisition, and the painting was eventually returned to the artist in exchange for a mediocre work. Fortunately, *Sowing new seed* later returned to Australia when the inspired collector and newspaper owner R.D. Elliot purchased it for his private collection, and then subsequently presented it to the Mildura Arts Centre.

The Edwardian works in the Australian and New Zealand collections have not received much special attention to date. In 1997, in Adelaide, Angus Trumble, the Art Gallery of South Australia's Curator of European art, staged the *Bohemian London* exhibition, based on that gallery's strong holdings of works by Camden Town and Bloomsbury artists. It is therefore fitting, given their strong holdings and their commitment to the display of their Edwardian collection, that this exhibition will also be shown at the Art Gallery of South Australia. We thank Director, Ron Radford, in particular, for his support and enthusiasm for *The Edwardians: Secrets and desires*.

As Holbrook Jackson has pointed out, during the 1890s 'the art of the shocking' and 'the bon mot' were supremely fashionable. Artists and writers wanted to surprise the 'middle class' along with anyone considered dull and traditional, with a view to gaining the attention of the public. As well as their works, the artists' lives and personalities became an important part of their reputations. James McNeill Whistler was almost as well known for his quick wit and pithy remarks as for his paintings. Augustus John established a reputation for his bohemian lifestyle and many amorous adventures, as well as for his powers as a draughtsman and his expressive paintings. George Lambert attained a reputation for his flamboyance as well as for his abilities as an artist. And the feisty redhead, Margaret Preston (Rose McPherson), was as well known for her promotion of modernist ideas as for her art. Rather than being the tail end of the Victorian era, the Edwardian period was perhaps the beginning of art as we know it today.

The exhibition offers sumptuous portraits of members of the British upper class and nouveaux riches, and paintings that artists created and exhibited in order to secure such commissions. But the exhibition also focuses on the middle class and the working class. It shows the change in artistic style that took place during the period, from an emphasis on tonalism to a more modern formalist approach using bright colours and strong forms. The exhibition consists largely of paintings and sculpture. But, in recognition of the important interest in decoration and design at this time, it includes a select number of fan designs, some of Charles Conder's decorations on silk, and some fashion garments and costumes from the period. It also contains Raoul Larche's *Loïe Fuller lamp*.

The Edwardians: Secrets and desires is the result of three years work under the inspired curatorship of Dr Anne Gray, the National Gallery of Australia's Assistant Director, Australian art, an expert on the art of the

period, and a brilliant team leader. Dr Gray has produced a formidable exhibition and publication and we are in her debt for her scholarship, dedication and enthusiasm in delivering this project. The work could not have been completed without the help of many people and organisations. Four scholars have generously written essays for this catalogue: Dr Ann Galbally, University of Melbourne; Professor Kenneth McConkey, University of Northumbria, Newcastle upon Tyne; Benedict Read, University of Leeds; and Christine Riding, Tate, London. MaryAnne Stevens, Royal Academy of Arts, London, and Angus Trumble, from the Yale Centre for British Art, New Haven, Connecticut have also provided invaluable support and advice.

I am indebted to fellow directors from around the world who have kindly agreed to lend works from their collections. In particular, I thank Christopher Brown, Director, Ashmolean Museum, Oxford; James N. Wood, Director, The Art Institute of Chicago; Alfred Pacquement, Director, Centre Pompidou, Musée National d'Art Moderne, Paris; Barbara Dawson, Director, Dublin City Gallery The Hugh Lane, Dublin; Mark O'Neill, Head of Museums and Galleries, Glasgow City Council; Penny Johnson, Director, Government Art Collection of the United Kingdom, London; Stephen Little, Director, Honolulu Academy of Arts, Hawaii; Seddon Bennington, Chief Executive, Museum of New Zealand Te Papa Tongarewa, Wellington; Charles Saumaurez Smith, Director, The National Gallery, London; Earl A. Powell III, Director, National Gallery of Art, Washington; Pierre Théberge, Director, National Gallery of Canada, Ottawa; Mike Tooby, Director, National Museum and Gallery of Wales; Sandy Nairne, Director, National Portrait Gallery, London; Alan Hobart, Director, Pyms Gallery, London; Lim How Seng, Director, Singapore History Museum; Sir Nicholas Serota, Director, Tate, London; and S. Brian Kennedy, Director, Ulster Museum, Belfast.

Our Australian colleagues have been particularly generous. I thank Edmund Capon, Director, Art Gallery of New South Wales, Sydney; Ron Radford, Director, Art Gallery of South Australia, Adelaide; Alan Dodge, Director, Art Gallery of Western Australia, Perth; Janine Barrand, Director, The Arts Centre, Performing Arts Collection, Melbourne; Philip Bacon, Director, Philip Bacon Galleries, Brisbane; Alan Smith, Director, Carrick Hill Trust, Adelaide; Peter Perry, Director, Castlemaine Art Gallery and Historical Museum, Castlemaine; Geoffrey Edwards, Director, Geelong Gallery, Geelong; Brian Allison, Grainger Museum, The University of Melbourne, Melbourne; Louise Dauth, Director, Historic Memorials Collection, Parliament House Art Collection, Canberra; Janet Holmes à Court, Paul Holmes à Court, The Holmes à Court Collection, Heytesbury Pty Ltd, Perth; Julian Bowron, Arts Manger, Mildura Arts Centre; Gerard Vaughan, Director, National Gallery of Victoria, Melbourne; Nick Mitzevich, Director, Newcastle Regional Art Gallery; Doug Hall, Director, Queensland Art Gallery, Brisbane; John Schaeffer, Schaeffer Collection, Sydney; Kerry Stokes, Kerry Stokes Collection, Perth; Diane Baker, Director, Toowoomba Regional Art Gallery; Michael Chaney, Managing Director, Wesfarmers Ltd; Helen Carroll, Manager, The Wesfarmers Collection of Australian Art, Perth and Peter O'Neill, Director, Wollongong City Gallery. I also extend my thanks to those private collectors who wish to remain anonymous, who have generously lent to the exhibition.

It is with great pleasure that we offer this exhibition to the Australian public, proud of its achievement in demonstrating a truly creative dialogue between Australia and Britain at the beginning of the 20th century.

Dr Brian Kennedy
Director
National Gallery of Australia

The Edwardians

What these Edwardian years produced was
not a pale reflection of what had already been
produced elsewhere. It was on the whole
very English, and it was created by a genuine
explosion, not world-shaking but a very
considerable explosion, of English fine talent.[1]

At the begining of 1901, Queen Victoria
was ill and dying; London, England and
the British Commonwealth were on the brink of
change. Victoria died on 22 January and people
began to re-think old ideas and explore new ways
of living. Edward VII changed the whole 'look'
of the monarchy. In contrast to his rather priggish
parents, he was a tolerant and good-natured man of
the world. An extrovert with a zest for pleasure, he
encouraged those around him to enjoy life to the
full. Moreover, he created an atmosphere in which
it was possible for social change to occur and for the
arts to flourish. 'The scene at Marlborough House
during the first weeks of King Edward's reign', Lord
Esher wrote, 'was in sharp contrast to everything
to which we were accustomed. He himself
was accessible, friendly, almost familiar, frank,
suggestive, receptive, discarding ceremony, with no
loss of dignity, decisive but neither obstinate nor
imperious ... The impression he gave me was that
of a man who, after years of pent-up action, had
suddenly been freed from restraint and revelled in
his liberty.'[2]

The Edwardians: Secrets and desires showcases the
broad range of art created during these exciting
times, from 1900 to 1914, and suggests that the
changes in art were as marked as those that took
place in society. This essay considers the Edwardian
period through three perspectives. First, in looking
at the art, it explores artists' desires or intentions
and considers similarities between their works.
Secondly, it looks at the context in which the art
was produced and the stories that this reveals.
Thirdly, in looking at the lives of the artists selected
for this exhibition, it highlights connections
between them.

John Singer Sargent *Almina, daughter of Asher Wertheimer* 1908
(detail) [cat. 121]

Anne Gray 11

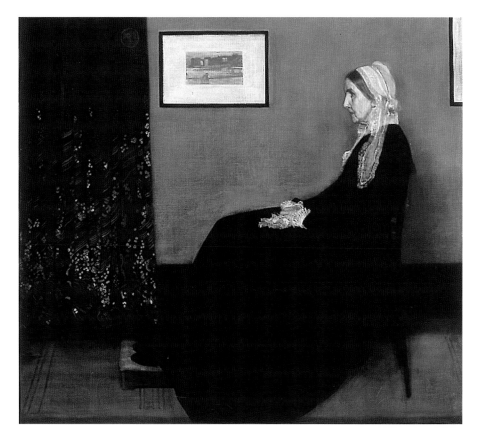

Fig. 1: James McNeill Whistler *Arrangement in grey and black: Portrait of the artist's mother* 1871 oil on canvas 144.3 x 162.5 cm Musée d'Orsay, Paris (photograph: RMN – J.G. Berizzi)

and, by setting these works alongside art from the new Commonwealth of Australia, it also gives an overview of what it took to be an artist in 'Greater' Britain.

While there are various studies of the Edwardian era, such as J.B. Priestley's or, more recently, Paul Thompson's *The Edwardians: The remaking of British society* (1992), the Edwardian period in British history has received far less attention than others.[6] No doubt this is partly due to its brief span, being strictly from 1901 to 1910, and still only 14 years if using the more generally accepted extended dateline of 1900 to 1914, the onset of the First World War. Nonetheless, the Edwardian era marked the beginning of our modern world.

The art: re-form, not revolution

In the late 19th century, James McNeill Whistler revolutionised British painting by removing the burden of narrative and moralistic approaches that had weighed down much Victorian art. By adopting musical terms for the titles of his pictures, such as *Arrangement in black* (fig. 2, cat. 143), he overcame the Victorian assumption that every picture should tell a story. Artists began to rethink what they should paint and how they should paint it and, as a result, adopted a diverse range of approaches.

In the years immediately after his death in 1903, exhibitions of Whistler's work were held in Edinburgh, Paris and London. His direct legacy was a tonalist approach, the careful placement of a figure within a confined space, the reduction of a composition to its essentials and the apparently effortless application of paint. Australian artist Hugh Ramsay was impressed by Whistler's portrait, *Arrangement in grey and black, no.2: Portrait of Thomas Carlyle* 1872–3 (Glasgow Museums: Kelvingrove Art Gallery and Museum) when he viewed it on display in the National Gallery of Scotland in 1902, writing that, 'it doesn't seem to have been painted, but just thought on by a most refined and distinguished mind'.[7] And the Scottish artist J.D. Fergusson remarked that Whistler was 'a man with a real sense of design, a real sense of colour and quality of paint'.[8]

Artists such as William Rothenstein and Albert Rutherston sought to emulate Whistler's studied elegance. They pared down their images to basic elements and used a restrained and understated approach to applying paint.

A number of these artists have been the subject of survey exhibitions and have had monographs written about them, but their works have rarely been seen together. Nor indeed have the works of Australian expatriates been shown alongside of their British, Irish and American contemporaries. By placing the paintings of these artists together, it is possible to see their achievements as a whole.

Survey exhibitions have examined Edwardian swagger portraits in the context of grand manner portraiture in Britain from 1630 to 1930; have looked at the British Impressionists and the British Post-Impressionists in the context of European art; and have explored in depth the work of the Newlyn Group, the Camden Town school and the Bloomsbury artists.[3] Exhibitions have also brought together those Edwardians artists who were Royal Academicians, and have focused on the social aspects of the period.[4] Kenneth McConkey has pioneered work on this period through his *Edwardian portraits* (1987), as well as through more recent publications such as *Memory and desire* (2002). Historians of British art, such as Susan Beattie, Richard Cork, Charles Harrison, David Peters Corbett, Anna Gruetzner Robins, Ysanne Holt, Benedict Read and Frances Spalding have considered this period as part of their overviews.[5] The scope of *Edwardians: Secrets and desires* is unique. It brings together a wide range of British paintings and sculpture of the period

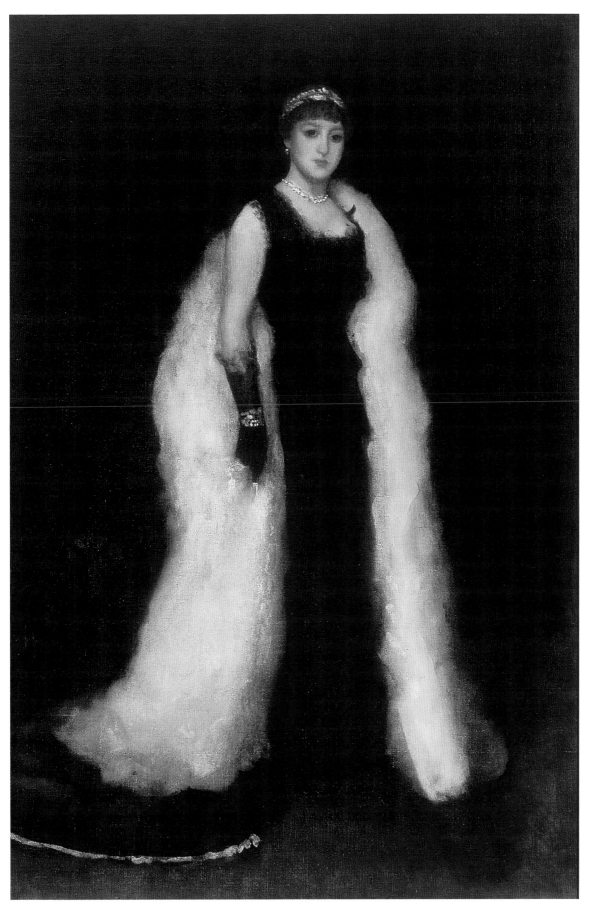

Fig. 2: **James McNeill Whistler** *Arrangement in black no. 5: Lady Meux* 1881 [cat. 143]

Fig. 3: **Rupert Bunny** *Madame Sadayakko as Kesa* c.1907 [cat. 12]

The figure placement and spare approach in Rothenstein's *The Browning readers* (cat. 114) and Rutherston's *Song of the shirt* (cat. 116) pay homage to Whistler's famous portrait of his mother, *Arrangement in grey and black: Portrait of the artist's mother* 1871 (fig. 1). In his *At the piano* (cat. 31), Malcolm Drummond also referred to Whistler's icon, although he simplified his forms to a greater extent than 'the Master' and introduced bright, bold colours that would have shocked him.

Others also followed Whistler's example. Australian artist Rupert Bunny's painting *Madame Sadayakko as Kesa* (fig. 3, cat. 12) was influenced by Whistler's restrained tonal harmonies, simplicity of design and economy of expression, as well as his use of Japanese themes. And Gwen John, who studied with Whistler, imbued all her work, including paintings such as *The nun* (fig. 4, cat. 60), with the subtlety of tone and refined taste that she had gained from him.

The tonalist approach of much Edwardian painting was also inspired by the work of the 17th-century Spanish artist Velasquez. Whistler, like his French contemporary Manet, had admired Velasquez and had shared his interest in using tonal restraint and the fluent application of paint. In 1895 the English art critic, R.A.M. Stevenson, published a substantial monograph on Velasquez, in which he suggested that 'the style and composition' of Velasquez's paintings of the two philosophers, *Aesop* and *Menippus,* both of 1639–40 (Prado, Madrid), 'recalls many of Whistler's tall dark portraits'.[9] Stevenson looked at Velasquez's paintings from an impressionist perspective, and created new interest in his works. He encouraged artists to study Velasquez's use of the unifying power of tone, his decorative placement of a figure on the canvas and his approach to paint.

Velasquez's most highly regarded painting was his image of an artist at work, *Las Meninas* 1656 (fig. 6). A number of artists created their own variations, such as Philip Connard's *The guitar player* (fig. 7, cat. 29), Max Meldrum's *The yellow screen* (fig. 5, cat. 83) and Ambrose Patterson's *Self-portrait* (cat.99). John Lavery also painted his own interpretation of Velasquez's masterpiece, in *Lady Lavery with her daughter and step-daughter: The artist's studio* 1911 (National Gallery of Ireland, Dublin) and related works. In Ramsay's *A mountain shepherd* (cat. 106), the choice of subject, uncompromising realism and use of light and dark were similar to that used by Velasquez in his paintings, *Aesop* and *Menippus.*

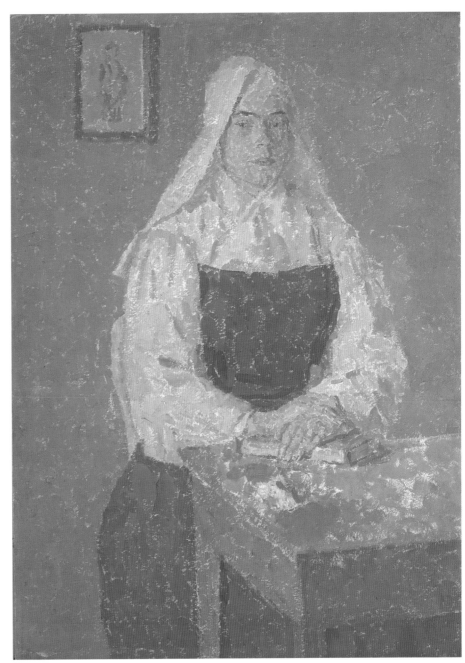

Fig. 4: Gwen John *The nun* mid-1910s [cat. 60]

Harold Gilman showed his admiration of Velasquez and the Spanish tradition of portraiture in *The Negro gardener* (fig. 10, cat. 48), as did George Lambert in *Lotty and a lady* (fig. 8, cat. 67). William Orpen had studied Velasquez's work on a trip to Spain in 1904, when he wrote: 'I am learning so much from Velasquez and Goya that I am nearly off my head with excitement.'[10]

During this period, artists, writers, choreographers and musicians quoted others in their work. They regarded themselves as part of a continuing tradition and paid homage to their predecessors, using quotations from other artists' works of art to add another layer of meaning to their own. T.S. Eliot commented that, 'if we approach a poet without … prejudice we shall often find that not only the best, but the most individual parts of his work may be those in which the dead poets, his ancestors, assert their immortality most vigorously'.[11]

Among the Edwardians, writers such as George Bernard Shaw and James Joyce took the themes of their major works, *Pygmalion* (1913) and *Ulysses* (1918) respectively, from classical mythology. For his ballet *L'après-midi d'un faune* (1912), Vaslav Nijinsky used as inspiration the frieze-like poses of the figures on antique Greek vases. Percy Grainger and Ralph Vaughan Williams used English folk music as a basis for some of their compositions. However, the tradition to which they all referred was essentially masculine. Women artists and writers typically felt a lack of feminine tradition.

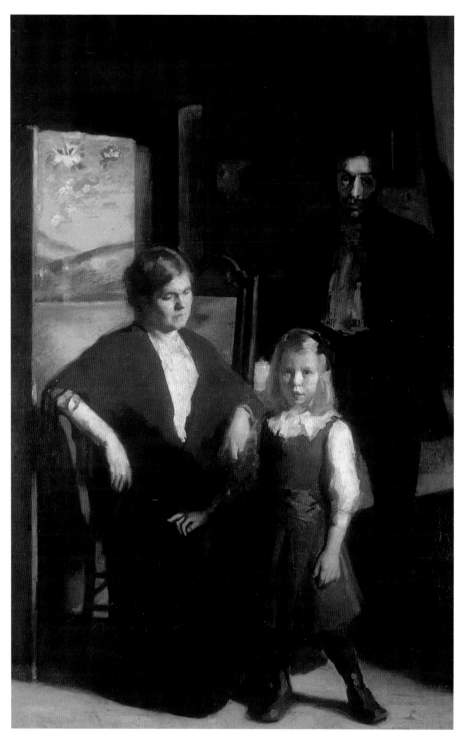

Fig. 5: **Max Meldrum** *The yellow screen (Family group)* 1910–11 [cat. 83]

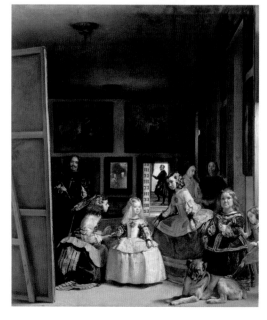

Fig. 6: **Diego Velasquez** *Las Meninas* 1656 oil on canvas 318.0 x 276.0 cm Museo del Prado, Madrid

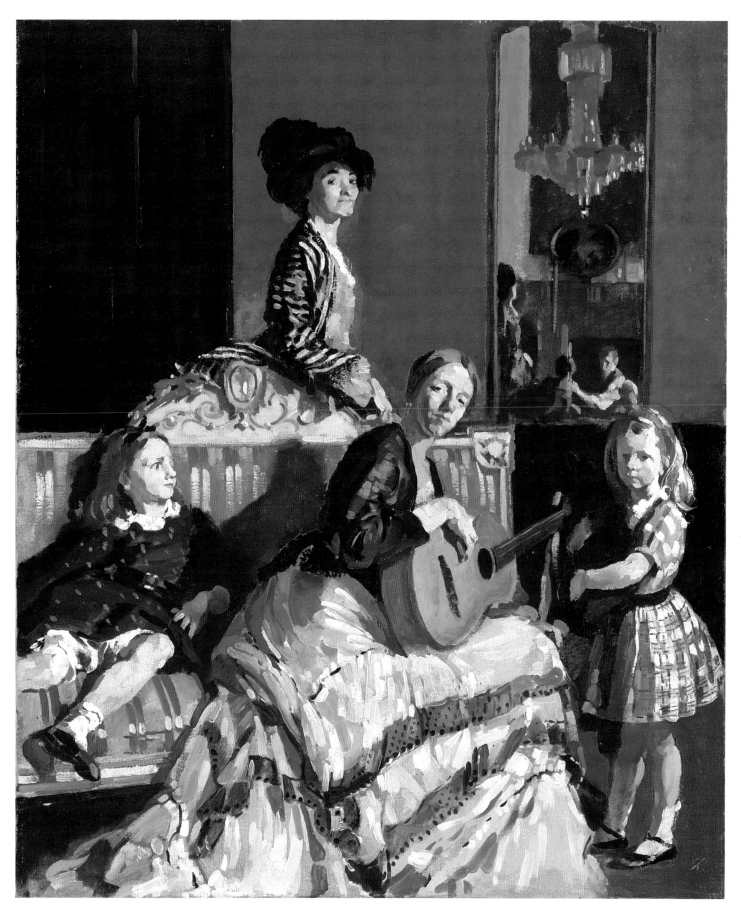

Fig. 7: **Philip Connard** *The guitar player* c.1909 [cat. 29]

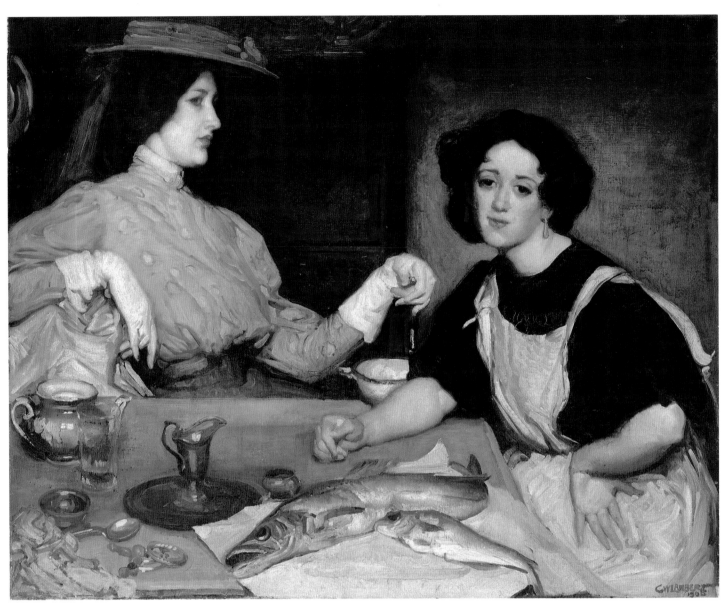

Fig. 8: George Lambert *Lotty and a lady* 1906 [cat. 67]

Fig. 9: Diego Velasquez *Kitchen scene with Christ in the house of Martha and
Mary* 1619-20 oil on canvas 60.0 x 103.5 cm National Gallery, London

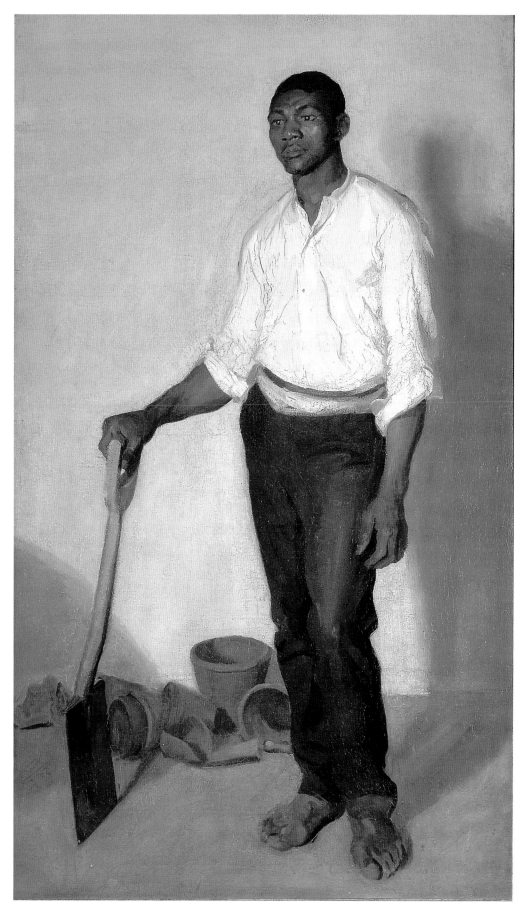

Fig. 10: Harold Gilman *The Negro gardener* c.1905 [cat. 48]

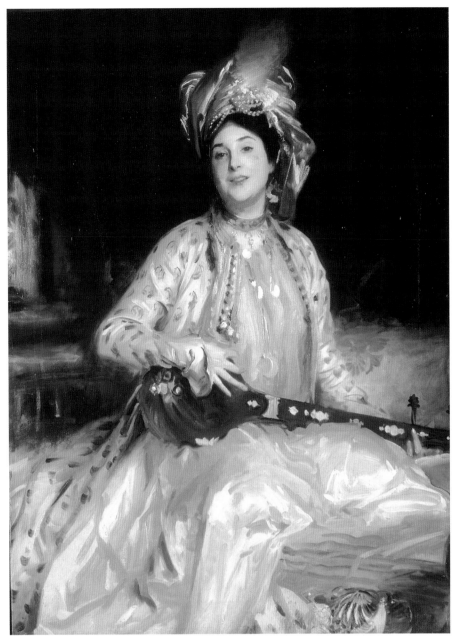

Fig. 11: **John Singer Sargent** *Almina, daughter of Asher Wertheimer* 1908 [cat. 121]

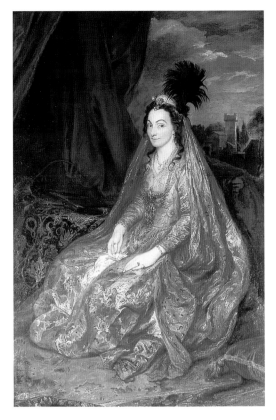

Fig. 12: **Anthony van Dyck** *Elizabeth, or Teresia, Lady Shirley* 1622 oil on canvas 200.0 x 133.4 cm National Trust, Petworth House, Sussex (photograph: Roy Fox, London)

In 1845, Elizabeth Barrett Browning wrote, 'I look everywhere for grandmothers and see none', and in the next century Virginia Woolf suggested something similar in her essay *A room of one's own*.[12] Nonetheless, when British artists appropriated past art into their own work they reflected the climate of their time, as well as a persistent British approach to change. It was a period of flux, of liberal reform, of shifts in thought and attitude to life, but in Britain these advances were made, as they always had been, within the established social order rather than through revolution.

In their commentaries on contemporary exhibitions, early 20th-century newspaper reviewers in Britain championed an aesthetic of the continuing tradition: they consistently sought, and wrote about, connections between contemporary artists and those of the past.[13] Reviewers and artists were assisted by the increasing number of illustrated art publications, as well as by ready access to photographs of works of art, which made it easier for them to perceive such references. Prior to the availability of these photographs, critics depended largely on prints that were untrustworthy records of original works, and artists relied on the sketches they made of the images that they admired.

After the positive reception of his portrait *Lady Agnew of Lochnaw* 1892 (National Gallery of Scotland, Edinburgh), John Singer Sargent became the most fashionable portrait painter of his time and received more commissions than he could fulfil. His opulent portraits of people in high society, such as *Lord Ribblesdale* (cat. 117) and *Evelyn, Duchess of Devonshire* (fig. 14, cat. 118), of men of Empire like *Sir Frank Swettenham* (cat. 119), and of the families of Jewish businessmen such as *Almina: Daughter of Asher Wertheimer* (fig. 11, cat. 121), helped to create an image of Edwardian wealth and splendour and of an Empire on which the sun never set. Using bravura brushwork and lively poses, Sargent made his subjects appear vibrantly alive. He suggested their wealth through their sumptuous silks and satins and their rich accessories. He also revealed their inner selves.

As Frank Rutter observed, 'Sargent developed powers of psychological penetration which made him supreme in the rendering of character. Some of his male portraits have been … merciless in their unmasking of the real minds of his sitters.'[14] By creating images with psychological insight, Sargent provided an alternative to Whistler's aestheticism. Contemporary French painting was also a source of inspiration for these artists. Sargent was one of the first artists working in Britain to show enthusiasm for Monet and one of the first to send Frank Rutter a cheque for the 'French Impressionist Fund'. Rutter had set up the fund

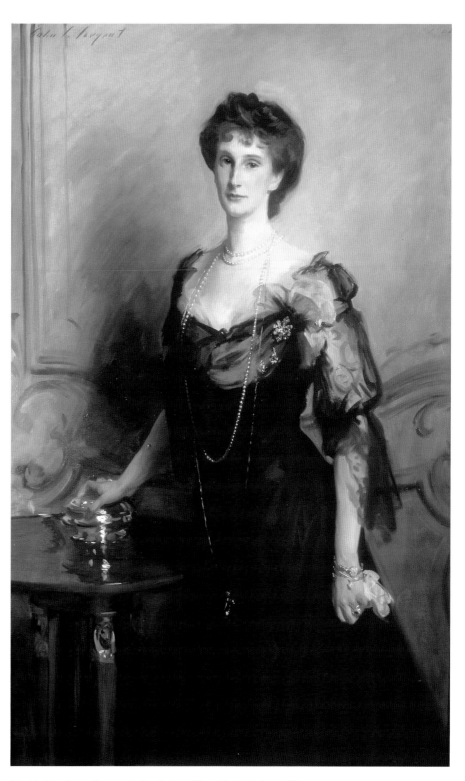

Fig. 14: **John Singer Sargent** *Evelyn, Duchess of Devonshire* 1902 [cat. 118]

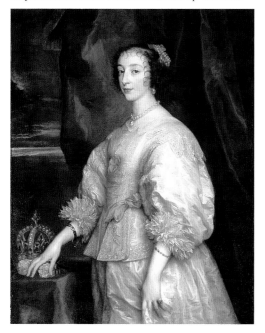

Fig. 13: **Anthony van Dyck** *Henrietta Maria* 1632 oil on canvas 108.6 x 86.0 cm The Royal Collection, Windsor (© HM Queen Elizabeth II)

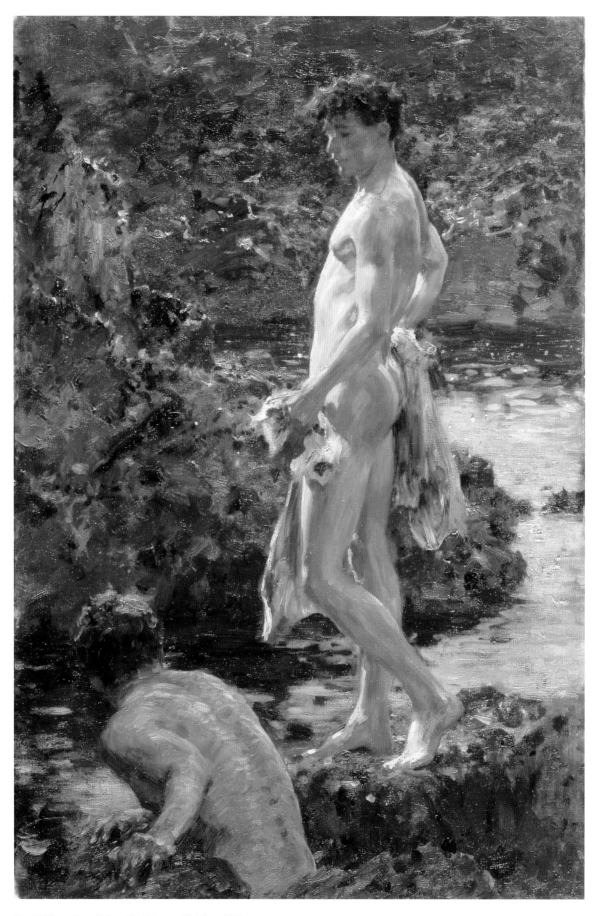

Fig. 17: Henry Scott Tuke *A bathing group* 1914 [cat. 139]

Of all the artists working in Britain around the turn of the century, Philip Wilson Steer was the one who came closest to adopting the impressionist aesthetic. After studying the work of the Impressionists in Paris, he returned to England and visited the Suffolk coast, where he began to paint views of the beaches and bathers, experimenting with various kinds of impressionist approaches. At first he used a flecked brushstroke to apply pure colour directly onto the canvas in a manner resembling that of Monet and Sisley, but later he used a form of divisionism. His subjects were holiday makers and his concern was to create poetic images of sensual delight, such as *Girls running, Walberswick Pier* c.1888–94 (Tate, London). Later, in works such as *Mrs Violet Hammersley* (cat. 130), Steer radically changed his style by painting portraits and nudes in the manner of Thomas Gainsborough, François Boucher and Antoine Watteau.

Charles Conder, like Steer, began by painting sunny plein-air landscapes such as *Sandringham* 1890 (National Gallery of Australia, Canberra) and, like Steer, he radically changed his approach when, in London, he started to work in an 18th-century manner, painting *fêtes galantes* and decorations, figures on silk panels for screens, wall decorations, garniture for dresses, as well as silk fans such as *Ladies at leisure* (cat. 28).

Fox was impressed by Steer's work, and by that of the French Impressionists. In many of his paintings he used high-key colour in broken dabs to create dappled lighting effects, as in *Al fresco* (fig. 48, cat. 36) and *Déjeuner* (fig. 61, cat. 40). In these works he turned to a theme that was popular around the turn of the century with European painters, including Monet, Renoir and Vuillard. Like the Impressionists, he often conveyed optimistic, leisurely scenes as well as joyous images of nudes, which capture the effects of light.

The other significant British artist to use an impressionist approach was Walter Sickert. He was one of the first in Britain to appreciate modern French art. Like the Impressionists, he used small interlocking brushstrokes and sought to capture the effects of light and, like these artists, he was interested in everyday subjects. However, Sickert's techniques were not those of the French Impressionists; he explored the nuances of shadows as opposed to sunlight and preferred urban streets

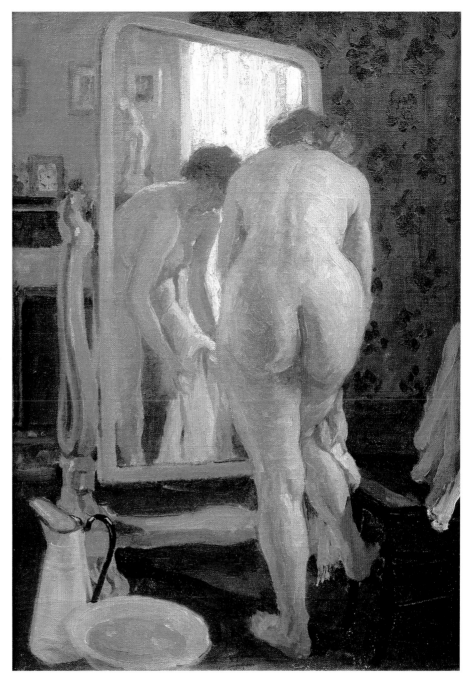

and bedsits, such as those of *Mornington Crescent nude, contre-jour* (fig. 19, cat. 123) and *Nude standing by an iron bedstead* (fig. 20, cat. 124), to a more leisurely outdoor environment. Moreover, like Degas, Sickert did not work rapidly in front of the motif, but carefully constructed his paintings in the studio from drawings that he had made on the spot. Like other artists, Sickert changed his approach in later years and, from about 1927, he painted brightly toned 'English Echoes', relying increasingly for his pictorial themes upon photographs from newspapers and magazines, as well as Victorian engravings.

Fig. 18: E. Phillips Fox *After the bath* c.1911 [cat. 39]

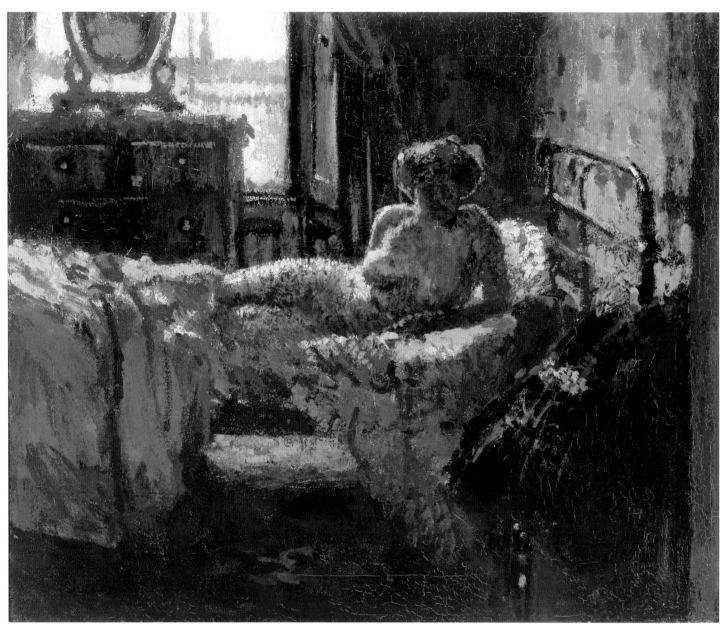

Fig. 19: Walter Sickert *Mornington Crescent nude, contre-jour* 1907 [cat. 123]

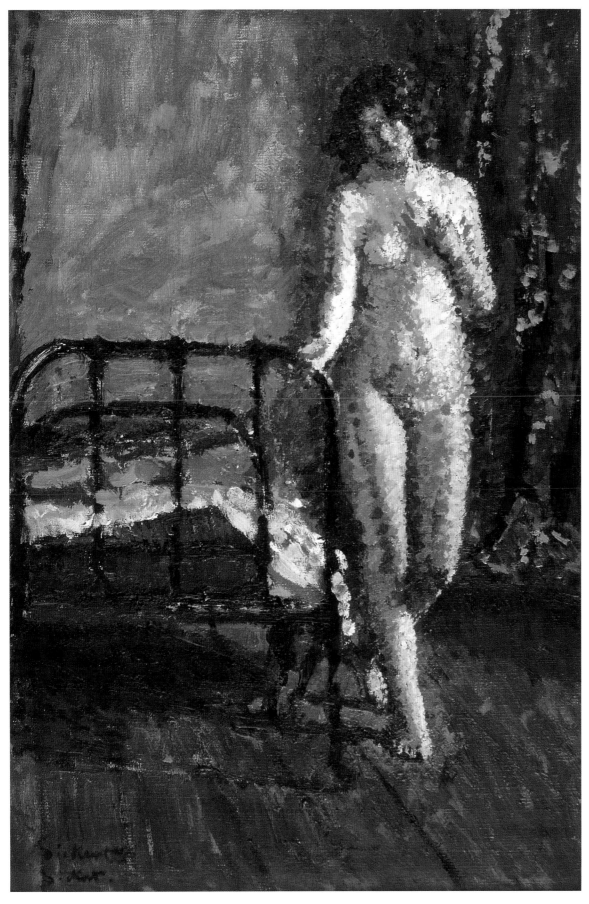

Fig. 20: **Walter Sickert** *Nude standing by an iron bedstead* 1909 [cat. 124]

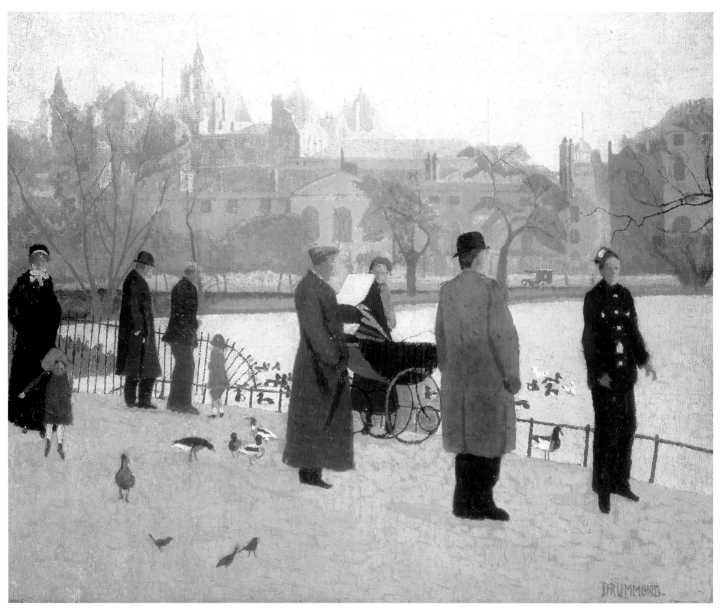

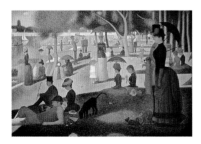

Fig. 22: Georges Seurat *A Sunday on La Grande Jatte —1884* 1884–6 oil on canvas 207.6 x 308.0 cm Art Institute of Chicago, Illinois, Helen Birch Bartlett Memorial Collection (© 2000 The Art Institute of Chicago)

Modern art in Britain is said to have begun in 1910, the year that Roger Fry's 'Manet and the Post-Impressionists' exhibition was shown at the Grafton Galleries, London. It included works by Cézanne, Denis, Gauguin, van Gogh, Matisse, Picasso and Seurat. Although most of the artists in the exhibition had shown works in London prior to 1910 (in exhibitions such as those of the International Society), Fry's show created a public and critical outcry. Sickert observed how the debate and discussion over the exhibition served to make this art better known and better understood, commenting: 'It has caused a rumpus. The rumpus has collected a crowd, and the crowd is quite willing to listen to reason and to learn.'[15]

Fry believed that he was promoting art that was based on formalist principles, on order and structure and grounded in tradition. However, Clive Bell observed that, to some people, Post-Impressionism implied anti-Impressionism. That is to say, a wide range of artists such as Clausen, Forbes, Knight and Munnings perceived the Post-Impressionist exhibition as an attack on plein-air painting. Inevitably, these artists became reactionary in response to this perceived attack.[16] A spoof Post-Impressionists' exhibition, inspired by the Academician James Jebusa Shannon, was held at the Chelsea Arts Club in December 1910, entitled 'Septule and the Racinistes'. It included joke drawings and paintings executed by H.M. Bateman and others caricaturing Cubism and Fauvism.[17] Australian artists who were members of the Chelsea Arts Club, such as George Bell and Tom Roberts, may have contributed to this comic Post-Impressionists' show.[18]

Whilst Whistler and his followers were concerned with the careful placement of figures and an economy of expression, the English Post-Impressionists took this further and simplified their scenes to a greater extent. Moreover, they turned away from Whistler's tonalist greys towards bright colours, and from a restrained and fluent approach in their application of paint to a method of applying thick paint in a solid mosaic. The Camden Town artists, Drummond, Gilman and Spencer Gore, were aware of recent developments in French art well before Fry's exhibition. They had considered its implication for their own work and had adopted the flat patterns and bold colours of the Post-Impressionists. They merged a formalist approach with the depiction of everyday scenes. For his *In the Park (St James's Park)* (fig. 21, cat. 32), Drummond found inspiration in a painting by Seurat (fig. 22), re-locating it to a very English setting. The Australian artist Norah Simpson studied at the Westminster Technical Institute where Gilman, Gore and Sickert were teachers, and visited the Parisian art dealers where she viewed works by the Post-Impressionists. She, too, learned from their example and painted *Studio portrait, Chelsea* (cat. 127) with the simplified forms and strong colours of the English Post-Impressionists. Inspired by the work of the Fauves in Paris, Fergusson adopted a flat decorative style of portraiture in works such as *Le Manteau chinois* (fig. 23, cat. 34), emphasising basic shapes rather than using modelling, and employing flat areas of vivid colour contrasts.

Artists like Augustus John, Lambert, Nicholson, Orpen and Philpot had also been moving in the direction of formalism before Fry's exhibition, as John did in his *Family group* (fig. 28, cat. 57). In 1911, the conservative reviewer for *The Times* criticised these artists' approaches to portraiture and argued that the 'greatest portrait-painters ... did not impose a kind of abstract "art" upon the likeness',[19] while Laurence Housman wrote in praise of the strong work of Lambert, Nicholson, Orpen and Philpot and their 'tendency to decorative realism'.[20] At the same time, P.G. Konody remarked in the *Observer* that 'Mr. W. Strang is more Post-Impressionist than ever in his family group gathered around "The Celestial Globe". Light and shade is anathema to him. The brightest yellow and red and green and black are set side by side in broad masses.'[21] The following year Konody again noted Strang's use of vivid colours in his painting

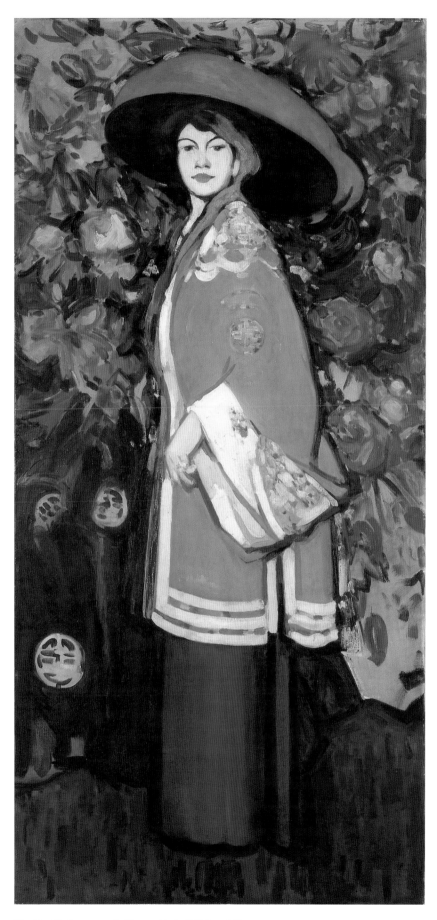

Fig. 23: J.D. Fergusson *Le Manteau chinois* 1909 [cat. 34]

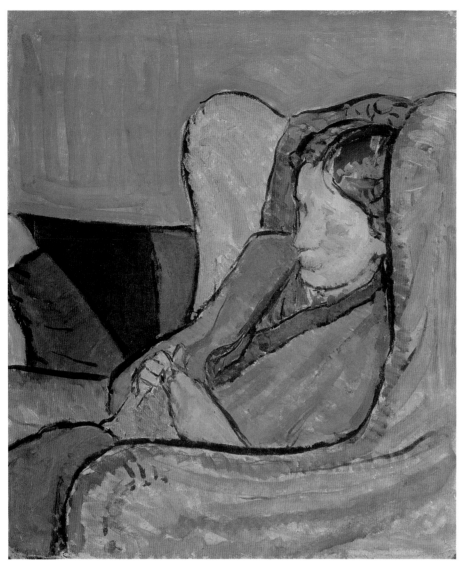

Fig. 24: **Vanessa Bell** *Virginia Woolf* c.1911–12 [cat. 4]

Bank holiday (fig. 64, cat. 131), his 'daring method of setting large cloisonné of pure, unbroken, unmodified colours side by side, dispensing with chiaroscuro, disregarding the effect of each colour upon its surroundings'.[22]

As a result of the Post-Impressionists' exhibition, some artists went further and looked at the decorative values of line, colour, shape, space and design in their own right and, in consequence, began to abstract their work to a significant extent. For instance, in works such as *Studland beach* 1912 (fig. 25) and *Virginia Woolf* (fig. 24, cat. 4), Vanessa Bell eliminated detail by reducing the image into strong semi-abstract forms and flat areas of colour. By bringing her subject into close focus and emphasising her head and hands, Bell left it to the viewer of *Virginia Woolf* to imagine the place her sitter inhabited.

C.R.W. Nevinson also abstracted his images in order to capture movement and energy, identifying with the Italian Futurist movement's celebration of modernity. He deliberately distanced himself from artists such as the Pre-Raphaelites and Whistler, commenting that 'The public cannot realise too soon that the modern artist is not the puny and effeminate long-haired creature of the 'eighties.' He maintained that 'Our Futurist technique is the only possible medium to express the crudeness, violence, and brutality of the emotions seen and felt on the present battlefields of Europe.'[23] In his series of paintings depicting the movement of soldiers marching, such as *Returning to the trenches* (fig. 26, cat. 86), he used a Futurist approach to convey the way in which servicemen became part of a vast military machine.

Fig. 25: **Vanessa Bell** *Studland beach* c.1912 oil on canvas 76.2 x 101.6 cm Tate, London (©Tate, London, 2004)

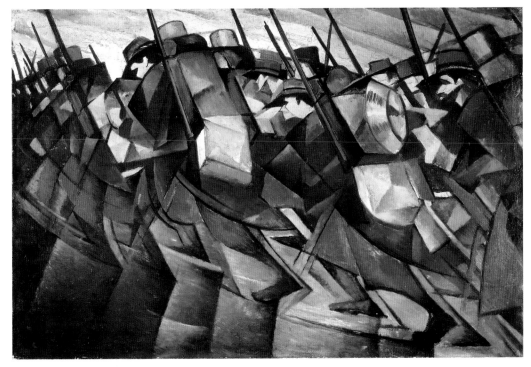

Fig. 26: C.R.W. Nevinson *Returning to the trenches* 1914 [cat. 86]

The Australian artist Thea Proctor recorded her reaction to Fry's exhibition, and how she responded to the shock of the new:

> we had the Post-Impressionists' exhibition ... another thrilling experience ... it was rather a shock, because I had been trained to draw the figure realistically, and of course, with the Gauguins, the form was very simplified ... But the colour was thrilling.[24]

Proctor was persuaded by Fry's view that modern art must be concerned with formal design rather than naturalistic representation, even if she (like Fry) never gave up the representational element. She quoted Clive Bell to the Students' Club at Sydney University: 'Art is not the imitation of form, but the invention of form.'[25] Likewise, her colleague Lambert also became convinced that artists must adopt an 'almost cubic construction' and 'reduce nature's complicated design to a definite form'.[26] And the writings and theories of Clive Bell and Fry formed the basis of George Bell's highly influential teaching of modernist principles in Australia during the 1930s and 1940s.

Fry not only organised an exhibition of modern art, but he also formulated the expression 'Post-Impressionism' and, with Clive Bell, advanced the aesthetic which described and popularised the formalist approach to art. Fry provided critics with a way of looking at, and talking about, contemporary British art. In the years immediately after Fry's exhibition, critics perceived aspects of Post-Impressionism in the work of British artists. They did so in part because these artists had adopted a modified form of Post-Impressionism, but also because the critics now had a language to describe it. Housman, reviewing the International Society's 1911 exhibition, commented in the *Manchester Guardian*:

> Most of the painters who exhibit here effectively show signs of having learned something from outside; they are still open to impressions, even to Post-Impressions, without, however, becoming revolutionaries. The Post-Impressionists do seem to have had on some of our artists a certain purgative effect, with the result that one sees here and there a decided tendency towards simplification, and the extraction from primaries of certain spontaneous decorative values which were the salient lesson taught by the show of last winter.[27]

Housman observed that the British artists adopted simplification, primary colours and 'decorative values' — qualities which Fry emphasised — but he also noted, gratefully, that the British artists modified what they learned from the French, that they followed the established British mode of reform rather than revolution.[28]

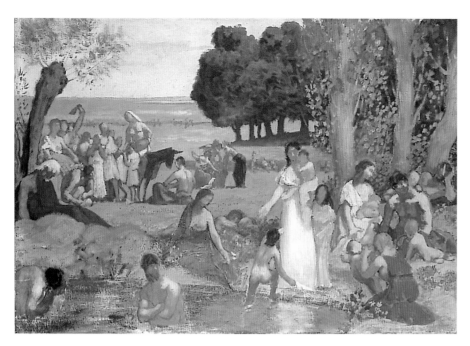

Fig. 27: Pierre Puvis de Chavannes *Summer* before 1873 oil on canvas 43.2 x 62.2 cm National Gallery, London

Edwardian artists were not solely interested in producing traditional easel paintings using a decorative aesthetic; they also wanted to create decorations. They had been trained in a tradition that placed history painting and mural decoration at the forefront of the hierarchy in art.[32] They believed that one of the greatest achievements of an artist was to improve general standards of taste by creating works for public spaces. A number of architects deliberately created areas in their buildings with a potential for mural decoration.

During the period 1868–9, Whistler devised for his patron Frederick Leyland a decorative frieze of figures (which was never completed), in which he looked to Greek and Japanese precedents. In his *Peacock room* 1876–7 for Leyland's house in Princes Gate, London, he adapted ideas from Japan, repeating images of the peacock throughout the room in gold leaf on verdigris blue to sumptuous effect.

Fry's formalist aesthetic looked to the 'decorative' qualities in art. 'Decorative painting' was a term widely used during the Edwardian period but never clearly defined. Critics such as P.G. Konody appear to have employed the word 'decoration' to describe formalist aspects of artists' work, using it to characterise a kind of stylised artifice, in opposition to representational concerns.[29]

Strang was one of the first artists in Britain to respond to Puvis de Chavannes. Around 1899, Strang was commissioned by the Wolverhampton brewer and collector Laurence Hodson to paint a series of ten large oils to be set as a frieze into the panelling of the library at his house, 'Compton Hall', near Wolverhampton. The *Adam and Eve* series was Strang's first major work and the only one of this kind that he created. When the series was exhibited in 1910, Sickert wrote: 'These seem to me to be works of the greatest importance. They are not for everybody … Here we have a modern painter setting to work on imaginative subjects in the grand, self-respecting classic manner … Every figure, every limb is studied out austerely to the end, for all the significance and beauty that it is worth.'[33]

Artists who were inspired to imbue their works with this decorative quality included Augustus John. A number of John's paintings are known by the alternative title of 'Decorative group', including the painting also entitled *Family group*, an image of an idealised family located within an imaginary landscape. These artists were impressed by the work of the French artist Puvis de Chavannes (fig. 27). Augustus John wrote: 'I went to see Puvis's drawings in Paris. He seems to be the finest modern … Longings devour me to decorate a vast space with nudes and — and trees and waters.'[30] They knew and admired Puvis' large decorative mural for the Paris Pantheon, *Histoire de Saint Genevieve* 1898, as well as his painting *Le Pauvre pêcheur* 1881 (Musée d'Orsay, Paris), which was then in the Musée du Luxembourg. They appreciated the decorative qualities of Puvis' work and the way which 'no passing fashion … influenced or deterred it'.[31] Such decorative qualities were central to the aesthetic adopted by many Edwardian artists who sought to emphasise the formal arrangement of their images.

In 1890, Sargent was invited to decorate part of the recently built Boston Public Library and, from that time until his death in 1925, he worked on the library murals, and those for the Museum of Fine Arts, Boston, and the Widener Memorial Library at Harvard University. In doing so, he abandoned the tenets of realism that had inspired his easel paintings and turned to a new range of allegorical subject matter, with a new visual vocabulary, using a more abstract decorative style appropriate to large-scale flat wall spaces. He regarded his murals as having a central place in his output, providing an intellectual and technical challenge far greater than any other work.[34]

Fig. 28: Augustus John *Family group (Decorative group)* 1908 [cat. 57]

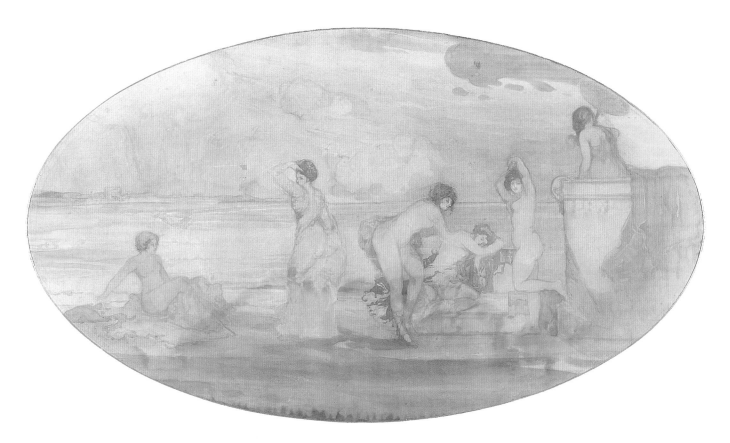

Fig. 29: **Charles Conder** *Maidens on a terrace by the sea* 1904 [cat. 25]

For over 30 years, from 1902 to 1937, Frank Brangwyn worked mainly on large murals, with those for Skinner's Hall, London, making his reputation as a painter of boldly designed and richly coloured works on a large scale. Like Sargent, Brangwyn considered that his murals had a significant place in his output. Both Brangwyn and Conder were invited to decorate rooms for Australian-born businessman, collector and philanthropist Sir Edmund Davis. Brangwyn decorated a room in Davis' house in Lansdowne Road, Holland Park, in 1900 and, in 1904, Conder produced a series of imaginative paintings on silk for rooms in the house. These dreamlike fantasies depict ladies and gentlemen at leisure, such as *Pastoral (a river landscape with ladies and anglers)* (cat. 24) and *Maidens on a terrace by the sea* (fig. 29, cat. 25). Conder also designed the decorations for the home of English designer and collector Pickford Waller, which included *A decoration* 1904 (fig. 30, cat. 27).

From around 1913 to 1919, Roger Fry, Vanessa Bell and Duncan Grant ran the London applied arts company Omega Workshops. Several strands of English modernism came together for a brief period of collaboration. The fluctuating community of about 20 artists, including Gaudier-Brzeska and Nina Hammett, worked primarily as designers and decorators of furniture, printed textiles, carpets, ceramics and embroideries. They also produced murals and mosaics for interiors of homes and public places. Through their improvised decorations they wanted to transform houses from claustrophobic Victorian places to freer and more contemporary spaces.

Edwardian artists, through the decorative aesthetic in their easel paintings and their decorative murals and designs for homes, sought to give their work a timeless quality using a modern approach.

Fig. 30: Charles Conder *A decoration* 1904 [cat. 27]

The stories: A changing world

The principal concerns of many artists of this period were painterly technique and formal construction. This focus did not exclude an interest in content — and no artist works in a vacuum. It is possible, therefore, to gain a further understanding of the art of this period by looking at what their images tell us about the Edwardian era.

The years 1900 to 1914 were ones of considerable social and economic change. They were years of hope, of Utopian ideals and of great inventions. The working class sought to gain a greater share of material prosperity and old age pensions were introduced. They were also times of disappointment and strife. There was the disaster of the sinking of the *Titanic*, the Irish fights for Home Rule

Fig. 31: Jacques-Emile Blanche *Percy Grainger* 1906 [cat. 6]

and the struggle for the vote for women. Inevitably, artists reflected some of these changes in their art.

In 1900, London was the largest city in the world with a population of around six and half million, almost double that of Paris; it was an international cultural centre. The energy of the city attracted artists, musicians and writers from all over Britain and Ireland, America, Australia, New Zealand and Europe. The Australian opera diva Nellie Melba was at the pinnacle of her success, singing in *La Traviata* at Covent Garden with the tenor Enrico Caruso in 1902, when she was captured in paint so impressively by Rupert Bunny (cat. 10). To help create her desired image, Melba enlisted the assistance of the flamboyant and stylish couturier, Jean-Philippe Worth. She praised him in her memoirs for 'making me realise how important it was to look as well as I sang … Some garments were dreams of beauty.'[35] One such magnificent garment was the cloak that Worth designed for her to wear as Elsa in Wagner's *Lohengrin* (cat. 146). In 1906 Percy Grainger, the Australian musician best known for his *Country Gardens,* had just started work on collecting and arranging English folksongs, pioneering the use of the Edison wax cylinder recorder, when the anglophile French artist Jacques-Emile Blanche painted his portrait (fig. 31, cat. 6). In 1907, Japanese actress Madame Sadayakko delighted the public in London and Paris with her 'extravaganzas' in which she fluttered the sleeves of her kimono like a butterfly, and Bunny painted her portrait in homage to her performances.

In the Edwardian era, the privileged lived a rarefied existence, hardly acknowledging the harsher side of life. Manners and breeding were seen as paramount. Some believed that the European forms of social behaviour were artificial whereas those in America and Australia were more natural. In Henry James' novel *The Europeans* (1878), one of his characters, Baroness Münster, comments, 'I had a sort of longing to come into those natural relations which I knew I should find here [in America].'[36] The divisions between the different classes were clearly marked and were generally accepted as normal. In Vita Sackville-West's novel, *The Edwardians* (1930), Anquetil observed: 'they and their friends formed a phalanx from which intruders were rigorously excluded; but why some people qualified and others did not, he could not determine'.[37]

Former actress Valerie Susan Langdon caused a
scandal in 1878 when she married in secret
Henry Meux, the heir to a brewery fortune.
She was never accepted by her husband's family
because, with her questionable past, she was not
the type of woman that the well-to-do were
supposed to marry. Whistler depicted Lady Meux
unashamedly displaying her sex appeal and flaunting
the wealth she had gained through her marriage.
Thomas Lister, 4th Baron Ribblesdale, kept his
private life more secret. Publicly, he served as
Master of the Queen's Buckhounds but in 1911,
after his first wife had died, he moved to the
Cavendish Hotel run by Rosa Lewis (the 'Duchess
of Duke Street'), and in all likelihood became
Rosa's lover.[38] Unlike Henry Meux, he did not
marry 'below himself' and, when he married again,
it was to Ava Willings, the widow of Jacob Astor.
Sargent painted Ribblesdale as the epitome of the
Edwardian aristocrat; he portrayed the public face
that the baron presented to the world.

During the days of the British Empire, the Colonial
Office sent young men to act as local officials in
India, Malaya, Africa and Australia. These men
frequently meant well, often learning the local
language and seeking to understand the local
customs. They could also be arrogant and ignorant
and sometimes contributed to the destruction of
traditional ways of life in the name of 'civilisation'.
Frank Athelstane Swettenham was an outstandingly
able and effective colonial administrator, ending
his career as governor of the Straits Colony and
high commissioner for the Federated Malay
States. Sargent portrayed his subject as a successful
proconsul, dressed in an immaculate white
uniform with the KCMG star. But he also revealed
Swettenham's vanity by showing his intricately
waxed moustache, and conveyed his proud
confidence through the arrogant thrust of his chin
and chest.[39] The Scottish laird, Lord Hopetoun, was
probably not such a good colonial leader, but he
may have been more personable. He was governor
of Victoria from 1889 to 1895 and Australia's first
governor-general from 1901 to 1902, earning
the reputation then of being popular but prone to
political blunders. Tom Roberts painted his portrait
when he had become the Marquis of Linlithgow,
after he had retired, looking directly and benignly
at the viewer (fig. 32, cat. 111).

Fig. 32: Tom Roberts *Marquis of Linlithgow* 1904–05 [**cat. 111**]

Fig. 33: George Lambert *Miss Alison Preston and John Proctor on Mearbeck Moor* 1909 [cat. 70]

During this period, women began to question their roles as wives or spinster daughters and to ask whether their sole purpose was ministering to the man of the household. Husbands were still responsible for their wives and a father had absolute authority over his children. In *Miss Alison Preston and John Proctor on Mearbeck Moor*, (fig. 33, cat. 70) Lambert created an interesting duality in the relationship between John Proctor and his niece, Alison Preston. Lambert showed Proctor in a paternalist role, with Preston included in the picture as part of his property, yet he also presented her as a modern woman, placed at the centre of the composition, dominating the picture. Lambert's portrait, with its possibilities for both traditional and more modern readings, suggests the changing balance of power between men and women at this time.

Some of the new rich industrialists and successful businessmen, as well as professionals such as John Proctor, sought social credibility and believed that images which portrayed them and their families in a historical style would provide this. Thus, when painting this portrait group for Proctor, Lambert paid homage to British sporting portraiture from the 18th century. In his stylistic approach, he demonstrated his admiration for the work of Velasquez, particularly his portrait, *Philip IV as hunter* c.1635–6 (fig. 34). In this way Lambert disguised the fact that his patron was a lawyer and made him appear to be a country squire delighting in rural life and privilege. When Steer painted his portrait of Violet Hammersley, the sister-in-law of the wealthy banker, Hugh Hammersley, he openly painted her in the manner of Gainsborough. But Steer went further by suggesting a similarity between Mrs Hammersley and one of the most famous beauties, dressing his subject in an oyster-coloured satin dress that closely approximated the one worn by Madame de Pompadour in Boucher's 18th-century portrait, and by placing her in a similar pose to that lady (Victoria and Albert Museum, London, see fig. 78, p. 85). When depicting Almina, the fifth daughter of the Bond Street dealer Asher Wertheimer, Sargent likewise created several levels of interpretation by portraying her ambivalently as both a member of the upper class and as an exotic woman of sexual allure, painting her in a pose resembling that of van Dyck's portrait of a noblewoman, *Elizabeth, or Teresia, Lady Shirley* 1622 (fig. 12) and also that of the figure of the musician in Ingres' *Odalisque with slave* 1842 (Walters Art Gallery, Baltimore).

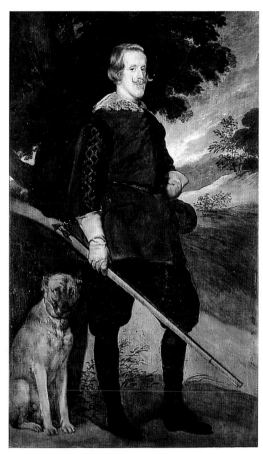

Fig. 34: Diego Velasquez *Philip IV as hunter* c.1635–6 oil on canvas 189.0 x 124.5 cm Musée Goya, Castres

The professional classes and the nouveaux riches wanted to look like people with well-established social pedigrees. Those who were already well placed wanted to affirm their long-standing ancestry, requesting portraits painted in the manner of earlier artists in order to demonstrate their continuing family tradition. For this reason, the Duke of Marlborough commissioned Sargent to paint a portrait of his family to hang 'in friendly rivalry' with Joshua Reynolds' well-known portrait of Marlborough's ancestors.[40] In a similar fashion, Sargent painted Lady Evelyn Fitzmaurice, daughter of the 5th Marquess of Lansdowne and wife of the Hon. Victor Cavendish (who became the 9th Duke of Devonshire) in the tradition of portraits by earlier artists. When depicting *Evelyn, Duchess of Devonshire*, he paid homage to van Dyck and to works such as *Henrietta Maria* 1632 (fig. 13), in which the figure is placed in a similar three-quarter view with one hand on a table and the other at her side.

The Edwardian middle classes believed that they were the backbone of the nation: solid, respectable people who tried to keep up appearances whether they were well-off or not.

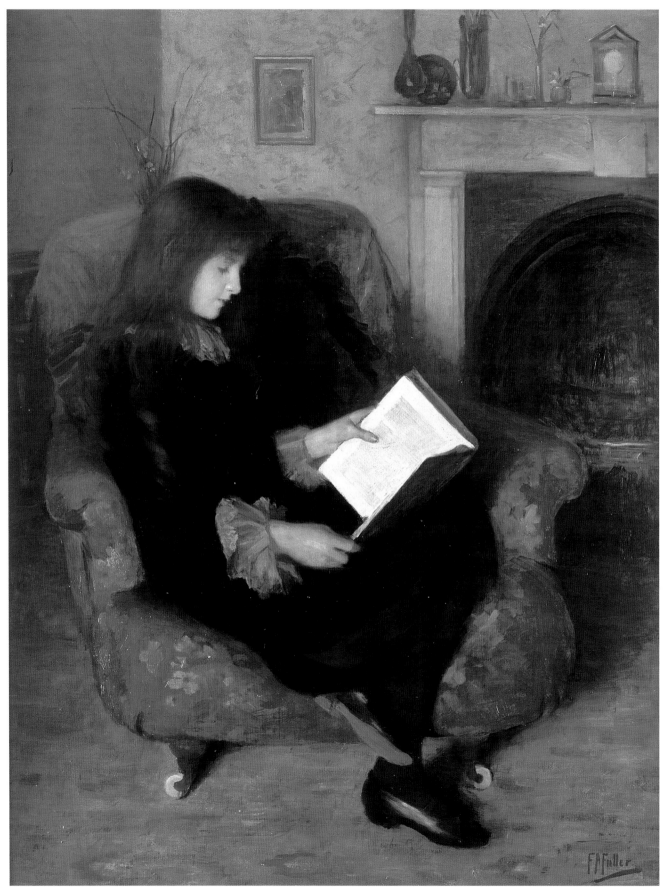

Fig. 35: Florence Fuller *Inseparables* c.1900 [cat. 43]

Although many middle-class women had received a good education, too often their husbands wanted their wives too stay at home, as 'the angel in the house'.[41] A group of intimate interiors painted by both British and Australian artists shows comfortable drawing rooms with women or girls sitting reading or in quiet contemplation, focused on their own purposes. Mary McEvoy painted such a room in *Interior: Girl reading* (cat. 82), as did Florence Fuller in *Inseparables* (fig. 35, cat. 43), and Rothenstein in *The Browning readers*. Bunny gave his pictures musical titles like *Nocturne* (cat. 13), and Ethel Walker called her painting *The forgotten melody* (cat. 141), both suggesting that these women were listening to music. Middle-class women and girls were privileged; they had sufficient time for contemplation, for pausing and dreaming in privacy. Like characters in period fiction by Anton Chekhov, Henry James and Henrik Ibsen, they seem trapped by their domestic lives, awaiting the opportunities of the new century. Nonetheless, in reading, in listening to music and in their thoughts, they could travel to places far outside the narrow confines of their homes: to the Indian plains, to Egypt, to Rome. As Virginia Woolf so aptly noted, 'There is no gate, no lock, no bolt that you can set upon the freedom of the mind.'[42] Forgetting their own selves for a time, they could dream all that their hearts desired.

At the end of Act I in Ibsen's *Pillars of the community*, Miss Hessel opens the doors and the windows and says, 'I am going to let in some fresh air.'[43] During the first years of the 20th century in Britain, there were many who wanted to let in some fresh air, to bring back joy after the stuffy Victorian era and also to create social, technical and artistic change. The darkened, brown rooms showing solitary women reading books were transformed into sunlit interiors in paintings such as Margaret Preston's *The studio window* (fig. 36, cat. 102), with its open curtains and lighter, brighter colours. In *The lesson* (fig. 37, cat. 41), Fox used high-key colours to depict light and fresh air streaming in through the window, creating a companionable image of mother and daughter seated on a divan reading a storybook together. These women, like those in Hilda Fearon's *Studio interior* (cat. 33), are located indoors but they have moved into a new place where fresh air, light and the outside world can penetrate.

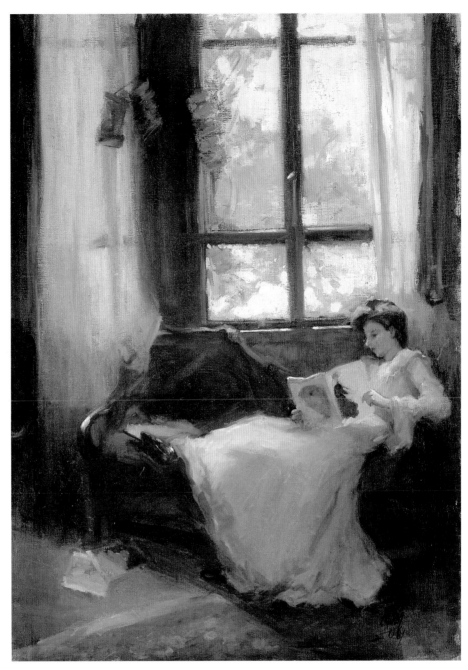

Fig. 36: Margaret Preston (Rose McPherson) *The studio window* 1906 [cat. 102]

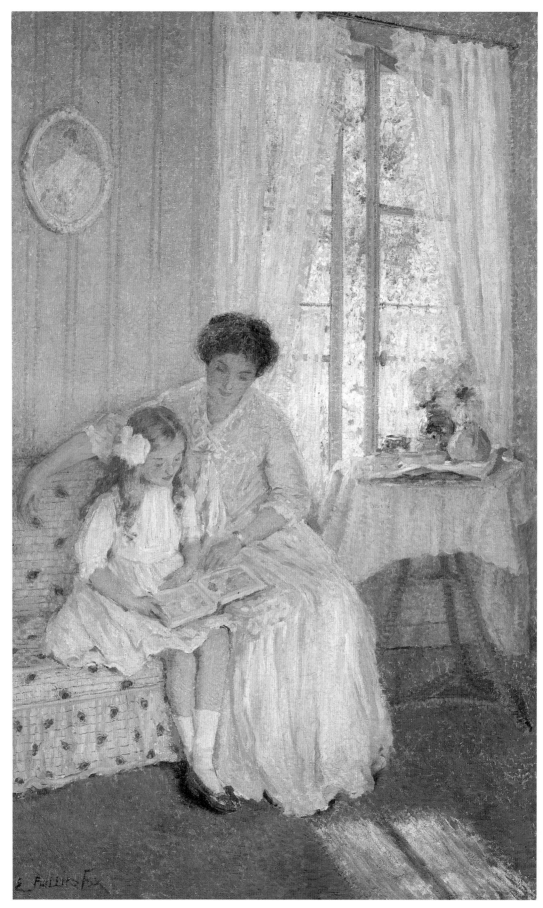

Fig. 37: E. Phillips Fox *The lesson* c.1912 [cat. 41]

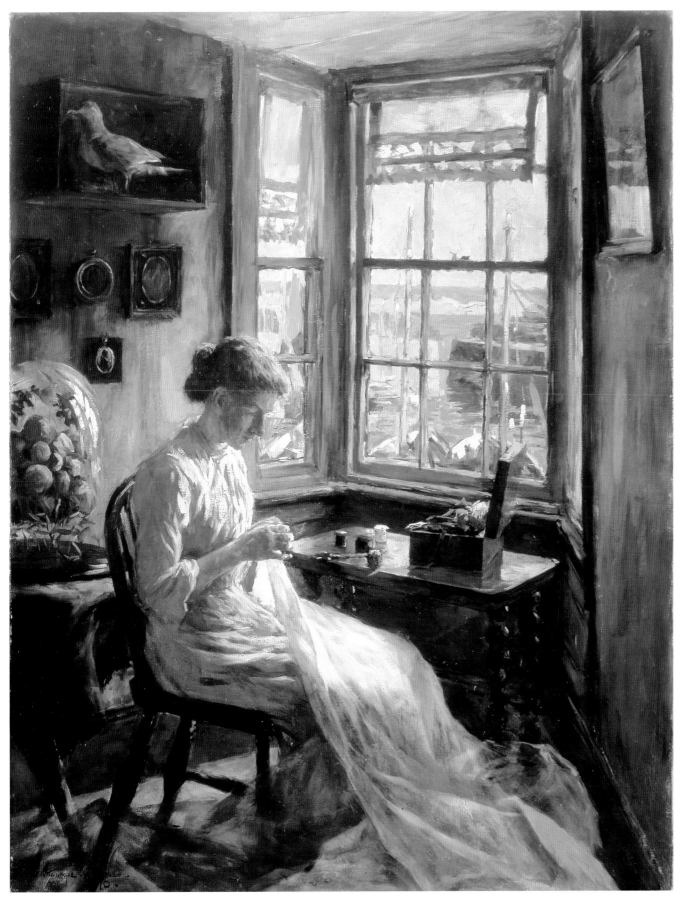

Fig. 38: Stanhope Forbes *The harbour window* 1910 [cat. 35]

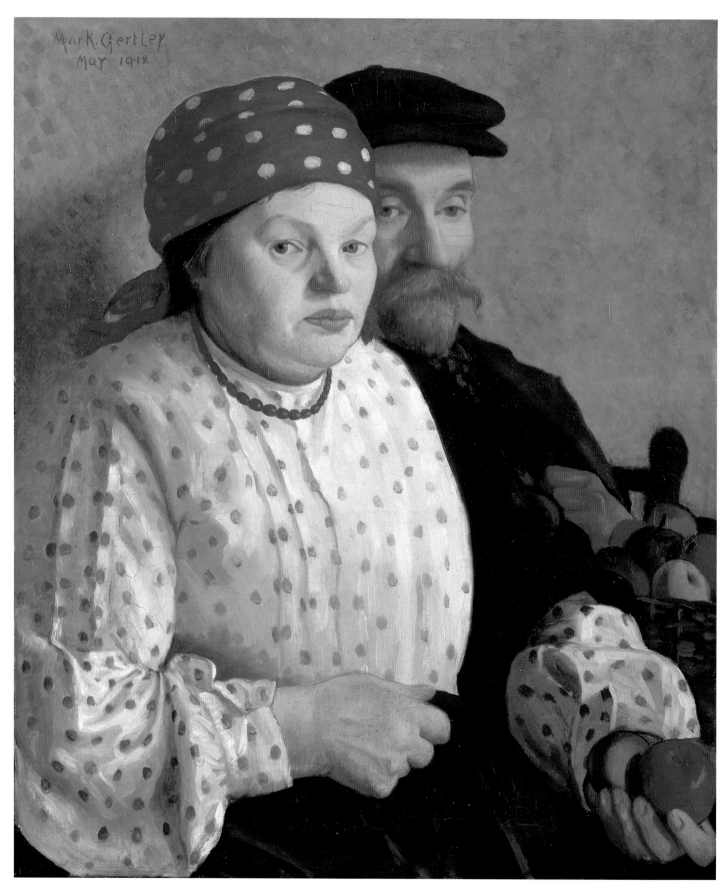

Fig. 39: **Mark Gertler** *The apple woman and her husband* 1912 [cat. 45]

Images of the gentry and the middle classes have created the impression that the Edwardian era was an age of opulence, and so it was for some. Edwardian high society, however, depended upon the 'secret' masses who worked quietly and unobtrusively for very small wages, living in crowded conditions. The growth of London went hand in hand with an increase in poverty and a crisis in housing. Employed as servants, working in the field, living in semi-poverty as seamstresses — these people wanted change. Although servants and workers were not obvious subjects for paintings, some artists had sympathy for them and portrayed them engaged in their labours. Clausen and Russell painted images of peasants at work in the fields. Gilman and Agnes Goodsir gave their servants a sense of nobility in *The Negro gardener* and *La Femme de ménage* (cat. 52) by posing them in the fashion of the gentry. Likewise, Ramsay gave a sense of dignity to his tramp in *A mountain shepherd*. In *Lotty and a lady*, Lambert challenged the traditional Edwardian social roles and behaviours by portraying the housemaid, Lotty, sitting in the kitchen together with the mistress of the house. Nonetheless, these artists conveyed a romantic reverence for the working class rather than showing in full the harsh realities of their existence. Albert Rutherston, however, depicted the sheer misery of a seamstress' life in his painting *Song of the shirt* (cat. 116), which implied the ruthless exploitation of this woman and those like her.

Mark Gertler and Gladys Reynell also sought to attain greater understanding for people living on the edge of poverty. Gertler's parents, portrayed in *The apple woman and her husband* (fig. 39, cat. 45), were Jewish emigrants, and their only way out of life in a London ghetto was through hard work. Likewise, the Irish couple with toil-worn hands that Reynell portrayed in *Old Irish couple* (fig. 40, cat. 110) were bound by circumstance. They would have had to bring up a large family on something like seven shillings a week (at a time when an artist could charge five shillings a lesson).

In *Important people* (fig. 41, cat. 74), Lambert mocked the assumption that importance is a matter of money or property and asserted that motherhood and physical prowess are as significant as wealth and power. A contemporary reviewer astutely observed that Lambert's painting reflected topical issues: the interest in flower girls that George Bernard Shaw's

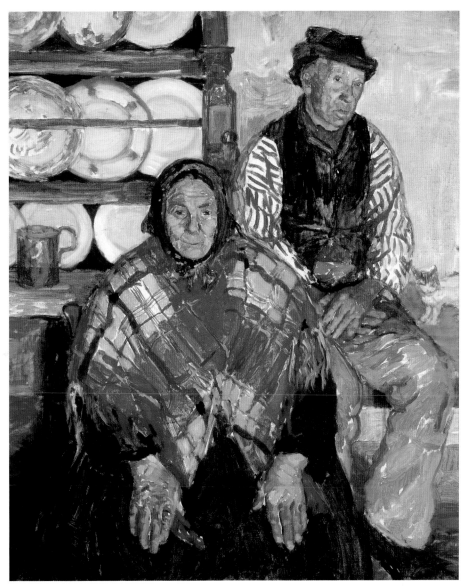

Fig. 40: Gladys Reynell *Old Irish couple* c.1915 [cat. 110]

Pygmalion had created, the current popularity of prize-fighting, and debates on the importance of producing babies.[44] Shaw demonstrated that society judged a woman to be a 'lady' by her way of speaking and behaving. *Important people* was not an illustration of Shaw's writing, but it was a variation upon Shaw's socialist ideas: it showed a flower girl and a prize-fighter posing with the authority of eminent citizens. Lambert admired Shaw's insight into society, and assimilated some of his socialist principles. In *Important people*, Lambert held up a mirror to society and to the falsity of social values (the type of woman suited to be a mother and the kind of people appropriate to group portraits). He also drew attention to the artificiality of the traditional group portrait.

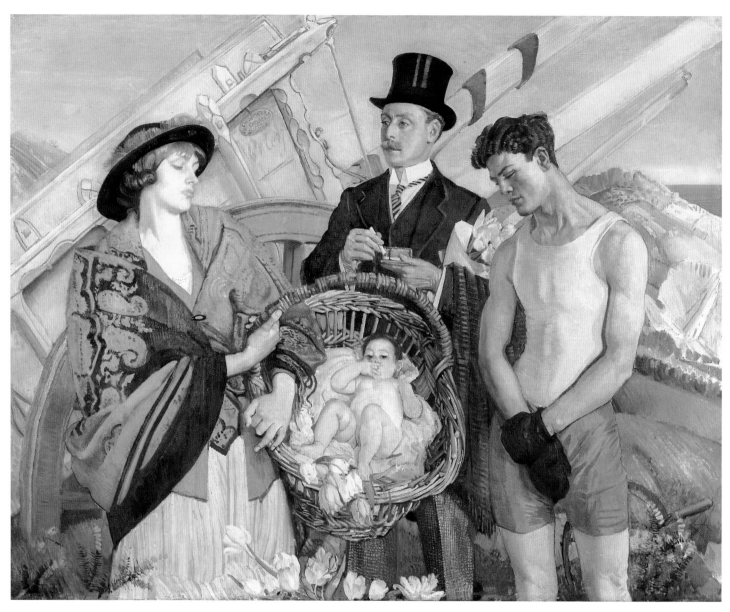

Fig. 41: George Lambert *Important people* 1914 [cat. 74]

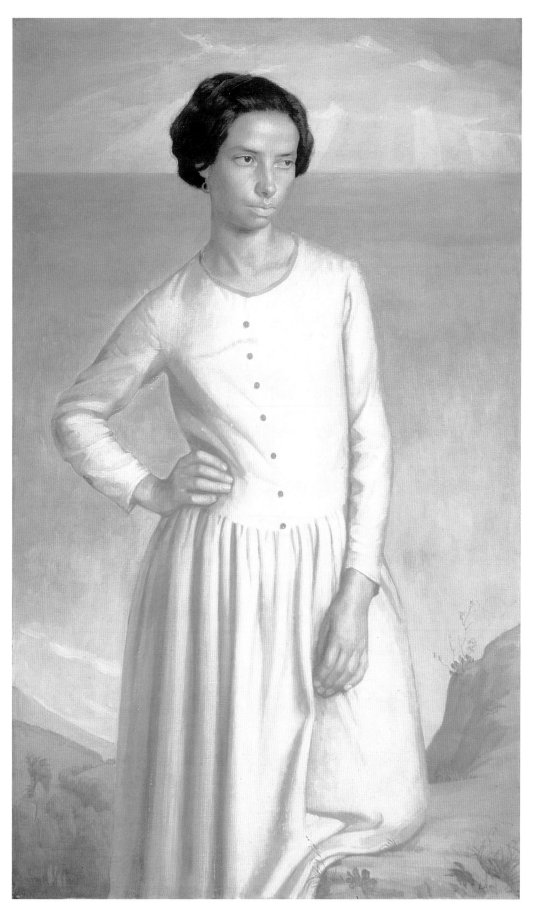

Fig. 42: **Henry Lamb** *Edie McNeill* 1911 [cat. 65]

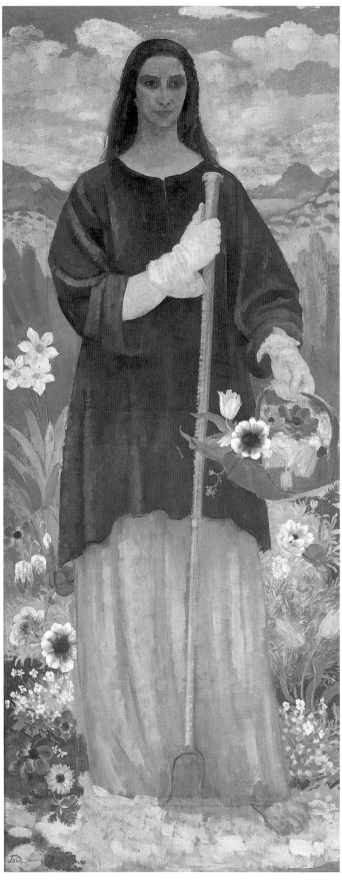

Fig. 43: Augustus John *La Belle jardinière* c.1911 [**cat. 58**]

Lambert's decorative and colourful arrangement of figures in *Important people*, and their fixed poses within a narrow picture space, resembles works in the decorative tradition by Strang and Eric Kennington with whom Lambert exhibited. Their figures all seem frozen in time in an unreal world, particularly those in Kennington's *Costermongers* (fig. 44, cat. 62) which, like *Important people*, was also exhibited in the International Society's 1914 exhibition. Critics described these paintings as 'huge staring groups of life-size people, represented in a brutal airless way' and acknowledged that they were protests against the 'namby-pambiness' of the usual group compositions.[45] But more than that, they presented working-class people in a frank and honest manner, with a view to encouraging a more sympathetic attitude to them.

Augustus John was also interested in depicting outsiders, such as costermongers and the Romany people, and did so in paintings like *The mumpers* 1912 (Detroit Institute of Arts). John took his extended family on trips in a gypsy caravan. His second wife, Dorelia, was known for her free-flowing dress, a style that was influenced by the clothing of John's gypsy friends. She encouraged others within her circle, such as her sister Edie, and Lyndra, the wife of Derwent Lees, to wear similar clothes. This is how John, Lamb and Lees depicted them in *La Belle jardinière* (fig. 43, cat. 58), *Edie McNeill* (fig. 42, cat. 65) and *The yellow skirt* (cat. 79). This 'artistic dress' was also the kind of clothing recommended by the 'maternal feminists', who claimed that if women wore freer clothes they would do less damage to their bodies and thus be better able to bear children.[46] These women not only dressed up as gypsies but also adopted aspects of gypsy life, releasing themselves from some restrictive middle-class conventions as well as constraining dress. John and his followers took to the bohemian life with enthusiasm but, unlike the costermongers, Jewish emigrants or Irish workers, they did so from choice.

During the Edwardian period, women with intelligence, social opportunities and strength of character — the New Women — were able to choose their careers and pursue independent personal goals. They not only let fresh air into their rooms but they also went out into the world.

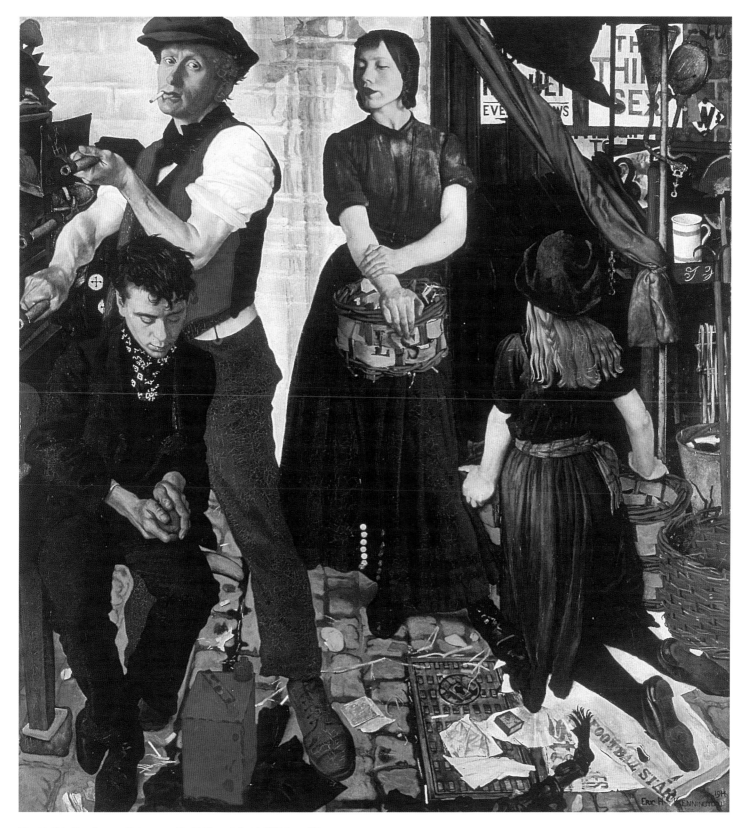

Fig. 44: Eric Kennington *Costermongers (La Cuisine ambulante)* 1914 [cat. 62]

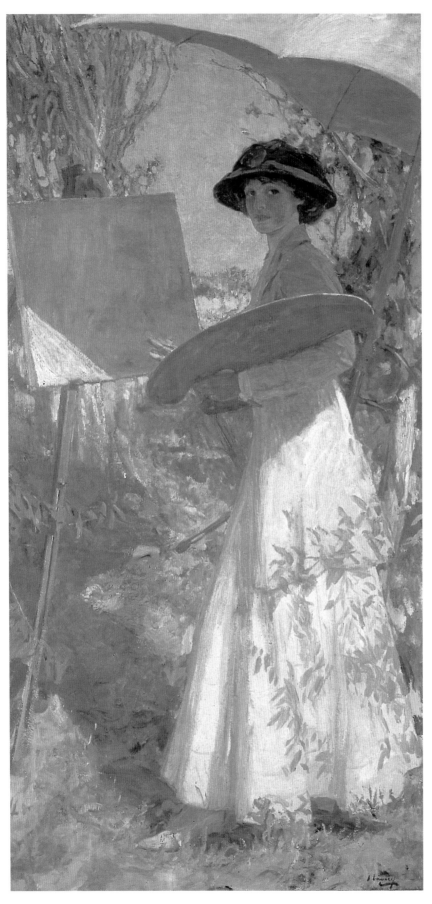

Fig. 45: John Lavery *Mrs Lavery sketching* 1910 [cat. 76]

They drove cars, as conveyed by Nicholson's painting *La Belle chauffeuse* (cat. 88). They actively engaged in adventures: they took a passage to India or travelled to Morocco or to Italy. The artist Jane de Glehn spent time painting in Italy with her husband, Wilfrid de Glehn, and John Singer Sargent. Sargent painted her there in *The fountain, Villa Torlonia, Frascati, Italy*, perched on the corner of a balustrade sketching the scene in front of her. Others, still confined to a more domestic role, began to enjoy the benefits of wearing looser garments and enjoying physical exercise by the sea, as portrayed in Sims' *By summer seas* (cat. 128) and Fox's *Bathing hour* (cat. 37). Such physical exercise, it was claimed, made women stronger and healthier and better able to look after their children.[47]

Afternoon teas in the garden were a welcome break from the formality of Edwardian dining. As Harold Knight's *In the Spring* (fig. 47, cat. 63) suggests, tea in the garden was a liberating experience, where it was possible to have an intimate discussion while partaking of simple food. Such was the pleasure of easy outdoors eating that many artists were drawn to this subject, from the French Impressionists to Fox (in *Al fresco* and *Déjeuner*). Other artists, like Kathleen O'Connor, showed women enjoying themselves in convivial conversation while somewhat daringly smoking cigarettes and drinking wine (cat. 89). In *Bank holiday*, Strang presented an even more modern life event; a showily dressed youth examining a wine list at a restaurant, watched by his companion and a sardonic waiter.

The Edwardians were interested in the spiritual force of nature. In a post-Darwinian era they were seeking new forms of spirituality. Authors such as E.M. Forster, Kenneth Graham and D.H. Lawrence wrote about the pleasures of the countryside and its spiritual aspect. In his short story, 'Other kingdom', Forster's Evelyn 'danced to the song of a bird' and 'danced away from our society and our life, back, back through the centuries … Her garment was as foliage upon her, the strength of her limbs as boughs, her throat the smooth upper branch that salutes the morning or glistens to the rain.'[48] She became transformed from a human being to a spirit of the forest.

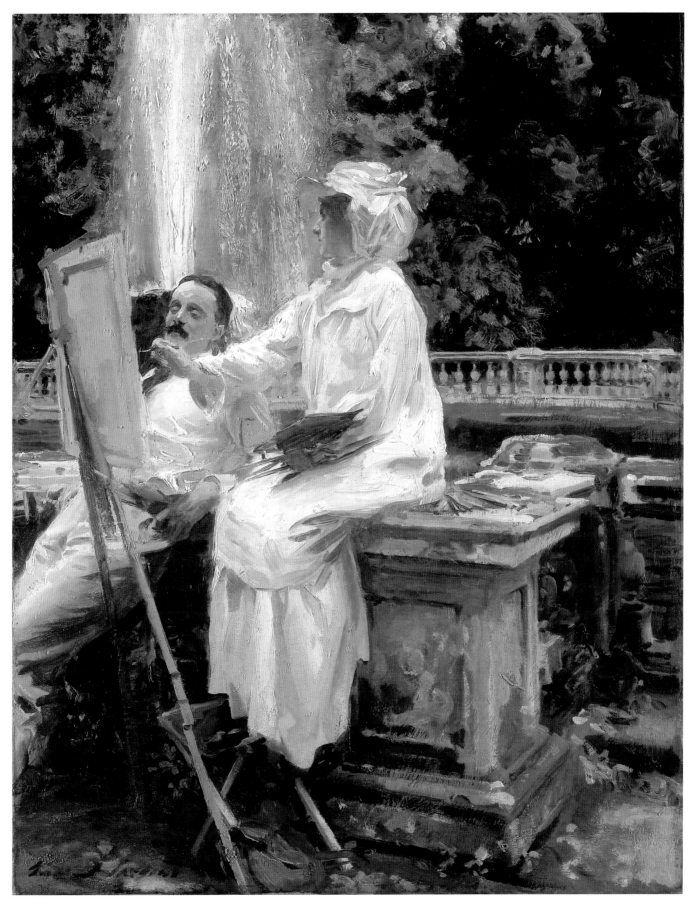

Fig. 46: **John Singer Sargent** *The fountain, Villa Torlonia, Frascati, Italy* 1907 [**cat. 120**]

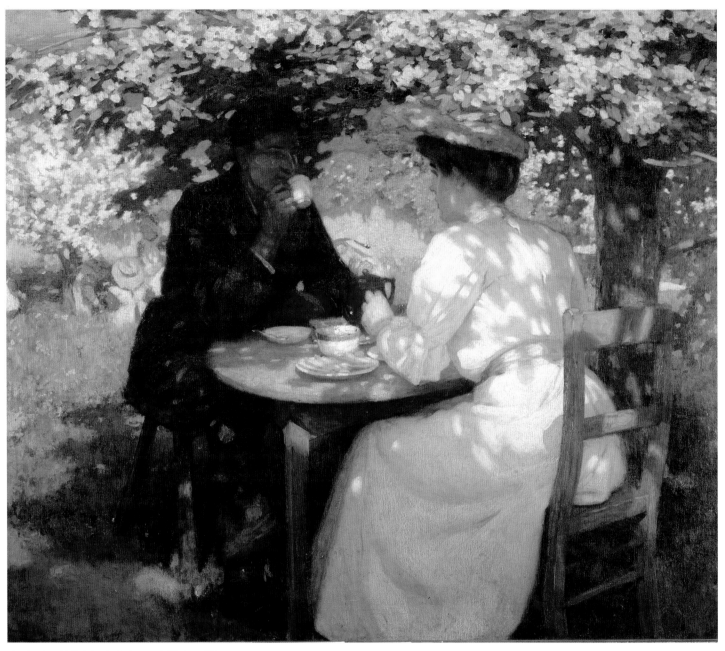

Fig. 47: Harold Knight *In the Spring* c.1908 [cat. 63]

Fig. 48: E. Phillips Fox *Al fresco* c.1904 [cat. 36]

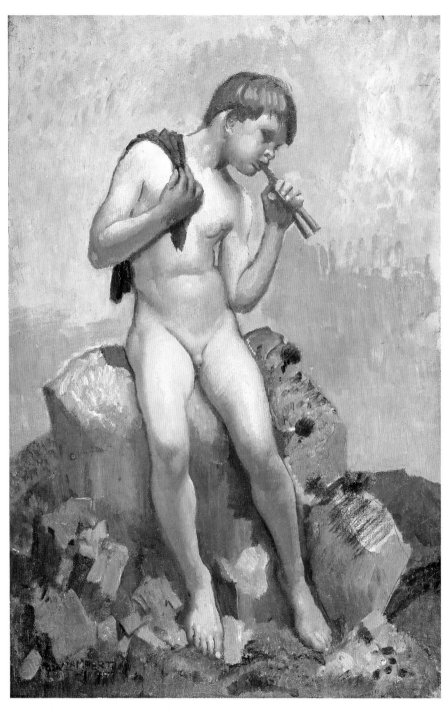

Fig. 49: George Lambert *Boy with pipes (The young shepherd)* c.1913 [**cat. 73**]

J.M. Barrie's 1904 play, *Peter Pan*, was about a child of nature, a boy who wouldn't grow up or, rather, wouldn't give up his pagan self to become a part of the civilised adult world. He was a child who could converse with animals, listen to fairies and experience the secret world behind appearances. In his sculpture of Peter Pan for Kensington Gardens, George Frampton created a grouping that suggests that the music from Peter's pipes is calling up rabbits and mice, fairies and elves. While no such creatures are visible in Lambert's *Boy with pipes* (fig. 49, cat. 73), it is easy to imagine that this youth is a pagan, living in an Arcadia, calling to other sprites with his pipe.

Edwardian artists were just as interested as those in any other era in portraying the nude. In the 1890s, in Parisian studios like Colarossi's, eight models posed in succession each day. The model suggested several poses from which the students selected one by voting.[49] Alfred Munnings' *A study of a male nude in Julian's atelier, Paris* (fig. 50, cat. 85) shows a nude model posing before student artists assiduously working at their easels.

Throughout the 19th century, artists had used traditional themes and classical forms to elevate their subjects, creating images of an ideal by placing their nudes within an imaginary timeless world. When Bunny painted *An idyll* (fig. 62, cat. 9) and Streeton depicted *Venus and Adonis* (cat. 132) — safe images that wrapped the nude in the classical past — they were working in this Victorian tradition. Almost at the same time, Orpen and Steer painted two daring nudes, *The English nude* (fig. 51, cat. 92) and *Seated nude: The black hat* (fig. 52, cat. 129). They painted nudes in a new way, moving away from the classical ideal towards the reality of the present, portraying everyday settings and warm, flesh and blood people. Seven years later, in the middle of the Edwardian era, Sickert and the Camden Town artists painted their nudes in a franker fashion. Sickert's *Mornington Crescent nude, contre-jour* revealed an aspect of their society that the Edwardians would have preferred not to have seen: a shameful world in the rough North London area of Camden Town, where prostitutes lived in squalid bedsits and where murderers lurked.

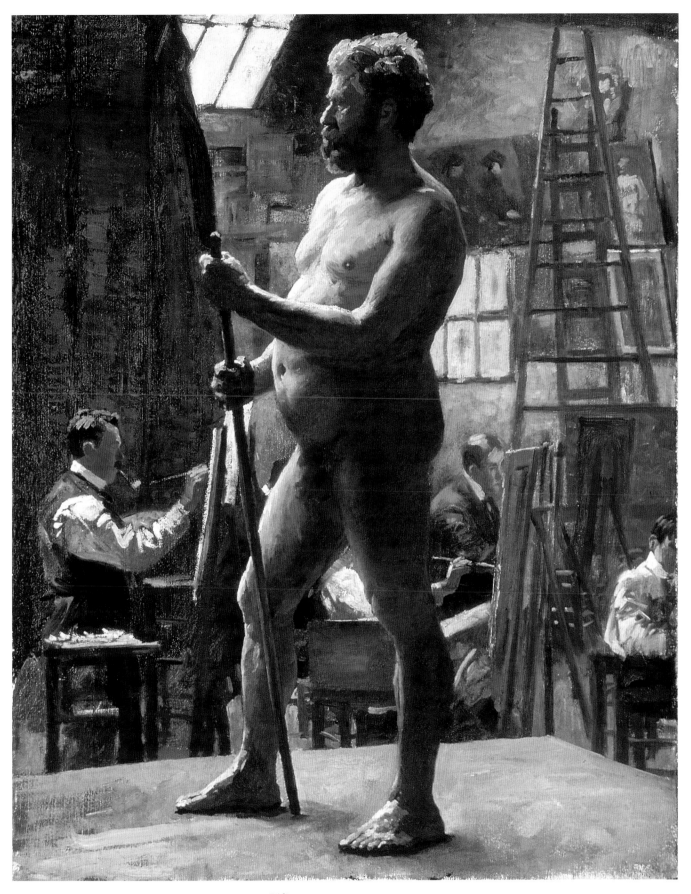

Fig. 50: **Alfred Munnings** *A study of a male nude in Julian's atelier, Paris* 1901 [cat. 85]

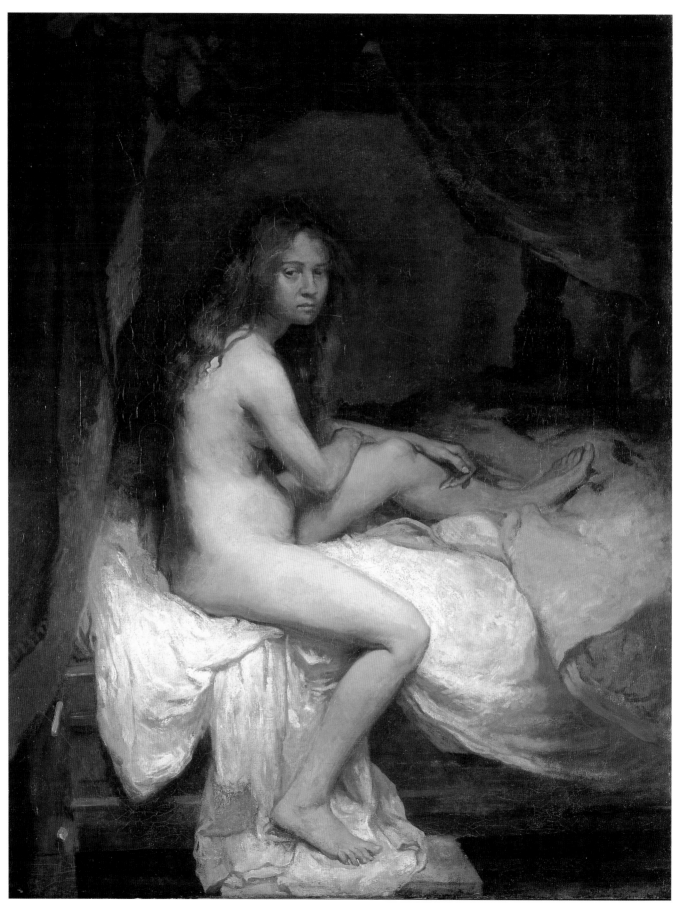

Fig. 51: **William Orpen** *The English nude* 1900 [cat. 92]

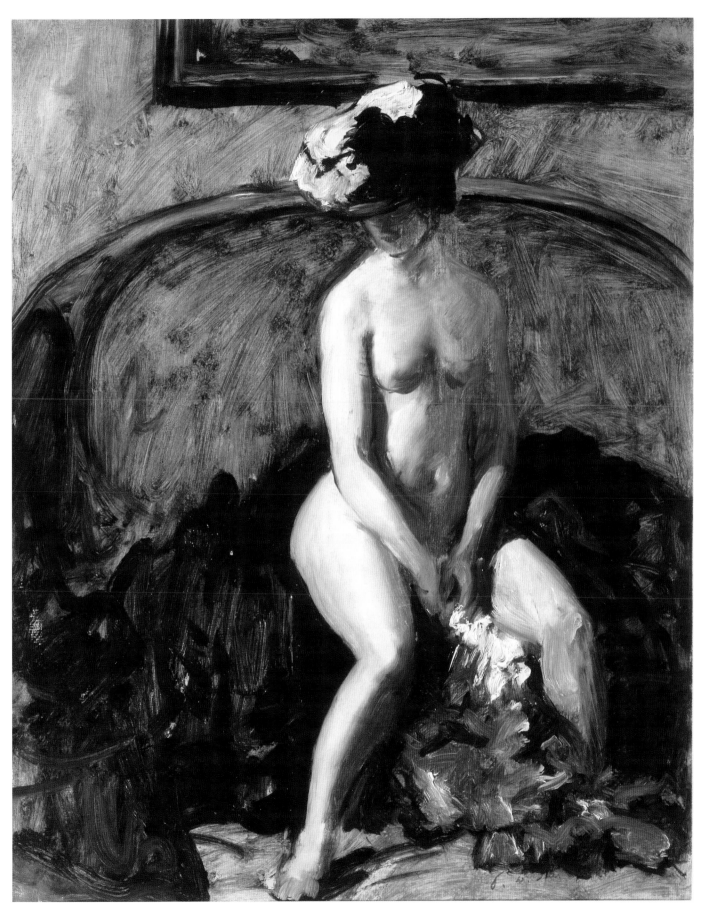

Fig. 52: Philip Wilson Steer *Seated nude: The black hat* c.1900 [cat. 129]

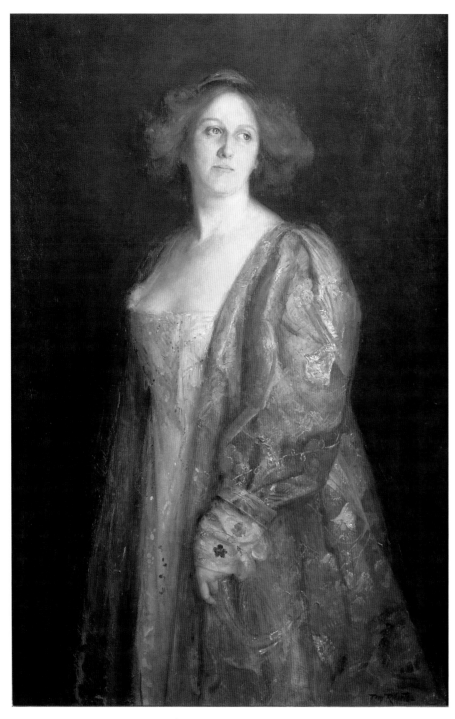

Fig. 53: **Tom Roberts** *Madame Hartl* c.1909 [cat. 112]

In *After the bath* (fig. 18, cat. 39), painted around the time of Edward VII's death, Fox depicted a more comfortable middle-class subject but, like Sickert, his interest was in using thick touches of colour to capture the effects of light. Like Sickert, Fox wanted to paint everyday scenes of people caught in action, carrying out their daily activities. Stylistically, these images show a transition from a tight handling of paint to a more impressionistic use of paint and concern with light.

Edward VII died on 6 May 1910 and his son George V became king, but the hedonistic life of the social set continued for a few more years. People frequented the theatre and the music hall, where they watched each other as much as the performers on stage. Images portraying men and women in a theatre box were common. In *Femme dans une loge au théâtre (In the foyer)* [1895–1900] (cat. 22), Conder used a theatrical setting to dramatise his subjects and to suggest the artifice of their lives. George Bernard Shaw commented that 'public and private life become daily more theatrical: the modern Kaiser, Dictator, President or Prime Minister is nothing if not an effective actor; all newspapers are now edited histrionically'.[50]

Throughout this period, artists and members of the social set were fascinated by fancy dress and spectacle. Wearing masks and costumes, they attended masked balls and fancy dress parties. Tom Roberts painted Madame Ruby Hartl in the spectacular Italianate costume of La Tornabuoni, which she wore to the Chelsea Arts Club Annual Costume Ball (fig. 53, cat. 112). When Charles Conder and his wife gave a fancy dress ball at their Chelsea house in 1905 (fig. 54), Conder wore the costume of a dandy of 1830 and one of the female guests wore a dress designed after Aubrey Beardsley's *The peacock skirt* 1893. The masks and costumes worn by men and women at these

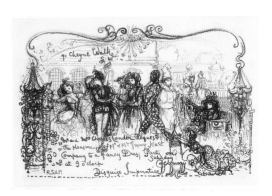

Fig. 54: **Charles Conder** *Invitation card: A fancy-dress party at the artist's house* 1905 transfer lithograph printed in black ink 15.8 x 24.7 cm National Gallery of Australia, Canberra

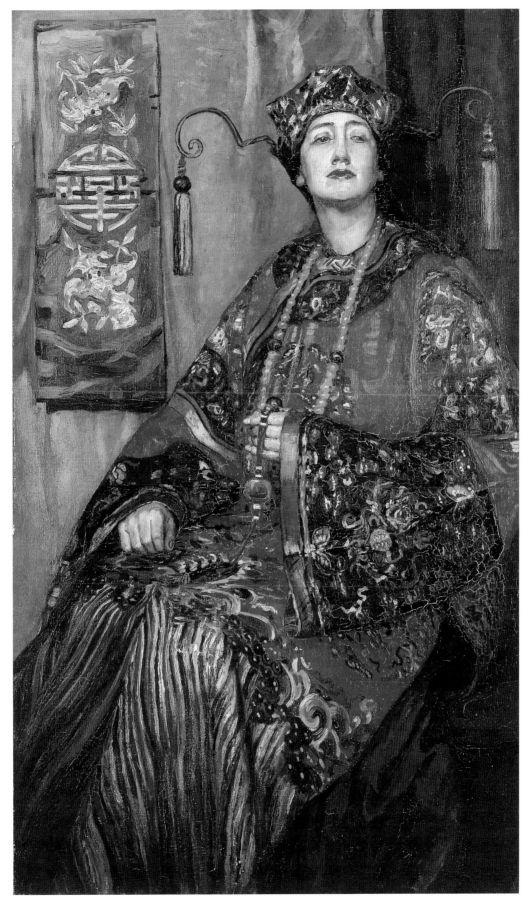

Fig. 55: Hilda Rix Nicholas *La Robe chinoise* c.1913 [cat. 87]

parties were often copies of those used in stage performances. At other times they were derived from richly illustrated catalogues for fancy dress costumes for masquerades, carnivals, popular balls and tableaux vivants.[51] The masks and costumes conferred anonymity on the wearers and enabled them to take on different personas.

Artists wanted to show that art was an artifice, a separate realm from reality. But they were also keen to suggest that the life of many around them was lived as a masquerade. They depicted their subjects in fancy costumes suggesting the masks that people assumed and sometimes hid behind. Sargent showed Almina Wertheimer wearing an exotic costume, a Persian dress and turban. Lavery depicted his wife dressed in Egyptian clothing (cat. 78). Orpen presented himself in the guise of the 18th-century painter, Jean-Baptiste Simeon Chardin (cat. 95). Hilda Rix Nicholas and J.D. Fergusson portrayed occidental subjects wearing oriental costumes (fig. 55, cat 87 and fig. 23, cat. 34).

Members of the Chelsea Arts Club put on theatrical tableaux, an extension of the Victorian tableaux vivants. These theatrical tableaux, however, were not party games for family entertainment but were pageants created for viewing as theatrical pieces. They were adventures in colour and movement, music and the human voice, in which performers moved in procession to the rhythm of instruments. In the Chelsea Arts Club pageant of 1909, a sculpture of Pan was brought to life, Pygmalion-like, by the kiss of Flora. The pageant of 1911, *Episodes*, consisted of seven symbolic tableaux describing Australia's development. It was created in order to honour the Australian parliamentary representatives who visited London for the coronation of George V. These pageants were not a mere diversion; they reflected the concerns of artists and of society, and were a contemporary performance art form.

Serge Diaghilev's Ballets Russes, with their merging of design, movement and music, elevated this vogue for spectacle to a high art. When they performed at Covent Garden in 1911, the British art world and high society were caught up in a wave of enthusiasm. Edward Marsh, a patron of young artists, described the Russian ballet as a 'Post-Impressionist picture put in motion'.[52] The 'sensuous stage pictures' and 'sumptuous barbarism' of *Schéhérezade* enthralled the *Observer*'s music reviewer.[53] Proctor delighted in the brilliant colour and design of the Russian ballet when she saw it in 1911 and later commented that 'it would

be difficult to imagine anything more beautiful and inspiring'.[54] Laura Knight wrote that 'I feel sorry for anyone who did not see Diaghileff's first seasons … it gave me the feeling of being born again into a new and glamorous world, with complete satisfaction for every aesthetic sense.'[55] Diaghilev blended the artistic talents of choreographers, composers and painters into one organic whole, with the dancers moving in a new and original fashion. In *L'Oiseau de feu* (1910), he combined the talents of the artists Léon Bakst and Aleksandr Golovin (cat. 50), choreographer Michel Fokine and the avant-garde music of composer Igor Stravinsky. In *Daphnis et Chloé* (1912), he brought together Bakst, Fokine and the composer Maurice Ravel.[56] Artists, designers, musicians and writers were at first dazzled and then stimulated by the dance and music, as well as by the brilliantly coloured costumes and decor. Henri Gaudier-Brzeska was so inspired by *L'Oiseau de feu* that he was moved to express his response to the ballet in sculpture (cat. 44). Designers transformed their apartments using brightly coloured 'oriental' decorations. Artists became conscious of the potential of portraying figures with exaggerated gestures of hands and feet, and in the turn of the neck and the torso. In *The apple of discord* (fig. 57, cat. 15), Bunny's figures appear to be acting out a dramatic tableau, and he adopted the bold colours and stylised gestures used by dancers of the Ballets Russes.

In 1912, when the 'unsinkable' luxury liner *Titanic* went down after hitting an iceberg, it brought home the shocking realisation that wealth did not make one inviolable. Although the period immediately before 1914 were years of uncertainty, with the gradual escalation towards war, for many people the descent into such a bloody conflict was unexpected. In a letter that the novelist Henry James wrote to a friend only weeks after the war began in August 1914, he poignantly stated how the war came to change people's understanding of the years that preceded it:

> The plunge of civilisation into this abyss of blood and darkness … is a thing that so gives away the whole long age during which we have supposed the world to be … gradually bettering, that to have to take it all now for what the treacherous years were all the while making for and meaning is too tragic for any words.[57]

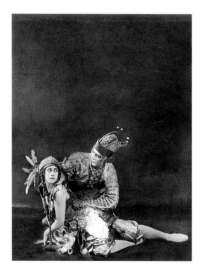

Fig: 56: E.O. Hoppe *L'Oiseau de feu (The Firebird) — Madame Thamar Karsavina and M. Adolph Bolm* 1913 rotogravure 20.4 x 15.4 cm National Gallery of Australia, Canberra

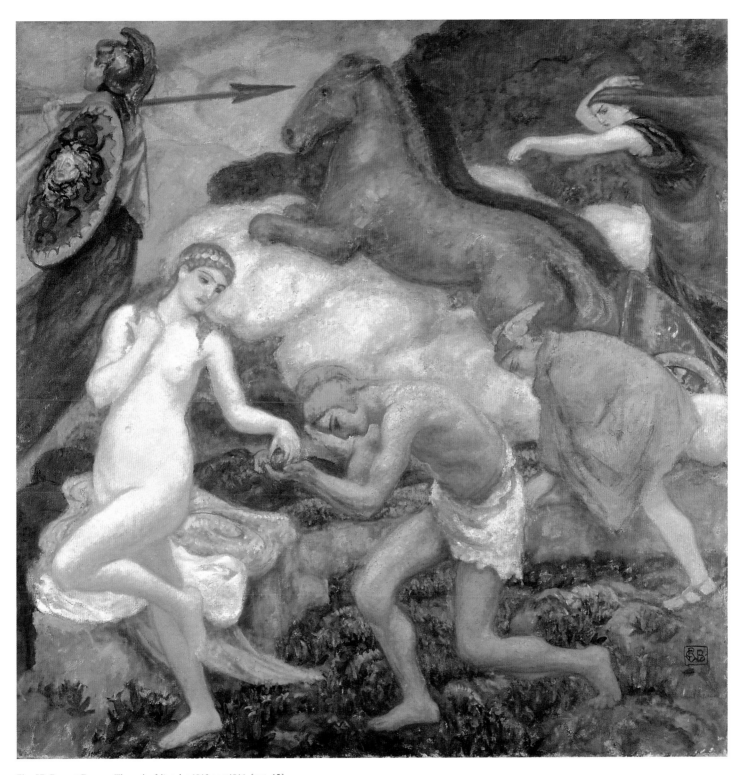

Fig. 57: **Rupert Bunny** *The apple of discord* c.1913 or c.1916 [**cat. 15**]

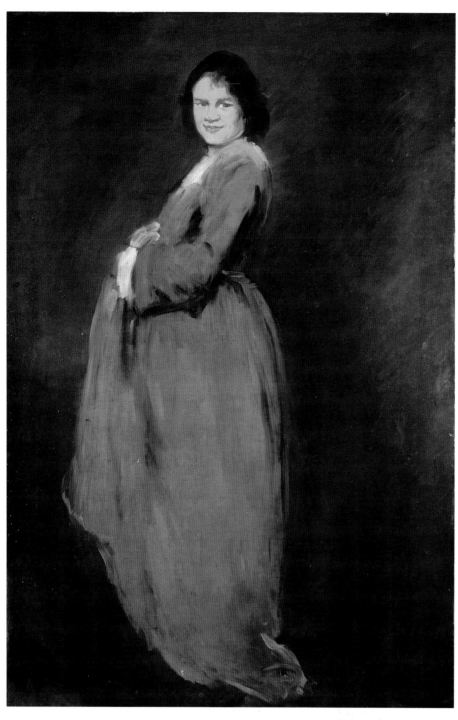

Fig. 58: Augustus John *Ida pregnant* 1901 [cat. 56]

Sickert conveyed this mood of disillusionment in his best-known work, *Ennui* (cat. 125). This painting has the informality of a snapshot, an open-ended moment. The scene is ambiguous; it is neither public nor quite domestic. The work captures an aspect of the time as few other works do. The man sits at the table, smoking his cigar and staring into space, lost in his private world. It may be that he does not yet know that he is tired of the life around him. But the woman certainly appears tired. Standing at the mantelpiece, head in hand, she conveys the hopeless dreariness of her life, the consciousness of the impossibility of escape from the monotony of her commonplace existence. Sickert first depicted this scene in around 1913 and reworked it several times, painting his last version sometime between 1914 and 1918, during the First World War. In the context of its time, this final variation not only suggests domestic boredom and disharmony, but also the troubles of the world beyond the room — the anguish experienced by so many as a result of war.

Sickert perceived the psychological impact of the war from the home front, whereas Nevinson was eye-witness to the heavy casualties and widespread devastation of the first battles in Flanders. In his earliest war paintings, he used a splintered Futurist approach to portray the harsh anonymity of modern warfare and the way men became powerless against the machinery of war. Fellow serviceman Siegfried Sassoon described a scene similar to that of Nevinson's painting *Returning to the trenches*:

> I visualized an endless column of marching soldiers, singing 'Tipperary' on their way up from the back areas; I saw them filing silently along ruined roads, and lugging their bad boots through mud … The idea of going back there was indeed like death.[58]

While serving at the front, artists and writers saw how the secrets and desires of so many soldiers were utterly destroyed by the horrors of the First World War.

The interchange between Edwardian artists

In the carefree years before the war, artists travelled constantly between Britain and France for artistic reasons rather than to fight in the trenches. The cost of a return fare was about £4 and the journey by boat-train took about a day, so most artists were able to move readily between London and Paris. Even Parisians such as Rodin and Jacques-Emile Blanche, and the Italian Giovanni Boldini, showed their work regularly in London, with Rodin serving as president of the London-based International Society of Sculptors, Painters and Gravers.

As might be expected of colonials, many of the artists commonly regarded as Australian had peripatetic parents. So too, did the two American artists included in this exhibition, Whistler and Sargent. A good number of the Australians were born in England and migrated to Australia with their families either as small children, like Harold Parker and Ramsay, or as teenagers, like Meldrum and Roberts. Perhaps more importantly, whether born in Australia or in Britain — or in Russia or South Africa — most of the so-called Australian artists considered themselves to be both British and Australian. They would have been born, and probably have left the country, before Australia became a federation of states in 1901. But even after 1901, Australia remained a British colony without full power to govern itself. The new Commonwealth of Australia did not have any diplomatic representation overseas until 1909 when George Reid became Australia's first high comissioner in London, and it was not able to make formal treaties with foreign powers. Commonwealth law could be invalidated by legislation in the British parliament and the Australian national anthem was still that of Britain. Moreover, Australia did not have the authority to declare war or peace and, in 1914, Australia did not declare war on its own behalf — the Empire was at war and so automatically were the dominions.[59] However, few Australians at this time would have thought this controversial because most of them, even if born in Australia, would have called Britain (or Ireland) 'home'. Indeed, 98% of people recorded in the census as living in Australia at this time were of British or Anglo-Celtic descent, with 1% born in Germany and 0.8% born in China.[60]

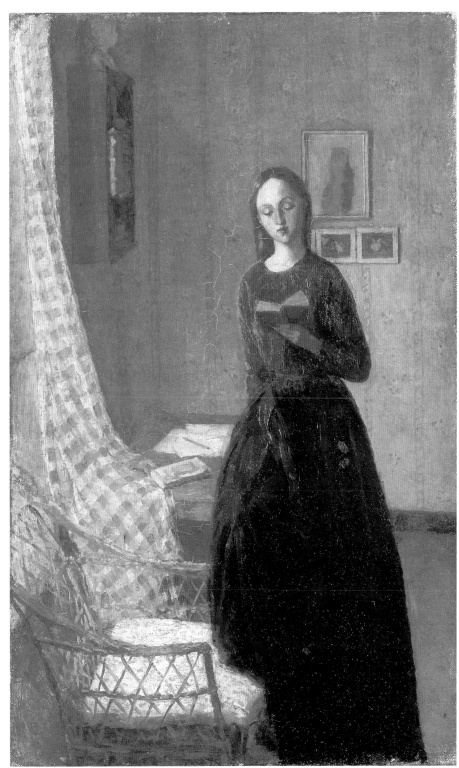

Fig. 59: Gwen John *A lady reading* c.1909–11 [cat. 59]

Fig. 60: Ethel Carrick *Arabs bargaining* c.1911
[cat. 17]

Society of Artists), as with John Longstaff (1887), James Quinn (1893), George Coates (1896), Meldrum (1899) and Lambert (1899, NSW). Such scholarships gave artists a small annual stipend for three years. For this they were expected to send back to Australia for their state collections several works that they had painted. While some Australians studied in London at their own expense, for many the fees at schools such as the Slade were too high and the teaching at the Royal Academy Schools too conservative. Thus, like a number of their British contemporaries, they went to one of the many ateliers in Paris to follow up their initial training, in the belief that a year or two at Julian's, the Ecole des Beaux-Arts or Colarossi's was worth 'a cycle of training in art' in London, with all its 'correctness and plaster casts'.[63] They appreciated that these ateliers required no entrance tests, and welcomed the opportunity to paint from models and to have contact with other artists.

Most artists travelled to Paris, Spain or Holland to study the works of old masters. They looked closely at the work of earlier artists, using the public galleries as a source of reference, examining how these artists used drawing, tone, colour and composition in their paintings. Whilst abroad, they also viewed and admired the work of Manet, Monet and Degas and the other Impressionists. As previously noted, a number of artists also came under the influence of Bastien-Lepage and, in summer, painted in the open air at artists' colonies in France and Britain. The women particularly enjoyed being in Paris —a more intimate city than London, with more liberated attitudes —where they had the opportunity to meet other aspiring women artists from all over the world. Women artists also travelled and some, such as Ethel Carrick and Hilda Rix Nicholas, visited exotic places like Morocco (fig. 60, cat. 17). These experiences enhanced their more formal training and gave their art a broader perspective.

As Humphrey McQueen has observed in his biography of Roberts, 'for Roberts the issue was one of emphasis: was he an Austral–Briton or a British–Australian? He shared this uncertainty with many native-born Australians in Britain.'[61]

Many British painters studied at the Slade School in London, with sculptors mostly attending the Royal Academy Schools. They followed this training by studying in Paris at the Académie Julian or other privately run ateliers, where established Salon artists gave advice to aspiring students. After women were given access to study at art schools around the turn of the century, they too studied at the Slade. A number of women students were reportedly pushed to tears by the scathing comments of Slade Professor Tonks, but he told one of his students, Helen Lessore, that he thought women made the best students because they were clever and did what he told them, whereas the men argued and wanted to try things out in different ways.[62] Some women artists studied abroad. As a result of their training, the approach of many of them was a blend of British and French traditions.

Australians who studied at the National Gallery School, Melbourne, or with Julian Ashton in Sydney, often followed these studies by travelling to Europe. For some this was made possible by the financial assistance of a Travelling Scholarship (National Gallery of Victoria or New South Wales

Despite the waning authority of the Royal Academy, many artists were keen to have their work exhibited there and hung well 'on the line'. Others turned to the newer and less restrictive exhibiting organisations such as the New English Art Club and the International Society of Sculptors, Painters and Gravers. By 1900, the official Paris Salon had ceased to exist, being replaced by three major annual salons: the Salon des Artistes Français (the 'Old' Salon); the Société Nationale des Beaux-Arts (the 'New' Salon), which showed the work

of established artists; and the Indépendants, which operated without a selecting panel and accepted the more radical art. Most artists wanted to have their work included in one of these salons, as well as in a range of other venues. While some artists became particularly associated with one of a number of exhibiting societies or organisations, by and large most of them showed their work with more than one group. Sargent exhibited regularly with the Royal Academy, but he also exhibited at the more modern thinking New English Art Club and the International Society. Lambert and Lavery were allied to the International Society, and Orpen was a member of the New English Art Club, but they all also showed at the Academy. They often carefully selected the kind of work that they exhibited at these groups. Lambert showed adventurous work such as *Chesham Street* (cat. 72) at the New English Art Club, and more modern work like *Important people* at the International Society. He exhibited more traditional images such as *Miss Thea Proctor* (cat. 66) and *Miss Alison Preston and John Proctor on Mearbeck Moor* at the Academy. The market was international and it was important to exhibit in both London and Paris, so artists sometimes showed the same work at the Academy and the International Society in London and at the Société Nationale des Beaux-Arts in Paris. Sargent showed *Lord Ribblesdale* at the Royal Academy in 1902 and at the Société Nationale des Beaux-Arts in 1904, and Fox exhibited *Déjeuner* at both the Royal Academy in 1911 and at the Société Nationale des Beaux-Arts in 1912.[64] Thus, the artists not only moved readily between cities but they also demonstrated a flexibility and catholicity as to where they showed their work. If interested, most artists had a good chance of being elected to the Royal Academy or being made a *sociétaire* of the Société Nationale des Beaux-Arts, but the status that they gained from these positions was becoming less and less significant during this period. Whereas at one time this had been vital to the sale of work and the obtaining of commissions, during the 1900s artists had a growing variety of options for showing and selling work, including the expanding number of private galleries such as the Baillie, Carfax, Chenil, Goupil, Grafton and Grosvenor in London.

Like their male counterparts, many of the women artists exhibited in Paris and London but only a few women were elected to the Royal Academy, such as Laura Knight and Ethel Walker, or made a *sociétaire* of the Société Nationale des Beaux-Arts,

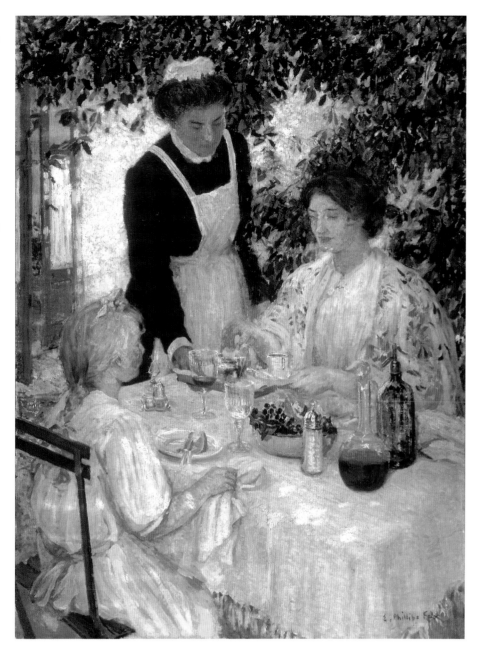

Fig. 61: E. Phillips Fox *Déjeuner* c.1911 [cat. 40]

as were Bessie Davidson and Goodsir. Women artists also showed their work in some of the specialist women's exhibiting societies, such as the Society of Women Artists and the Women's International Art Club in London and the Société des Femmes Peintres and Sculpteurs in Paris. When they exhibited, they often had to tolerate chauvinist comments such as:

No one would wish to restrict the art of women to mere sentiment and prettiness; but women have to some extent interest, emotions, and values different from those of men, and they are most likely to succeed in art if they do not try to conceal this difference and if they do not overstrain their powers from excessive ambition.[65]

Anne Gray 65

A number of the women signed their work with their initials only, which may well have been in order to keep their gender undisclosed and to prevent such comments. Perhaps as a consequence of such remarks, some of the women rarely exhibited their work, preferring to sell it privately.

Most artists came from middle-class families, their fathers working in professions such as the clergy, medicine, engineering, the law, education or as professional artists. This was even more the case with women artists who, by and large, needed to have sympathetic parents who could support their desire to become artists and to travel away from home and who could provide them with some financial support.

A highly successful artist at this time, such as Orpen, earned about £5,500 per year, while a reasonably successful artist, such as Charles Furse, estimated that he would earn £1,800 in 1900 (from which £600 would have been required for bills and expenses) and he anticipated earning £2,000 the following year. Lambert may have earned about £1,000 in a year (less expenses), at a time when the upper middle-class family could lead a comfortable life on £2,000 per year; the average annual income for doctors and lawyers was £400, for teachers £191, for a clerk £122 and a labourer £50.[66] A number of artists, such as Lees, Steer and Tonks, had a regular wage as teachers or, like

Sickert, supplemented their income by teaching. Others worked as illustrators for magazines. Still others were reliant on a patron, such as Gertler who received £10 a month from Edward Marsh in return for first refusal on his paintings. Bunny, likewise, received an annual annuity from Alfred Felton. Some of the women artists, such as Laura Knight, made a comfortable living from their art, but a number depended on a stipend from a patron — or their families — to supplement their income. For instance, Goodsir lived in Paris with the financial support of her father from 1900 until his death in 1906, and from 1910 to 1924 Gwen John received an annual allowance from the New York collector, John Quinn, in exchange for paintings. Other women artists, such as Preston and Reynell, followed the male example and worked as teachers. Others were employed in interior design, like Hamnett and O'Connor. Still other women artists, like Gwen John, worked as models.

It was not easy for the Australians to break into the London art world. In 1903, Barbara Baynton commented on the difficulties experienced by expatriate artists in London:

> I should like to sound a note of warning to artists ... about going to London. For artists, especially, it generally means starvation. The shop windows are crowded with paintings for sale at two guineas or three guineas, paintings which, if they were in Australia, would rank

Fig. 62: Rupert Bunny *An idyll* 1901 [cat. 9]

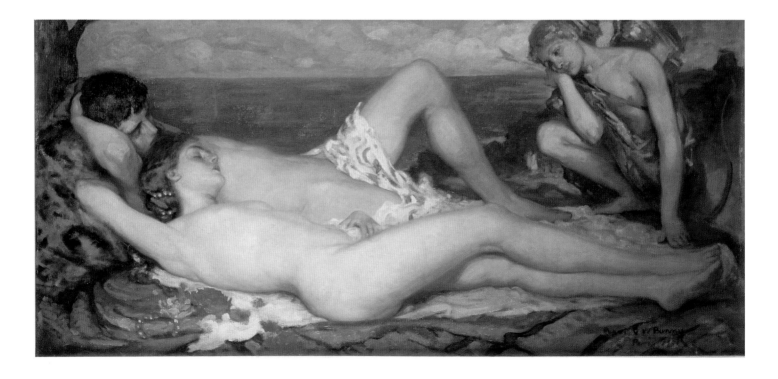

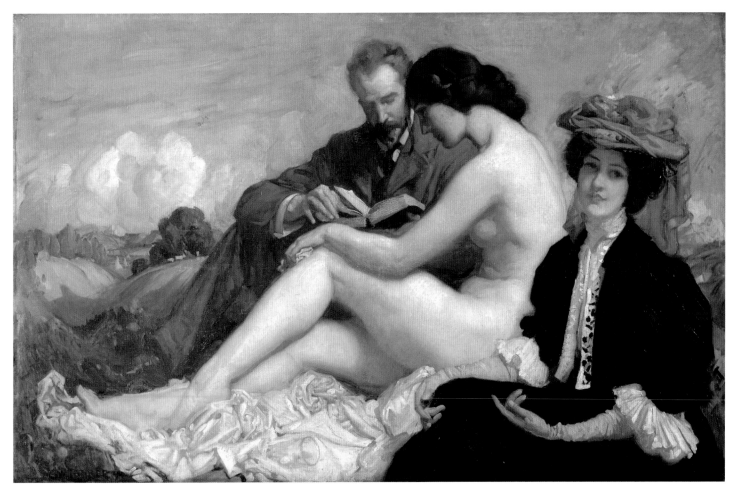

Fig. 63: George Lambert *The sonnet* c.1907
[cat. 68]

the artist as a genius, and would probably
be valued at from 50 pounds to 100 pounds.
Sometimes an Australian artist gets a picture
(skied) in the Academy, or accepted by the
Paris Salon, and then his hopes run high;
but the pictures invariably come back to the
studio unsold.[67]

Most of the artists included in *The Edwardians:
Secrets and desires* did eventually achieve a measure
of success, although for some it was greater than for
others. Conder established firm friendships with
British artists and became so much a part of the
British art world that he is now regarded as much a
British artist as an Australian. His fellow 'Australian
Impressionists', Streeton and Roberts, had a much
harder time establishing themselves in Britain and
Streeton subsidised his life in London through
visits back to Australia to paint and sell his work.

Most of the Australians, however, did make
friends with British artists and became, to some
extent, part of the British art scene. Some were
students together: Frampton with Roberts; Conder
with Rothenstein; Hamnett with O'Connor.

Others worked together: George Bell painted
with Connard, and Parker became an assistant to
Thomas Brock, Hamo Thornycroft and Goscombe
John. Some taught at the same place: Bunny with
Blanche and Fergusson in Paris, and Lambert
with Nicholson at Brangwyn's school in London.
During the First World War Coates, Roberts and
Streeton worked with Nevinson and Wood at
the 3rd London General Hospital, Wandsworth.
Others lived in close proximity: George Coates
and Dora Meeson were neighbours of Ambrose and
Mary McEvoy, and Lambert worked in a studio at
'Lansdowne House', Holland Park, where Charles
Ricketts and Charles Shannon also had studios.
Most of the artists married, with some meeting
their future partners at art school or an artists'
colony. Although most of them married, only
about half of the artists included in this exhibition
had children. Given the attitudes of the time, and
the trial and jailing of Oscar Wilde in 1895, it was
difficult for artists to acknowledge openly their
homosexuality. As Humphrey McQueen noted,
'In England 1895 became a year of heterosexual
panic as men, especially bachelors, who had

Notes

1 J.B. Priestley, *The Edwardians*, [1970], Harmondsworth: Penguin, 2000, p. 92.

2 Lord Esher, quoted in Stanley Weintraub, *Edward the caresser*, New York: The Free Press, 2001, p. 392.

3 Andrew Wilton, *The swagger portrait: Grand manner portraiture in Britain from Van Dyck to Augustus John 1630–1930*, London: Tate Publishing, 1992; Kenneth McConkey, *Edwardian portraits: Images of an age of opulence*, Woodbridge: Antique Collectors' Club, 1987; Alan Bowness, (ed.), *Post-Impressionism: Cross-currents in European and American painting 1880–1906*, Washington: National Gallery of Art, 1980; Carolyn Fox and Francis Greenacre, *Artists of the Newlyn School 1880–1900*, Newlyn: Newlyn Orion Galleries, 1979; Wendy Baron and Malcolm Cormack, *The Camden Town Group*, New Haven: Yale Centre for British Art, 1980; Angus Trumble, *Love and death: Art in the age of Queen Victoria*, Adelaide: Art Gallery of South Australia, 2002; Richard Shone, *The art of Bloomsbury: Roger Fry, Vanessa Bell and Duncan Grant*, London: Tate Publishing, 1999.

4 MaryAnne Stevens (ed.), *The Edwardians and after: The Royal Academy 1900–1950*, London: Royal Academy of Arts, 1988; Jane Beckett and Deborah Cherry (eds), *The Edwardian era*, Oxford: Phaidon, 1987. See also *Edwardian reflections*, Bradford: Bradford Art Galleries and Museums, 1975.

5 Kenneth McConkey, *Edwardian portraits*, 1987; Kenneth McConkey, *Memory and desire: Painting in Britain and Ireland at the turn of the twentieth century*, Aldershot: Ashgate, 2002; Susan Beattie, *The New Sculpture*, New Haven: Yale University Press, 1983; David Peters Corbett, Ysanne Holt and Lara Perry (eds), *English Art 1860–1914: Modern artists and identity*, Manchester: Manchester University Press, 2000; David Peters Corbett, Ysanne Holt and Fiona Russell (eds), *The geographies of Englishness: Landscape and the national past 1880–1940*, New Haven: Yale University Press, 2002; Richard Cork, *Vorticism and abstract art in the first machine age*, 2 vols, London: Gordon Fraser, 1976; Anna Gruetzner Robins, *Modern Art in Britain 1910–1914*, London: Merrell Holberton, 1997; Charles Harrison, *English art and modernism, 1900–1939*, London: Allen Lane, 1981; Ysanne Holt, *British artists and the modernist landscape*, Aldershot: Ashgate, 2003; Benedict Read, *Victorian sculpture*, New Haven: Yale University Press, 1982; Frances Spalding, *British art since 1900*, London: Thames and Hudson, 1986.

6 J.B. Priestley, *The Edwardians*, [1970], 2000; Paul Thompson, *The Edwardians: The remaking of British society*, [1975], London: Routledge, 1992; Stanley Weintraub, *Edward the caresser*, New York: The Free Press, 2001

7 Hugh Ramsay to Bernard Hall, 19 June 1902, Bernard Hall Archive, National Gallery of Australia Research Library, Canberra, 2BH434.

8 J.D. Fergusson, quoted in Philip Long, *The Scottish Colourists 1900–1930*, Edinburgh: National Galleries of Scotland, 2000, p. 16.

9 R.A.M. Stevenson, *Velasquez*, [1895], London: George Bell, 1900, p. 48.

10 William Orpen to Grace Orpen, 1904, in Bruce Arnold, *Orpen: Mirror to an age*, London: Jonathan Cape, 1981, p. 145.

11 T.S. Eliot, 'Tradition and the individual talent', in *Selected prose*, Harmondsworth: Penguin, 1953, p. 22.

12 Frederic G. Kenyon (ed.), *The letters of Elizabeth Barrett Browning*, 2 vols, London: Smith, Elder, 1898, vol. 1, p. 232; Virginia Woolf, *A room of one's own*, London: Hogarth Press, 1928.

13 C.H. Collins Baker suggested that Lambert had 'gone on by going back' to artists such as Velasquez (C.H. Collins Baker, 'The paintings of Mr. G.W. Lambert', *The Studio*, London, vol. 51, October 1910, p. 19). Hugh Stokes commented in the *Ladies Field* that Philpot referred to a different old master in every work. P.G. Konody suggested in the *Observer* that William Strang paraphrased Velasquez and Giorgione, and that he modernised themes frequently treated by the old masters, and the *Westminster Gazette*'s writer remarked that Strang had a number of historical styles at his command, as did many others at this time (Hugh Stokes, 'The Autumn Exhibition of the International Society of Sculptors, Painters and Gravers', *Ladies Field*, London, 19 October 1981; P.G. Konody, 'Art and artists. The art of Mr. William Strang', *Observer*, London, 22 October 1911, p. 9; O.R.D., 'The International Society', *Westminster Gazette*, London, 11 October 1918, p. 2).

14 Frank Rutter 'The art of today', in William Orpen, *The outline of art*, London: George Newnes, c.1929, pp. 634–5.

15 Walter Sickert 'The Post-Impressionists', *Fortnightly Review*, January 1911, published in Osbert Sitwell (ed.), *A free house! or, the artist as craftsman: being the writings of Walter Richard Sickert*, London: Macmillan, 1947, p. 97.

16 Jacques-Emile Blanche and Charles Ricketts were also critical of the exhibition. However, Sickert suggested that 'so intelligent a French painter as Monsieur Blanche is surely making himself the mouthpiece of less-informed English prejudice' and that Ricketts may have known better and have been 'merely naughty', writing 'a delightful and witty' English defence (Sitwell, *A free house!*, 1947, p. 98 and p. 106). In general, artists, critics and the public approved of Gauguin, thought Cézanne difficult, questioned van Gogh and disliked the work of Matisse and Picasso. Augustus John, who was himself thought to have post-impressionist tendencies, was much impressed by the work of Gauguin and van Gogh, and considered Cézanne to be 'one of the greatest' but, in 1910, he felt Matisse's *La Femme aux yeux verts* 1908 (San Francisco Museum of Modern Art) to be vulgar and spurious. By 1928, however, John had come to regard Matisse as 'the best, the most sensitive, of French painters'. (Malcolm Easton and Michael Holroyd, *The art of Augustus John,* London: Secker and Warburg, 1974, p. 20, fn. 42) Sickert maintained that 'nothing can prevent [Cézanne's] masterpieces from taking rank', that Gauguin's figures had 'National Gallery quality at its highest level', and that van Gogh said 'what he had to say with fury and sincerity', yet he too was critical of the work of Matisse and Picasso; Sitwell, *A free house!*, 1947, pp. 98–108).

17 Tom Cross, *Artists and bohemians: 100 years with the Chelsea Arts Club*, London: Quiller Press, 1992, pp. 37–8; 'Septule and the Racinistes', London: Chelsea Arts Club, 1910.

18 June Helmer, *George Bell: The art of influence*, Melbourne: Greenhouse, 1985, pp. 39–40; Bernard Smith, 'The myth of isolation', in *Antipodean Manifesto*, Melbourne: Oxford University Press, 1976, p. 65.

19 'The Royal Academy. Second notice. Review of the portraits', *The Times*, London, 3 May 1911, p. 7.

20 Laurence Housman, 'The International Exhibition', *Manchester Guardian*, 8 April 1911, p. 9.

21 P.G. Konody, 'The Academy. Notable pictures of the year', *Observer*, 30 April 1911, p. 5.

22 *The Observer*, 5 May 1912, pp. 6–7

23 C.R.W. Nevinson, *Daily Express*, 25 February 1915.

24 Thea Proctor, interview with Hazel de Berg, 25 September 1961, quoted in Geoffrey Dutton, *Artists' portraits*, Canberra: National Library of Australia, 1992, p. 29.

25 'Design: Miss Thea Proctor's talk to the students', *Undergrowth*, Sydney, September–October 1926, unpag. [p. 6].

26 Sergius, 'Farewell advice', *Undergrowth*, Sydney, July–August 1926, unpag. [p. 10].

27 Laurence Housman, 'The International Exhibition', *Manchester Guardian*, 8 April 1911, p. 9.

28 Other critics also noted this aspect of the British moderns. Robert Ross announced of Fry's own work that he 'makes quite English what proceeds from France' (Robert Ross, *Morning Post*, London, 4 January 1912).

29 Indeed, S.K. Tillyard has argued that, in using words such as 'decoration', 'pattern' and 'design' to describe works in the Post-Impressionist exhibition, Fry reached out to a female public (S.K. Tillyard, *The impact of modernism, 1900–1920: Early modernism and the Arts and Crafts movement in Edwardian England*, London: Routledge, 1988, pp. 102–3). Tillyard also maintained that this language had overtones of the Arts and Crafts movement, and that this was a factor in the exhibition's success (Tillyard, 1988, pp. xix and 125–6).

30 Augustus John to William Rothenstein, 1907, quoted in Michael Holroyd, *The art of Augustus John*, 1974, p. 253. See also David Fraser Jenkins, 'Slade School Symbolism', in John Christian (ed.), *The last Romantics: The Romantic tradition in British art*, London: Barbican Art Gallery, 1989, pp. 71–6.

31 George Lambert, 'Lecture on the many and various movements in art during the last twenty years', unpublished typescript, Miscellaneous Papers, Lambert Family Papers, Mitchell Library, State Library of NSW, Sydney, ML MS 97/8, item 5, p. 291.

32 Alan Powers, 'Public places and private faces', in John Christian (ed.), *The last Romantics*, 1989, pp. 63–9.

33 Walter Sickert, quoted in Philip Athill, *William Strang*, Sheffield: Graves Art Gallery, 1980, p. 32.

34 Richard Ormond, 'Sargent's art' in *John Singer Sargent*, London: Tate Publishing, 1999, pp. 31–3.

35 Nellie Melba, *Melodies and Memories*, [1925], Melbourne: Thomas Nelson, 1980, p. 104

36 Henry James, *The Europeans*, [1878], Harmondsworth: Penguin, 1964, p. 77.

37 Vita Sackville-West, *The Edwardians*, [1930], London; Virago, 1983, p. 19.

38 Michael Harrison, in *Rosa*, [1962], London: Corgi, 1977, suggests that Lord Ribblesdale kept rooms at the Cavendish until his death in 1925.

39 H.S. Barlow, *Swettenham*, Kuala Lumpur: Southdene, 1995.

40 See 'The Royal Academy' (first article), *The Times*, London, 29 April 1905, p. 14.

41 Coventry Patmore in his poem, 'The angel in the house' wrote 'Man must be pleased; but him to please/ Is woman's pleasure; down the gulf/ Of his condoled necessities/ She casts her best, she flings herself.' Patmore's poem was published in 1854, revised through to 1862. Initially this ideal primarily expressed the values of the middle classes. However, with Queen Victoria's marriage to Prince Albert and devoting herself to a domestic life, the ideal spread throughout 19th-century society, and continued through the Edwardian era. For Virginia Woolf, the repressive ideal of women represented by the 'angel in the house' was still so potent that she wrote, in 1931, 'killing the Angel in the House was part of the occupation of a woman writer', ('Professions for women', [1931] in Virginia Woolf, *Death of the moth and other essays*, London: Hogarth Press, 1942).

42 Virginia Woolf, *A room of one's own*, [1928], Harmondsworth: Penguin, 1963.

43 Henrik Ibsen, *Hedda Gabler and other plays*, Harmondsworth: Penguin, 1961, p. 51. *Pillars of the community* was first performed in England in 1880, under the title of *Pillars of society*. Edouard Vuillard made a lithograph of this episode in *Pillars of the community*.

44 'New Conundrums by Puzzle Painters: Quaint humour at the Grosvenor Gallery', *Daily Express*, London, 16 April 1914.

45 T.L. 'Staring life-size groups', *Daily Mail*, London, 24 April 1914.

46 Carol Bacchi, 'Evolution, eugenics and women: The impact of scientific theories on attitudes towards women, 1870–1920', in Elizabeth Windschuttle (ed.), *Women, class and history*, Sydney: Fontana/Collins, 1980, pp. 132–56; Olive Banks, *Faces of Feminism: A study of Feminism as a social movement*, Oxford: Basil Blackwell, 1986.

47 See Bacchi, 'Evolution, eugenics and women', 1980 and Banks, *Faces of Feminism*, 1986.

48 E.M. Forster 'Other kingdom' in *Collected short stories*, [1947], Hamondsworth: Penguin, 1977 p. 82.

49 Alice Muskett, 'A day at the Atelier Colarossi', *Daily Telegraph*, 24 February 1896, p. 6.

50 George Bernard Shaw, 'Preface' in *Plays pleasant*, [1898], London: Penguin, 1946, p. 11.

51 *Masquerade & carnival*, London: Butterick, 1892.

52 Letter from Edward Marsh to Rupert Brook, quoted in Christopher Hassall, *Edward Marsh*, London: Longmans, 1959, pp. 231–2.

53 'Music: The Russian Ballet and the "Ring"', *Observer*, London, 22 October 1911, p. 9.

54 J.G. Lister, 'Australians must develop taste says Miss Thea Proctor', *The Home*, Sydney, 1 June 1922, p. 37.

55 Laura Knight, *Oil paint and grease paint*, London: Ivor Nicholson and Watson, 1936, p. 190.

56 Roger Leong, et al., *From Russia with love: Costumes from the Ballets Russes 1909-1933*, Canberra: National Gallery of Australia, 1998.

57 Henry James, letter to a friend August 1914, in *The letters of Henry James*, London: Macmillan, 1920.

58 Siegfried Sassoon, *Complete memoirs of George Sherston*, [1937], London: The Reprint Society, 1940, p. 540.

59 See Richard White, *Inventing Australia*, Sydney: George Allen and Unwin, 1981, pp. 111–12. When the new Australian Constitution came into being few would have questioned it. Indeed, this was symbolised by Prime Minister Deakin and his colleagues travelling to London to request the British government to enact the Commonwealth Bill. The notion of a wholly autochthonous constitution made by the people of Australia would have seemed to most of the Founders, and to the people of Australia at that time, to have been bizarre. Curiously, it was British legislation which made the difference, not Australian law, and, although Britain passed the Statute of Westminster in 1931, which basically recognised the right of self determination by the dominions, Australia did not ratify it until 1942. (I am grateful to Peter Stanley for his assistance with this information.)

60 See White, *Inventing Australia*, 1981. The Indigenous population was not counted in the census but was estimated at 67,000.

61 Humphrey McQueen, *Tom Roberts*, Sydney: Macmillan, 1996, p. 517.

62 Helen Lessore, 'Henry Tonks as I remember him, in his setting — the Slade', in Lynda Morris, *Henry Tonks and the 'Art of pure drawing'*, Norwich: Norwich School of Art Gallery, 1985, p. 10.

63 Clive Holland, 'Student life in the Quartier Latin, Paris', *The Studio*, London, vol. 27, no. 115, October 1902, pp. 33–40.

64 Other examples include: Rupert Bunny, *The sonata*, Royal Academy 1910 and Société Nationale des Beaux-Arts 1912; George Lambert, *Lotty and a lady* 1906, Royal Academy 1906 and Société Nationale des Beaux-Arts 1907; Jacques-Emile Blanche, *Charles Shannon and Charles Ricketts* 1904, New English Art Club 1904 and Société Nationale des Beaux-Arts 1904; John Lavery, *Anna Pavlova* 1911, International Society of Sculptors, Painters and Gravers 1911 and Société Nationale des Beaux-Arts 1911. Malcolm Drummond exhibited *In the Park (St James's Park)* at both the Camden Town Group in London and at the Salon des Indépendants in Paris.

65 'The Women's International Art Club', *The Times*, 4 March 1912, p, 12.

66 William Orpen, one of the most successful artists earned £5,500 in 1910 (Arnold, *Orpen: Mirror to an age*, 1981); George Lambert earned approximately £1,000 in that year (Anne Gray, *Art and artifice: George Lambert 1873–1930*, Sydney: Craftsman House, 1996). See also Katharine Furse, *Hearts and pomegranates: The study of forty-five years, 1875–1920*, London: Peter Davies, 1940, p. 201. For the average incomes see 'British Historical Statistics', in Thompson, *The Edwardians*, 1992, pp. 6–7 and John Standen, *The Edwardians*, London: Faber and Faber, 1968, pp. 35–6, 50–1 and 64–5.

67 Penne Hackforth-Jones, *Barbara Baynton*, Ringwood: Penguin, 1989, p. 78.

68 McQueen, *Tom Roberts*, 1996, p. 402.

69 Mary McEvoy gave up her art until her husband's death.

70 Ethel Carrick, Laura Knight, Margaret Preston and Gladys Reynell married, but did not have children. Nina Hamnett did marry, but basically lived a single life, enjoying relationships with many lovers including Roger Fry.

71 Marie Stopes (1880–1958) is primarily remembered as a pioneering propagandist for birth control, but her concern for contraception was deeply rooted in her conceptions of ideal motherhood and marriage. She was involved with a range of feminist campaigns aimed at ameliorating women's role in marriage even before the grant of suffrage in 1918 (for which she campaigned). She was equally concerned with the over-burdened working-class mothers addressed in *A letter to working mothers* as with the medical professionals who were the target of her book, *Contraception*. Her best-known books were *Married love* and *Wise parenthood*, both published in 1918.

72 'Australian art to-day: Notes from the president's address at the Society of Artists' 1921 exhibition', *Art in Australia*, no. 11, December 1921; G.C. Dixon 'Art in Australia "Too parochial", says Mr Lambert, A brilliant painter and his views', *Herald*, Melbourne, 3 November 1922, p. 8; Norman Lindsay, 'The transplanted artist', *The Home*, 1 December 1921, pp. 18–9, 91.

73 Vanessa Bell, *Sketches in pen and ink*, [1951], London: The Hogarth Press, 1997, p. 111.

Old Masters and Edwardian Society Portraiture

*I*n a lecture delivered to the London Institution in 1880, the designer and social reformer William Morris noted, 'We are here in the richest city, of the richest country, of the richest age of the world: no luxury of time past can compare with our luxury.'[1] If the decades from 1880 to the First World War were to witness conspicuous consumption on an even greater scale, they were equally marked by an increased interest in public ceremonial and spectacle. In Britain, the Diamond Jubilee of Queen Victoria (1897) and the Coronation of Edward VII (1901) were events designed to be a focus for patriotic sentiment, representing, on the surface at least, a position of prosperity, stability, unity and shared identity, with the monarch firmly at the centre of the political and cultural life of Britain and its Empire. Of course, such pageants — part tradition, part invention — concealed as much as they revealed about the status quo. Indeed, 'this more stately, more theatrical, more ceremonially-conscious age', to quote historian David Cannadine, was also one of continuous — even rapid — social, economic and political change.[2] British economic supremacy was challenged on world markets by America, Japan and Germany. At home, there was industrial unrest, with calls for widespread parliamentary reform, and the constitution itself saw the decline of the relative powers of the monarchy and the House of Lords. In his treatise, *The English Constitution* (1867), the journalist Walter Bagehot argued that the monarchy's primary function lay not in the day-to-day governing of the country, which was now largely the concern of the House of Commons, but in its 'dignified' capacity: its ability to capture the imagination of the populace, to be a moral force and head of society and to 'act as a *disguise*', enabling 'our real rulers to change without heedless people knowing it'.[3]

Giovanni Boldini *Portrait of a lady, Mrs Lionel Phillips* 1903 (detail) [cat. 7]

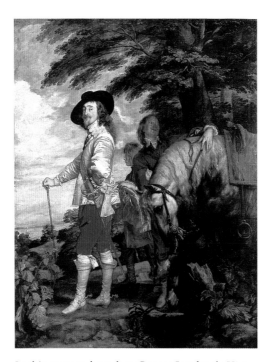

Fig. 65: Anthony van Dyck *Charles I, King of England, at the hunt* c.1635 oil on canvas 266.0 x 207.0 cm Louvre, Paris (photograph: RMN – C. Jean)

In this context, how does George Lambert's *King Edward VII* (fig. 66, cat. 71) function as an official image of the British monarchy in the early years of the 20th century? Much of the cultural resonance of Lambert's portrait comes from overt references to 17th- and 18th-century artists who, as the 19th century progressed, had become designated as 'old masters'. For example, the painting clearly acknowledges 18th-century painters Joshua Reynolds, Thomas Gainsborough and Thomas Lawrence. By the turn of the 20th century, the work of these and other native artists was perceived as a high point of British cultural endeavour. Lambert's painting more specifically — hence more self-consciously — evokes, in composition and scale, the grandiose equestrian portraits of Charles I by van Dyck in the 1630s, thus establishing a direct visual link between a monarch of the present and a monarch of the past. It is as much an image of continuity as it is an image of status and supreme authority. But it can also be viewed, to use Bagehot's meaning of the word, as a disguise: a time-honoured visual conceit that paradoxically accommodates and denies the process of change.

Continuity and stability

We would expect Lambert's *King Edward VII*, as a state portrait of a monarch, to have at its foundation long-established artistic conventions and sources. However, portraits painted of the Edwardian social elite, as with late Victorian portraits, also drew upon similar conventions. As Richard Ormond

has noted, when, by 1900, John Singer Sargent's patronage base had broadened into the British aristocracy, he looked for 'a pictorial environment appropriate to their status' and drew on 'the vocabulary of sixteenth- and seventeenth-century portraiture and to the images of their ancestors so glamorously defined by Van Dyck'.[4] When Lord Ribblesdale died in 1925, *The Times* obituary was accompanied by a reproduction of Sargent's 1902 portrait (fig. 68, cat. 117), the writer observing that the aristocrat had come to represent 'the traditions of a time and of manners that are not of today, and were not wholly of 1902', and concluded that he had 'looked like an Old Master'.[5] This tellingly demonstrates the fundamental role played by contemporary portraiture, which referenced elite portraiture of the past, in promoting 'the aristocracy's own (and often deliberately misleading) self-image of antiquity and permanence'.[6]

The old master vocabulary had, of course, been assimilated over a century before the Edwardian period within the 'grand manner' portraiture of the British school. Developed from the 1750s, these paintings elevated and ennobled the sitter primarily through associations with European courtly portraiture, especially that by Titian, Rubens, Velasquez and, above all, van Dyck. Van Dyck's image of the Caroline aristocracy, elegantly posed against a background of classical architecture, a poetical landscape, or swags of sumptuous silk or velvet, was as seductive a model for artists and patrons of the 18th century as it was to their late Victorian and Edwardian counterparts: a representation of wealth, status, innate 'good breeding', self-assurance and intellectuality. Gainsborough, who, perhaps more than any other painter of his generation, sought to emulate van Dyck both in technique and social position (that is, as a court painter), reputedly said on his death bed, 'We are all going to Heaven and Vandyke is of the party.'[7] The same reverential tone can be gleaned, over 100 years later, from the comment by George Moore in 1893 that it was 'to the influence of Vandyke that we owe all that is worthiest and valuable in English art.'[8] Reynolds also developed the grand manner style by fusing the specific (that is, a portrait of an individual) with the general or 'timeless' associations of the classical/High Renaissance tradition, achieved through costume, pose and gesture and, in more extreme cases, by allegorising or historicising the sitter.

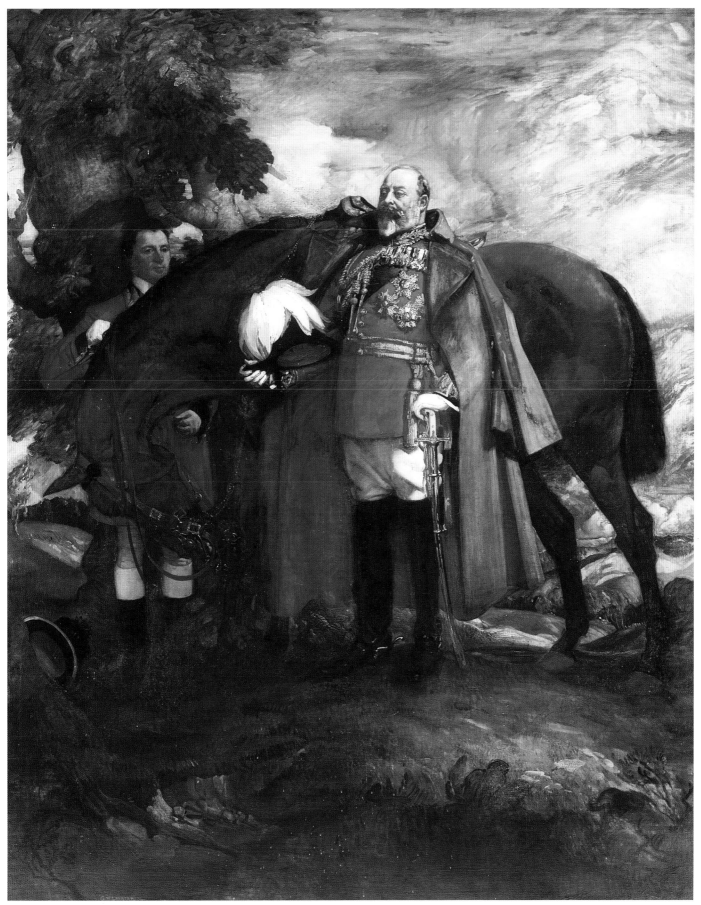

Fig. 66: George Lambert *King Edward VII* 1910 [cat. 71]

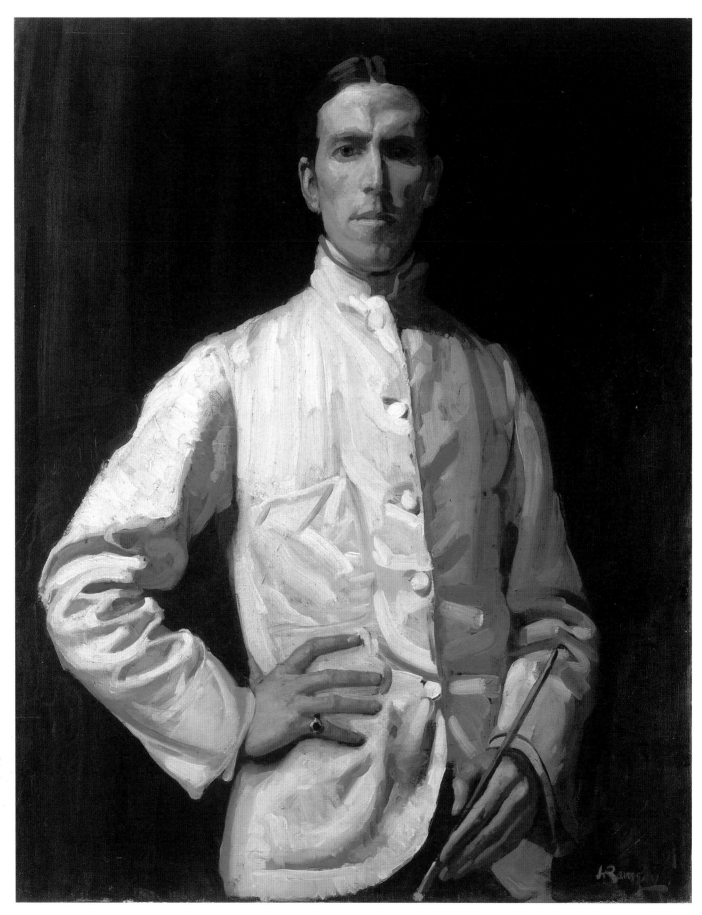

Fig 67: Hugh Ramsay *Self-portrait in white jacket* 1901–02 [cat. 108]

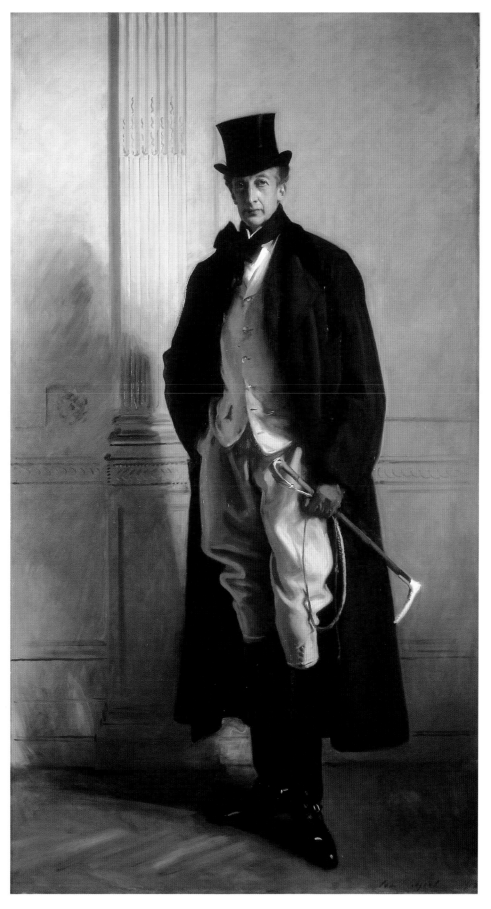

Fig. 68: John Singer Sargent *Lord Ribblesdale* 1902 [cat. 117]

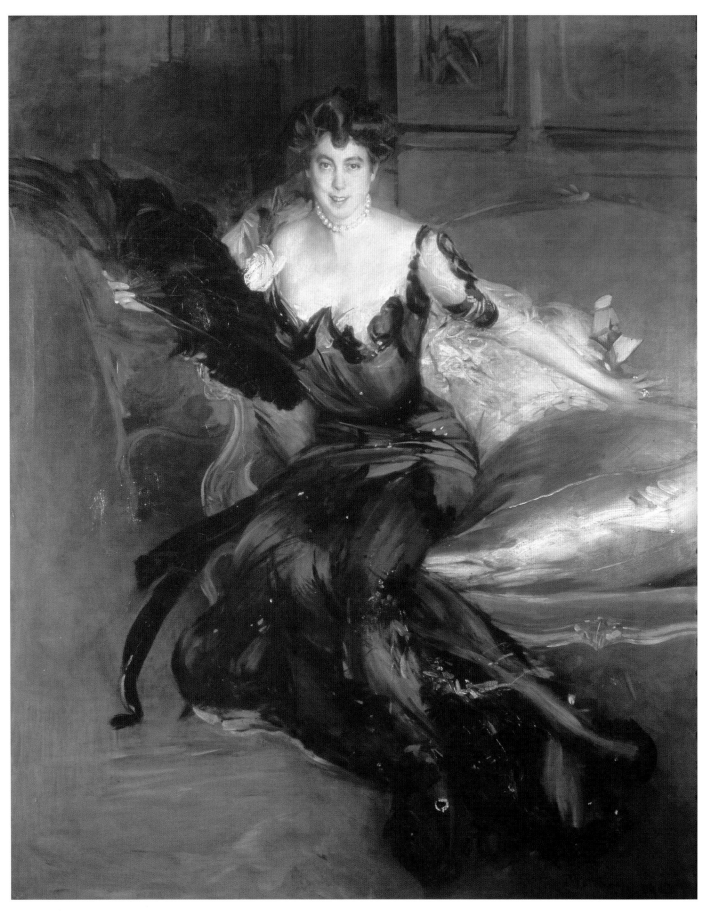

Fig. 69: **Giovanni Boldini** *Portrait of a lady, Mrs Lionel Phillips* 1903 [cat. 7]

Although portraits such as *Sarah Siddons as the Tragic Muse* 1784 (fig. 70) were clearly too bombastic and theoretically high-minded to be incorporated into mainstream society portraiture, their spirit at least can be found in such works as Philip De Lazló's full-length portrait, *Countess of Verulam and her eldest son as Venus and Cupid* 1919 (Gorhambury).

On a practical level, Edwardian society portraiture sat comfortably in visual terms with existing portraits hanging in town and country houses by painters such as Reynolds, Gainsborough and George Romney, just as 18th-century portraits were intended to complement those by van Dyck, Rubens, Peter Lely and Godfrey Kneller. Sargent's group portrait of the Marlborough family (fig. 71) was conceived as a pendant or matching piece to Reynolds' *The family of the fourth Duke of Marlborough* 1777–78, and hung in the same room in Blenheim Palace, Oxfordshire. Of course few houses in Britain could boast a full complement of van Dycks, Gainsboroughs *and* Sargents. Nonetheless, making such connections appeared to define, on the canvas at least, 'the social elite'. However, as noted by William Vaughan of 18th-century portraiture, the grand portrait was 'a fantasy', but 'it was a brilliant and powerful one'.[9] Like van Dyck and Gainsborough before them, Sargent, Lambert,

Fig. 70: **Joshua Reynolds** *Sarah Siddons as the Tragic Muse* 1784 oil on canvas 236.2 x 146.1 cm The Huntington Library, California (photograph: The Photolibrary, Sydney)

Giovanni Boldini (fig. 69, cat. 7) and other artists brought glamour, confidence, beauty and nobility to the images of their sitters — qualities that they may, or may not, have possessed in reality — and the same is true of their social status. Indeed, at the turn of the 20th century, two of the best known 18th-century portraits (the aforementioned portrait of Sarah Siddons and the so-called *The blue boy,* fig. 72, Gainsborough's most overt homage to van Dyck) did not represent members of the upper classes. Siddons was an actress, admittedly the most celebrated of her time, and Jonathon Buttall was the son of an ironmonger, albeit a prosperous one. The inherent role-play or 'disguise' (to return to Bagehot) of society portraiture is, however, crucial given that Sargent and others were painting a society in transition. As discussed by David Cannadine, J. Mordaunt Crook and other historians of this period, one of the most significant social changes from the 19th century was the movement of the upper classes from aristocracy to plutocracy. To quote Mordaunt Crook, the Victorian and Edwardian period was thus 'the age, *par excellence*, of the *arriviste*'.[10] Sargent's Marlborough portrait, showing the 9th Duke, his wife (the American heiress Consuela Vanderbilt) and his children, appropriately dressed in costumes not unlike Gainsborough's *The blue boy,* at once demonstrates the fusion of old master and contemporary art and the convergence of the old and new elites.[11]

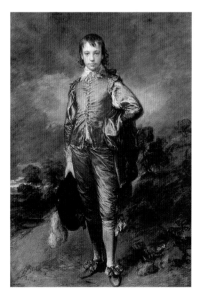

Fig. 71: **John Singer Sargent** *Duke of Marlborough family* 1905 oil on canvas 332.7 x 238.8 cm Duke of Marlborough Collection, Blenheim Palace, Oxfordshire

Fig. 72: **Thomas Gainsborough** *Jonathon Buttall: The blue boy* c.1770 oil on canvas 178.0 x 122.0 cm The Huntington Library, California (photograph: The Photolibrary, Sydney)

Emulation and innovation

The transformative (one might add subversive) potential of the grand manner style was acknowledged and utilised by artists across centuries. The 17th-century artist John Riley, for example, in his large-scale portrait of Bridget Holmes (fig. 73), shows the nonagenarian maid of the Royal household clutching her broom in a dignified stance, with all the staging and accoutrements of fashionable Baroque portraiture.[12] Like Gainsborough's *Blue boy*, the possible satirical or moral intention of this painting cannot be ignored. Agnes Goodsir's *La Femme de ménage* (fig. 74 , cat. 52) and Harold Gilman's *The Negro gardener* (cat. 48) display comparable ambitions, in terms of ennobling the sitter. Hugh Ramsay's elegant self-portrait of 1901–02 (fig. 67, cat. 108) demonstrates a similar concern to Rembrandt, Velasquez, Reynolds and numerous other painters, past and present, in representing 'the artist as gentleman'. Ramsay's portrait underlines the fact that referencing old masters was not only an artistic conceit to lure and flatter wealthy patrons but also gave testimony to the artistic and social ambitions of contemporary painters themselves. A formal engagement with the compositional and technical qualities of previous artists, even to the extent of

Fig. 73: John Riley *Portrait of Bridget Holmes* 1686
oil on canvas 225.4 x 148.6 cm The Royal Collection, Windsor
(© Her Majesty Queen Elizabeth II, 2004; photograph: A.C. Cooper Ltd.)

making copies of their works, was a cornerstone of academic art training in Europe. But to a varying degree most contemporary artists, whether affiliated to an academy or not, defined their work in terms of the perceived *gravitas* and prestige of the old master tradition. Thus descriptions such as Rodin's concerning Sargent as 'the Van Dyck of our times', and the frequent allusions made between living artists and old masters by art commentators and biographers (for example, James McNeill Whistler, Sargent and John Everett Millais were all compared at various times to Velasquez) were loaded with artistic and broader cultural associations.[13] The clear debt owed to Velasquez's *Las Meninas* 1651 (Prado, Madrid, see fig. 6, p. 16) demonstrated in Sargent's *The daughters of Edward Darley Boit* 1882 (private collection), the link to portraits by Velasquez and Rembrandt seen in Ramsay's *Portrait of the artist standing before easel* (cat. 107), and the striking parallels between William Orpen's *Self-portrait with glasses* (cat. 95) and the self-portraits of the 18th-century French artist Jean-Baptiste Simeon Chardin, suggests that these comparisons were actively sought and even promoted by the artists themselves. Whistler, who 'rarely paid homage to the old masters', executed his portrait of Elinor Leyland or 'The blue girl' (destroyed 1879) in emulation of Gainsborough, whose technical facility was of great interest to him from the 1860s.[14] However, it could as easily be a competitive exercise as an emulative one. Millais' portrait of the Armstrong sisters, exhibited in 1872 as *Hearts are trumps* (Tate, London), was reputedly executed after the artist read a review claiming that he 'was quite incapable of making such a picture of three beautiful women together ... as Sir Joshua Reynolds had produced in his famous portrait of "The Ladies Waldegrave"'.[15]

The interest in, and familiarity with, European old masters was directly related to their increased accessibility, through the saleroom (to be discussed later in this essay) and through temporary exhibitions via loans from private collections. Such exhibitions were to have a profound impact on contemporary artists, collectors and the art-going public alike.[16] The British Institution, founded in 1805, initially exhibited contemporary art in its Pall Mall galleries. However, in 1813 the Institution held a retrospective exhibition containing 141 works by Reynolds. Staged in the last years of the Napoleonic Wars, the agenda was primarily patriotic and aimed, as stated in the accompanying

catalogue, 'to call attention generally to British, in preference to foreign Art'.[17] The following year's exhibition included works by William Hogarth, Gainsborough and other British artists, as well as van Dyck, Rubens and Rembrandt. This trend continued throughout the century and beyond with single or group old master exhibitions, fine and decorative art exhibitions (such as the massive 'Art Treasures of the United Kingdom' in Manchester, 1857, which boasted approximately 1,000 European old master paintings, including Velasquez, Franz Hals and Vermeer and 700 works of the British school), or occasionally the exhibition of private collections. Of the latter, perhaps the most celebrated was that belonging to Sir Richard Wallace (Bethnal Green Museum, London, 1872–5), which contained, apart from British, Dutch, Flemish, Italian and Spanish old masters, one of the finest private collections of French 18th-century fine and decorative art. In parallel, one might cite the creation of public galleries, to name but four in London: the National Gallery (1824), the South Kensington Museum, later the Victoria and Albert Museum (1901), the Tate Gallery (1897) and the Wallace Collection (1900), bequeathed by Lady Wallace in 1897. As Richard Dorment has noted, the catalyst for the change in Whistler's technique in the 1860s was his exposure to British 17th- and 18th-century portraiture in a series of exhibitions held at the South Kensington Museum in 1866, 1867 and 1868 (according to Dorment's calculations, a total of 2,846 portraits, with 81 by van Dyck, 64 by Lely, 39 by Hogarth and 78 by Gainsborough).[18] In 1899, there was also a major retrospective exhibition of van Dyck's work at the Royal Academy, which may have further brought his work to the attention of Sargent and to patrons. These exhibitions were influential, not only in broadly educational terms for artists and the public and for establishing a canon of old masters, but also in creating cultural and national icons. The totemic status of Gainsborough's *The blue boy* in the early 20th century was surely due, in part, to its inclusion in numerous public exhibitions (the Manchester 'Art Treasures' exhibition in 1857, the 'International Exhibition' of 1862, the Royal Academy's 'Old Masters' exhibition of 1870, the Grosvenor Gallery exhibition of 1885, the Royal Academy's 'Old Masters' exhibition of 1896 and the 'Franco–British Exhibition' of 1908, as well as a number of exhibitions abroad).[19]

Fig. 74: **Agnes Goodsir** *La Femme de ménage* 1905 [**cat. 52**]

Fig. 75: Charles Furse
Diana of the uplands 1903–04 oil on canvas
236.9 x 179.1 cm Tate, London
(© Tate Gallery, London, 2004)

But artists of the late 19th and early 20th centuries did not aim to be 'followers of', producing pastiches of old masters with a contemporary twist. As Andrew Wilton has observed, Sargent's achievement was to 'evoke the atmosphere of Van Dyck … without in any way copying him'.[20] Sargent was, in fact, more directly influenced in technical terms by the virtuoso brushwork of Velasquez, through his contemporary Manet. In 1910, Sadakichi Hartmann wrote that Whistler 'repeats the same [old master] inspirations but in an etherealized, modernized and individualized manner', creating, to quote Richard Dorment, 'the impression that he belonged to no school at all'.[21] And yet, to quote Dorment once more, 'he is the one Victorian painter who may be said to have placed the revitalization of the grand manner of British painting at the very heart of his work'.[22]

Aspiration and nostalgia

The agricultural depression of the 1870s, the implementation of death taxes in 1882 and the greater political representation apportioned to cities meant that land was no longer the source of wealth and power that it had been in the 18th and early 19th centuries. But even though the wealth of the new elite was based on manufacture and finance, the traditional upper class, with its rituals and signifiers, remained the model. The Edwardian period, for example, saw a dramatic expansion of the baronetage with financiers and industrialists, and the almost legendary infiltration into the aristocracy of wealthy heiresses from the United States, memorably described in Edith Wharton's *The buccaneers* (1938).[23] One dramatic off-shoot of the decline in the rural economy was that aristocratic families were not only selling whole or portions of their estates but also works of art. Of the important British paintings purchased by the American industrialist Henry E. Huntington from about 1909, 50 per cent came from British aristocratic and landed gentry collections, including Gainsborough's *The blue boy*, Lawrence's *Pinkie* (Huntington Art Collection, Malibu, California) and Reynolds' *Sarah Siddons as the Tragic Muse*.[24] The trade in old masters, largely from British collections to American ones, had reached such proportions by the beginning of the 20th century that one article published in the *Burlington Magazine* (1904) described the phenomenon as the 'American Invasion'.[25]

Although land ownership was no longer the source of wealth and status that it once had been, it remained an aspiration. Achievable only by the mega-rich, the 18th-century country house and estate, with its quasi-feudal hierarchy and exclusive lifestyle of leisure, most obviously hunting on horseback and shooting, was a yardstick of gentility. In H.G. Wells' novel *Tono-Bungay* (1909), 'Bladesover House', in the words of the narrator, 'illuminates England; it has become all that is spacious, dignified, pretentious, and truly conservative in English life'.[26] Perhaps not surprisingly, when Baron Ferdinand de Rothschild completed Waddesdon Manor in 1889, he hung a number of the rooms with British 18th-century grand manner and half-length portraits (largely purchased from aristocratic collections), many of which show the sitters in an appropriately rural setting.[27] Edwardian paintings, such as Lambert's *Miss Alison Preston and John Proctor on Mearbeck Moor* (cat. 70), find antecedence in 18th-century British sporting art, epitomised by George Stubbs and, of course, society portraiture. In the 18th century, hunting was thought to be an ennobling and heroic pursuit that by law separated the rural elite from their urban counterparts. A country gentleman 'could thus flaunt his social status, in the field and in painted form, through a leisure activity that suggested action, daring and physical fitness' and simultaneously display a 'natural' affinity with the countryside, through ease of manner and comparative informality of dress.[28] Both Lambert's portrait and Sargent's *Lord Ribblesdale* (albeit staged indoors) suggest a similar agenda.

As with portraits of a sporting nature, 18th-century 'outdoor leisure' portraits — showing the sitter walking in a generalised, idyllic landscape, sometimes accompanied by a dog, or alternatively reading or in a meditative mood — were not unselfconscious compositions for private rather than public consumption but rather constructed to suggest the refined sensibility of the 'man or woman of feeling'. Judging from the sheer volume of commissions during the 18th century, this type of rural sensibility portrait was a highly attractive form of self-imagery for art patrons and clearly experienced a revival in the late Victorian and Edwardian period, as *Diana of the uplands* 1903–04 by Charles Furse (fig. 75) and *Madame Melba* by Rupert Bunny (fig. 76, cat. 10) demonstrate.[29] With the subject standing off-centre and buffeted by the wind, Furse's portrait finds a parallel with Reynolds' portrait of *Lady Jane Halliday* 1779 (Waddesdon Manor), although the former, as with *Madame Melba*, retains a strictly 'society' air. In this context, both paintings relate more closely to Lawrence's glittering portraits of *Miss Elizabeth Farren* 1790 (Metropolitan Museum, New York) or *Pinkie*. Lambert's *Miss Thea Proctor* (cat. 66) and Philip Wilson Steer's *Mrs Violet Hammersley* (fig. 77, cat. 130), however, demonstrate a more reflective mood, a quality that was identified by Edwardian commentators with Gainsborough's portraits, especially those of the 1780s. In the introduction to Mary Craven's *Famous beauties* (published 1906), Martin Hume observed that:

> The Gainsborough beauty, clad in diaphanous drapery and with sylvan surroundings, suggests gentle and somewhat pensive life in the open air — a life of greater freedom and less affectation than the fashions that preceded it … They loved the country background, which they pervaded with satin slippers and gauze draperies … because it lent itself to sentimental self-communion, to the tender contemplation of the troubles of Clarissa, or rapt absorption in the rustic lays of Thomson or of Gray.[30]

The portrait of Mrs Hammersley, in its composition, gentle Arcadian mood and flickering brushwork, is in many ways an Edwardian evocation of these sentiments. As with a number of artists (and collectors) in the 1890s, Steer was also attracted by the rococo revival style. Thus his portrait not only evokes the work of Gainsborough, who was himself influenced by the French rococo, but also the elegant, aristocratic fantasy world of the

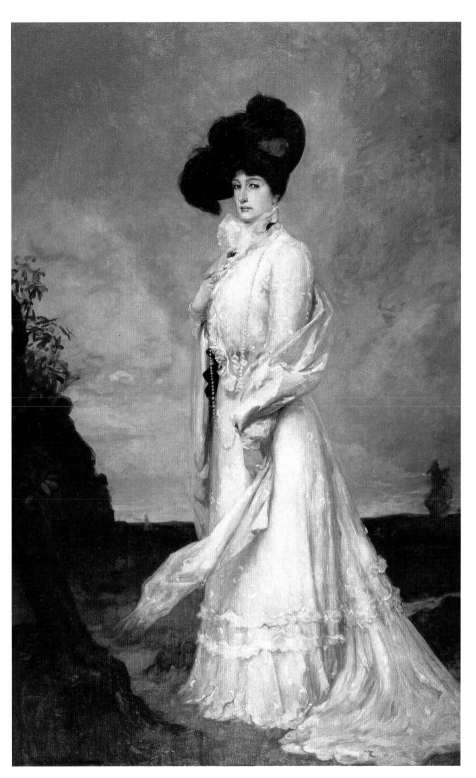

Fig. 76: Rupert Bunny *Madame Melba* 1901–02 [cat. 10]

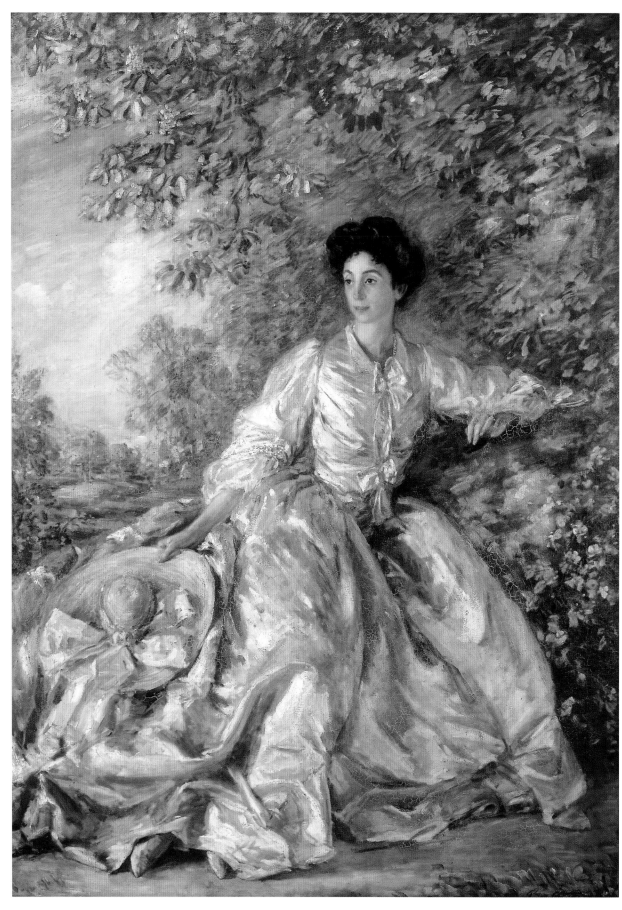

Fig. 77: Philip Wilson Steer *Mrs Violet Hammersley* 1907 [cat. 130]

fêtes galantes by Antoine Watteau and Jean-Honoré Fragonard and, it would seem, François Boucher's languid portrait *The Marquise of Pompadour* 1758 (fig. 78). As Ysanne Holt has noted in discussing work that Steer executed at the turn of the 20th century, the appeal of the 18th century was, on the one hand, purely escapism: 'What attracts us,' wrote poet and dramatist W.E. Henley, 'is its outside. We are in love with its houses and its china and its costume. We are not enamoured with it as it was, but as it seems.'[31] But for Steer and others, looking to the past was 'instinctive and genuine, not an affectation — a special perception of a vanished culture, prior to industrialisation and contemporary instability'.[32] Given this context, *The forgotten melody* by Ethel Walker (fig. 79, cat. 141), both painting and title, is especially resonant. This nostalgia was symptomatic of the anti-urbanism and concern for rural regeneration that marked the period, paralleled by developing notions of national character and the countryside, and enquiries into the essential character of native art itself, using the example set by British old masters.[33]

When, only four years after the First World War, *The blue boy* was exported to America, the *New York Times* described it as 'a picture ... which Englishmen wept to see leaving their country'.[34] Indeed the loss of this one painting seems to have encapsulated, for some at least, the feeling of national crisis and subsequent dislocation from a 'Golden Age'. In an article entitled 'Farewell to The blue boy', published in a London newspaper in 1922, the author opined:

> He is going to leave us ... we hardly know why. Perhaps it was because some of the lovely youth of our country seemed to be going with him, some grace of the old time, when, men and women wore those gorgeous clothes, and were untroubled by the many self-questionings of our generation; something of the courtly grace and serene carriage of a people who knew themselves a great people.[35]

Christine Riding
Curator, Tate Britain, specialising in 18th-century and 19th-century British art

Fig. 78: **François Boucher** *The Marquise of Pompadour* 1758 oil on canvas 72.5 x 57.0 cm Victoria and Albert Museum, London (photograph: V&A Picture Library)

Notes

1 William Morris, *The prospects of architecture in civilisation in hopes and fears for art*, London, 1882, n.p.
2 David Cannadine, *Aspects of aristocracy: Grandeur and decline in modern Britain*, New Haven: Yale University Press, 1994, p. 77.
3 Walter Bagehot, *The English Constitution*, London, 1867, pp. 4–5: for further discussion on Walter Bagehot and the role of the monarchy, see also Christine Riding and Jacqueline Riding (eds)
The Houses of Parliament: History, art, architecture, London: Merrell, 2000, pp. 179–93.
4 Elaine Kilmurray and Richard Ormond (eds), *John Singer Sargent*, London: Tate Publishing, 1998, p. 34.
5 Quoted in Judy Egerton, *National Gallery catalogue: British Collection*, London: National Gallery, 1998, p. 237.
6 Cannadine, *Aspects of aristocracy*, 1994, p. 10.
7 As quoted in John Hayes, *Thomas Gainsborough*, London: Tate Publishing, 1980, p. 26.
8 George Moore, *Modern painting*, London, 1893, p. 139.
9 William Vaughan, *British painting: The golden age from Hogarth to Turner*, London: Thames and Hudson, 1999, p. 68.
10 J. Mordaunt Crook, *The rise of the nouveaux riches: Style and status in Victorian and Edwardian architecture*, London: John Murray, 1999, p. 4.
11 Crook, *The rise of the nouveaux riches*, 1999, p. 19.
12 Douglas Stewart in his forthcoming *Dictionary of National Biography* entry suggests that this may have been painted by John Closterman.
13 H. Barbara Weinberg, 'American artists' taste for Spanish painting', in Gary Tinterow and Geneviève Lacambre (eds), *Manet/Velasquez: The French taste for Spanish art*, The Metropolitan Museum of Art, New Haven: Yale University Press, 2003, p. 261, p. 305; Peter Funnell and Malcolm Warner (eds), *Millais: Portraits*, London: National Portrait Gallery, 1999, p. 24.
14 Richard Dorment, 'Whistler and British art' in Richard Dorment and Margaret F. Macdonald (eds), *James McNeill Whistler*, London: Tate Publishing, 1994, p. 25.
15 As quoted in Peter Funnell and Malcolm Warner (eds), *Millais: Portraits*, London: National Portrait Gallery, 1999, p. 203.
16 Francis Haskell, *The ephemeral museum: Old masters and the rise of the art exhibition*, New Haven: Yale University Press, 2000, pp. 4–6, pp. 51–7.
17 As quoted in Haskell, *The ephemeral museum*, 2000, p. 57.

Fig. 79: Ethel Walker *The forgotten melody* 1902 [cat. 141]

18 Dorment, 'Whistler and British art', 1994, pp. 24–5.
19 Robyn Asleson and Shelley Bennett, *British paintings at the Huntington*, New Haven: Yale University Press, 2001, p. 54.
20 Andrew Wilton, *The swagger portrait: Grand manner portraiture in Britain from van Dyck to Augustus John, 1630–1930*, London: Tate Publishing, 1992, p. 59.
21 Weinberg, 'American artists' taste for Spanish art', 2003, p. 270; Dorment, 'Whistler and British art', 1994, p. 23.
22 Dorment, 'Whistler and British art', 1994, p. 23.
23 Crook, *The rise of the nouveaux riches*, 1999, pp .17–18, p. 25.
24 Asleson and Bennett, *British paintings*, 2001, p. 1.
25 'The Consequence of the American Invasion', *The Burlington Magazine*, XVI, vol. V, July 1904, pp. 353–5.
26 H.G. Wells, *Tono-Bungay*, London, 1909, p. 75.
27 Martin Postle, 'Reynolds's portraits at Waddesdon Manor: Painting for posterity', in *Waddesdon Manor: The Rothschild Collection/Apollo Magazine*, vol. CXXXIX, no. 386, April 1994, p. 19.
28 Michael Rosenthal and Martin Myrone (eds), *Gainsborough*, London: Tate Publishing, 2002, p. 96.
29 Rosenthal and Myrone, *Gainsborough*, 2002, p. 104, pp. 144–7, pp. 180–03.
30 Mary Craven, *Famous beauties of two reigns, being an account of some fair women of Stuart and Georgian times*, London, 1906, p. 23.
31 As quoted in Ysanne Holt, *Philip Wilson Steer*, Bridgend: Seren, 1992, p. 70.
32 Holt, *Steer*, 1992, p. 70.
33 Ysanne Holt, 'Nature and nostalgia: Philip Wilson Steer and Edwardian landscapes', *Oxford Art Journal*, vol. 19, no. 2, 1996, pp. 28–45.
34 As quotes in Asleson and Bennett, *British paintings*, 2001, p .13, n. 57.
35 As quoted in Asleson and Bennett, *British paintings*, 2001, p. 14, n. 59.

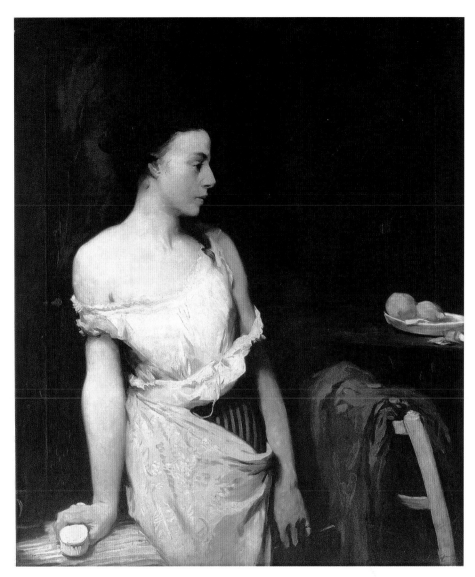

Fig. 80: **Glyn Philpot** *Girl at her toilet* c.1908 [cat. 101]

New English *Intimisme*
The painting of the Edwardian interior

Two paintings from consecutive Royal Academy exhibitions in 1900 and 1901 reveal new possibilities in the representation of interior space. They are John Singer Sargent's *An interior in Venice* (fig. 81) and Stanhope Alexander Forbes' *22nd January 1901* (fig. 82).[1]

Class, wealth and race obviously underscore the comparison. Money and breeding in one instance contrast with the relative lack of it in the other. Boston Brahmins are juxtaposed with Cornish fisherfolk. The generations — aged parents, sons and daughters-in-law — that in Forbes are clustered together, in Sargent are separated. Literacy is a given in both cases but, while Sargent's people idly browse and read silently, Forbes' read aloud and listen with purpose. There is no moralising about the apparent indolence of Sargent's rich — any more than there is required approval for the implied industry of Forbes' fisherfolk. It would have been easy for Sargent to flood the interior with artificial light and tell us about the Tiepolo on the wall in the background, just as Forbes could possibly give us more about a family which, despite the introduction of steam trawlers, may now be struggling to make a living. But Sargent and Forbes were not seduced by decoration.[2] And these are Royal Academy exhibits, not social tracts. Their respective artists are *metteurs en scène*. Forbes' play is no less subtle than Sargent's, and his actors are no less skilled. Sargent's figures were members of the Curtis family. Bostonians who came to Europe in 1879, they purchased the upper apartments of the Palazzo Barbaro in 1885.[3] Forbes' models were members of the Hichen family, although the grandfather, reading the newspaper, was not related to the others. Too much effort, for some viewers of Sargent's picture, was expended upon impressing the public with the contingency of a great space.[4] There was too much flicker, too much suggestion. At the same time, Forbes' family gathering, with its poignant empty chair, also reveals a degree of subtle contrivance which takes us back to the narrative stratagems of painters like Luke Fildes.[5] For the younger generation of painters, stagecraft like this had to be stripped away.

George Clausen *Twilight: Interior (Reading by lamplight)* c.1909 (detail) **[cat. 20]**

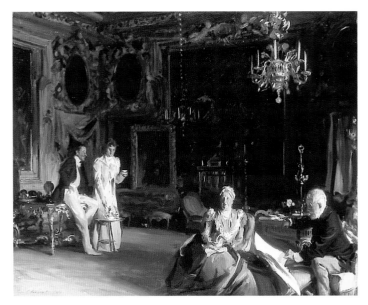

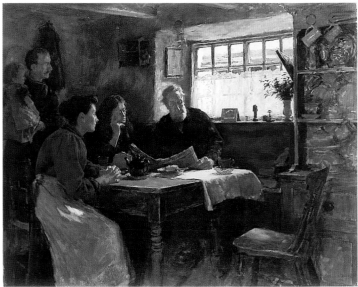

(left) **Fig. 81: John Singer Sargent** *An interior in Venice* 1898 oil on canvas 66.0 x 83.5 cm Royal Academy of Arts, London (photograph: Prudence Cuming Associates)

(right) **Fig. 82: Stanhope Forbes** *The 22nd January 1901 (reading the news of the Queen's death in a Cornish cottage)* 1901 oil on canvas 96.4 x 124.0 cm Exeter City Museums and Art Gallery

Taken at face value, however, the death of the sovereign provided an opportunity for Forbes to transform an otherwise inconsequential genre painting into something momentous. That particular instant when an aged couple, their son, daughter-in-law and grandchild come together to read the news is one which all will remember. In picturing them, Forbes describes their habitat. While we contemplate the queen's death, our eye passes from an empty rustic chair to the vase of wild flowers on the cottage windowsill. There is no necessary connection between what we hear and what we see — it is simply an association. By contrast, Sargent's *An interior in Venice* represents no datable day. Here are two disconnected couples. Again, the patriarch is reading, but the son and daughter-in-law are taking tea across the gloom of the salon of the Palazzo Barbaro. Faced with such impressive surroundings, we might have expected more guidebook detail than we are given, but Sargent envelopes us in layers of knowing.

Both painters had powerful paparazzo instincts. One of the significant aspects of social spectacle in the Edwardian period was the degree to which private space became public.[6] Mass literacy and the thirst for images, supported by the proliferation of illustrated newspapers, catered to public curiosity as never before. In three weeks time Forbes' protagonists will be able to see special numbers of the illustrated papers commemorating the crowds assembled to watch the passing of the queen's funeral cortège, with vignette portraits of the chief mourners. By the turn of the century, looks and lifestyles faced unprecedented exposure. Paintings

of interiors, like those of Sargent and Forbes, were subject to a new kind of scrutiny. Although, at one level, artists reported on what they found, they were fundamentally responding to rooms which re-enforced notions of identity, class, culture and taste, and in such a climate the genre was refreshed.

Both painters therefore approached the rooms they painted with an urgency that is evident in shorthand phrases — rapid brush marks intended to convince us of the truth of representation. The reporting style — one which is swift and which stresses the unity of perception and its act of realisation — is applied to the slow, sedentary activity of reading.[7] Something has happened and the readers need to know about it. Sunlight, which falls equally upon the furnishings of the palace and the peasants' dwelling, brings with it news of the Boers, of the prices of preference stock, of the death of Victoria. In most cases the content of the reading matter may not be disclosed, yet there was nevertheless a commonly held belief that reading, concentrating on the page, was one of the most important vehicles by which the occupants of the room were released from it. The depiction of solitary acts of absorption — reading, writing, making and listening to music, studying pictures — reveal new and complex ways in which painters and their audiences confront the domestic sphere.

William Rothenstein, for instance, only has to title his picture *The Browning readers* (fig. 83, cat. 114) to summon up Robert Browning's poems 'Childe Roland' or 'Andrea del Sarto'.[8] At the same time, the more precise the painter is about the interior

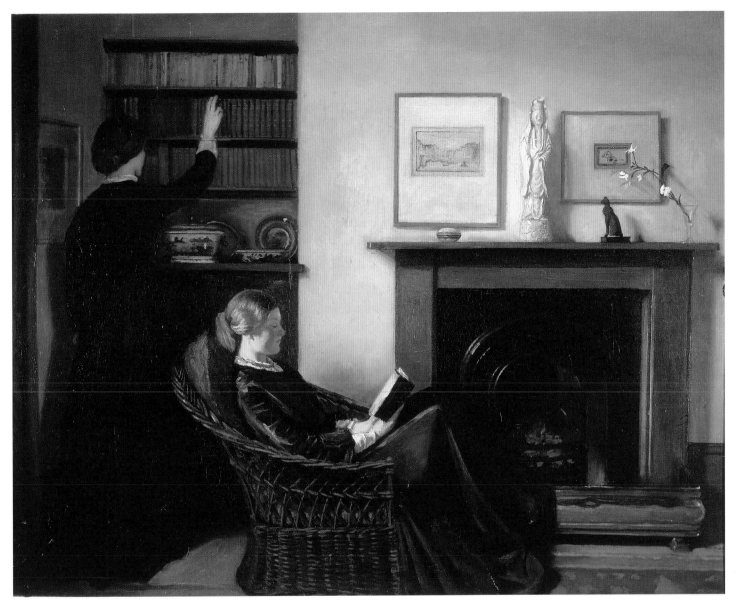

Fig 83: **William Rothenstein** *The Browning readers* 1900 [cat. 114]

Fig 90: **Albert Rutherston** *The confessions of Claude* 1901 oil on canvas 76.2 x 96.4 cm UCL Art Collection, University College, London

praised for its 'flickering play' of sunlight upon the 'pale stuffs' of a girl's dress and the sofa on which she rests, exemplifies the trend.[27] However, the 'beautiful smudge' style with which the older members of the club had been popularly associated was giving way to punctilious painting.[28] Although the return to Victorian values was popularly preached in the corridors of the Slade by Tonks, the important proponent of this new orthodoxy was Rothenstein himself.[29] The painted walls and pictures limited to a few well-placed prints or traditional landscapes, and single, simple pieces of classic English furniture, quickly became formulaic.

There was the sense that these rooms were Spartan for reasons other than plain fact. Isolated objects, which in works by artists such as Edouard Vuillard lose their identity in palpitating surface, here take on a life of their own. There were, in short, aesthetic choices that signified new approaches to interior decoration. So familiar was the general ambience that the The Speaker's art critic remarked in 1902:

> The genteel interior, always a feature of this club's exhibitions, is possibly more conspicuous this spring than it ever has been before. We are familiar with these interiors. They consist of dingy London rooms with plain walls, highly polished furniture, a green door or dado, one figure or more, and frequently a green-shaded lamp; and they suggest as they reappear, exhibition after exhibition, the presence somewhere of a property room which sundry enthusiastic and maybe promising art students take their turns at painting.[30]

It is the case that the Rothenstein and Orpen interiors occasionally contain some of the same props. The harpsichord noted in the background of Rothenstein's *An interior* reappears in Orpen's *The refugees*. The Regency convex mirror, the ship model, the angle-bracketted oil lamp and the circular inlaid tables also reappear in Orpen's *A window in London Street,* Rothenstein's *An interior* and other works. *Blanc-de-chine* figures, single porcelain vases or framed prints become common features throughout.[31] MacColl, who observed this, proposed that it would take some latter day expert to separate their works.[32] We could start to read the sailing ship model and the Chinese figures as references to imperial trade, but this would be wrong.[33] Beyond noting the classic style of Orpen's rooms — dadoes and chandeliers,

Fig 91: **William Orpen** *The valuers* 1902 oil on canvas 83.0 x 109.0 cm private collection (photograph: courtesy Pyms Gallery, London)

a late Georgian or Regency sense of propriety — discretion forbade any reference to the story that might be implied in these accoutrements. These interiors of dingy lodging houses offer resistance to the belief that such spaces should, as in Forbes, support the identity of their inhabitants.[34] They tell us that we are dealing with a shifting population and that the few talisman objects and framed prints might indeed be passed from place to place. The temporary nature of this inner city life is underscored by Orpen's *The valuers* (fig. 91) shown at the New English in the spring of 1902, in which a group of property agents debate the likely value of chattels. In this instance, they stop to study a picture, the content of which has aroused their curiosity. Referring to this work, the critic of *The Speaker* noted:

> The depth of the shadowy room is unmistakable, and the postures are easy and eloquent — particularly that of the self-satisfied, silk-hatted individual waving his left hand jauntily towards the suspended picture under discussion — whilst the pure painting of the whole calls for unstinted praise.[35]

However, ennui was beginning to creep in:

> As bits of painting, they (the interiors) are mostly well done; it is quite pleasant to mark a dextrous highlight here or a carefully studied shadow there, the clever drawing of a figure or a face. The bulk of them however, owing to the absence of original idea, are rather the language of art than art itself … Those genteel interiors appear indeed, to be the body and the spirit of the club … Messrs Orpen and Rothenstein do them very well; but we should prefer to see these artists do them less often as far as the club is concerned, for the sake of the public, and also for that of these artistic aspirants who seem bent on tendering them the sincerest form of flattery.[36]

This caution went unheeded, presumably because such pictures had their supporters.[37] Around Rothenstein and Orpen grouped artists such as Mary and Ambrose McEvoy and David Muirhead, who worked new variations on the familiar theme. In the McEvoys' reveries, such as Mary's *Interior: Girl reading,* 1901, (fig. 92, cat. 82) and Ambrose's *The engraving* 1901 (private collection), *The convalescent* 1903, (fig. 93) and *The book* 1903 (private collection), there are equally bare settings and the literary references are even more vague.

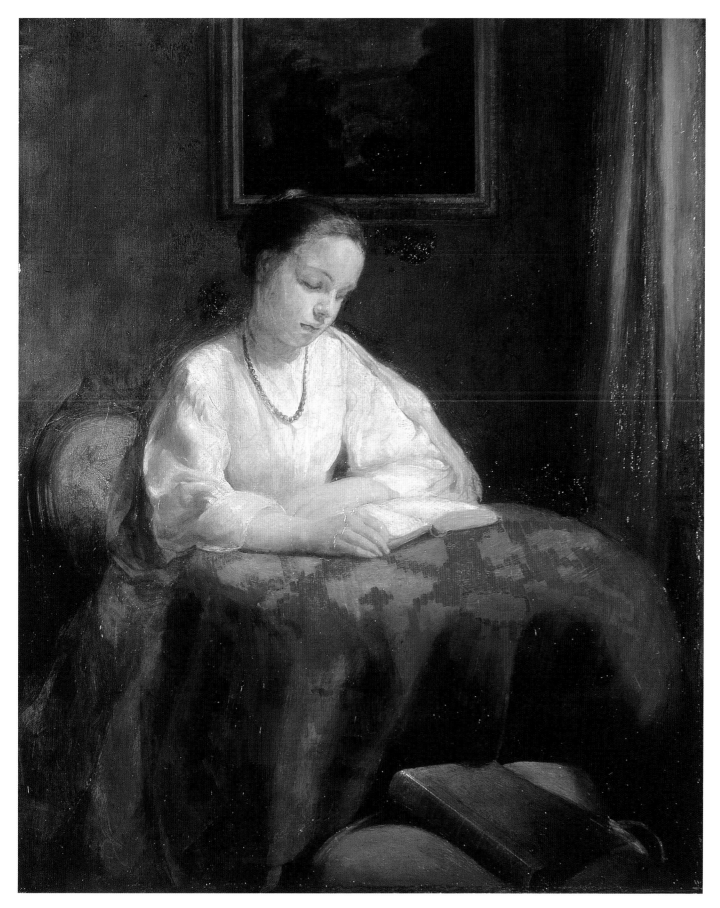

Fig 92: **Mary McEvoy** *Interior: Girl reading* 1901 [cat. 82]

Fig 93: **Ambrose McEvoy** *The convalescent*
c.1903 oil on canvas 53.0 x 43.0 cm
private collection

Mary's *Interior* is a modern Dutch master, down to
the heavy brocade tablecloth, while in the first of
Ambrose McEvoy's works, young women gaze at
portrait engravings or books with the seriousness of
those in the work of Henri Fantin-Latour.[38]
These were the paintings of a 'true intimist'.[39]
In *The convalescent* and *The book,* the subject, again,
is reading. However, where Rothenstein's reference
to Browning was specific, here the context is merely
'literature'. For *The Studio* critic, T. Martin Wood,

> This art is wedded to literature — [it] comes
> from a page of a book as well as from life,
> and the artist's imagination passes from art
> to life and back again, finding no barrier to
> its dreams, embracing outer objects as part
> of them, meeting everyday people as if they,
> too, lived the interesting vivid life that is in
> books.' [40]

The ambiance of literature thus provides the subject
matter for Mary and Ambrose McEvoy. Purposeful
young women in student accommodation or 'digs',
temporarily enriched by the occasional shrewd
purchase of an early English landscape, read serious
works rather than a local paper or a 'shilling
shocker'. The image of such a woman is openly
suggestive. It arouses curiosity. It reminds us that
rooms in bourgeois houses in the 19th century
began to be configured to facilitate this purpose,
equipped with shelves, lecterns and revolving
bookcases.[41] Domestic libraries and studies had
become more common as literacy spread and,
crucially, they were more accessible to women than

to men. They defined private and public space,
as much as circulation libraries and the publication
of weekly serials regulated reading time. Where
formerly it might have been a group activity, cut
through with conversation, reading became solitary
and silent in bourgeois homes by the turn of the
century.[42] There was considerable speculation about
the activity itself and the closed communication
which takes place between readers and authors.[43]
Arriving in the private space of the bed-sitting
room, the McEvoys were the unseen witnesses
of this communion with the unknown.[44]

Of Ambrose McEvoy's works, *The convalescent*
comes from the world of Rothenstein's *The doll's
house,* Rutherston's *Song of the shirt* (fig. 94, cat. 116)
and Orpen's *A window in London Street.* Despite
the fact that the interior is manifestly seedy, Wood
found that it and McEvoy's other early New English
exhibits expressed 'a feeling for the gentle side of
life … always to be found in that art which turns
indoors to the peacefulness of the room'. The room
thus provided comfort and its few accessories —
'the ticking clock, the pattern of the carpet' — 'are
all important friends'. In this and in McEvoy's other
interiors, there is a sense of intimacy, of repose, of
resignation and longing. The rooms are filled with
the ghosts of the past, of 'artificial weather' and
'graceful illness'. Significantly, Wood declares that
these Pimlico interiors are those that 'a Thackeray
character would live in'.[45]

The allusion to the imagined world of 'literature',
in Thackeray and the early Dickens seems at first
to exclude the decorative on the one hand, and
the ethos of reportage on the other. The models
are taken from the Dutch masters in whose work
narrative is artfully concealed. However 'literature',
in the abstract, in the broader context of the
Academy, opened up the route to the crinoline
confections of Philip Connard, John Young Hunter
and Leonard Campbell Taylor, the portrayers of
simpering drawing room dramas which carry the
aura of *Quality Street*.[46] At the same time, Sargent,
as D.S. MacColl noted, had his true successors in
the painters of 'portrait interiors' such as Patrick
William Adam and John Lavery.[47]

The New English Art Club, however, retained its
allegiance to what Laurence Binyon described as
'sunny morning-rooms',[48] and to plain walls and
contemplation, while the visual entanglements

Fig. 94: Albert Rutherston *Song of the shirt* 1902 [cat. 116]

of late Victorian domesticity had to be reclaimed in Harold Gilman's Snargate Rectory paintings, produced between 1903 and 1905. These works take us back into the deep signification of sentiment in the dense patterning and clutter of the drawing room.[49] They allude to an older world of maids and mistresses. Although works like *In the nursery, Snargate Rectory,* (fig. 95) retain the formal attributes of the Orpen/Rothenstein interiors, they depict wallpapered rooms in which the daily domestic rituals of servants and children are performed. The fact that the occupants of these rooms are hemmed in by possessions signalled a 'very English *intimiste*', but one who was apparently unfamiliar with the work of Vuillard.[50]

Gilman's early visual vocabulary was nevertheless acquired from artists who, like Walter Sickert, were adapting the reporter's shorthand to the examination of the unsettling circumstances of the urban interior. Sickert found his only escape from the middle-class values of his contemporaries on the jury of the New English by insistence upon the underclass maelstrom. *The new home,* (fig. 96), shown at the club in 1908, from what we can see of its discoloured wallpaper has all the potential of Gilman's interiors, and yet it is quickly apparent that an impoverished coster woman has just moved into her lodgings and has yet to take off her hat.[51] Thinking perhaps of the painters of 'portrait interiors' he famously wrote that 'the more our art is serious, the more it will tend to avoid the drawing room and stick to the kitchen'.[52] Elsewhere in his

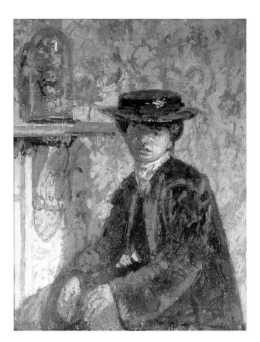

Fig 96: **Walter Sickert** *The new home* c.1908 oil on canvas 50.8 x 40.6 cm Courtesy of Ivor Braka Ltd, London

social criticism, Sickert expanded upon the subject of wallpaper. Attacking the notion of 'refinement' he declared, 'with this goes, in the region of taste, an utter impossibility of living for twenty four hours in a room with the "wrong" wallpaper, and as a corollary of the wallpaper, a mild liking for inoffensive and slight watercolours in the "*right*" mounts, framed in the "*right*" way'.[53] Sickert, when he entered the dingy rooms that became *The new home,* relished the 'wrong' wallpaper. Its faded glory denies the apparent securities, continuities and refinements of the stable middle-class parsonage. The coster woman has arrived in another temporary abode.

Despite other fluctuations of fashion, interior painting, as Binyon noted in 1908, remained at the core of the club's bi-annual shows. Speaking of Orpen, Tonks and Steer, he declared,

> Secluded from the unrestful emotions of our age, with its fever of ideas and its profound dissatisfactions they remain serene. Collecting pieces of admirable furniture, choosing with fine judgement gaily harmonious patterns of fine chintz, their art dwells in charming interiors, where filtered sun caresses old silver and porcelain and bowls of flowers reflected in polished wood.[54]

This point was repeated a year later by T. Martin Wood who observed that, with the majority of New English exhibitors, 'it is still the effects of

Fig 95: **Harold Gilman** *In the nursery, Snargate Rectory* c.1903–05 oil on canvas 68.5 x 59.1 cm private collection (© Christie's Images Ltd. 2004)

nature that are pursued indoors'.[55] The club was firmly associated with the depiction of atmospheric room-sets, in which a surrogate spectator might be found quietly reading a book or playing a piano. This is what we see in the paintings by S. Noel Simmons and F.H.S. Shepherd that were chosen to illustrate the review.[56] Simmons' panelled, painted interior, *The cosy corner*, replicates the setting of Rothenstein's *Mother and child* (private collection) and *In the morning room* (private collection), both painted in 1903, while Shepherd's *The Bach player* relies heavily upon Orpen's *The piano,* c.1902 (private collection). In both instances the rooms are austere and masculine. Both are purged of Victorian clutter. In scale and substance they take the exhibition visitor away from the grand Academy set piece naturalism of 20 years earlier, exemplified in the crowded cottage in Forbes' *By order of the court* 1890 (Walker Art Gallery, Liverpool).[57] The New English Art Club painters had rejected this sense of art's purpose and its implicit construction of the audience.[58]

By 1909, the club had refined its constituency. Whilst it had never courted — never been able, or willing to court — the populism of the Academy, it also sought to place at the margins those painters who, although they came from the right stable, were judged to be out of step with the club's clientele. There is an equally important distinction to be made between these pictures and the interiors of the Fitzroy Street Group that included Gilman and Sickert. In practice this expressed itself in hanging decisions rather than in edicts or policy statements.[59] We only have to look at the young and middle-aged cronies in Orpen's *The selecting jury at the New English Art Club* 1909 (National Portrait Gallery, London) to realise why this should be so. The taste of Tonks, Frederick Brown, Steer, McEvoy, Rothenstein, Orpen and John tended to dominate successive exhibitions, so that when we look at the work of Charles Stabb, Simmons and Shepherd we clearly understand their derivation.[60] Orpen's interiors for instance remained influential beyond the confines of the New English Art Club. His 'Night' series, for example, which was unveiled with a work of this title in 1907, acts as the most powerful precedent for Clausen's *Twilight: Interior* (fig. 97, cat. 20).[61] Its carefully crafted *petit maître*, which typifies New English *Intimisme* as much as anything, led Sickert to the scullery. Listening to his advocacy

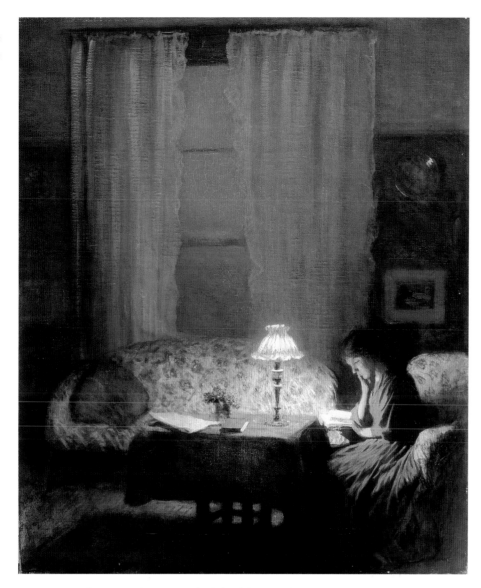

Fig 97: George Clausen *Twilight: Interior (Reading by lamplight)* c.1909 [**cat. 20**]

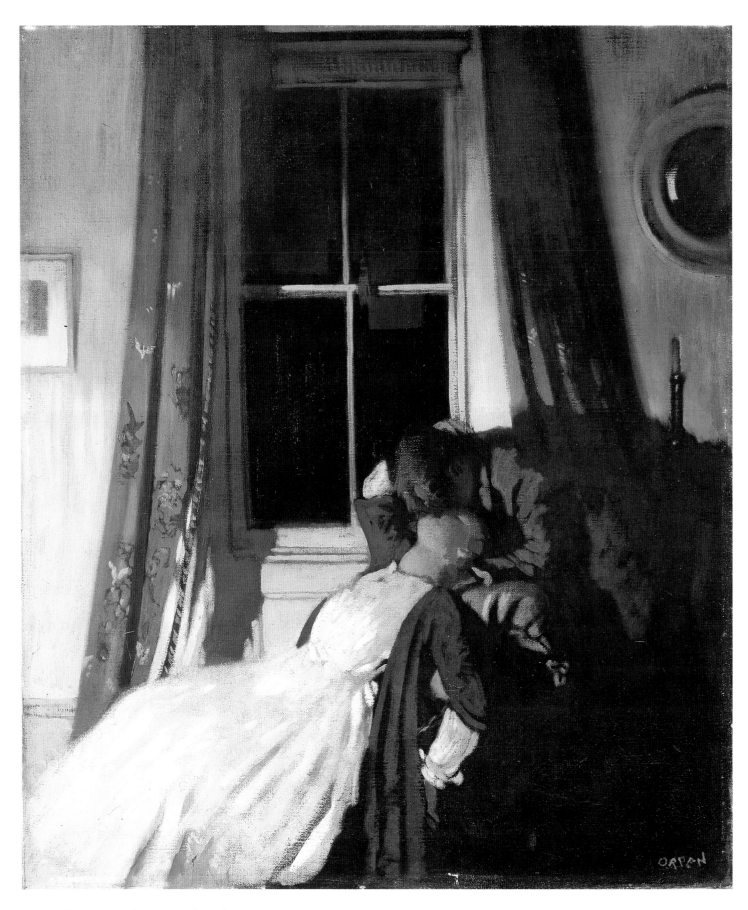

Fig 98: William Orpen *Night (no. 2)* 1907 [cat. 94]

of what became the Camden Town school, it is clear that these retiring, bourgeois pursuits are what he required his readers to reject. The devouring passion which he sought in the 'murder' series and which is coincidentally the subject of Orpen's extraordinary *Night (no. 2)*(fig. 98, cat. 94) is suppressed in favour of the lower-class lassitude of *Ennui* (fig. 99, cat. 125).[62] However, the New English sub-genre needs more explicit attention if only to show that Sickert's invective was more about his own momentary positioning than rejection in absolute terms.

In important ways the exhibition visitor was being reconstituted in these works. No longer left scanning the crowd for a recognisable face in a picture, he or she reviewed the neglected room for evidence of human habitation. T. Martin Wood was exercised by the topic and penned a further article on modern interior painting for the September 1909 issue for *The Studio*. His readers were given a selection of illustrations of works by Jacques-Emile Blanche, Pierre Bracquemond, Walter Russell, Orpen and Vilhelm Hammershoi. He tells us that the paintings are as much the product of the momentary glow of nature as a landscape. The moment when the sun comes through the window is one of transformation, '*music ...* born of a moment, [which] continues for ever the spirit of the moment in which it was born'.[63] While Orpen, Rothenstein, McEvoy and others place figures in their rooms, for Blanche the furniture and discarded objects simply refer to human presence beyond the picture itself. All contain a romantic, 'dusty atmosphere', for, according to Wood, dust is the '*poudre d'amour* on the face of faded things', it colours the air. This vague romanticism contrasts with the clinical white interiors, designed by Ferdinand Knopff, that were enlivened only by the display of a single photographic reproduction of Edward Burne-Jones' *The wheel of fortune* 1883. Nor does it define the equally white room, hung with the works of Matisse, to which Lewis Hind referred after his visit to the home of Michael and Sally Stein in Paris.[64] While the spaces portrayed by Blanche were relentlessly of their time and contained no inherent justification for a Matisse, there is more to them than meets the eye. They are middle-class reveries.[65] The truth of Walter Benjamin's observation that the interior sustained the private individual in his illusions merely serves to reinforce

the point. This is his or her world: a cabinet, which appeals to educated amateur and dilettante values, and which Benjamin did much to underscore.[66] Between 1901 and 1909, New English exhibitions were leading their clientele into this enclosed environment of reading, playing the piano and quiet reflection, in the familiar surroundings of a consciously crafted space. The cabinet may be private, but it is not exclusive. We look into it through the meta-language of painting. The viewer of 1909 might well recognise objects, furniture or colour schemes, and slip into the painting with easy intimacy, for this was the exhibition visitor's temporary abode and the collector's permanent address.

And what did these works signify for the club? Atrophy? The failure to develop? Its preference for modern English versions of the Dutch *petits-maîtres,* produced consistently and at high quality, oblivious of the fact that the market will change and sweep them away, was all too clear. The market did not change. This was the bedrock of Edwardian painting.

Kenneth McConkey
Professor and Dean of School of Arts and Social Sciences, Northumbria University

Notes

1 For discussion of the former, see Richard Ormond and Elaine Kilmurray, *John Singer Sargent: Portraits of the nineties, complete paintings* vol. 2, New Haven: Yale University Press, 2002, pp. 154–5, (no. 367).
For Forbes see Caroline Fox and Francis Greenacre, *Painting in Newlyn, 1880–1930,* London: Barbican Art Gallery, 1985, p. 111.

2 At this time there was a great deal of debate concerning ideas about decoration and the decorative. I can do no more than point to the substantial contemporary literature on 'ideal' homes and decorative schemes and styles that was already underway by 1893, when *The Studio* commenced publication. The early issues of this and other art periodicals of the period, including *Art et Décoration,* are peppered with articles on 'artistic' homes. An important focus of attention was Seigfried Bing's 'Maison de l'Art Nouveau', to which Conder and Brangwyn contributed in 1895. The complex stylistic battles, symptomatic of deeper anxieties in the period, are described in Debora L. Silverman, *Art Nouveau in fin-de-siècle France: Politics, psychology and style,* Berkeley: University of California Press, 1989, pp. 63–106 (1992 ed.).

3 Ormond and Kilmurray, *John Singer Sargent*, 2002, p. 154.

4 For Sargent's use of dark space, see Susan Sidlouskas, 'Psyche and sympathy: Staging interiority in the early modern home', in Christopher Reed (ed.), *Not at home: The suppression of domesticity in modern art and architecture,* London: Thames and Hudson, 1996, pp. 65–80. Sidlouskas interestingly calls attention to the dark empty spaces at the centre of Sargent's important interiors and the modern sense of alienation which this conveys.

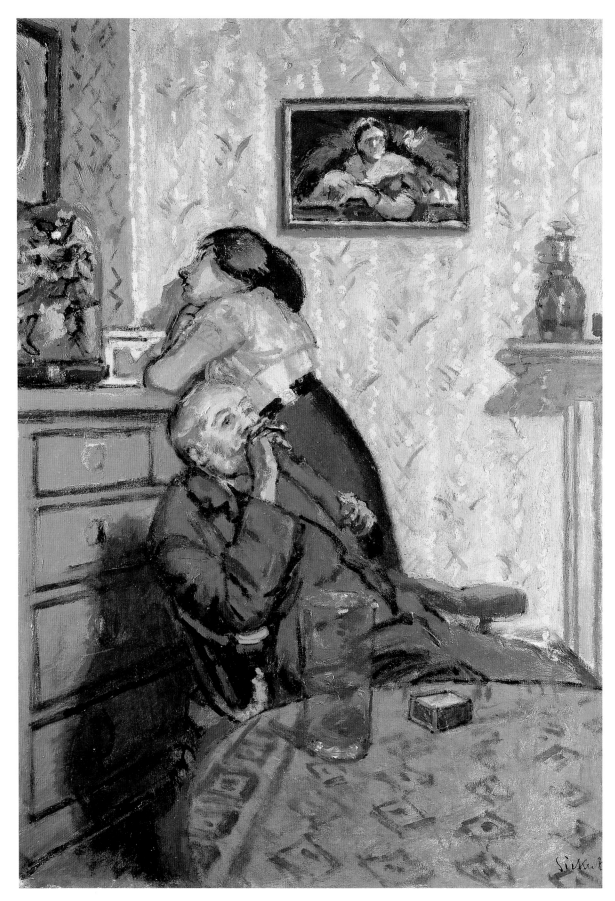

Fig 99: Walter Sickert *Ennui* c.1914–18 [cat. 125]

5 Luke Fildes RA (1843-1927), in his career path, typified many late Victorian Academicians who established their reputations with social realist subjects, only to forsake them for the more lucrative genre of portraiture. Fildes had to be persuaded back to his origins in order to produce his best-known work, *The Doctor* 1891 (Tate, London). The reference here is to *The Empty Chair – Gad's Hill, Ninth of June 1870*, a celebrated illustration of Charles Dickens' study, made immediately after his death, and which appeared in the Christmas number of *The Graphic*, in that year. As is well-known, this illustration acted as an inspiration for Vincent van Gogh's later paintings of empty chairs.

6 Much has been said about the perception of public and private space in the late 19th century. Jules and Edmond de Goncourt, witnessing the transformation of central Paris, famously declared that 'The home is dying. Life is threatening to become public ... I am a stranger to these new boulevards which ... make one think of London or some American Babylon of the future.' (Robert Baldrick trans., *Pages from the Goncourt Journal*, Oxford: Oxford University Press, 1978, p. 53.) See also notes 9 and 12 below.

7 Walter Gay, quoted by Ormond and Kilmurray, *John Singer Sargent*, 2002, p. 155, considered that the elder Curtis was turning the leaves of a portfolio.

8 For reference to *The Browning readers*, see Alan Bowness (introd.), in John House and MaryAnne Stevens (ed.), *Post-Impressionism, Cross-currents in European painting*, London: Royal Academy of Arts/Weidenfeld and Nicolson, 1979, (entry by Anna Gruetzner) p. 205.

9 The New English Art Club had been formed in 1886. Its original members, who included George Clausen, Stanhope Forbes and Philip Wilson Steer, were more or less united by their student experiences in the Paris ateliers. The club immediately grew to take in Walter Sickert, John Lavery and Jacques-Emile Blanche, painters who exemplified avant-garde tendencies. Beyond this, the members had a series of more confused objectives which centred around the reform of the Royal Academy, both as an exhibiting venue and as an educational establishment. In its first dozen years it had survived many purges as particular factions came and went. The principal 'interiors' shown at the club in either its spring (s) or winter (w) exhibitions were: William Rothenstein, *A doll's house*, 1899, exh. 1903 (s); William Rothenstein, *The Browning readers*, 1900 (w); William Rothenstein, *An interior*, 1901 (s); William Rothenstein, *Mother and child*, 1903 (s); Albert Rutherston, *The confessions of Claude*, 1901; Albert Rutherston, *Song of the shirt*, 1902 (w); William Orpen, *A mere fracture*, 1901 (s); William Orpen, *A window in London Street*, 1901 (w); William Orpen, *The valuers*, 1902 (s); William Orpen, *The refugees*, 1901–5; Ambrose McEvoy, *The engraving*, 1901 (s); Ambrose McEvoy, *The thunderstorm*, 1901 (w); Ambrose McEvoy, *The convalescent*, 1903 (s); Ambrose McEvoy, *The book*, 1903 (w); Mary McEvoy, *Interior: Girl reading*, 1902 (w).

10 Walter Benjamin, *The arcades project*, The Belknap Press of Harvard University Press, 1999, pp. 19–23, (Exposé of 1939) in a few classic statements alludes to the interior as domestic space which sustains the 'private individual ... in his illusions' (see also convolutes H and I, pp. 203–227). Benjamin's observations in this regard have been extremely influential. They underpin for instance, a number of the essays in Christopher Reed (ed.), *Not at home*, 1996. Within the Benjamin literature there is also a formidable critical discourse. For an illuminating recent account see Tom Gunning, 'The exterior as *Interieur*, Benjamin's optical detective', in Kevin McLaughlin and Philip Rosen (eds), 'Benjamin now: Critical encounters with *The arcades project*' in *Boundary 2*, Duke University Press, vol. 30, no. 1, Spring 2003, pp. 105–129.

11 *The Saturday Review*, vol. 91, 20 April 1901, p. 498. MacColl was of the view that the trend was initiated by Sargent's *Venetian interior*.

12 Works like Philip Wilson Steer's *Mrs Cyprian Williams* 1891 (Tate, London) and Henry Tonks' *The hat shop* 1892 (Birmingham Art Gallery), for instance, indicate the early interest in interior subjects among New English painters.

13 Michelle Perrot, 'At home', in Michelle Perrot (ed.), *A history of private life, vol. IV: From the fires of revolution to the Great War*, The Belknap Press of Harvard University Press, 1990, p. 343. See also Walter Benjamin, *The arcades project*, 1999.

14 For reference to *The mirror*, see Bruce Arnold, *Orpen: Mirror to an age*, London: Jonathan Cape, 1981, pp. 78–80. For a consideration of Orpen's paintings of costers in the context of works by Rothenstein and William Nicholson, see Ysanne Holt, 'London types', *The London Journal*, vol. 25, no. 1, 2000, pp. 34–51.

15 The first substantial production of Ibsen's *A doll's house* (1879) in England was staged at the Novelty Theatre, London on 7 June 1889, by William Archer, although Rothenstein appears not to have seen it. He records that he first heard about Ibsen from Charles Conder, whom he met in Paris in the autumn of 1890 (see William Rothenstein, *Men and memories*, 1931, vol. 1, p. 56). The play was extensively discussed in George Bernard Shaw's *The quintessence of Ibsenism*, (1891, 2nd ed., 1913) pp. 187–205. For further reference, see James McFarlane (ed.), *Henrik Ibsen*, Harmondsworth: Penguin Books/Critical Anthologies, 1970, pp. 128–9. The setting appears to have been derived from the inn at Vattetot. Orpen would, therefore, have had the opportunity to see this picture emerge. At the same time both he and Rutherston painted bedroom scenes in the inn.

16 The foreground figure, that of Alice Knewstub, is one of many variations on Whistler's, *Arrangement in grey and black: Portrait of the artist's mother* 1871 (Musée d'Orsay, Paris, see fig. 1, p. 12), while the figure in the background taking a book from the shelves is derived from Puvis' *Le Ballon* 1870 and *Le Pigeon* 1871 (Musée d'Orsay, Paris).

17 Orpen had recently engaged Whistler directly in his portraits of Augustus John and Herbert Everett. *The mirror* 1900 (Tate, London/fig. 84), presents a female figure in surroundings which are not unproblematic — her dress-style and confrontational stance for instance, suggesting a coster. One critic for instance, commenting upon the 'lowly' dress of the girl, stated that the picture was 'almost worthy to be classed with the worthiest of the old Dutch masters, whose imperishable gift for this type of subject is their strongest claim on posterity's admiration', see F.J.M., 'The New English Art Club', *The Speaker*, 24 November 1900, p. 201. In the patient attention to surface, Terborch and Metsu were seen as the primary sources, see P.G. Konody and Sidney Dark, *Sir William Orpen, artist and man*, London: Seeley Service, 1932, p. 141.

18 Orpen added a portion of canvas to the left side of the picture in order to establish the setting with greater confidence. More elaborate than *The Browning readers*, the picture nevertheless borrows significant aspects of its mise en scène, with the chimney breast and alcove to the left and strong light entering the room from the right.

19 For further reference see Christie's, *The Irish Sale*, 22 May 1998, lot 21 (entry by the Orpen Research Project (ORP), I am grateful to my colleague Christopher Pearson of the ORP for his collaboration on Orpen's work). The incident, taken from William Makepeace Thackeray's *The Newcomes*, depicts the moment when we learn that Mr Binnie, a friend of Clive Newcome, had fallen from a horse and 'wrenched' his ankle on the pavement. Newcome dispatched his friend, Arthur Pendennis, possibly the man on the right, to visit him and report back. This figure may, however, have been intended as 'a French consulting doctor', which William Crampton Gore reported as Orpen's own identification of this figure (quoted by Arnold, *Orpen: Mirror to an age*, 1981, p. 92). Gore himself played the attending English doctor, Pendennis or the French doctor, the caretaker, Mr Hayard and Binnie was played by a fellow Slade student named Carr. Pendennis found Binnie being tended by his sister and her daughter, either of which is being played by Emily Scobel.

20 Orpen was living in 21 Fitzroy Street, in close proximity to the house in Fitzroy Square reputed to be that in which Thackeray set his novel, *The Newcomes*. In the 1890s, Thackeray's reputation was rising. It profited from the romanticisation of art student life in Paris, which found its principal expression in the publication of George du Maurier's *Trilby* (1894). Indeed the re-issue of Thackeray's *Paris sketchbook* (1840) as a pocket edition in 1885 (George Routledge and Sons), may be said to have paved the way for du Maurier in portraying an Englishman's view of the *vie de bôhème*. Not long after *A mere fracture* was exhibited, Lewis Melville's 'Thackeray's London', *The English Illustrated Magazine*, 1901–2, pp. 329–41, was published.

21 *An interior* was shown at the Fine Art Society, 'Spring Exhibition,' 1988, (no. 27). A related variant, *At the window,* (Manchester City Art Gallery) dates from the same period.

22 Rothenstein's conscious contrivance, his spatial theatre, sensitises the viewer to both time and scale. In this instance, we may infer that the space has been traversed and the instrument has been played.

23 Victorian illustrated fiction, of the sort commended by Henry Tonks, frequently portrayed such scenes and these were given visual form in work of Frederick Walker, William Small and Charles Green. Although frequently mistitled *A window in a London street* (see Arnold, *Orpen: Mirror to an age,* 1981, p. 100), this picture was actually exhibited as *A window in London Street,* at the New English Art Club in 1901 (w). As Chris Pearson has shown (private correspondence with the author), the present Maple Street, which intersects with Fitzroy Street, was, before 1916, known as London Street. The assumption has also been that the figure is looking down into the street, when it seems more likely that the view from the window shows the backs, rather than the fronts, of neighbouring houses. Since the whole area has been redeveloped and few of the original houses remain, it is no longer possible to be certain on any of these points.

24 For further reference see Alan and Mary Hobart (introd.), *An Ireland …imagined,* London: Pyms Gallery, 1993, (entry by Kenneth McConkey) pp. 44–7. *The refugees* was the title of a popular novel by Conan Doyle, published in 1893.

25 Hubert Wellington, 'The Slade School summer compositions since 1893' in John Fothergill (ed.), *The Slade MDCCCXCIII – MDCCCCVII,* London: Slade School, 1907, p. 26. Rutherston's *The confessions of Claude* 1901 (University College London, Fig. 88), was a first prize-winning summer composition. The title refers to Zola, one of whose principal characters was the failed artist, Claude Lantier. However the reference is vague, according to Wellington, who wrote, 'there is evidently some "story" influencing the action of the figures … but it served only as a motive to the painter, and is not explicit in the picture' (p. 26).

26 C.L.H. (Lewis Hind), 'New men and old manners', *The Academy,* 12 April 1902, pp. 391–2, recognised that the club had been a launch-pad for new talent, 'of those who were exhibitioners in the last decade in the last century, some are now in Burlington House, some have been "taken up" by dealers, some have tired, some have grown sad and civil in teaching, and a few have remained loyal to the club'.

27 *The Athenaeum,* no. 3843, 20 April 1901, p. 505.

28 While this was true up until 1905, in the second half of the decade 'impressionist' interiors recaptured attention. This was the case with Steer and Russell. Steer's *The music room* (Tate, London) shown in 1906, for instance, was greeted with enthusiasm by critics in *The Speaker* (23 June 1906, p. 270) and *The Studio,* (vol. 38, 1906, p. 225), while George Moore (*The Saturday Review,* 23 June 1906, p. 785), declared Steer's objective to be no more than to produce 'a decorative scheme'.

29 Alan Powers, 'William Rothenstein and the RCA', in *Apollo,* vol. 144, November 1996, pp. 21–4. Although Powers deals with Rothenstein's educational stance in the inter-war period, he stresses Rothenstein's lifelong belief in the interdependence of the fine and applied arts.

30 F.J.M., 'The New English Art Club', *The Speaker,* (vol. VI, new series), 12 April 1902, p. 106.

31 In Orpen and Nicholson's cases, these objects are extracted from the setting for special study in still-life paintings.

32 D.S.M., 'Picture exhibitions of the month', *Saturday Review,* 7 December 1901, p. 711. MacColl declares, 'Now in the absence of documents the Berenson of the future, however acute, would probably hit on the facts that there were actually two ladies, two lamps, two houses and so forth. He would almost necessarily go off on the false scent of supposing that the same lady had been painted with variations in form owing to personal tricks of vision in the artist. But a critic as acute as Mr Berenson would notice a difference in the manner of drawing and putting on paint in these two pictures, might connect the Orpen on the strength of this with other Orpens passing under other names (say Mr Legros for Verrochio, Mr Conder for Filippino) and thus finally surmise a "Friend of Billy" who, when he painted the "London Window", was attracted in his imitative days into the picture of another man.'

33 Similar galleons of course appear in the contemporary livery company murals of Frank Brangwyn and in the work of Academy painters such as Frederick Gribble and Charles M. Padday. Ship models appear in works by Rothenstein, Nicholson and George Belcher around this time. Chris Pearson points out that Herbert Everett, traveller and marine painter, in whose sitting room *A mere fracture* is set, is likely to have been the owner of the model.

34 Thus, in Rutherston's dependence upon Zola and Orpen's upon Thackeray, the consolidation of identity through possessions, à la Benjamin, is displaced.

35 F.M.J., 'The New English Art Club', *The Speaker,* vol. VI, (new series), 12 April 1902, p. 106.

36 F.M.J., 'The New English Art Club', *The Speaker,* vol. VI, (new series), 12 April 1902, p. 106.

37 Thus, for instance, a year later, C.L.H., in 'New Englishmen and Italy', *The Academy and Literature,* 11 April 1903, pp. 371–2, declared, 'The most devoted friend of the New English Art Club could hardly describe the present exhibition as new. The note is still, as it has been for the past two or three years, a room, beautifully painted, displaying the figure of a woman who seldom seems quite congruous of her surroundings. She is reclining on a couch, arranging prints or china, sewing or reading, or — singing while her husbands plays. Three years ago this return to early Victorian domesticity was a trifle novel: this year is a trifle stale. … Many of the subjects are as anecdotic as the typical Royal Academy pictures that the New English Art Club was founded to exorcise … The New English Art Club has become eclectic. The influence of certain personalities is obvious, and those who are not influenced by others pant up-hill trying to regain the heights they themselves once reached; but it is the same hill, not another.'

38 Admiration for the sobriety of Fantin-Latour's work was also apparent at this time. Commenting upon McEvoy's exhibition at the Carfax Gallery in 1907, *The Saturday Review* (8 June 1907, p. 714) declared that 'He may be destined some day to fill a place in our art something akin to that of Fantin in French art.'

39 Christian Brinton, *The Ambrose McEvoy exhibition,* New York City: Duveen Brothers, 1920, n.p.

40 T. Martin Wood, 'The pictures of Ambrose McEvoy', *The Studio,* vol. 42, 1908, p. 98.

41 John House, '*Curiosité',* in Richard Hobbs (ed.), *Impressions of French modernity,* Manchester: Manchester University Press, 1998, pp. 34–57.

42 For a discussion of changes in reading habits throughout the 19th century, see Alain Corbin, 'The secret of the individual', in Michelle Perrot (ed.), *A history of private life,* 1990, pp. 534–47.

43 The extensive contemporary writing about the act of reading includes popular texts by Oliver Wendell Holmes, Sir Walter Raleigh and Hilaire Belloc. Proust's translation of Ruskin's *Sesame and lilies* was accompanied by a preface 'On reading', in which he considered that the imaginative reader was as much an artist as the writer — a theme taken up by Virginia Woolf in 'How should one read a book?' in *The second common reader,* 1932 (Pelican Books ed., 1944, pp. 196–206). Finally, and of particular note in this context, Holbrook Jackson, cultural historian of the 1890s, produced several works on the subject of reading and popular literacy. These include *The anatomy of bibliomania* (1934) and *Maxims of books and reading* (1930). His *The reading of books* (1946), summarises the debates about the act of reading in its opening chapter, 'The reader as artist'.

44 Similar points might be made about works by Gwen John. It has been suggested that the model for *The convalescent* could conceivably have been Gwen John, but there is no documentary evidence for this.

45 T. Martin Wood, 1908, pp. 98–101. The reference to Thackeray is revelatory in this context, given Orpen's earlier work. Being essentially of the Regency and early Victorian period, he was seen as a writer who came from a period of innocence, uncontaminated by Morris and Arts and Crafts.

46 For Connard's interiors see Marion Hepworth Dixon, 'The paintings of Philip Connard', *The Studio,* vol. LVII, 1913, pp. 269–80; For Young Hunter see Kenneth McConkey, *Edwardian Pre-Raphaelites: The art of John and Mary Young*

Hunter, London: Pyms Gallery, 2000; for Taylor see Herbert Furst, *Leonard Campbell Taylor R.A, his place in art,* Leigh on sea: F. Lewis, 1945. The drama *Quality Street* was a romantic farce written by J.M. Barrie in 1901 (and which later gave its name to the *Quality Street* chocolate brand and inspired its packaging).

47 For Adam see Patrick J. Ford (introd.), *Interior paintings by Patrick William Adam RSA,* Glasgow: Maclehose, Jackson and Co., 1920; for Lavery see Kenneth McConkey, *Sir John Lavery,* Edinburgh: Canongate, 1993, pp. 169–92.

48 Laurence Binyon, 'Three exhibitions', *The Saturday Review,* 6 June 1908, p. 720, quoted in Ysanne Holt, *British artists and the modernist landscape,* Aldershot: Ashgate, 2003, p. 49.

49 Gilman and his young family were living with his parents at this time. For further reference see Andrew Causey, *Harold Gilman, 1876–1919,* London: Arts Council of Great Britain, 1981.

50 Mary Chamot, Dennis Farr and Martin Butlin, *Tate Gallery: The modern British paintings, drawings and sculpture, vol. 1, A–L,* London: Oldbourne Press, 1964, p. 237, quoting correspondence from Hubert Wellington on a work entitled *Edwardian interior.*

51 See Wendy Baron and Richard Shone (eds), *Sickert Paintings,* Royal Academy, 1992, catalogue entry no. 67, p. 204.

52 Osbert Sitwell (ed.), *A free house!, or, the artist as craftsman: being the writings of Walter Richard Sickert,* London: Macmillan, 1947, p. 208 (extracted from *The Art News,* 12 May 1910).

53 Osbert Sitwell (ed.), *A free house!,* 1947, p. 92 (extracted from *The New Age,* 29 July 1910).

54 Laurence Binyon, 'Three exhibitions', *The Saturday Review,* 6 June 1908, p. 720.

55 T.M.W., 'The New English Art Club's summer exhibition', *The Studio,* vol. 47, 1909, p. 178.

56 Simmons' *The cosy corner* and Shepherd's *The Bach player,* both unlocated, were 156 and 69 respectively in the NEAC Spring exhibition in 1909.

57 'Democratic' interiors such as Forbes' Chantrey purchase, *The health of the bride,* (Tate, London) and *By order of the court,* intended for public, municipal spaces, were crowded with ordinary 'types', as various as those found in one of William Powell Frith's panoramas. They aimed to engage the 'citizen' spectator visiting the gallery with his family on a wet Sunday afternoon.

58 This fundamental shift in sensibility has been addressed in my chapter, 'The end of Naturalism' in Kenneth McConkey, *Memory and desire: Painting in Britain and Ireland at the turn of the twentieth century,* Aldershot: Ashgate, 2002, pp. 131–56.

59 Thus, for instance, by 1909 Spencer Gore began to observe that his, Henry Lamb's, Robert Bevan's, Harold Gilman's and Lucien Pissarro's paintings at the New English exhibitions were being rejected or 'gently pushed' into inner rooms.

60 Stabb's *The crumpled dress* 1908 (National Museums on Merseyside), shown in the NEAC, repeats the mise en scène of Rutherston's *The confessions of Claude.*

61 Orpen's *Night,* (private collection) later known as *Solitude,* was exhibited at the Goupil Gallery Salon in the winter of 1907 (no. 91); Clausen's *Twilight: Interior* was shown at the Royal Academy in 1909 (no. 491).

62 We may assume that *Night no. 2* was painted around the same time, or immediately after *Night.* A more complex work, it shows a male figure, thought to be Orpen himself, embracing his wife, Grace, in one of the rooms of 13 Royal Hospital Road, Chelsea. See Arnold, *Orpen: Mirror to an age,* 1981, pp. 214–5. The picture plays an interesting variation on Sickert's Camden Town murder series of 1908–9.

63 T. Martin Wood, 'The problem of modern interior painting', *The Studio,* vol. 47, 1909, p. 251.

64 C. Lewis Hind, *The consolations of a critic,* London: Adam and Charles Black, 1911, p. 81.

65 Walter Sickert, writing in 1910, contrasted Blanche's interiors with those of Vuillard (Osbert Sitwell (ed.), *A free house!,* 1947, pp. 269–70), recognising different qualities and favouring the latter. With Blanche 'every touch bespeaks them painted for the owners of the rooms'.

66 I am of course well aware of Benjamin's political colouring. Benjamin enthusiasts, of which I am one, have often commented upon the central contradiction implied in his dalliance with the 'individual' and 'private' at a time when more orthodox Marxist critics were attempting to assure their readers that the private life was dead.

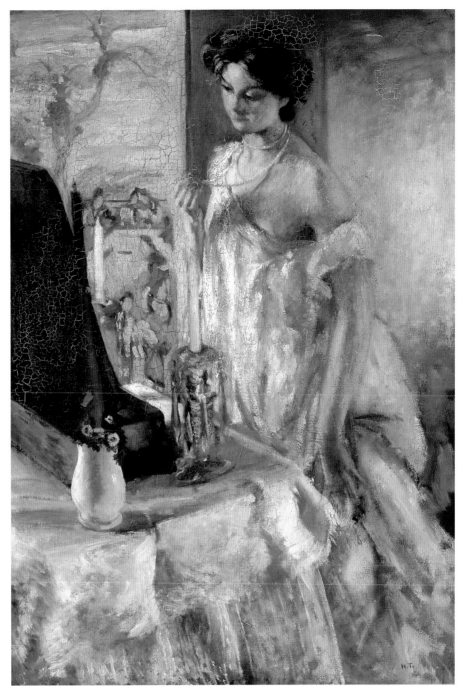

Fig. 100: Henry Tonks *The pearl necklace* c.1905 [cat. 135]

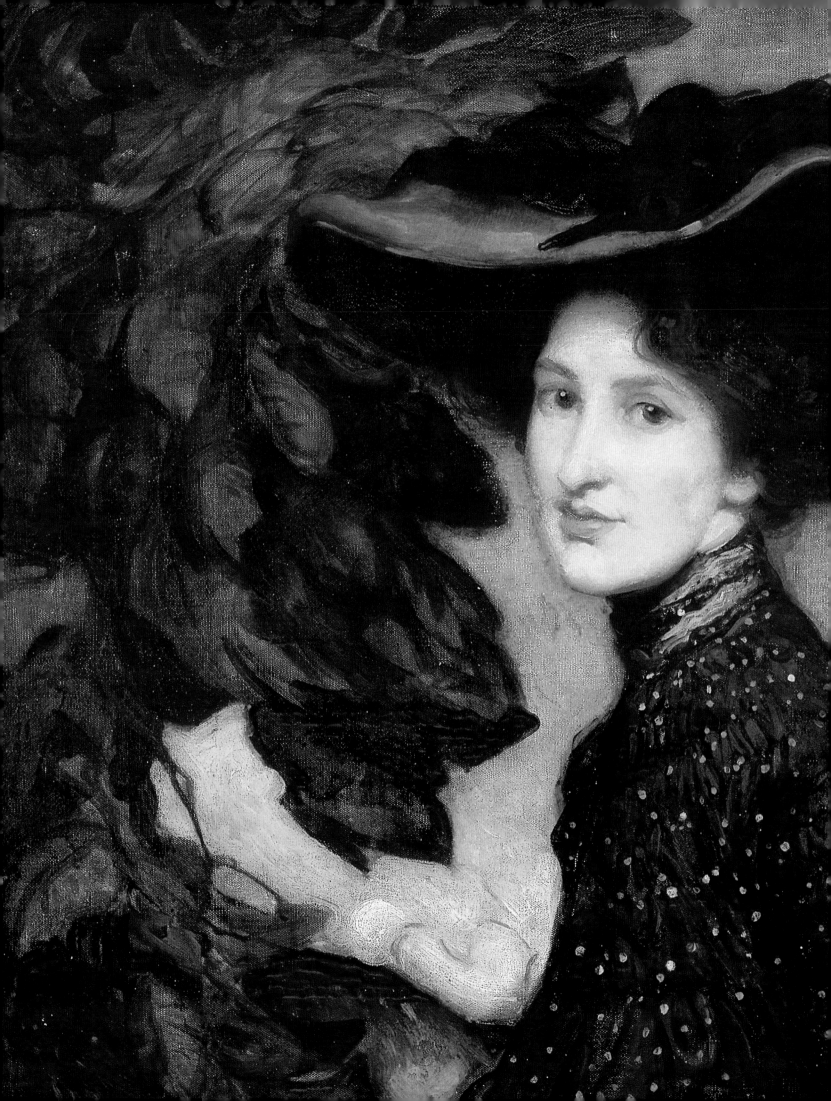

Reflected Selves
Australian expatriate artists in an Edwardian world

Caelum non animum mutant qui trans
mare current
<div align="right">Horace, Epistles, 1:xi, 27</div>

*'They change their skies but not their souls
who run across the sea.'*

Australian artists working in France and England during the Edwardian period have attracted what can only be described as bipolar critical attention. They are either acclaimed for whatever Salon or Royal Academy successes they had, or else dismissed as merging too closely with the artistic *mores* of their adopted countries, thereby losing sight of what it was to be an Australian artist.

Most chroniclers of Australian art have seen the period between 1900 and 1914 as one to be hurried through. Little, they felt, was happening on the home front and those who carried the flag overseas had lost direction and become unsatisfactory cultural hybrids. Indeed, the variety of art produced during this period by Australian artists, either at home or abroad, makes it difficult to see any specific direction being taken. Critics lamented that the nationalist expectations that arose in the 1890s, culminating in Federation, were not fulfilled artistically. The period can be characterised as a lull in these terms, an absence or calm before a new outpouring of Australian imagery generated by the First World War.

Looking back a century later, and to Europe rather than Australia, the Edwardian period appears strangely isolated culturally, sandwiched between Victorian certainties and modernist disruption. It was a time when the historical narratives that so dominated the Victorian imaginative world were stilled: the great classic myths painted by the leading Royal Academicians Lord Leighton and Sir Edward Poynter had collapsed under their own weight, and the art of sentiment of Sir John Everett Millais and his imitators finally congealed in the public taste.

George Lambert *Miss Thea Proctor* 1903 (detail) [cat. 66]

What was left? What should artists paint? In the early years of the new century, the new belief systems of mystical abstraction and geometric construction had not yet been born. Continental Europe offered exciting new stylistic innovations but the English-speaking artistic world was, as yet, only responding on the fringes.

For Australian artists seeking a career in this curiously stilled context, certainty seemed to lie in received truths, passed on to them by their colonial teachers — most of whom represented an academy in the European Old World — and in the established institutions of that world, the Royal Academy and the Salon. One of the prime reasons why artists had left Australia in the 19th century was to study their calling at its heart: in the great artistic centres of Rome and Paris and, in the second half of the century, in London.

For anyone who had trained in any of the art schools in the Australian colonies, it was really only a question of how and when they should leave to take their chance on the big stage. The National Gallery School, Melbourne, institutionalised the practice with their Travelling Scholarship established in 1887 and the Art Society of New South Wales followed suit a decade later. Paris was the preferred centre to study in the period before the First World War, with London the next step for patronage and sales. John Longstaff's career pattern can stand as an example. Awarded the first Travelling Scholarship at the National Gallery School, Melbourne, in 1887, he left for Paris where, after a few years spent in the ateliers and copying at the Louvre, he won critical acclaim at the Old Salon. In the mid-1890s, he came back to Melbourne, only to leave again in 1900, this time for London where he enjoyed success as a portraitist, with the patronage of Nellie Melba. After the First World War, he again returned to Australia for the latter part of a highly successful career.

Certainty of belief underlay this career structure. It was a well-tried path with well-recognised stages of progression. By 1900, however, this certainty of belief and its associated standards were no longer what they had been. When idealistic Arthur Streeton finally arrived in London in 1898 at the age of 31, he was not the only one to be disillusioned by what he found:

> Somehow the academy has an inartistic atmosphere — just like all the other shops in London with their imposing fronts etc — [1]

For the young colonials, distance had lent enchantment to these almost mythical institutions. They were not prepared for the changes that had resulted from a process which had been in train for almost a half a century: that of the popularisation and an accompanying commercialisation of art, particularly that seen at the annual exhibitions. Streeton and his contemporaries, steeped in the theories of aestheticism and the writings of James McNeill Whistler — who proclaimed the artist and his creations as superior to the rest of society — would find it difficult to see their art in the pragmatic terms outlined by *Fraser's Magazine* many years earlier:

> an exhibition of pictures is a kind of Art Exchange where the painter lays out his imagination, his invention, his ideas of beauty and his technical skill, and awaits the effect of his wares on the passer-bye, which … will depend upon the amount of merit in his merchandise. [2]

Disturbing questions arose for those newly arrived from Australia. If the Royal Academy could be likened to a shopfront, a commercial market, then what did it say of the standards of the art admitted to its walls? What were the criteria? And where were they to be found? Streeton's experience of disillusionment with the public presentation of art was mirrored by the younger Australian artists' experience of the Paris ateliers in the early years of the 20th century. And it was not simply a problem of colonial time-lapse, or of being out of touch.

The late 1890s and the first decade of the 20th century saw an internal collapse of the old 19th-century certainties in art. They fell to the battering ram of the new individualism in art, which in France meant a complete break with the centuries-old traditions of the Academy. These traditions included strict principles regarding the priority of serious and elevating subject matter (history painting); the necessity of mastering the human figure as the vehicle through which the subject is revealed; and the lesser importance given to rendering the fleeting appearance of the everyday world (landscape painting). In England, much the same weakening of authority had occurred, although in a different form, with the lessening of aristocratic patronage and the rise of the new industrial collector with a preference for landscapes and subjects from modern life.

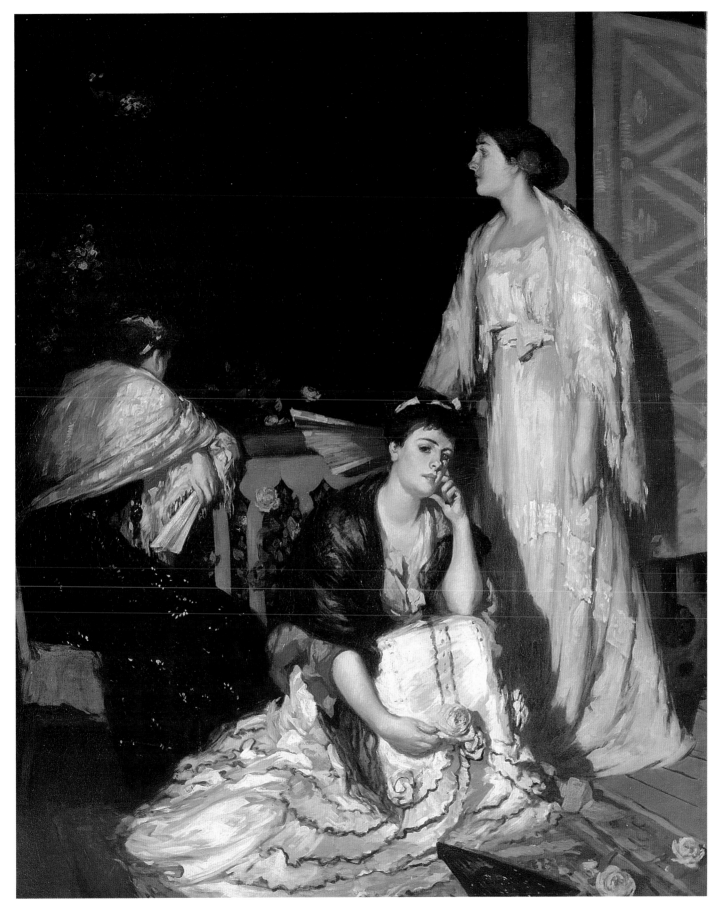

Fig. 101: Rupert Bunny *Nocturne* c.1908 [cat. 13]

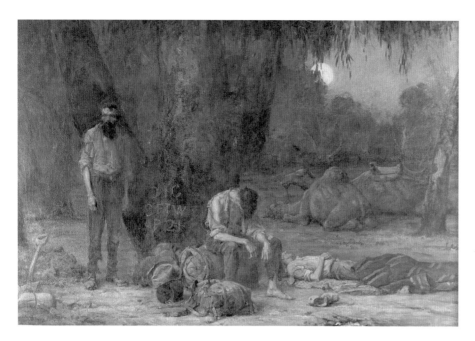

Fig. 102: John Longstaff *Arrival of Burke, Wills and King at the deserted camp at Cooper's Creek, Sunday evening, 21ˢᵗ April 1861* 1902-1907 oil on canvas 285.7 x 433.0 cm National Gallery of Victoria, Melbourne, Gilbee Bequest in 1907

The Gilbee Bequest, awarded by the National Gallery of Victoria in 1900, highlighted this problem for two Australians in particular, John Longstaff and E. Phillips Fox. They had jointly won the commission, established by the 1886 will of a Melbourne surgeon, to paint a history painting of an Australian subject. But in the 14 years that elapsed between the offering of the bequest and its awarding, 'history painting' had lost credibility. John Longstaff and Fox who, under the terms of the will had to paint their commissions in London, both chose seemingly appropriate subjects. But the results of their efforts — Longstaff's *Arrival of Burke, Wills and King at the deserted camp at Cooper's Creek, Sunday evening, 21ˢᵗ April 1861 1902*–1907 (fig. 102) and Fox's *The landing of Captain Cook at Botany Bay, 1770* 1902 — were not well received at the time and both retain an awkward self-consciousness. Longstaff painted what has to be the gloomiest melodrama in Australian art history and Fox's history painting comes embarrassingly close to pictorial illustration. It would seem that neither artist could convince himself of the significance of his task or subject matter in the way William Strutt could half a century earlier with *Black Thursday* 1862–4 (State Library of Victoria, Melbourne). The moment had gone.

However, if, as Australians found on transporting themselves abroad, there was no clear direction as to style and subject matter and no subject matter worth aspiring to — what remained?

What seemed to be left to those who had been trained to master the figure and figure compositions was just that: the human form, subjectless. Here, mastery of draughtsmanship and technique could be admired for its own sake. And so paintings became valued for their surface attributes, such as pose, dress, colour and paint application — exemplified in John Singer Sargent's 1904 tour de force portrait of *Sir Frank Swettenham* (fig. 103, cat. 119). In the Edwardian Salons these qualities were valued for their own sake, almost as abstract elements, a heightened form of the aestheticism of the eighties perhaps, but now displayed in portraits and sumptuous but meaningless figure compositions such as in the work of Australian expatriate, Rupert Bunny. It would seem that, bereft of the grand historical subject or the heart-rending social realist moment, figure painters suddenly decided to avoid a subject altogether. The face or figure on its own became the subject.

Alongside this developed a new cultivation of the artistic self. Young English ex-graduates of the Slade School, William Orpen and Augustus John, set the pace here, but it was a trend George Lambert quickly picked up on and made his own. Sometimes a kind of double take was put into play to tease and taunt the viewer. In Orpen's *Self-portrait with glasses* (fig. 104, cat. 95), for instance, the artist portrays himself in the guise of another, admired figure, the 18th-century French master, Jean-Baptiste Simeon Chardin. Orpen paints himself in the costume of Chardin's *Self-portrait* in the Louvre, turning from his palette and accosting the viewer with a challenging stare. In the early years of the 20th century, Orpen became a great friend of Charles Conder and they both enjoyed dressing up and disguising themselves as someone from an earlier artistic era. In 1905, Conder drew himself in 1830s costume as Eugène de Rastignac (National Portrait Gallery, London), the character created by Balzac in *La Comédie humaine*. However not all such self-portraits were exercises in romanticising artistic identity. They could also imply real aesthetic or intellectual allegiances, as in the National Gallery School's Travelling Scholarship winner Max Meldrum's *Souvenir of van Dyck (Self-portrait)* c.1904 (private collection); or English artist James Pryde's study of himself as Scarron, the 17th-century French poet and writer of burlesque (*Self-portrait as Scarron* c.1903, Nottingham City Museum).[3]

Complex self-portraits and portraits of close colleagues, associates and family members — not just single studies but repeated variants of the same person and self — were a remarkable feature of Edwardian art and one in which a number of young Australian figurative painters became involved. Lambert painted his first *Self-portrait* in 1900 (National Portrait Gallery, London), not long after arriving in London on the Art Society of New South Wales' Travelling Scholarship. He made a black ink and wash portrait of a self-consciously *louche* Hugh Ramsay when the latter visited him later that year (*Hugh Ramsay in London*, National Gallery of Australia, Canberra) and painted him again when they were both students in Paris the following year (*Hugh Ramsay*, Art Gallery of New South Wales, Sydney). Lambert painted fellow artist *Miss Thea Proctor* (fig. 105, cat. 66) in 1903 and showed it at the Royal Academy in 1904; he also placed her in a number of paintings he made of his wife and young sons over these years.

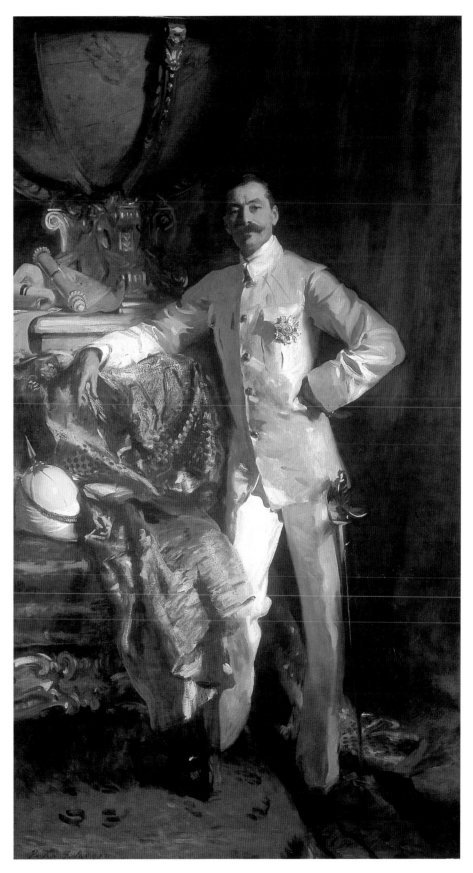

Fig. 103: John Singer Sargent *Sir Frank Swettenham* 1904 [cat. 119]

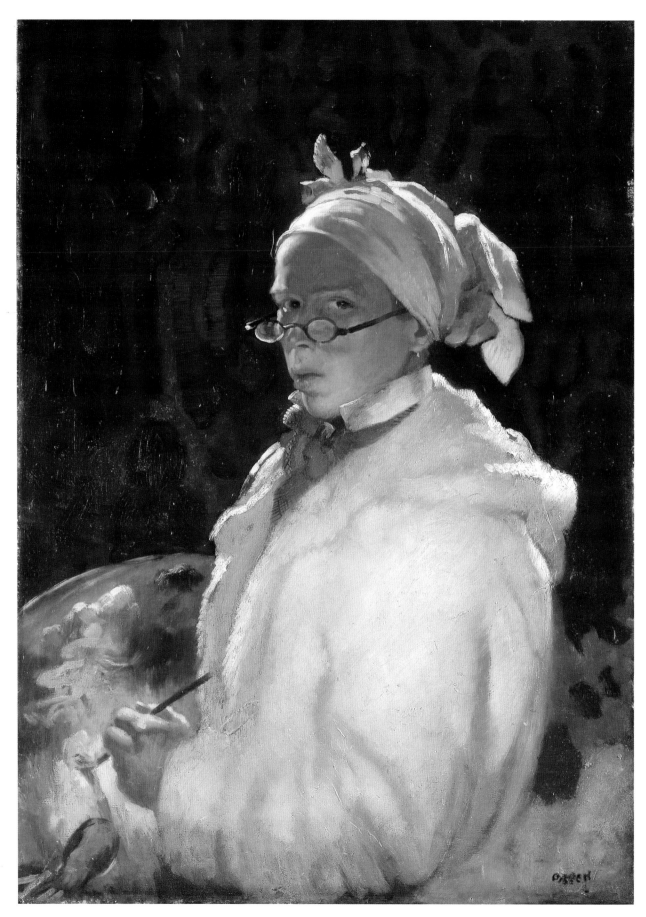

Fig. 104: **William Orpen** *Self-portrait with glasses* 1907 [cat. 95]

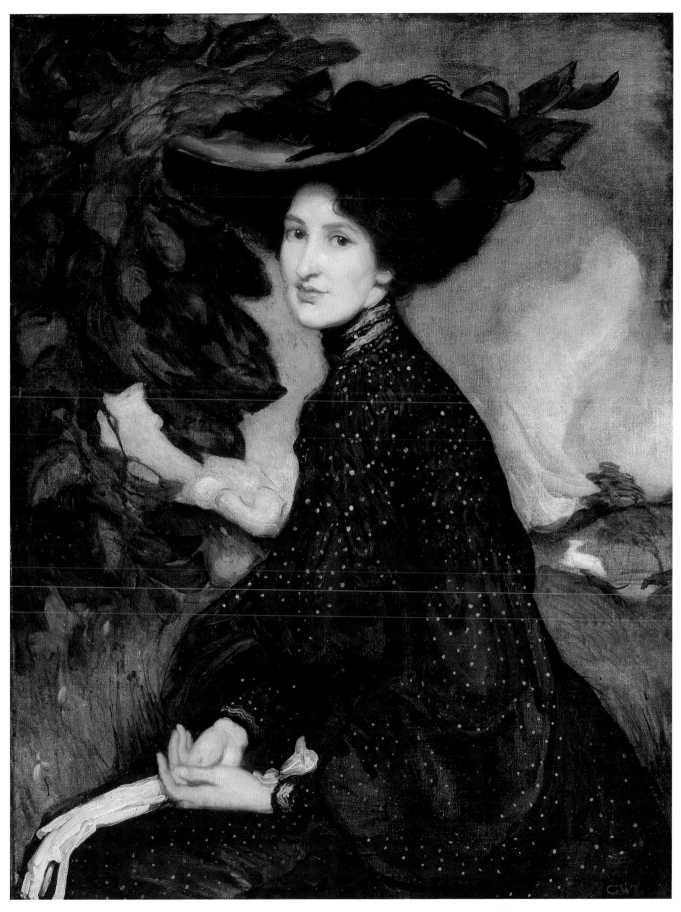

Fig. 105: George Lambert *Miss Thea Proctor* 1903 [cat. 66]

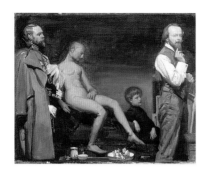

Fig. 106: George Lambert *The shop* 1909 oil on canvas 71.0 x 91.5 cm Art Gallery of New South Wales, Sydney (photograph: Ray Woodbury)

In 1906, Lambert painted himself provocatively smoking a cigarette in another *Self-portrait* (private collection), exhibiting it at the Modern Society of Portrait Painters the following year, and then painted two further self-portraits in 1909. In one, *A pageant portrait sketch* (fig. 107), he wears Elizabethan dress, and in the other, *Self-portrait* (Queensland Art Gallery, Brisbane), a half-length study, he defines himself by wearing an artist's coat over his suit. The following year, he produced the most extraordinary of them all, *Chesham Street* (fig. 108, cat. 72), portraying himself being examined in a doctor's consulting room.

This concentration on the self and an immediate social circle has been thoughtfully interpreted as reflecting Freudian discourse and Einstein relativity.[4] Yet there is something about the persistent blandness of these images that defeats attempts to see them as in any way analytical.

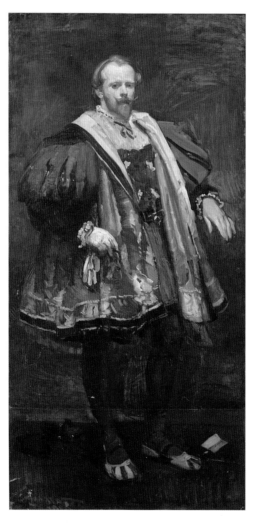

Fig. 107: George Lambert *A pageant portrait sketch (self-portrait)* 1909 oil on canvas 213.5 x 106.6 cm National Trust of Australia (NSW), S.H. Ervin Gallery, Sydney (photograph: Michael Brouet)

They seem to be more about surfaces and forms relating to abstract or formal notions of art than they do to problems of psychological analysis. Lambert's constant re-presentation of his artistic self, as in the strangely repetitive frieze-like composition of *The shop* 1909 (fig. 106) — a repetition without any real exploration of a persona — strengthens this reading.

Victorian artist Ambrose Patterson studied at the National Gallery of Victoria before leaving Melbourne for Paris in 1898. There he worked at the Académie Julian before moving on to Colarossi's and Delécluze's academies, where J.S. MacDonald and then Hugh Ramsay — both also trained at the National Gallery School, Melbourne — joined him. In 1902, these three resided in the same building in Paris, near Lambert, and to all accounts lived as typical expatriates; it seemed they kept close company. More than this, their work of this period reveals a shared aesthetic. Portraits and self-portraits dominate, and for reasons beyond the obvious factors of poverty and camaraderie.

The group was involved in the aesthetics of two contemporary critics, R.A.M. Stevenson and D.S. MacColl, who dominated the English-speaking art world at the turn of the century. Both writers argued for the primacy of technique over subject matter. MacColl wrote for the *Spectator* magazine. Stevenson's book, *Velasquez*, published in 1896, analyses the 17th-century Spanish master in just these terms. It would seem that, in their self-portraits, Ramsay and Patterson in particular attempted to put Stevenson's ideas into practice. Stevenson's publication included black-and-white illustrations of Velasquez's works in the Prado and one can see Patterson playing with the complex structure of *Las Meninas* 1656 (Prado, Madrid, see fig. 6, p. 16) in his own *Self-portrait* (*La Fenêtre de l'atelier*) (fig. 109, cat. 99).

Using a rich tonal palette, Patterson has portrayed himself full length in his studio, against an open window, turning to face the viewer. His face is in shadow, and thus unreadable. A small mirror, propped on an easel against the window and facing the viewer, reflects his profile, but turned away. Both the mirrored face and the face in the shadow are inaccessible. It can be argued that this deliberate obscuring of the subject has a formal, rather than psychological, intent.

Fig. 108: George Lambert *Chesham Street* 1910 [cat. 72]

Fig. 109: Ambrose Patterson *Self-portrait (La Fenêtre de l'atelier)* c.1902 [**cat. 99**]

Rather than using the self-portrait to reveal himself, Patterson has instead explored the aesthetics of spatial ambiguities and surprises. The painting is constructed in terms of planes and verticals, with a large square of light intercepted by angled dark squares of the easel and the mirror, the whole dominated by light, reflected light and deep shadows — all the formal elements of *Las Meninas*.

Ramsay's otherwise inexplicably large number of self-portraits in the period 1901–02 (dating from his student years in Paris) can be similarly read, not as a series of studies of the young artist-as-dandy on the brink of a brilliant career, but as formal explorations. His self-portraits are studies in form and technique rather than self-revelations. We never go beyond a repeated formula with Ramsay: most are three-quarter views, usually in his studio where the subject is guarded, sometimes even posed in the act of turning or pivoting as in *Portrait of the artist standing before easel* (fig. 110, cat. 107). Here, the easel itself is angled in the same way as Patterson's and their common source, Velasquez's easel in *Las Meninas*. These studies read as defensive rather than overt and exploratory. Why? Because Ramsay is not interested — and nor are Lambert or Patterson — in character revelation; they are interested in what they can do with paint. As followers of the critic R.A.M. Stevenson, they are committed to the method of painting and not the subject matter.

Agnes Goodsir, Lambert, J.S. MacDonald, Max Meldrum, Patterson and Ramsay were all in Paris in 1900–02, and all responding to the aesthetic notion that painting is about technique and illusion rather than subject. Goodsir completed her first *Self-portrait* in Paris in 1900 (private collection) and another in 1912 (fig. 111). Her *La Femme de ménage* (cat. 52) painted in Paris 1905 is a further response to the loss of the subject. It should not be interpreted as an empathetic rendering of her cleaning woman but rather as a form dynamically constructed in space.

Subject matter that had won critical acclaim and popular support in Australia, such as Lambert's *Across the black soil plains* 1899 (private collection), *A pastoral idyll* 1896 (Art Gallery of New South Wales, Sydney) or *The heart of the bush* 1900 (private collection),[5] was not to be repeated or developed in the new context. Lambert dropped all such imagery

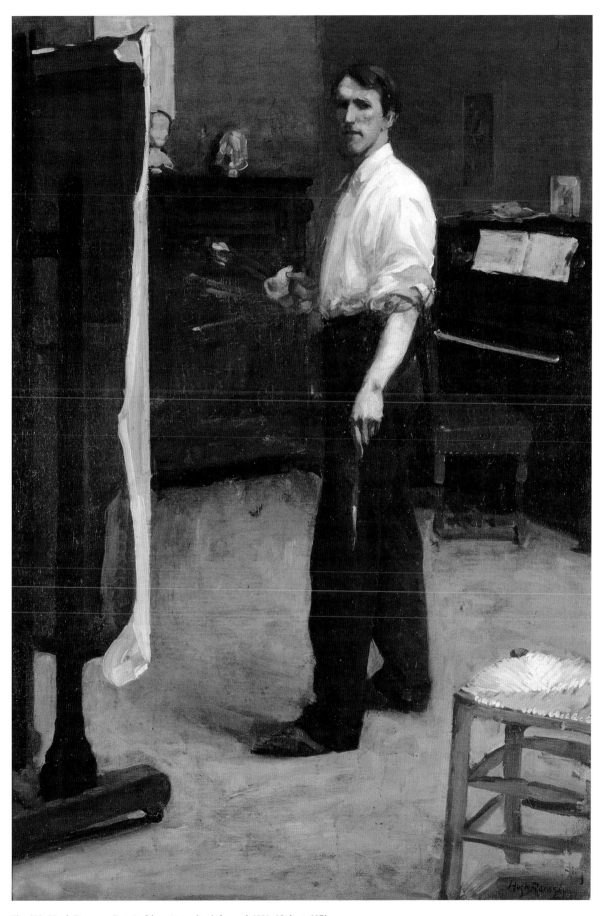

Fig. 110: Hugh Ramsay *Portrait of the artist standing before easel* 1901–02 [cat. 107]

Fig. 111: Agnes Goodsir *Self-portrait* 1912 oil on hardboard 58.2 x 44.0 cm Art Gallery of New South Wales, Sydney, on loan from Norman R. Goodsir (photograph: Jenni Carter)

Fig. 112: Max Meldrum *A peasant of Pacé* c.1908 oil on canvas 131.0 x 97.8 cm National Gallery of Victoria, Melbourne, presented by the artist under the terms of the National Gallery of Victoria Travelling Scholarship in 1912

in his painting (although he continued it in his black-and-white work for the *Bulletin*) responding immediately to a new, highly sophisticated artistic milieu. Other expatriate Australians persisted with a variant of this — the theme of the peasant — right through the Edwardian period, but treated what had been in the mid-19th century originally revolutionary subject matter, in a theatricalised manner, bereft of social meaning.

Ramsay painted *A mountain shepherd* (*An Italian dwarf*) (fig. 113, cat. 106) in his first year as a student in Paris. Here the subject is frontally posed, full-length, clutching his staff, his unique costume carefully observed, but placed against a studio background with no indication of his true context, for all the world as though he were in fancy dress. Meldrum, rejecting Paris and settling in Brittany, depicted a peasant from the local village, but again this figure was not characterised by his context but was theatricalised, seated in a tenebrous indoor setting. *A peasant of Pacé* (fig. 112) was hung at the Old Salon in 1908, the same year Meldrum was elected Associate of the Société National des Beaux-Arts. Such work won approval from Australian critics who approved of the 'honesty' of the subject matter and praised the painting's 'Rembrantesque' (aestheticised) qualities. It was acquired by the National Gallery of Victoria in 1912, under the terms of the Travelling Scholarship. Meldrum returned to Australia the following year and painted a similarly tonal study of his mother, which was snapped up immediately by the Felton Bequest for the National Gallery of Victoria.

Hilda Rix Nicholas took the theatricalisation of the peasant figure to even greater lengths. Like Meldrum she enjoyed working in rural France, at the artists' colony at Etaples. Here she painted a number of studies of elderly peasant women, such as *A mother of France* 1914 (Australian War Memorial, Canberra) and *Grandmère* 1914 (Art Gallery of New South Wales, Sydney), almost as quasi-portraits with a quasi-allegorical significance, as the embodiment of the idea of the peasant. Such works may read today as over-inflated and theatrical, but at the time they were in harmony with contemporary audience expectations. The subjectless subject — a large-scale figure dominating the picture space and embedded in a particular setting — was to become the staple of the subsequent careers of Goodsir, who remained in Europe, and Rix Nicholas, who returned to

Australia. For both the figure becomes a type, depersonalised and representative of a way of life: for Goodsir, the elegant Parisienne, for Rix Nicholas, the wholesome male or female living on the land, exemplified in an Australian portrait of a female veteran, *The Monaro pioneer* c.1922 (Art Gallery of South Australia, Adelaide).

Australian artists studying in Paris in this period followed one another closely. None were admitted to the official Ecole des Beaux-Arts and all moved between the three major ateliers: Julian's, Colarossi's and Delécluze's. All were dissatisfied with the teaching offered and Meldrum especially felt he had learned more from Bernard Hall in Melbourne. Studying at the Louvre was seen by the men as preferable to working in the studios and Meldrum became a serious copyist. Ramsay was accepted by the New Salon in 1901 and 1902, and Goodsir at the Old Salon in 1901 and the New Salon in 1902–04. Meldrum and Goodsir were both in Paris for the 1905 Salon des Indépendents exhibition, which included the famous 'Fauve' room, but their colonial certainties precluded interest in new art.

Meldrum in particular remained independent of other Australians in Paris, and increasingly of any artistic structures, working out his own response to a realist canon seen to begin with Velasquez and culminating with Corot. In 1904, he was accepted at the Old Salon with *La Leçon* (location unknown). Ramsay and Lambert had moved on to London by late 1902, and then Ramsay returned to Melbourne. Meldrum and Goodsir remained in Paris although not in touch with one another. In the summer of 1907, Rix Nicholas also arrived there to study at the Académie Delécluze.

In an attempt to characterise the art produced by expatriate Australian artists in the Edwardian period, one can say that all directed their art — and subject matter — to an educated upper middle class. Unlike a number of their English contemporaries, such as Ambrose McEvoy, William Strang, Walter Sickert, or Albert Rutherston, they did not paint the troubling or the disturbing, but played the game of pleasure in which the Royal Academy Summer exhibitions and the Parisian Salons were deeply enmeshed. Art was for pleasure.

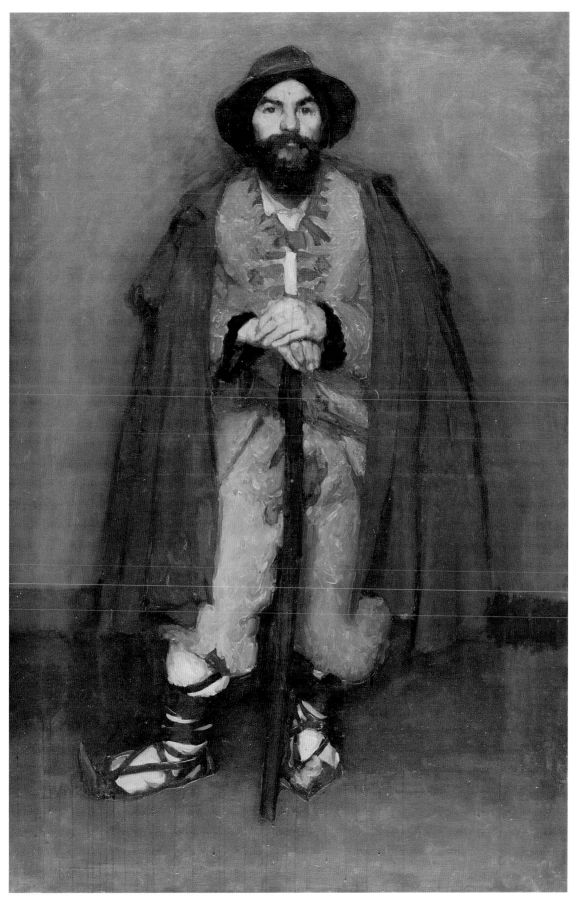

Fig. 113: **Hugh Ramsay** *A mountain shepherd* (*An Italian dwarf*) 1901 [**cat. 106**]

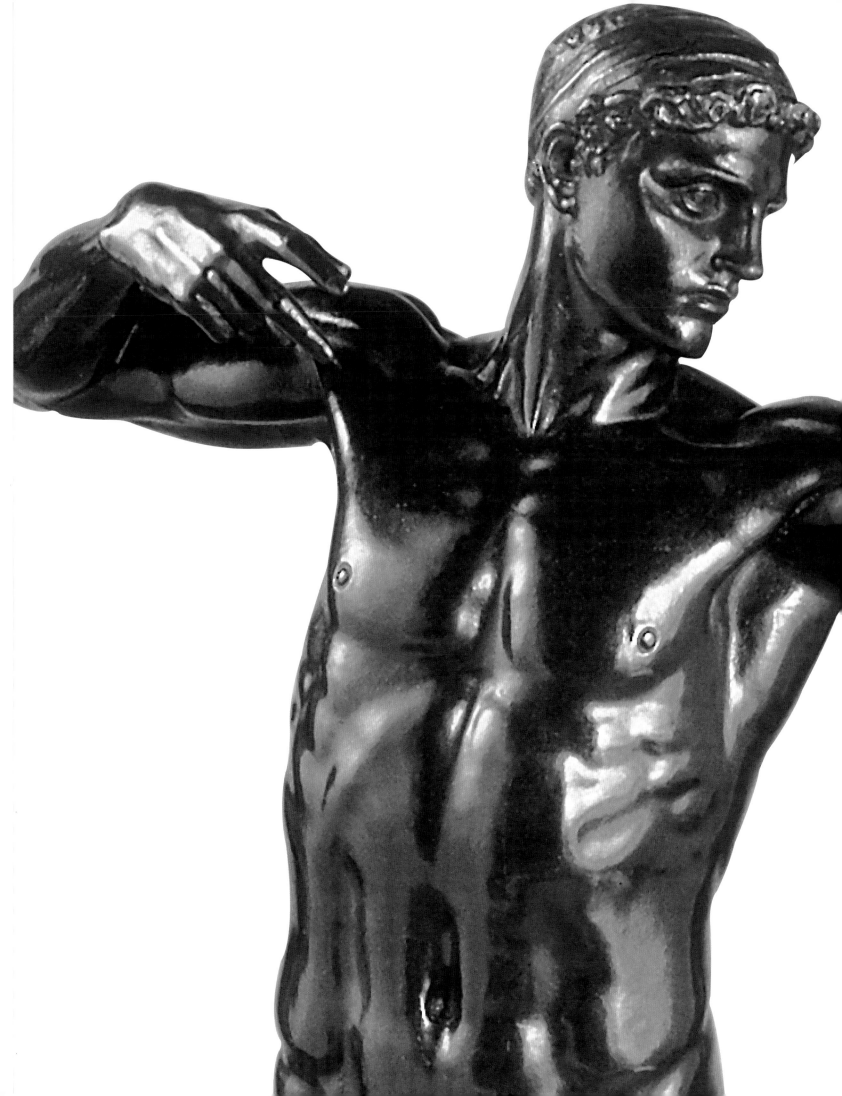

'Edwardian' Sculpture

I n one way, the London *Victoria Memorial* 1901–24 outside Buckingham Palace can be viewed as an apposite symbol of Edwardian sculpture (fig. 115).[1] It was conceived during King Edward VII's reign; the sculpture component, to which the architectural element was always seen as subservient, was the preserve of Thomas Brock, one of the leading sculptors of the age; and the major part of the sculpture was unveiled a year after the king's death.

At the same time, the monument can also be seen to represent a series of temporal and ideological overlaps. In simple chronological terms, the entire monument was not completed until 1924, well into George V's reign, while the overall idea of the monument with its assembly of narratives can be seen as relating back to the London *Albert Memorial* 1861–76. Brock had been involved in the latter stages of the *Albert Memorial* as principal assistant to John Henry Foley, who was responsible for the *Asia* group and the central figure of *Prince Albert*; the latter was far from completion at Foley's death in 1874 and Brock was assigned the task of finishing the plaster model and then casting and installing the completed figure.

The fact that Brock was given sole authorship of the major central sculptural feature of the *Victoria Memorial* is also testimony to his significant role in the execution of public statues during the previous 30 years. In addition, the very style and vocabulary that Brock employed in his central feature quite deliberately recalls some of the outstanding ideologies of late Victorian sculpture, so much so that his work is sometimes dismissed as mere pastiche.[2] The main movement in late Victorian sculpture is generally known as 'The New Sculpture', and its notional predecessor and inspiration, Alfred Stevens, is clearly commemorated in Brock's *Courage* and *Constancy* towards the top of the monument, recalling Stevens' *Valour* and *Truth* on his monument to the Duke of Wellington in London's St Paul's Cathedral. Brock's *Motherhood* on the central feature, and his outlying

Hamo Thornycroft *Teucer* c.1904 (cast) (detail) [cat. 134]

Fig. 118: **Alfred Gilbert** *St Catherine (The miraculous wedding)* 1900 (cast) [**cat. 47**]

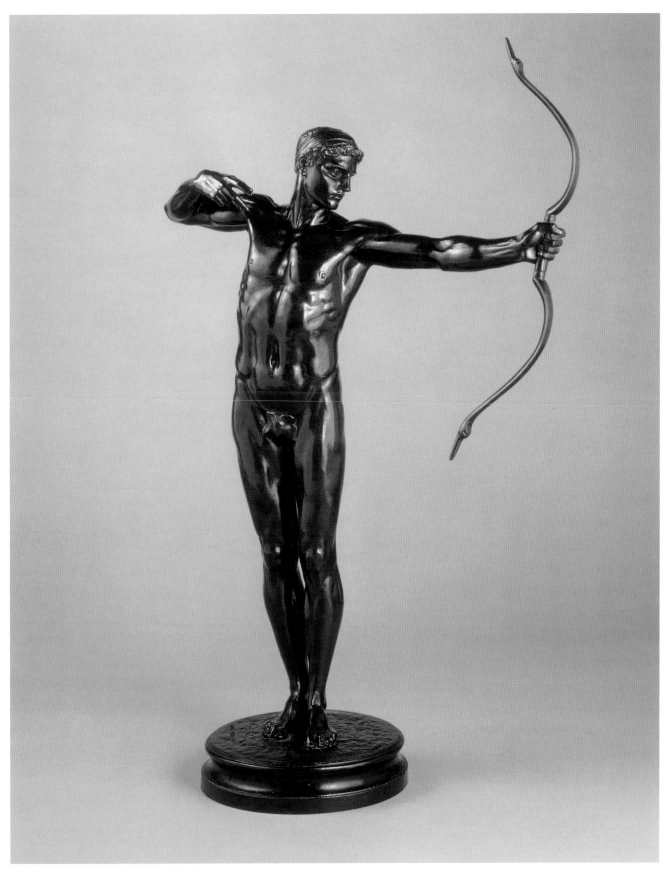

Fig. 119: **Hamo Thornycroft** *Teucer* c.1904 (cast) [cat. 134]

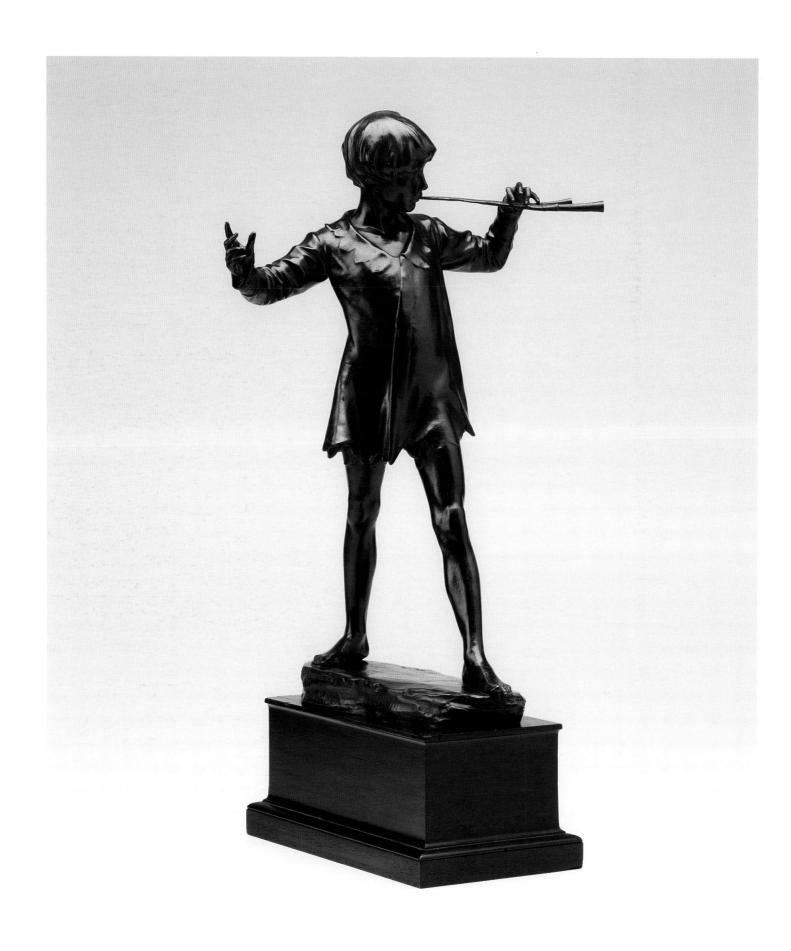

Fig 120: George Frampton *Peter Pan* 1912 [cat. 42]

The bronze full-scale version of Hamo Thornycoft's *Teucer* was first exhibited in 1882 but the sculptor produced smaller bronze statuette versions from 1899 to 1935 (fig. 119, cat. 134), including two series of 25 at separate sizes.[7] George Frampton made four additional full-scale versions of his original *Peter Pan*, unveiled in London's Hyde Park in 1912: that in Brussels is dated 1924, that in St John's, Newfoundland, 1925, that in Camden, New Jersey, 1926, that in Liverpool, 1927,[8] in other words extending the shelf life of Edwardian sculpture well into the reign of George V. The artist also produced small-scale versions (fig. 120, cat. 42), one of 1914 with an accompanying message to its recipient: 'Little Peter Pan would be much honoured if you would kindly accept the bronze statuette of himself as a souvenir of his grateful thanks for the sympathetic interest you took in securing for him such a charming abode in Kensington Gardens.'[9] Rodin was not afraid to replicate either his studies for works (as in *Study for Monument à Whistler*) (fig. 122, cat. 113) or indeed take parts of larger compositions and turn them into independent works of art (as Gilbert had done with his *Victory*). Indeed, Rodin's commitment to almost mass-production of his works, and his directive that the Rodin Museum could continue to make bronze casts of his works after his death,[10] played a significant part in the development of the modernist myth of 'originality' residing in a single one-off work, this development fuelled by artistic moral outrage at the Rodin industry and (maybe) the effect on prices that the absence of a factory line of work might induce.

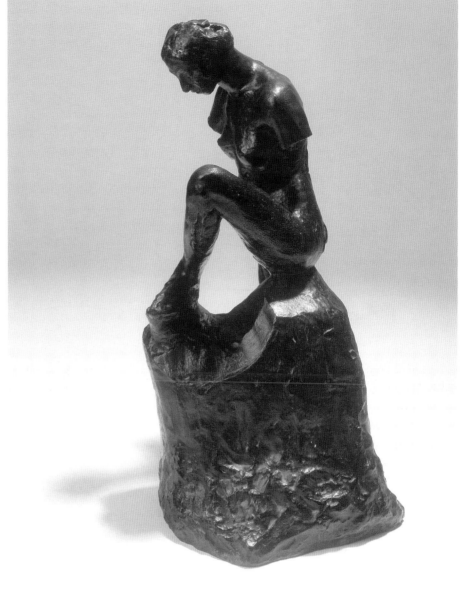

The notion of 'Greater Britain' evident in the gateposts of the London *Victoria Memorial* can be applied more generally to art. Contributing to the London *Victoria Memorial* did not prevent Australians commemorating the queen on their own territory — sometimes by a Greater Briton as in Brock's (smaller) *Victoria* in Brisbane, sometimes by a naturalised Australian, as in James White's Melbourne memorial. From the later 19th century onwards, there was an active artistic relationship between Australia and Britain. Tom Roberts came to Britain and made friends with the British sculptor Harry Bates, whose studio he painted in the talismanic *The sculptor's studio* 1884–5 (National Gallery of Australia). Roberts was later portrayed by the sculptor of the 'Australia' gateposts, Francis Derwent Wood (fig. 121, cat. 145).

Fig. 122: Auguste Rodin *Study* for *Monument à Whistler* 1910 [cat. 113]

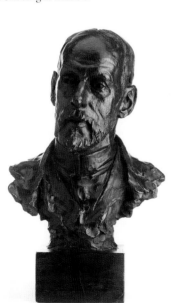

Fig. 121: Francis Derwent Wood *Tom Roberts* 1910 [cat. 145]

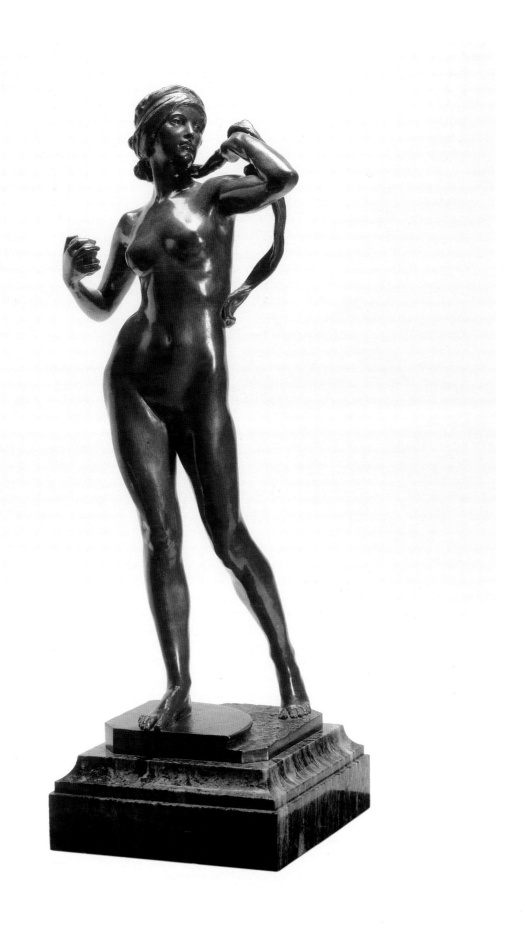

Fig. 123: Paul Montford *Atalanta defeated (Atalanta and the golden apples)* c.1900 [cat. 84]

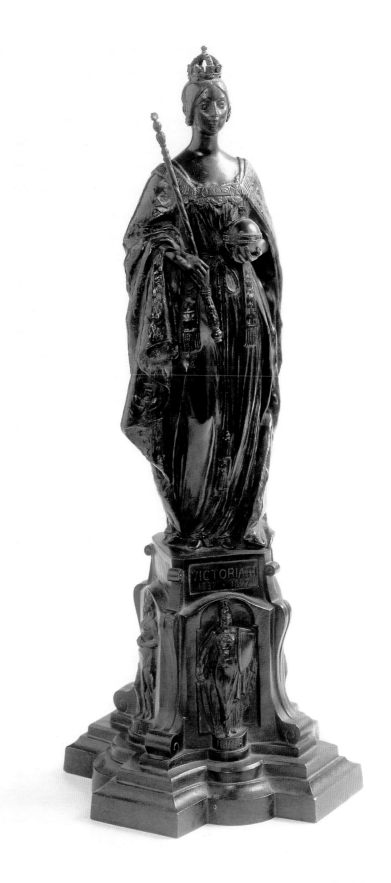

Fig. 124: Bertram Mackennal *Queen Victoria at her coronation* 1897 [cat. 81]

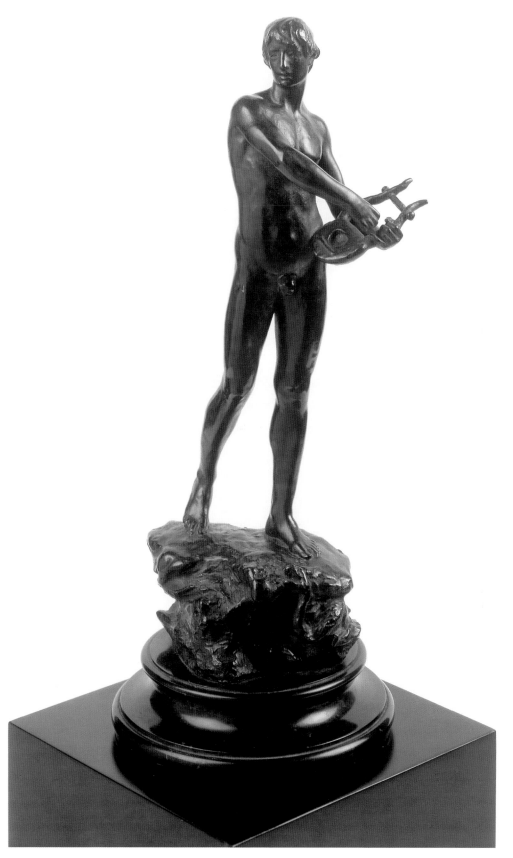

Fig. 125: Harold Parker *Orpheus* 1904 [cat. 97]

Bertram Mackennal and Harold Parker both
came to England and exhibited at the London
Royal Academy, Mackennal becoming a Royal
Academician in 1922. They produced bronze
statuettes like their British confrères — a reduced
scale edition of Mackennal's *Circe*, originally shown
full-scale in 1893 in Paris and 1894 in London, was
published between 1902 and 1906, while he showed
a bronze statuette of *Diana wounded* at the Royal
Academy in 1905 before showing the full-scale
marble there in 1908.[11] Parker's *Orpheus* of 1904/09
(fig. 125, cat. 97) is analogous to Sydney March's
Orpheus of 1903.[12] Both Parker and Mackennal
worked on the major architectural sculpture
displays at Australia House in London, with Parker
executing *Peace and prosperity* and *The awakening
of Australia* (fig. 131) between 1915 and 1918, and
Mackennal producing *Apollo driving the horses of the
sun* between 1915 and 1924. These works occupy
a pivotal, dominant position in the urban space of
central London and represent emphatically the way
in which a wider community of nationhoods could
be embraced by a Greater Britain. Indeed, although
Australia asserted a separate national identity
with the establishment of the Commonwealth in
1901, the Queen of Britain remains the Queen of
Australia (just) to this day.

Mackennal's *The dancer* (fig. 126, cat. 80) — though
perhaps a statuette in formal terms along the lines
of those executed by himself, Gilbert, Parker and
Paul Montford (fig. 123, cat. 84) — can be seen as
a more contemporary version of Edward Onslow
Ford's renowned flighty ladies of the 1880s, *Folly*
1886 or *Peace* 1887, though one might note that
these too were considered daringly 'realist' in their
time.[13] Brock (of all people) had exhibited in 1900
a full-scale modern *Eve*, which the major critic
Marion Spielmann described as 'not endowed with
that perfection of beauty which is the conventional
rendering of the First Mother; nor yet the gross
peasant which art-Anarchists have sought to present
her; but just one of ourselves in figure and nature …
beautiful with the beauty we see around us.'[14] This
too was circulated in an edition of bronze statuettes.
Mackennal's work was also 'modern' in its reference
to the stage, but this should not surprise us in
an artist who had so effectively portrayed Sarah
Bernhardt and Dame Nellie Melba. Raoul Larche's
Loïe Fuller lamp (fig. 127, cat. 75) refers to the
modern stage and, as a lamp, also serves a modern
function. Such a blurred distinction between art and

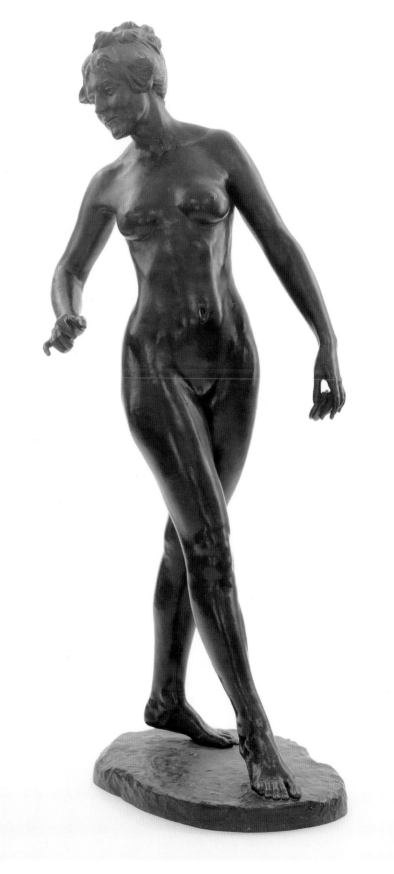

Fig. 126: Bertram Mackennal *The dancer* 1904 [cat. 80]

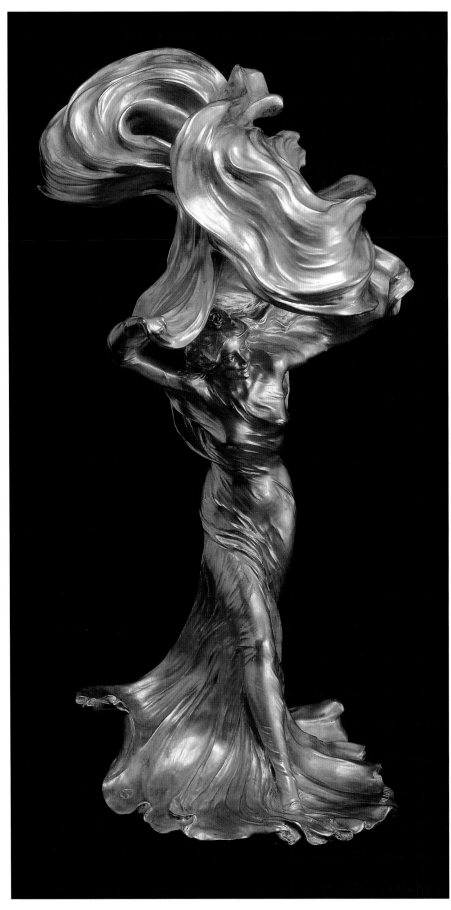

Fig. 127: Raoul Larche *Loïe Fuller lamp* c.1900 [cat. 75]

utility was almost commonplace in 19th-century France — witness the large number of lamps and clocks that featured figures derived from work by fine art sculptors, let alone the series of industrially produced art bronzes that poured out from the foundries such as Barbedienne or Susse.[15] One modern scholar has written of the sculptor Albert-Ernest Carrier-Belleuse:

> His early commitment to the decorative arts never slackened, and no aspect of the decorative arts was untouched by his craft … He executed commemorative trophies, statuettes, furniture, clocks, vases, dolls, jewelry, swords — anything that the human figure could conceivably ornament.[16]

During the 19th century, there had been occasional gestures towards industrial art production in Britain. Many of the sculptures exhibited at the London 'Great Exhibition' of 1851 featured under an Industrial rubric according to the works' founders.[17] There were mid-century efforts to produce editions of sculpture in ceramic ware, often published by the various Art Unions, as well as under the more obviously industrial identity of Henry Cole's 'Felix Summerly's Art Manufactures'.[18] In England from the 1880s, a distinctive movement for editions of bronze statuettes had developed, to which belonged the Montford, Parker and Mackennal bronzes. But these were always fine art bronzes, edited and often individually cast and prepared under the supervision of the sculptors themselves and not necessarily mass-produced or manufactured.[19] Although the critics who evangelised this type of work as suitable adornments for the cultured middle-class home — writers such as Edmund Gosse and Marion Spielmann — were to claim by the early years of the 20th century that this particular type of work had not caught on, this has to seem today a matter of degree. William Reid Dick's *The catapult*, originating in 1911, was still being cast for the sculptor in the late 1940s,[20] while sculptors such as Henry Pegram, Alfred Drury and William Goscombe John were reasonably active in this area until their respective deaths in 1937, 1944 and 1952.[21]

The Mackennal and the Larche works differ from those of Montford and Parker in the way their style, their identity, has shifted from late Victorian Neo-classicism to what might rather generally be described as Art Nouveau. A further shift, and still

within the strictly Edwardian period, is represented in the work of Henri Gaudier-Brzeska and Jacob Epstein. Gaudier-Brzeska's work has been claimed as a forerunner of British Modernism, but this should be treated with some caution. He was certainly an adherent of direct carving, that is, of cutting the stone himself directly, thus being 'true to his material'. But this shibboleth of sculptural Modernism has become a mantra, with an automatic assumption of the truth of the notion. A closer study of the history of sculpture reveals that a number of French sculptors were developing such a focus on *taille directe* (direct carving) as a clearly identifiable mode of execution in the last 20 years of the 19th century and, in any case, many British 19th-century sculptors learned how to carve marble directly as part of their studio training as assistants to an established sculptor.[22] There is also the distinct possibility that an impoverished young sculptor such as Gaudier-Brzeska was forced to cut stone himself because he could not afford the cost of an assistant to help him, as had been standard practice until that time. It is hard to see Gaudier-Brzeska's *The Firebird* (fig. 128, cat. 44) as any more 'modern' than Larche's *Loïe Fuller lamp* or Mackennal's *The dancer*. It is a dancing subject, like theirs, and it might well have been cast in bronze in an edition of more than one, had the market conditions existed.

A more legitimate claim to represent the arrival of Modernism in British sculpture can be made for Epstein's British Medical Association figures of 1908.[23] It was not just that they were offensively anatomically realistic to some spectators (especially to those occupants of the National Vigilance Association office immediately opposite), it was that they pushed the language of an accepted genre of late 19th-century sculpture, one which featured on buildings, well beyond the accepted parameters. If you look carefully enough, with the help of binoculars, you can spot notionally offensive 'bits' on different examples of architectural sculpture in 19th- or early 20th-century Britain.[24] But these were within a stylistic convention of Neo-classicism or the Baroque, both based ultimately on the art of Ancient Greece or Rome where such nakedness was acceptable. Epstein's offence of course was to do this with modern figures, as one journalist wrote: 'They are a form of statuary which no careful father would wish his daughter, or no discriminating young man, his fiancée, to see.'[25]

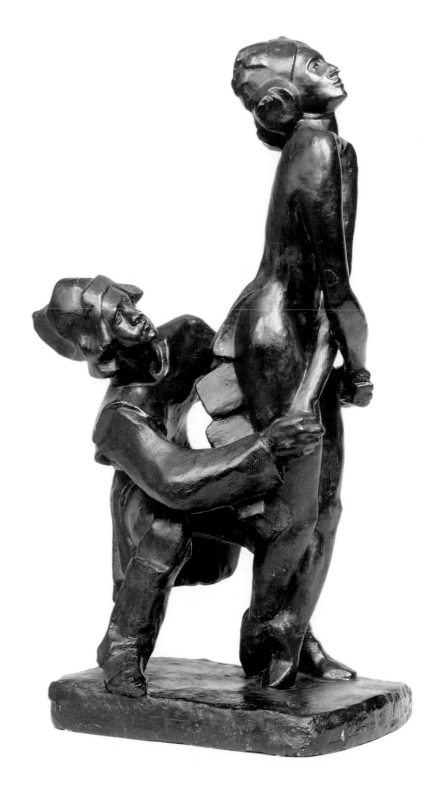

Fig. 128: Henri Gaudier-Brzeska *The Firebird* 1912 [cat. 44]

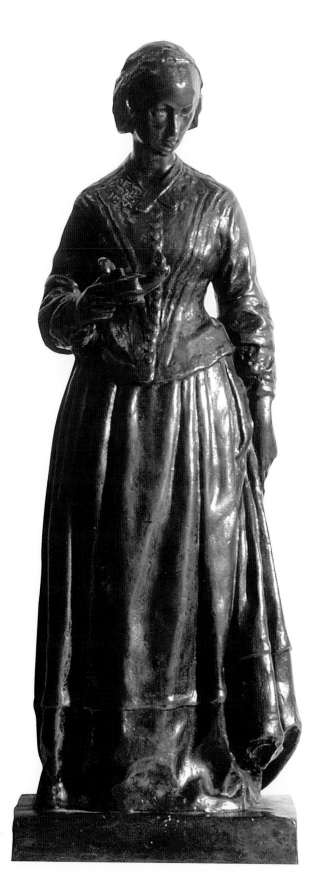

Fig. 129: Arthur Walker *Florence Nightingale* c.1913 [cat. 140]

To some extent Epstein's work was so shocking because it fell within the established genre of architectural sculpture. Edwardian sculpture can be characterised as generally working within convention. Mackennal and Parker worked in architectural sculpture, as we have seen with their Australia House compositions. Portrait busts, such as Derwent Wood's *Tom Roberts* or Parker's *Arthur Streeton* (cat. 98), maintained their position in a sculptor's output as had happened for centuries.

The main public arena for sculpture was the commemorative statue: London in the Edwardian period witnessed Hamo Thornycroft's *Gladstone* 1905 in the Strand, Adrian Jones' *Duke of Cambridge* 1907 in Whitehall and Brock's *Sir Henry Irving* 1910 outside the National Portrait Gallery, to be followed by his *Victoria Memorial* with which this essay began. There was to be no let-up in London; when Arthur Walker's *Florence Nightingale* (fig. 129, cat. 140) was put up in Waterloo Place in 1915, it brought with it (through relocation from nearby) John Bell's *Guards' Crimea monument* 1860 and Foley's *Sidney Herbert* 1867. This confluence of monuments in 1915 demonstrated graphically the continuity of this sculptural genre from the previous century. In 1921, the Edwardian era itself was commemorated in London by Mackennal's monument to Edward VII in Waterloo Place (fig. 130), another symbol of how defined periods can overlap. Mackennal was also responsible for the Edward VII monuments in Melbourne and Calcutta ('Greater Britain' again?). The same continuity with the Victorian period in this field is found in Melbourne with Mackennal's *Sir William Clarke* 1902, while White's *Fitzgibbon* 1908 joined his *Victoria* 1907 there.

Edwardian sculpture is a reflection of a complex of ideas and notions. There are overlapping time frames that continue the past while at the same time modifying and developing it, most clearly seen in the context of the core genres of work that have been described. Styles and conventions overlapped: the traditional, the contemporary, the advent of the modern. Some have indeed claimed to see in late Victorian and Edwardian bronze statuettes a source for British modernist sculpture.[26] One could even make a plea for the London *Victoria Memorial* as a post-modern precedent. The original scheme for the memorial envisaged not only the central grouping of sculptures, but also a new facade for

Buckingham Palace (which was carried out); a new urban focal point placed at the other end of the Mall, Admiralty Arch, its supporting sculptures executed by Brock (carried out); and, between the two backdrops, a further gallery of statuary that unfortunately was not proceeded with as planned. It is unlikely that the denizens of the London Institute of Contemporary Arts, relocated in the Mall in the 1960s after its original foundation as a bastion of Modernism in 1947, quite appreciate as they emerge from its main entrance into the Mall that they are participating in an Edwardian prototype of Rosalind Krauss's 'Sculpture in the expanded field'.[27] In 1978 she alleged it was only in the postwar period that the crucial viewing focus of sculpture radically changed, from the fixed object walked around by the spectator to the new experience of the spectator being surrounded by the field of sculpture. Is this not in a way exactly the ideology behind the London *Victoria Memorial*?

Benedict Read
University of Leeds

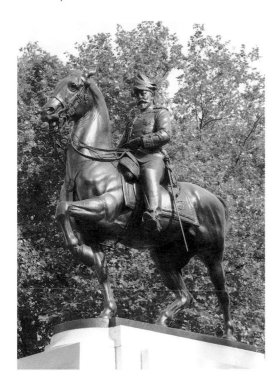

fig. 130: **Bertram Mackennal** *King Edward VII* 1921 bronze Waterloo Place, London

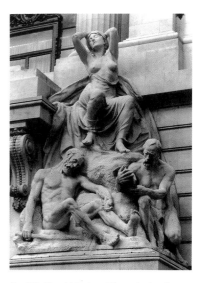

fig. 131: **Harold Parker** *The awakening of Australia* 1915–18 Portland stone Australia House, London

Notes

1 For the *Victoria Memorial*, see John Sankey, 'Thomas Brock and the critics', unpublished PhD thesis, University of Leeds, 2003, chapters 17 to 20, pp. 210–52; Benedict Read, *Victorian sculpture*, New Haven: Yale University Press, 1982, pp. 371–9.

2 See Susan Beattie, *The New Sculpture*, New Haven: Yale University Press, 1983, p. 230.

3 See Richard Dorment, *Alfred Gilbert, sculptor and goldsmith*, London: Royal Academy of Arts, 1986, pp. 128–9.

4 *Sydney Morning Herald*, 26 February 1879, p. 7.

5 See an example of 1910 in Dorment, *Alfred Gilbert*, 1986, note 3, p. 129.

6 See Dorment, *Alfred Gilbert*, 1986, pp. 154–67, 183–4.

7 Elfrida Manning, *Marble and bronze: The art and life of Hamo Thornycroft*, London: Trefoil Books, 1982, p. 210.

8 Andrew Jezzard, 'The sculptor Sir George Frampton', unpublished PhD thesis, University of Leeds, 1996, pp. 151–4.

9 John Christian (ed.), *The last Romantics: The Romantic tradition in British art*, London: Barbican Art Gallery, 1989, p. 145.

10 See for instance Albert Elsen (ed.), *Rodin rediscovered*, Washington: National Gallery of Art, 1981, pp. 275–93.

11 Alison Smith (ed.), *Exposed: The Victorian nude*, London: Tate Publishing, 2001, pp. 242–4.

12 See Christian (ed.), *The last Romantics*, 1989, note 9, p. 149.

13 See Beattie, *The New Sculpture*, 1983, note 2, p. 242.

14 Marion Spielmann, *British sculpture and sculptors of to-day*, London, 1910, p. 30.

15 See Philip Ward-Jackson, 'Sculpture colouring and the industries of art in the 19th century' in Andreas Bluhm et al., *The colour of sculpture 1840–1910*, Amsterdam and Leeds: Van Gogh Museum and Henry Moore Institute, 1996, pp. 73–82.

16 June Hargrove in Peter Fusco and Horst W. Janson (eds), *The Romantics to Rodin — French nineteenth-century sculpture from North American collections*, Los Angeles and New York: Los Angeles County Museum of Art and George Braziller, 1980, p. 160.

17 Read, *Victorian sculpture*, 1982, note 1, p. 29.

18 See Paul Atterbury (ed.), *The Parian phenomenon*, Shepton Beauchamp: Richard Dennis, 1989; Read, *Victorian sculpture*, 1982, note 1, p. 65.

19 See Beattie, *The New Sculpture*, 1983, note 2, pp. 181–99; Benedict Read, 'Introduction', *Gibson to Gilbert: British sculpture 1840–1914,* London: The Fine Art Society, 1992, p. 4.

20 See *Leighton and his sculptural legacy — British sculpture 1875–1930*, London: Joanna Barnes Fine Arts, 1996, p. 56.

21 For the continuance of the New Sculpture see Benedict Read, 'Whatever happened to the New Sculpture?' in *Reverie, myth, sensuality: Sculpture in Britain 1880–1910*, Stoke-on-Trent: City Museum and Art Gallery, 1992, pp. 21–5; Alexander Kader, 'Athletes, adolescents and antique drapery; some critical and sculptural responses to Leighton's sculpture 1890–1930', in *Leighton and his sculptural legacy*, 1996, note 20, pp. 13–22.

22 See Antoinette Le Normand Romain, 'La Taille directe' in *La Sculpture Française au XIXe siècle*, Paris: Grand Palais, 1986, p. 119. The contemporary British sculptor and critic Herbert Maryon attributed this specifically to the French sculptor Albert Bartholomé (1848–1928) though without giving a date. See Herbert Maryon, *Modern sculpture: Its methods and ideals*, London: Pitman, 1933, p. 38.

23 Richard Cork, *Art beyond the gallery in early 20th century England*, New Haven: Yale University Press, 1985, pp. 8–60.

24 See naked female figures by Frederick William Pomeroy of 1906 on the Central Criminal Court, London, naked males and females by Richard Garbe of 1912 on Thames House, London, in Philip Ward-Jackson, *Public sculpture of the city of London*, Liverpool: Liverpool University Press, 2003, pp. 64, 306–7.

25 Cork, *Art beyond the gallery in early 20th century England*, 1985, note 23, p. 24.

26 See David Getsy in *The cult of the statuette in Late Victorian Britain*, Leeds: Henry Moore Institute, 2000, p. 4.

27 See Rosalind Krauss, *The originality of the avant-garde and other modernist myths*, Cambridge and London: MIT Press, 1986, pp. 276–90.

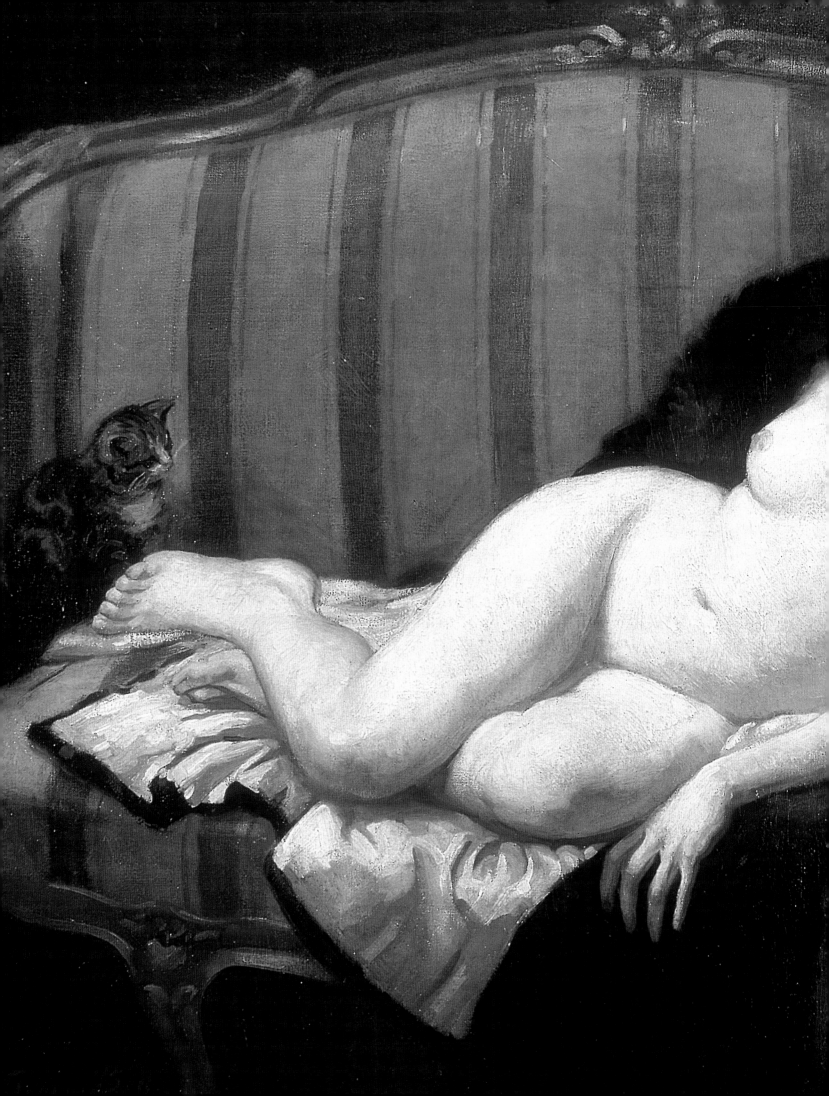

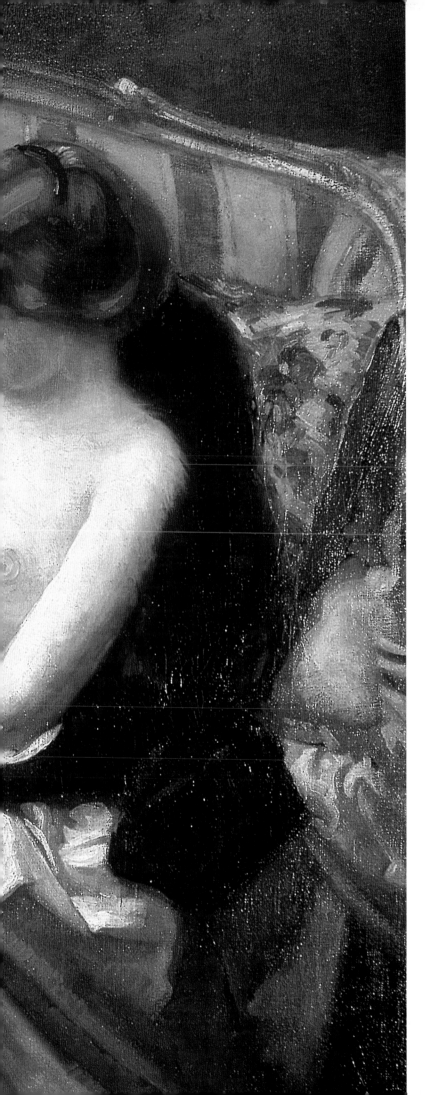

Catalogue

*M*easurements are in centimetres, height before width. In the catalogue entries, where a question mark is used this indicates that scholarship is uncertain. The exhibitions listed include only those where the works were shown prior to 1914 in order to highlight where the artists were exhibiting during the Edwardian period. The references include only key works on the artist, and further references can be found in the bibliographies of those publications listed. The publications by authors who are cited at the end of quotations and texts are detailed in the references. Where a brief picture essay is signed without a date, this indicates that it is new text written for this catalogue, as are the unsigned texts.

George Bell *Nude* 1910 (detail) [cat. 2]

Léon Bakst
1866–1924

Russian painter and stage designer, Léon Bakst was born Lev Samoilovich Rozenberg on 10 May 1866 in Grodno, Belarus, changing his name to Bakst in 1889. He studied at the Academy of Arts in St Petersburg from 1883 to 1886 and at the Académie Julian in Paris with, Jean-Léon Gérôme. He joined the World of Art group of artists in 1890, illustrating its magazine and collaborating with Alexandre Benois and Serge Diaghilev. His interest in Symbolism, Art Nouveau and Orientalism began to be seen in his work for the stage; in 1902 he began designing for the productions of St Petersburg's Hermitage and Alexandrinsky theatres. From 1909 to 1921 he maintained a close professional association with Serge Diaghilev, designing for his Ballets Russes productions in Paris. As artistic director, Bakst gained international attention with his 1910 production of *Schéhérazade*, its exotic costumes and sets becoming a major influence on fashion and interior design in the late Edwardian period. He died in Paris on 27 December 1924, aged 58.

references: Robyn Healy and Michael Lloyd, *From studio to stage: Costumes and designs from the Russian Ballet in the Australian National Gallery,* Canberra: Australian National Gallery, 1990; Roger Leong et al., *From Russia with love: Costumes for the Ballets Russes 1909–1933,* Canberra: National Gallery of Australia, 1998.

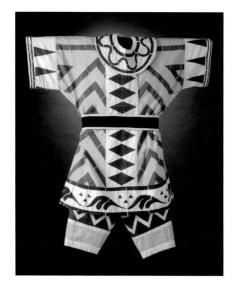

1 *Costume for a brigand*
in the Ballets Russes' production
of *Daphnis et Chloé,* 1912
made in Paris?, 1912
tunic, shorts and belt: yellow,
cream and black wool with green
and black stencilling
tunic; height: 98.0, width at shoulders:
105.0, width at hem: 82.0,
trousers; width at hip: 50.0, length: 71.0
National Gallery of Australia, Canberra

This costume was designed for Serge Diaghilev's Ballets Russes' production of *Daphnis et Chloé,* which premiered at the Théâtre du Châtelet in Paris on 8 June 1912, with music by Maurice Ravel, choreography by Michel Fokine and sets and costumes by Léon Bakst.

Bakst's designs for this 'Greek' ballet interpreted the costume of ancient Greece and were influenced by his visit in 1907 to the Minoan palace at Knossos, which had been unearthed in 1900 by the British archaeologist Sir Arthur Evans. Bakst's vivid geometric abstraction in the costumes, based on figures on traditional Attic black figure ceramics, contributed to the visual spectacle of this production. The pure, flat colour and unconstricting geometric design of this tunic was further articulated through the boisterous choreography devised for the brigand characters in this performance.

Robert Bell

George Bell
1878–1966

Australian painter, teacher and art critic, George Bell was born on 1 December 1878 at Kew, Melbourne, the son of a public servant. From 1896 to 1901 he studied at the National Gallery School, Melbourne, where fellow students included **Rose McPherson (Margaret Preston), Max Meldrum, Ambrose Patterson** and **Hugh Ramsay.** He also attended painting classes at **George Coates'** studio. He travelled to Europe and studied at the Académie Julian, and at various other Paris academies from 1904 to 1906. He went to England in 1906, where he became associated with a group of painters, which included **Stanhope Forbes,** who worked outdoors and were based in St Ives. Bell left St Ives in 1908 to work in a studio in London; from 1908 to 1915 **Philip Connard** was an important influence, the two artists going on painting trips together around London, Suffolk and Norfolk. Bell was also a friend of **Philip Wilson Steer**. He was a member of the Modern Society of Portrait Painters together with **Gerald Kelly** and **George Lambert**, painting portraits and interiors in a realist manner. At the Chelsea Arts Club, Bell mixed with Australian artists such as **Coates** and **Tom Roberts**. During the First World War, he worked as a schoolteacher and in munitions and was an Australian official war artist from 1918 to 1919. In 1920, he returned to Melbourne and, in 1923, became art critic for the Melbourne *Sun News-Pictorial,* a post he held until 1951. Throughout the 1920s, his painting was conservative but, in the 1930s, his work began to reflect the influence of Cézanne. In 1932, together with Arnold Shore, he established the Bell–Shore school, which he continued to run on his own after 1937. In 1934 and 1935 he revisited Europe, studied drawing under Iain McNab at the Grosvenor School, London and became interested in the writings and theories of Clive Bell and Roger Fry, which formed the basis of his own teaching of modernist principles in Australia during the 1930s and 1940s. During these years, he played an active and influential role in promoting the modern art movement in Australia. He died in Melbourne on 22 October 1966, aged 87.

references: Fred Williams, 'George Bell', in *Australian dictionary of biography, 1891–1939*, vol. 12, Melbourne: Melbourne University Press, 1990; Mary Eagle and Jan Minchin, *The George Bell school: Students, friends, influences*, Melbourne: Deutscher Art Publications, 1981; June Helmer, *George Bell: The art of influence*, Melbourne: Greenhouse, 1985; Felicity St John Moore, *Classical modernism: The George Bell circle*, Melbourne: National Gallery of Victoria, 1992.

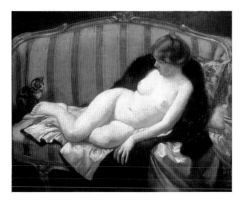

2 *Nude (Edwardian nude)*
painted in London, 1910
oil on canvas 102.0 x 126.8
signed and dated 'George Bell 1910'
lower left
Geelong Gallery, gift of the artist's daughter, Mrs Antoinette Niven in 1967

In *Nude*, George Bell provocatively juxtaposed a luminous naked body with sombre outdoor clothing. The nude rests comfortably on a rather formal sofa, nestling into, but not concealed by, her warm coat. A little cat perches at her feet at the end of the sofa, a picture of feline composure. Bell's meticulous rendering of the textures of fabrics and fur heightens the sensuality of contrasting flesh tones. Bell was also concerned with classical geometric structure, with the relationship between forms.

Bell's *Nude* is similar to **Philip Wilson Steer**'s *Seated Nude: The black hat* c.1900 (cat. 129) in that it places the nude rather shockingly in a drawing room rather than in the more traditional boudoir. Stylistically, however, Bell's *Nude* is painted in a more academic tradition and **Steer**'s *The black hat* with freer and more expressive brushstrokes.

Gillian Fergusson

3 *Portrait of Philip Connard*
painted in London, c.1912
oil on canvas 51.4 x 61.4
exhibited: Modern Society of Portrait Painters, London, 1912 (33, as 'P. Connard, Esq.')?
Art Gallery of Western Australia, Perth, purchased with funds from the Hackett Bequest Fund in 1949

Bell painted outdoors with **Philip Connard** who, like Bell, had studied under Jean Paul Laurens at the Académie Julian and, according to Bell's biographer June Helmer (1985), had an important influence on him. They shared ideas about how to paint a picture. Bell wrote in the Melbourne *Sun*, March 1938: 'Connard's work showed a keen appreciation of paint quality — and understanding and love of the material used.'

In its loose brushwork and in its subject of an artist painting plein-air at his easel, *Portrait of Philip Connard* is in the tradition of **John Singer Sargent**'s iconic image, *Claude Monet painting at the edge of a wood* c.1885 (Tate, London). It can also be compared with **Sargent**'s *The fountain, Villa Torlonia, Frascati, Italy* 1907 (cat. 120) and **John Lavery**'s *Mrs Lavery sketching* 1910 (cat. 76), which also show artists sketching outdoors.

Vanessa Bell
1879–1961

English painter and designer, Vanessa Stephen (Vanessa Bell) was born in London on 30 May 1879, the daughter of eminent literary critic, Sir Leslie Stephen, and the sister of Virginia Woolf. From 1894 to 1896, she studied drawing under Ebenezer Cooke; from 1896 to 1900, under Arthur Cope at his school in Pelham; from 1901 to 1904, at the Royal Academy Schools, where one of her teachers was **John Singer Sargent**; and, in 1904, briefly at the Slade School, where she felt 'crushed' by the teaching of **Henry Tonks**. She founded the Friday Club in 1905 in order to provide a meeting place for artists and people interested in art. Those who attended included **Derwent Lees** and **Henry Lamb**, as well as Clive Bell, whom she married in 1907. **Walter Sickert** was an early admirer of her work. Bell and the painter and critic Roger Fry influenced each other profoundly, both personally and intellectually. After Fry's 1910 exhibition, 'Manet and the Post-Impressionists', Bell, like other artists in her circle, became enthused by the work of Cézanne, Matisse and Picasso and became a committed modernist. At this stage, Bell's work had a strong formal quality, with brilliant colour and striking simplicity. Bell was an important designer for the **Omega Workshops**, from its inception by Roger Fry in 1913 until its closure in 1919. She painted mural schemes with Duncan Grant and designed pottery and textiles. This experience broadened her attitude to painting and helped to liberate her from representationalism. At the workshops, she associated with **Henri Gaudier-Brzeska** and **Nina Hamnett**. In 1914, she met Picasso in Paris and was profoundly impressed with the work that she saw in his studio. Like most of her circle, she held pacifist views and spent the First World War in the country with Duncan Grant (who was her lifelong companion from around 1916). From 1916, she made 'Charleston' in Firle, Sussex, her principal home, providing an environment of contentment in which all her extended family could live and work. After 1919, she designed book jackets for Virginia and Leonard Woolf's Hogarth Press. Between the wars she lived privately, devoted to her painting, her family and her close friends and travelling regularly to Paris and elsewhere. The death of Fry in 1934 was a severe loss

to her and, when her elder son Julian was killed in the Spanish civil war in 1937, she never fully recovered. The suicide of her sister Virginia Woolf four years later was a further calamity. She died on 7 April 1961 at 'Charleston', aged 81.

references: Virginia Woolf, *To the lighthouse*, London: Hogarth Press, 1927; Frances Spalding, *Vanessa Bell*, London: Weidenfeld and Nicolson, 1983; Isabelle Anscombe, *Omega and after: Bloomsbury and the decorative arts*, [1981], London: Thames and Hudson, 1984; Jane Dunn, *A very close conspiracy*, London: Jonathan Cape, 1990; Regina Marler, *Selected letters of Vanessa Bell*, London: Pantheon, 1993; Angus Trumble, *Bohemian London: Camden Town and Bloomsbury paintings in Adelaide*, Adelaide: Art Gallery of South Australia, 1997; Vanessa Bell, *Sketches in pen and ink: A Bloomsbury notebook*, London: The Hogarth Press/Chatto and Windus, 1997; Rachel Tranter, *Vanessa Bell: A life of painting*, London: Cecil Woolf, 1998; Richard Shone, *The art of Bloomsbury: Roger Fry, Vanessa Bell and Duncan Grant*, London: Tate Publishing, 1999.

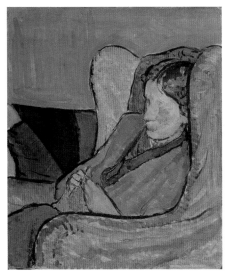

4 *Virginia Woolf*
painted in Sussex, England
c.1911–12
oil on board 40.0 x 34.0
National Portrait Gallery, London

For now she need not think about anybody. She could be herself, by herself … All the being and the doing, expansive, glittering, vocal, evaporated; and one shrunk, with a sense of solemnity, to being oneself, a wedge-shaped core of darkness, something invisible to others. Although she continued to knit, and sat upright, it was thus that she felt herself; and this self having shed its attachments was free for the strangest adventures.(Woolf, 1927)

When Virginia Woolf wrote this of her character Mrs Ramsay, she could just as easily have been describing herself as painted by her sister, Vanessa Bell. Bell's portrait captured a moment of quiet intimacy between the sisters, with Virginia knitting or sewing, quite unselfconsciously 'being herself', seated indoors in a large armchair. Although Bell carefully designed the image by presenting her subject from an unusual aspect, she gave it the appearance of being unposed and of having the informal quality of a photograph.

At this time, Bell was already simplifying her compositions and using blocks of contrasting colours, evoking body language rather than descriptive details or physiognomy or dress. By bringing her subject into close focus and emphasising her head and hands, Bell captured Woolf's intensity of concentration.

Bell wrote of her sister: 'I cannot remember a time when Virginia did not mean to be a writer and I a painter. It was a lucky arrangement for it meant that we went our own ways and one source of jealousy at any rate was absent.' (Bell, 1997)

English novelist and essayist, Virginia Woolf (1882–1941) contributed to modern literature by abandoning traditional narrative style and characterisation and by focusing on her characters' thoughts, perceptions and feelings. Her prose style is poetic, heavily symbolic and filled with visual images. Bell painted this portrait at either little Talland House, Firle, or at Asham House, near Lewes, which she subsequently leased. At this time, Woolf was still unmarried and was working on her first novel, published as *The voyage out* (1915). It was before she had established her reputation as a pioneer of modern literature by writing works such as *To the lighthouse* (1927), *Mrs Dalloway* (1925) and *The waves* (1931). A fervent supporter of women's rights, Woolf considered the difficulties of the woman artist in *A room of one's own* (1929). Her biography of the art critic and artist, *Roger Fry* (1940), is a careful study of a friend.

In 1911, around the time this portrait was painted, she wrote to her sister, Vanessa Bell: 'As a painter, I believe you are much less conscious of the drone of daily life than I am, as a writer. You *are* a painter. I think a good deal about you, for purposes of my own, and this seems to me clear. This explains your simplicity.'(quoted in Anscombe, 1984)

This portrait is just one of four early portraits that Vanessa Bell painted of Woolf between late 1911 and mid–1912. Duncan Grant also painted a portrait of Woolf at about this time (Metropolitan Museum of Art, New York).

Jacques-Emile Blanche
1861–1942

French painter, teacher and writer, Jacques-Emile Blanche was born on 1 January 1861 in Paris, the son of a nerve specialist. Blanche became acquainted with writers and artists as a child: he was taught English by the poet Mallarmé, the philosopher Henri Bergson was his classmate and, as a schoolboy, he was taken to visit Manet and Henri Fantin-Latour in their studios. He studied briefly under Henri Gervex and Ferdinand Humbert, but had no formal training and was influenced by Manet, **John Singer Sargent** and **James McNeill Whistler**. He also knew Degas and in later years painted his portrait. Blanche visited London every year from 1884 and spent his summers at his family house in Dieppe, entertaining friends such as **Sargent** and **Walter Sickert**, but Paris was his true base, where his friends included **Giovanni Boldini**. In the early 1900s, he had a teaching atelier in Paris that attracted many students including the Australian **Kathleen O'Connor**, the Russian **Aleksandr Golovin** and British artists Duncan Grant and **Henry Lamb**. **Rupert Bunny** and **J.D. Fergusson** taught with him for a period. His many portraits show the range of his connections, from the upper bourgeoisie to the avant-garde. Although his art was not progressive, he supported new talent. Like many others, he supplemented commissioned works with studies of artist friends, such as **Sickert**, **Rodin** and **Charles Conder**. He also painted portraits of the composer Igor Stravinsky and authors Marcel Proust, Colette, André Gide and James Joyce. His English style was largely responsible for his success. French critics accused Blanche of plagiarising Joshua Reynolds, Thomas Gainsborough and Thomas Lawrence, but in England he was totally accepted at a time in which 18th-century traditions were being revived. He produced two volumes of memoirs, *Portraits of a lifetime* (1937) and *More portraits of a lifetime* (1939), which, together with his private journals, his correspondence and his articles for periodicals, are informative about the period but which are often more entertaining than accurate. He died in Paris on 20 September 1942, aged 81.

references: Jacques-Emile Blanche, *Portraits of a lifetime*, London: J.M. Dent and Sons, 1937; Kenneth McConkey,

Edwardian portraits: Images of an age of opulence, Woodbridge: Antique Collectors' Club, 1987; Jane Abdy, 'Jacques-Emile Blanche', *The Grove dictionary of art*, London: Macmillan, 1996; Claude Pétry et al., *Jacques-Emile Blanche, peintre*, Rouen: Musée des Beaux-Arts, 1998.

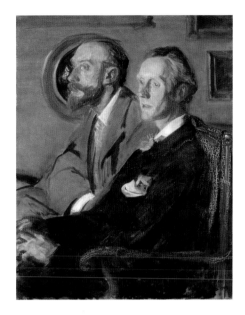

5 *Charles Shannon and Charles Ricketts*
painted at 'Lansdowne House', London, 1904
oil on canvas 92.1 x 73.0
signed, dedicated and dated
'To Ricketts/ & Ch. Shannon/
J.E. Blanche 1904' lower right
exhibited: New English Art Club, London, Winter 1904 (116); International Society, Cartwright Hall, Bradford, 1905 (43); Société Nationale des Beaux-Arts, Paris, 1906 (123); National Portrait Society, London, 1911 (44); X Venice Biennale, 1912 (8); Royal Scottish Academy, Edinburgh, 1914 (397)
Tate, London, bequeathed by Charles Shannon in 1937
© TATE, London 2003

Jacques-Emile Blanche painted portraits of many artists and writers, including this double portrait of Charles Ricketts (1866–1931) and his lifelong friend and partner, **Charles Shannon** (1863–1937). Blanche commented: 'Ricketts's lean face reminded one of Francis of Assisi or a Van Eyck; **Shannon** was like one of Burne-Jones's Knights of the Round Table.' (Blanche, 1937)

Ricketts and **Shannon** met as students in 1882, and lived together for 50 years. Shannon was a painter and printmaker. Ricketts, dominant in the partnership, was a painter of densely symbolist allegories, and also a sculptor, wood engraver, book designer, art critic and theatre and jewellery designer. Together, Ricketts and **Shannon** shared a choice collection of art and antiquities. Blanche wrote: 'Their flat was filled with exquisite things; Persian miniatures, Tangara figures, Egyptian antiques, jewels, and medals, which millionaires had overlooked. For genuine collectors are poor; they are seekers and men of knowledge guided by their taste' (Blanche, 1937). Oscar Wilde was a frequent visitor, remarking that it was 'the one house in London where you will never be bored'.

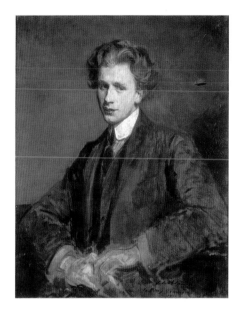

6 *Percy Grainger*
painted in London, 1906
oil on canvas 90.1 x 71.0
signed, dedicated and dated 'J.E. Blanche to Percy Grainger 1906' lower right
Grainger Museum, The University of Melbourne

Virtuoso pianist, composer and conductor, Percy Grainger (1882–1961) was Australian by birth and American by citizenship. From 1901, he was based in London, where he became popular at Edwardian salons because of his exceptional good looks (Blanche portrayed his thick curly, reddish blond hair and piercing blue eyes) and his ability to enliven events with his effervescent high spirits and outrageous behaviour. He made

extensive tours with the Australian contralto Ada Crossley in 1903 and 1908, and was a friend of Nellie Melba. He moved to America in 1914. Best known for lighter works such as *Country gardens*, he was also a pioneer of electronic music and the first Australian composer to include Asian influences within his compositions.

Blanche painted Percy Grainger, aged 24, at the height of his London success. He had just started work on collecting and arranging English folk songs, pioneering the use of the Edison wax cylinder recorder. 1906 was also the year that Grainger met Edvard Grieg, who greatly admired his playing.

On 14 June 1906, the *British–Australasian* reported proudly of the Australian musician:
> Mr. Percy Grainger's settings of three old Lincolnshire songs … have been most favourably received in all quarters … This evening Mr. Grainger is playing at Mrs. Charles Hunter's At Home, and tomorrow at Mrs. Wodehouse's musical evening at 21, Sloane-gardens, S.W. M. Jacques Blanche, the well-known French artist, is painting Mr. Grainger's portrait.

Giovanni Boldini
1842–1931

Italian painter and printmaker, Giovanni Boldini was born in Ferrara on 31 December 1842, the son of the painter and picture restorer, Antonio Boldini. He was initially trained by his father and by the age of 18 was recognised as a capable portrait painter. While studying at the Accademia di Belle Arti in Florence in 1862, he came into contact with the Macchaioli group of Italian artists who encouraged him to paint plein-air landscapes. On visits to London in 1870 and 1871, he was impressed by the portraits of van Dyck, Thomas Gainsborough and Joshua Reynolds. He settled in Paris in 1871, where he quickly established himself as a painter of fashionable genre scenes and views of Parisian life. He became a friend of **John Singer Sargent** and **James McNeill Whistler**, whose portraits he painted. He also established a strong friendship with Degas, under whose influence he began to experiment with etching and drypoint and to produce large pastel portraits. In 1889, he and Degas travelled to Spain, where they studied the works of Velazquez in the Prado and, in 1890, in Paris he was inspired by Anders Zorn's dynamic portraits. In the 1890s Boldini was the leading portrait painter in Paris, producing vibrant portraits in a flamboyant style using striking tonal contrasts. He was also well known in London, where he regularly visited. His clientele included some of the wealthiest and most beautiful, including Count Robert de Montesquiou, Lady Colin Campbell, the Duchess of Marlborough and the Marchesa Luisa Casati. His slashing brushwork and sophisticated elongations led **Walter Sickert** to describe him as the 'parent of the wriggle and chiffon school of portraiture' (Wilton, 1992). He resided in Britain during the First World War and on his return to Paris he lived in semi-retirement. From 1927, he produced only charcoal drawings. He died in Paris on 11 January 1931, aged 88.

references: Gary Reynolds, *Giovanni Boldini and society portraiture 1880–1920*, New York: Grey Art Gallery and Study Centre, 1984; Ettore Camesasca et al., *Boldini*, Milan: Mazzotta, 1989; Andrew Wilton, *The swagger portrait: Grand manner portraiture in Britain from Van Dyck to Augustus John, 1630–1930*, London: Tate Publishing, 1992; Barbara

Dawson, *Images and insights*, Dublin: Hugh Lane Municipal Gallery of Modern Art, 1993; Efrem Gisella Calingaert, 'Giovanni Boldini', *Grove dictionary of art*, vol. 4, London: Macmillan, 1996; Bianca Doria, *Giovanni Boldini, catalogo generale*, Milan: Rizoli, 2000.

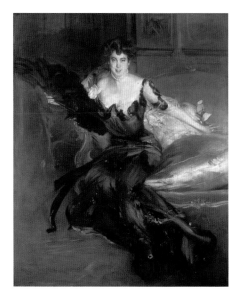

7 *Portrait of a lady, Mrs Lionel Phillips*
painted in Paris, 1903
oil on canvas 193.3 x 155.0
signed 'Boldini 1903' lower right
exhibited: 'Third Exhibition of Fair Women', International Society of Sculptors, Painters and Gravers, London, 1910 (90, as 'Portrait of a lady')
Dublin City Gallery The Hugh Lane, presented by Sir Lionel Phillips in 1909

Florence, Lady Phillips (1863–1940) was the daughter of a South African land surveyor. In 1885, she met and married Lionel Phillips, who had moved to South Africa in 1875 and had become wealthy in the 1880s by mining diamonds. They lived in England for eight years from 1898 to 1906, in a town house in Grosvenor Square, London and at a country estate in Hampshire. During this time Lady Phillips acquired a keen interest in art and bought contemporary works — by **William Orpen**, **William Rothenstein**, **Walter Sickert** and **Philip Wilson Steer**, as well as by Pissarro, Monet and Sisley. She campaigned for the establishment of the Johannesburg Art Gallery, and gave many of the works she had collected to the gallery. In 1919, her daughter Edith married the artist **William Nicholson**.

In *Portrait of a lady, Mrs Lionel Phillips*, Giovanni Boldini modelled the face and flesh softly, in contrast to the long flowing strokes with which he painted the black dress and large feather fan. By portraying Lady Phillips perched on the edge of a chaise longue, he created a suggestion of suspended animation. He showed his subject wearing a number of diamond rings, promoting her husband's interests.

Boldini also painted a portrait of Lionel Phillips, in a glossy coat and trousers and highly polished patent leather shoes, which was shown in the Society of Portrait Painters exhibition in London in 1903. The *Observer*'s critic commented on 15 November 1903: 'He is positively the most wide awake, restlessly alert human being that we ever saw on canvas, and there is a diabolical cleverness about the Franco-Italian's method which fascinates the spectator whether he likes it or not.'

Frank Brangwyn
1867–1956

British painter, printmaker, illustrator and designer, Frank Brangwyn was born on 12 May 1867 in Bruges, Belgium, the son of a Welsh ecclesiastical architect and textile designer. Largely self-taught, he received his first training in his father's textile design workshop. In 1875, the family returned to England and Brangwyn entered the South Kensington Art Schools. Then, between 1882 and 1884, he worked in William Morris' workshop where he copied tapestries and made working drawings for carpets and wallpapers. Enhancing his already broad acquaintance with Dutch and Flemish art, he copied Raphael and Donatello in the Victoria and Albert Museum, London. In his plein-air paintings, made in Cornwall from 1884 to 1888, he used subdued tones, but his extensive travels in the early 1890s and contact with Arthur Melville led him to adopt a brighter palette. He visited Venice in 1896 and was impressed by the art of Titian and Veronese. In 1900, the Australian-born patron Sir Edmund Davis commissioned him to design bedroom and music room interiors for his home in Lansdowne Road, London, later contracting **Charles Conder** to design the drawing room. For over 30 years, from 1902 to 1937, Brangwyn was mainly occupied with creating large murals, with those for Skinners' Hall, London, forming his reputation as a painter of boldly designed and richly coloured works on a large scale. In 1904, he began etching and evolved a monumental style using striking tonal contrasts. He also illustrated books and designed furniture, jewellery, textiles and stained glass. Industry, shipping and contemporary London were among his favourite themes, and he often depicted the working classes and their labours. In 1904, in conjunction with John Swan, Brangwyn established the London School of Art in his studio in Stratford Road, Kensington, which was run like a French atelier, with instructors visiting to comment on the students' work. In addition to Brangwyn, **George Lambert** and **William Nicholson** taught at this school, while **Kathleen O'Connor** and **Nina Hamnett** were both students. In 1914, Brangwyn was nominated as one of the judges for the proposed decorations for Australia House in London. From 1924, he worked on his best-known murals, large panels on the

theme of the British Empire, commissioned to form part of a war memorial for the House of Lords, but ultimately considered too flamboyant for this venue and presented to the City of Swansea in 1932. From 1934, Brangwyn devoted himself to religious art. In 1919, he was elected a full member of the Royal Academy, and was knighted in 1941. He paid little regard to contemporary developments in art and in his later years lived virtually as a recluse. He died at Ditchling, Sussex, on 11 June 1956, aged 89.

references: Walter Shaw-Sparrow, *Frank Brangwyn and his work*, London: Kegan, Paul, French and Trubner, 1910; William de Belleroche, *Brangwyn talks*, London: Chapman & Hall, 1944; Rodney Brangwyn, *Brangwyn*, London: William Kimber, 1978; Julian Freeman, *The art of Frank Brangwyn*, Brighton: The Gallery, Brighton Polytechnic, 1980; Clare Willsdon, *Mural painting in Britain 1840–1940*, Oxford: Oxford University Press, 2000.

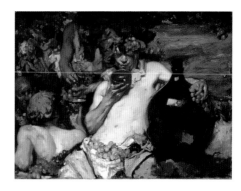

8 *Wine*
painted in London, 1909
oil on canvas 114.5 x 154.7
exhibited: Royal Academy, London, 1910 (213)
Mildura Arts Centre, Senator R.D. Elliott Bequest, presented to the city of Mildura by Mrs Hilda Elliott in 1956
reproduced courtesy of Bridgeman Art Library 2004

Frank Brangwyn commented: 'When younger … I was a lover of the juice of the grape. I may say that I've sampled all the wines of the earth … I gave them all up as far too seductive and dangerous — no use at all if you want to work' (William de Belleroche, 1944).

The critic for the Sydney *Daily Telegraph* wrote on 1 September 1907: '"Returning from the Garden" — a well-poised figure of a lady passing by a mirror, at which she gazes reflectively — is an excellent study, the draperies, the hat dangling by the side, and the elaborate mass of flowers being all admirably treated.'

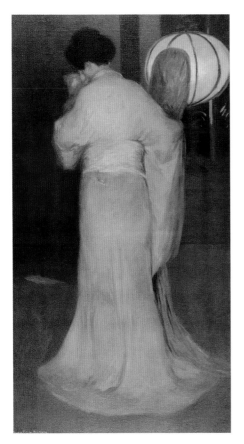

12 *Madame Sadayakko as Kesa*
painted in Paris, c.1907
oil on canvas 175.0 x 95.0
signed 'Rupert C W Bunny'
lower left
exhibited: Salon d'Automne,
Paris, 1909 (230 or 231, as
'Mme Sada Yacco, Kesa')
Philip Bacon Collection, Brisbane

Madame Sadayakko as Kesa reflects the turn-of-the-century European interest in the Orient. In its simplicity of design, economy of expression and subtle tonal harmonies, as well as in its Japanese theme, *Madame Sadayakko as Kesa* shows **James McNeill Whistler**'s influence on Bunny. Painting his subject from behind, with her head bowed and slightly turned, Bunny demonstrated how Sadayakko

was able to convey emotion through pose and gesture; he showed her in an expressive pose, while at the same time maintaining a considerable degree of privacy, of oriental inscrutability.

Sadayakko (1871–1946) was Japan's most celebrated and beautiful geisha, and the first to enjoy international adulation. From a successful career as a geisha, she married an actor, Kawakami Otojirô, and joined him on stage during the Imperial Japanese Theatre Company's tour of America and Europe from 1899 to 1902. She delighted the public with her extravaganzas in which she fluttered the sleeves of her kimono like a butterfly. In Washington she gave command performances for President McKinley and in London for the Prince of Wales. Emperor Franz Josef saw her perform in Vienna and Tsar Nikolai II saw her in St Petersburg. Gide, Debussy, Degas and **Rodin** were among her devotees. When composing *Madame Butterfly*, Puccini is said to have been inspired by her and by the melodies played by her company. She became so popular that sophisticated ladies sought to purchase a 'Sadayakko kimono'. After Otojirô's death, Sadayakko continued to act and to train other young actresses.

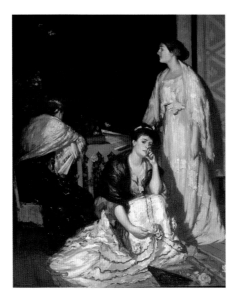

13 *Nocturne*
painted in Paris, c.1908
oil on canvas 220.8 x 180.5
signed 'Rupert C W Bunny' lower left
exhibited: Société Nationale des
Beaux-Arts, Paris, 1909 (184)
National Gallery of Australia,
Canberra

Nocturne is one of a series of images of summer called 'Days and Nights in August'. Painted by Bunny between 1907 and 1911, these works evoke a mood of intimacy and luxurious leisure, of perfume, poetry and distant music. Though ostensibly intimate, the scenario is theatrical. Two or three women (one or more invariably posed by Bunny's wife, Jeanne), gowned elaborately, with accessories of roses and richly coloured shawls and fans, pose together on a balcony. Black night presses down upon them from outside, while they are lit warmly by lamplight from a room this side of the picture plane. The women gaze out, inwards, and across the balcony, but their eyes do not meet. Meditative, preoccupied, languorous and at ease, unsmiling and rapt, they listen to distant music.

For some critics Bunny was 'a painter of pretty draperies and females'. Others thought that women were not his subject and that his interest was not in characterisation; rather, the women that filled his canvases were decorative objects, their purpose the same as the accessories — the elaborate gowns, vases, fans, shawls, Chinese lanterns and Persian rugs. Taking this point of view further, there were critics who admired the formal qualities of these paintings, specifying, for instance, Bunny's use of pattern, his interest in light, his 'rhythmic' organisation, the 'cadences' of tone and the small touches of light and bright colour.

Although during these years Bunny explored the warm and flexible play of light and at least could seem an 'impressionist', his art overall was ruled by something very different: an interest in suggestion. Bunny cleverly created spectacles for our enjoyment. He painted illusions, and at times showed that he was doing so by repeating the image and, by slight changes, altering the illusion. A series of night balcony images was to suggest music — women grouped on balconies listening to distant music, music that is suggested by the lack of communication between the women and by the flowing elaboration of their gowns, the roses fallen on the floor, the half-folded fan, the darkness into which they gaze. He painted this tableau over and over again for some years, every now and then altering the illusion entirely: a suggestion of conspiracy in the women's postures and the subject became 'Scandal', of weariness and it was 'After work', of accusation and the theme was 'Caught out'.

Thus Bunny was the creator of suggestive effects and not the slave of appearances. He had an astonishing ease in the use of different styles and inventiveness in image-making. In this respect he was a truly modern artist. In *Nocturne*, Bunny juggled literal description and suggestive darkness. Dim glimpses of sea, foliage and a night sky combine with costumes and poses to arouse non-visual sensations of warmth, perfume and music.

Mary Eagle, 1991

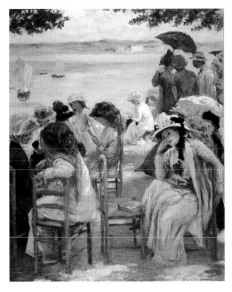

14 *Last fine days, Royan*
(*Summer time, Royan*)
painted in Paris, c.1908
oil on canvas 78.5 x 64.8
signed 'Rupert C W Bunny'
lower right
exhibited: Société Internationale de Peinture et de Sculpture, Paris, December 1908 (35)
Newcastle Region Art Gallery, presented by the Art Gallery and Conservatorium Committee in 1962

Bunny spent the summer of 1908 at 'Villa Lili', St Georges de Didonne, near Royan, depicting fashionably dressed people strolling on the promenade or entertaining themselves and their children on the beach front. *Last fine days, Royan* is composed from separate sketches of individual groups, lone figures and boats on the water. It was probably painted back in his studio in Paris, where Bunny shaped the sketches and pencil notes made on the spot into a composition that has the informality of a shapshot: a view of family and friends gathered by the seaside, chatting and relaxing in the open air.

Last fine days, Royan is one of a group of three paintings including *On the beach (Royan)* c.1908 (Art Gallery of New South Wales, Sydney) and *Under the trees (Royan)* c.1908 (private collection), which are similar in size and form an almost continuous view. *On the beach* depicts an expanse of sand with distant bathers and beach tents, with a mother helping her daughter with her socks and a woman reading a book. In *Under the trees* Bunny introduced an older group on a shaded seat, with a mother watching her toddler chase a red ball.

Henry James wrote in *The Tribune*, 26 August 1876:

> The French do not treat their beaches as we do ours — as places for a glance, a dip, or a trot, places animated simply during the couple of hours of bathing time and wrapped in natural desolation for the rest of the twenty-four. They love them, they adore them, they take possession of them, they encamp upon them. The people here sit upon the beach from morning till night; whole families come early and establish themselves, with umbrellas and rugs, books and work. (quoted in James, 1961)

In writing this, James could have been describing the scene in Bunny's *Last fine days, Royan*.

15 *The apple of discord*
painted in Paris, c.1913 or c.1916
oil on canvas 120.5 x 120.5
signed with monogram lower right
National Gallery of Australia, Canberra

In 1910, as a member of the jury of the Salon d'Automne, Bunny saw Matisse's paintings *Music* 1910 (The Hermitage, St Petersburg) and *Dance* 1909-10 (The Hermitage, St Petersburg). Although he passed them for exhibition, he found the style 'ridiculous' and Matisse a 'humbug'. The impression made on Bunny, although initially negative, was so strong that seven months later he was able to describe the paintings fully and accurately. The radical simplicity, jumping colours and rhythmic concept of Matisse's two paintings were to typify the style Bunny developed three years later.

Bunny had already shared a bias common to the modern movement. He had been interested for a long time in the notion that painting could express the abstract qualities of music, dance and a subliminal poetic narrative in a purely formal way, through colour and design. His style had always been 'decorative', meaning, in contemporary terms, flat, muralist and orientated to the expression of ideas.

Bunny, like many artists early this century, certainly looked at drawings and paintings by Puvis de Chavannes in which groups of figures were combined organically. Bunny extended the idea of rhythmic organisation to figures performing the same, or a sequence of the same, movements, like a chorus. This occurs in *The apple of discord*. He drew single figures bent forward at the waist, or bent with arms or legs so that lines of arms, trunk and legs are parallel. Subsidiary elements within an image were drawn to amplify the rhythms. Curves of hills, clouds and water, as well as drapery and the lines of a chariot, were made animate. As well as the rhythmic patterning, paintings from 1913 were characterised by rich colours. In the years between 1913 and 1922, Bunny's paintings reflected a change in contemporary decor and fashion. From the advent of the Ballets Russes in 1909 until the outbreak of war in 1914, orientalism was the dominant note in Paris — an orientalism of rich colours, arabesque curves, an abundance of drapery, soft cushions, rugs and a lavish use of pattern-on-pattern.

The apple of discord is an unusual depiction of the Judgement of Paris. Athena, a spear over one shoulder, wearing a helmet and carrying her distinctive shield, is leaving the scene to the left, head held high, while Hera, in a great hurry and quite possibly angry, is whipping

her horses forward. The stooping man with the winged helmet is Hermes, and the hillside is Mount Ida, where he brought Hera, Athena and Aphrodite to the beauty contest to be judged by Paris. Paris was a son of Priam, King of Troy, and the contest was part of a chain of events leading to the Trojan wars. Bunny's image shows Paris making obeisance to the winner, Aphrodite, who takes the apple from his hand.

The artist provides some of the conventional cues. Aphrodite, who had promised Paris the love of the most beautiful woman in the world in exchange for the apple, appears as a beautiful nude. Athena, who had offered victory in battle, is described in her warlike aspect (she had others). Hera offered dominion over the earth (hence the chariot, symbolising sovereignty, and her purple cloak, indicating royalty), and as she was goddess of the lower sky — specifically the atmosphere and moody weather — she rides the clouds.

Seeing the mythologies for the first time as a group in 1936, the painter and critic **George Bell** was struck by their 'new way of treating old stories'; Bunny, in adopting 'a new angle in stressing the human side of these, after all, very human fairy tales and turning his gods and goddesses into very human people, makes them much more accessible to us mortals and of easier relation to our own experience' (*Sun*, 23 September 1936).

Mary Eagle, 1991

F.C.B. Cadell
1883–1937

Scottish painter Francis Campbell Boileau Cadell was born on 12 April 1883 in Edinburgh, the son of a doctor. Initially influenced by **James McNeill Whistler**, he studied at the Royal Scottish Academy and at the Académie Julian and other studios in Paris from 1899 to 1903, where he viewed the works of the Impressionists. In 1905 and 1906 he also saw in Paris the work of Matisse and the Fauves. In 1906, when his father became ill, the family moved to Munich but, in 1908, following the death of his mother, the family returned to Edinburgh. He regularly spent his summers at Iona with S.J. Peploe. In 1910, he visited Venice and painted a set of impressionistic compositions in a loose, fluid manner, using touches of bright colour. He was a member of the Modern Society of Portrait Painters together with **George Bell**, **Gerald Kelly**, **George Lambert** and **Glyn Philpot** and, in 1912, he became a founder-member of the Society of Eight, a group of artists with strong Scottish connections, who included **John Lavery** and, later, Peploe. He became a popular figure in Edinburgh society, known for his flamboyant style of dress, his generous spirit, his infective gaiety and sardonic wit. Due to a heart condition, he was initially unable to serve in the First World War and worked on a farm in Galloway, but on recovery he served as an officer in the Argyll and Sutherland Highlanders, his experience in the trenches having a profound effect on him and his art. By 1920, he had replaced his fluid, impressionist approach with one using primary colours and flat forms painted with a smooth finish. With **J.D. Fergusson**, Leslie Hunter and Peploe, he became known as one of the Scottish colourists. A concern with elegance and optimism can be found in the best of all his work. Towards the end of his life he suffered from poor health, few of his paintings sold and he lived in genteel poverty. He died of cancer on 6 December 1937 in Edinburgh, aged 54.

r e f e r e n c e s : Tom Hewlett, *Cadell: The life and works of a Scottish colourist*, London: The Portland Gallery, 1988; Roger Billcliffe, *The Scottish colourists*, London: John Murray, 1989; Kenneth McConkey, *Impressionism in Britain*, London: Barbican Art Gallery, 1995; Philip Long, *The Scottish colourists 1900–1930*, London: Mainstream Publishing, 2001.

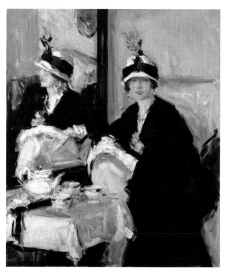

16 *Reflections*
painted in Edinburgh, c.1915
oil on canvas 116.8 x 101.6
Glasgow Museums: Kelvingrove
Art Gallery and Museum,
presented by David Perry in 1940

In his *Reflections* series, F.C.B. Cadell conveyed a world of elegance and refinement, through the clothes his women wore and in the interiors they inhabited. He enhanced the glamour of this realm by depicting objects reflecting light, such as the mirror and gleaming porcelain tea service seen here. He used his favourite model, Miss Bethia Don-Wauchope, for this series of paintings.

Cadell was inspired by Manet to paint rapidly and energetically and to be economic in his use of colour. As in *Reflections*, he often used a cool colour spectrum of blues, silvers and pale lilacs, set off by true whites.

Guy Peploe wrote:
> The almost complete lack of 'angst' in his work seems to derive from an intense love of life, a sensuous enjoyment of good living and an admiration for men who were masculine and women who were elegant. His subject-matter reflected his hedonism. Whether he was painting landscape, still life, interiors or figures, there was in it a glow of health and beauty. (Hewlett, 1988)

Gillian Ferguson

Ethel Carrick
1872–1952

English-born Australian painter, Ethel Carrick was born on 7 February 1872 in Uxbridge, near London, the daughter of a well-to-do draper. She initially trained at the Guildhall School of Music, before studying under Francis Bate and, from 1898 to 1903, at the Slade School under **Philip Wilson Steer** and **Henry Tonks**. Fellow students included **Hilda Fearon** and **Derwent Lees**. She then went to the artists' colony in St Ives in Cornwall, where she met Australian painter **E. Philips Fox**. They married in 1905 and settled in Paris, where their closest friends included **Rupert Bunny** for whom Carrick modelled occasionally. In 1908, Carrick made her first visit with her husband to Australia, staying in Melbourne for several months. She was made a *sociétaire* of the Salon d'Automne in 1911. In February 1911 the two painters travelled to Algiers, Bou Saâda and Tangier, returning to Paris via Spain. In 1913, Carrick and **Fox** returned to Australia where she became involved with the Theosophical Society in Sydney. In 1916, after **Fox**'s premature death, Carrick returned to Paris. Making this city her home, she continued to exhibit widely and gave private lessons to American and Australian students. She visited Australia in 1925 to promote an exhibition of **Fox**'s and her own works, also visiting India on this trip. In 1933 she again returned to Australia, and was successful in her campaign to persuade Australian art galleries to purchase Impressionist and Post-Impressionist works for their collections. During both world wars she organised art unions to raise money for the war effort. Her works are characterised by broad brushstrokes and vibrant colours. Her favourite subjects were market scenes, parks and flower gardens, beach and oriental scenes, genre interiors and especially flower pieces, all allowing her to experiment with intense colour and pattern. Carrick died in Melbourne during her eighth visit to Australia on 17 June 1952, aged 80.

references: Margaret Rich and Ruth Zubans, *Ethel Carrick (Mrs E. Phillips Fox): a retrospective exhibition*, Geelong, Geelong Art Gallery, 1979; Janine Burke, *Australian women artists: 1840–1940*, Melbourne: Greenhouse Publications, 1980; John Pigot, *Capturing the Orient: Hilda Rix Nicholas & Ethel Carrick in the East*, Melbourne Waverly City Gallery,

1993; Joan Kerr, *Heritage: The national women's art book*, Sydney: Craftsman House, 1995; Ruth Zubans, *E. Phillips Fox; His life and art*, Melbourne: The Miegunyah Press, 1995; Susanna de Vries, *Ethel Carrick Fox: Travels and triumphs of a post impressionist*, Brisbane: Pandanus Press, 1997; Mary Eagle, *The oil paintings of E. Phillips Fox in the National Gallery of Australia*, Canberra: National Gallery of Australia, 1997.

17 *Arabs bargaining*
painted in Paris, c.1911
oil on canvas 64.5 x 81.0
signed 'CARRICK FOX' lower left
exhibited: Salon d'Automne, Paris, 1912 (299, as 'Marché à Bou Saada'); 'Paintings by Mrs E. Phillips Fox (Miss Ethel Carrick)', Melbourne 1913 (4); 'Exhibition of Pictures by Mrs E. Phillips Fox (Miss Ethel Carrick)', Sydney, 1913 (3); Société des Peintres Orientalistes Francais, 21ᵉ Exposition, Paris, 1913 (150 as 'Le Marché de Bou Saâda')
Fosters Group, Melbourne

By 1911, when Ethel Carrick and her husband **E. Phillips Fox** first visited North Africa, it was already a well-established painting destination for western artists, and pictures of exotic oriental subjects had long been popular with European audiences. For Carrick, the intense light and colourful costumes of the Arab people provided a rich visual spectacle that allowed her to experiment with ever more intense blocks of colour and pattern in her work. In *Arabs bargaining*, Carrick's interest is as much in describing this commonplace market scene as in constructing a painting of abstract elements and high-keyed and vibrant colours. It is possibly the same locality depicted by **Fox** in his painting *A market in the desert* 1911 (New England Regional Art Museum, Armidale).

Carrick's and **Fox**'s trip is recorded in a letter from **Fox** to Hans Heysen: 'We had a most enjoyable trip staying 3 or 4 days at each place after leaving Bou Saâda and working everywhere. We were in travelling order and I had fixed up a special box which turned out quite a success also [as a] method of carrying our canvases' (quoted in Zubans 1995).

Elena Taylor

18 *The quay at Dinard*
painted in Paris c.1911
oil on canvas on plywood 71.0 x 91.5
signed 'CARRICK FOX' lower left
exhibited: Salon d'Automne, Paris, 1912 (298, as 'Sur le quai à Dinard'); 'Paintings by Mrs E. Phillips Fox (Miss Ethel Carrick)', Melbourne, 1913 (5)
National Gallery of Victoria, Melbourne, Felton Bequest in 1942

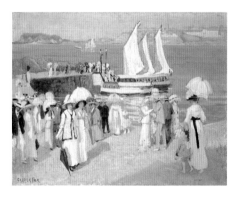

During the summers of 1909, 1910 and 1911, Ethel Carrick and **Fox** visited the French seaside towns of Trouville, St Mâlo and Dinard on the Channel coast. These towns were popular holiday destinations and Carrick's painting *The quay at Dinard* captures a mood of relaxed sociability and leisure as fashionably dressed men and women stroll along the harbourside. In the middle distance, a small group wait to board a small pleasure boat, which is gaily decorated with French flags, the colours echoed by Carrick's predominant use of white and blue with red highlights in her painting. Carrick depicts the dazzling light of the day in the reflections on the water and in the bright shadows cast by the figures. In *The quay at Dinard*, Carrick has created an image of a modern idyll, an elegant scene of outdoor pleasure where the protagonists are the middle classes enjoying the sunshine on a summer day.

Elena Taylor

George Clausen
1852–1944

English painter George Clausen was born in London on 18 April 1852, the son of a Danish interior decorator father and a Scottish mother. He initially worked for a firm of decorators then, encouraged by the painter Edwin Long, he studied art at the South Kensington Schools from 1873 to 1875. After seeing the work of Jules Bastien-Lepage around 1880, Clausen began to work along the lines of the French plein-air school, painting naturalistic scenes of farm labourers using a square brush technique. In 1886, he was a founder member of the New English Art Club with **Stanhope Forbes**, **Philip Wilson Steer** and **Henry Scott Tuke**. With his friend Henry Herbert La Thangue he became a keen advocate for the reform of the Royal Academy. In 1889, as he grew to admire the paintings of Courbet and Monet, he moved away from the influence of Bastien-Lepage to create his own form of Impressionism, working with a more luminous palette and using a more fluid approach to convey a sense of figure movement. He settled in London in 1905, where his friends included **William Rothenstein, Charles Ricketts** and **Charles Shannon**. From 1904 to 1906, Clausen was professor of painting at the Royal Academy Schools. As adviser to the Felton Bequest of the National Gallery of Victoria, Melbourne, from 1906 to 1907, he recommended the purchase of Corot's *Sketch At Scheveningen* 1854 as well as works by **William Rothenstein** (*Aliens at prayer* 1905) and **Philip Wilson Steer** (*The Japanese gown* 1896). He was president of the Chelsea Arts Club when **Tom Roberts** was vice-president. During the First World War, he was a British official war artist, producing paintings of gun manufacture. From the 1920s onwards, he painted small landscapes of the countryside around his Essex cottage, as well as a mural for the palace of Westminster. In 1908, he was elected a full member of the Royal Academy and was knighted in 1927. His collected lectures, *Six lectures on painting* (1904) and *Aims and ideals in art* (1906) demonstrate his study of the methods of the old masters. On 23 November 1944 he died at Cold Ash near Newbury, Berkshire, aged 92.

references: Dyneley Hussey, *George Clausen*, London: Ernest Benn, 1923; Kenneth McConkey, *Sir George Clausen, RA 1852–1944*, Bradford and Newcastle: Bradford Art Galleries and Museums and Tyne and Wear County Council Museums, 1980; Anne Kirker, *The first fifty years: British art of the 20th century*, Wellington: National Art Gallery of New Zealand, 1981; Kenneth McConkey, *Impressionism in Britain*, London: Barbican Art Gallery, 1995.

19 *The haymakers*
painted at Widdington, Essex, England, 1903
oil on canvas
77.0 x 64.3
signed and dated 'G. Clausen/1903' lower left
exhibited: Royal Academy, London, 1903 (442); 'British Fine Art', Crystal Palace, London, 1911; 'Baillie Exhibition of the Works of British artists', Wellington, 1912 (14); 'New Zealand Academy of Fine Arts Exhibition of the National and Academy Collections', Wellington, 1912
Museum of New Zealand Te Papa Tongarewa, Wellington

During the 1880s and 1890s, George Clausen painted many scenes of labourers in the fields and, in 1897, he produced the first of a series of barn and stable interiors which reflected his concern with extremes of light and shade. In *The haymakers*, Clausen combined his interest in interior and exterior views, viewing the scene from within the barn, *contre-jour*. In contrast to the theatricality of some Edwardian paintings, Clausen's work was simple and unaffected, although he tended to idealise rural themes. In their shared interest in depicting labourers out of doors, Clausen's images of rural workers have similarities to some of those by **E. Phillips Fox** and **John Peter Russell**.

However, on 10 June 1903, the *Guardian*'s critic Walter Armstrong drew attention to the fact that Clausen was as much interested in making a picture and with the effects of light as with his subject. He wrote: '"Haymakers," by Mr. George Clausen has little enough to do with making hay: an old man with a hay-rake, and two boys, make a fine pattern of colour and line against the evening sky, as they come towards the painter and through the barn door.'

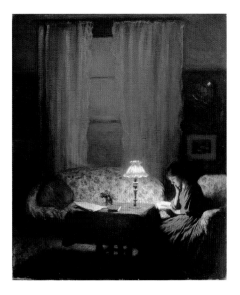

20 *Twilight: Interior (Reading by lamplight)*
painted in London, c.1909
oil on canvas 73.2 x 58.4
signed 'G. Clausen' lower right
exhibited: Royal Academy, London, 1909 (491, as 'Twilight: Interior')
Leeds Museums and Galleries, City Art Gallery, bequeathed by Stanley Wilson in 1940

Twilight: Interior depicts the artist's sitting room at 61 Carlton Hill, St John's Wood, London, looking out through the tall windows into the garden. It would be appropriate to see this 'dainty interior' (*The Times*, 4 May 1909) in terms of the contemporary work of **Ethel Walker** and **Harold Knight**. In this picture, Clausen's format is dictated by the shape of the window. As with many of his works of this period, he transferred the final image to the canvas by means of squaring up. This image was therefore not actually painted in the room it represents.

Contemporary critic, Abel Torcy, wrote in *The Studio*, December 1916: 'An interior *Twilight* shows Clausen freed from all extraneous influence. It is a charming picture, harmonious in composition and fine in sentiment. It marks the triumph of a painter who in his landscapes has striven to resolve the modern problems of light and *plein air*.'

Kenneth McConkey, 1980

George Coates
1869–1930

Australian painter George Coates was born on 9 August 1869 at Emerald Hill, Melbourne, the son of a bookbinder and his Irish-born wife. In 1884, he was apprenticed to the stained-glass firm, Ferguson and Urie, where he worked for seven years. He studied art at the North Melbourne School of Design, and was a part-time student from 1886 to 1896 at the National Gallery School, Melbourne, where he became one of the school's best draughtsmen. Fellow students included **Rose McPherson (Margaret Preston)**, Dora Meeson, **Max Meldrum**, **James Quinn** and **Hugh Ramsay**. From 1895 to 1896, Coates ran a drawing class in his Swanston Street studio, where his students included **George Bell**. He travelled to Europe in 1897 on a National Gallery Travelling Scholarship. He studied in Paris at the Académie Julian, where Meeson was a fellow student and **James Quinn** was a friend. In 1900, he moved to England where he became known principally as a portrait painter. In 1903, he married Meeson. About 1906, they rented **Augustus John**'s studio at 9 Trafalgar Studios, Chelsea, where Ambrose and **Mary McEvoy** were neighbours. As a source of income, Coates produced black-and-white illustrations for H.S. Williams' *Historians' history of the world* and the *Encyclopaedia Britannica*. Coates and Meeson supported the suffrage movement. During the First World War, Coates was an orderly at the 3rd London General Hospital, Wandsworth, alongside **C.R.W. Nevinson**, **Tom Roberts**, **Arthur Streeton** and **Francis Derwent Wood**. His painting *Casualty clearing station* 1920 (Australian War Memorial, Canberra), effectively conveys the emotional drama of war that he experienced while working in the hospital. In December 1921 he visited Australia, returning to England in 1922. After his return to England, he worked on further commissions for large historical paintings from the Australian War Records Section. An assiduous painter, he remained faithful to his essentially representative approach. He died suddenly of a stroke on 27 July 1930, aged 60.

references : Dora Meeson Coates, *George Coates: His art and his life*, London: J.M. Dent, 1937; Anne Gray and Gavin Fry, *Masterpieces of the Australian War Memorial*, Adelaide: Rigby, 1982; Karen Quinlin, 'George and Dora', *The World of Antiques and Art*, December 1999–June 2000; Myra Scott and Michael Varcoe-Cocks, 'The portrait of Arthur Walker and his brother Harold, (1912)', *Gallery*, April/ May 2001.

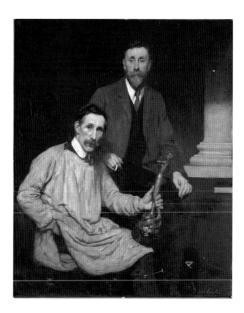

21 *Arthur Walker and his brother Harold (The Walker brothers)*
painted in London, c.1912
oil on canvas 158.6 x 130.4
exhibited: Royal Academy, London, 1912 (243, as 'Arthur and Harold Walker, Esquires'); Société Nationale des Beaux-Arts, Paris, 1913
National Gallery of Victoria, Melbourne, gift of Mrs George Coates in 1934

In *Arthur Walker and his brother Harold*, Arthur, wearing an artist's smock, holds a bronze statuette, possibly his most recent work, *Snake charmer*, which he exhibited the following year. Harold supportively sits behind him. George Coates implied the harmonious relationship between the two brothers through his use of a traditional composition and a subtle tonal scheme of muted greys and browns, and his sensitive use of cream against white, and of grey against black. He depicted the brothers in surrounding darkness, throwing into relief the two strongly-lit heads.

The sculptor **Arthur Walker** and his brother, Harold, were good friends with Coates and Dora Meeson, all living in Chelsea. In his rendition of the faces, Coates caught the honest earnestness and quiet good manners of both brothers and their 'old-fashioned grace'.

Meeson recorded that the Australian artist, John Longstaff, wrote to Coates in 1912: 'Went to the Academy yesterday. Want to tell you how much I appreciate your picture of the two Walkers. Amongst all the banalities in portraiture it stands out as something real and vital' (Meeson Coates, 1937).

Charles Conder
1868–1909

Anglo-Australian painter Charles Conder was born on 24 October 1868 in Tottenham, Middlesex, the son of a civil engineer. His father sent him to Sydney in 1884, where he spent two years working in surveying camps in rural New South Wales. From 1887 to 1888 he worked as a line illustrator for the *Illustrated Sydney News* and studied painting with Julian Ashton and A.J. Daplyn. He made plein-air excursions in the Hawkesbury region and around Sydney's beaches, including Coogee, where he painted with **Tom Roberts**. In Sydney, aged 19, he contracted syphilis from his landlady. In 1888, he joined **Roberts** in Melbourne and painted with Frederick McCubbin at Mentone and **Roberts** and **Arthur Streeton** at Eaglemont. In 1889, he studied at the National Gallery School, Melbourne, and was a major instigator with **Roberts** and **Streeton** of the '9 by 5 Impressions' exhibition, named after the size of the small cedar panels that the artists painted on. In his few years in Australia, Conder produced a remarkable body of work in which he expressed his natural instinct for colour and design. In 1890, he returned to Europe and studied in Paris at the Académie Julian, where he became friends with **William Rothenstein**, and in 1891 he attended the Académie Cormon. While frequenting the cabarets at Montmartre, he became a friend of Louis Anquetin and Toulouse-Lautrec. Bohemian to the core, he lived a life of passionate excess, but was also dedicated to his work, dividing his time between painting in the countryside and in his city studio. For a period from 1893 he moved between London, Dieppe and Paris. His English friends included the writers and artists Aubrey Beardsley, Ernest Dowson, Arthur Symons and Oscar Wilde, as well as Charles Ricketts and **Charles Shannon**. He was also a friend of **Jacques-Emile Blanche** and **Walter Sickert**. Conder made many works using the medium of watercolour on silk and painted innumerable designs for fans, which resulted in some of his most exquisite images. He created a poetic world evoking the spirit of *fêtes galantes*, with lovers and troubadours in beautiful settings. He also produced a significant body of lithographs based on tales by Balzac and Murger's *La Vie de Bohème*. In 1898, Conder visited La Roche-Guyon with **Rothenstein** and others and, in 1899, he painted at Vattetot-sur-mer with **Augustus John**, **William Orpen**,

Rothenstein and **Albert Rutherston**. In 1901, he married Stella Belford and in 1904 settled in Chelsea, London. In 1904, the Australian-born patron, Sir Edmund Davis, commissioned him to design rooms for his home in Lansdowne Road, London. Conder gradually descended into syphilitic madness and died in an asylum for the incurably insane on 9 February 1909 at Virginia Water, Surrey, aged 40.

references: T. Martin Wood, 'A room decorated by Charles Conder', *The Studio*, vol. 44, April 1905; Frank Gibson, *Charles Conder: His life and work*, London: John Lane, The Bodley Head, 1914; John Rothenstein, *The life and death of Conder*, London: Dent, 1938; Augustus John, *Chiaroscuro*, London: Jonathan Cape, 1952; Ursula Hoff, *Charles Conder*, Melbourne: Lansdowne, 1972; Ann Galbally and Anne Gray (eds), *Letters from Smike: The letters of Arthur Streeton 1890–1943*, Melbourne: Oxford University Press, 1989; Mary Eagle, *The oil paintings of Charles Conder in the National Gallery of Australia*, Canberra: National Gallery of Australia, 1997; Ann Galbally, *Charles Conder*, Melbourne: Miegunyah Press, 2002; Ann Galbally and Barry Pearce: *Charles Conder*, Sydney: Art Gallery of New South Wales, 2003.

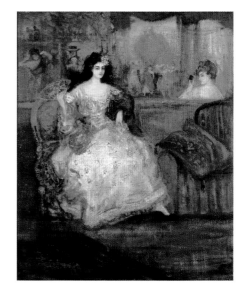

22 *Femme dans une loge au theatre (In the foyer)*
painted in London or Paris, 1895–1901
oil on canvas 75.0 x 62.0
signed 'CONDER' lower left
The Holmes à Court Collection,
Heytesbury Pty Ltd, Perth

Charles Conder often depicted groups of women in elegant costume, engaged in conversation or sitting out at a theatre or ball. The women's poses and dresses in *Femme dans une loge au theatre* resemble those in Condor's lithograph, *Gossip (Conversation)* 1905. The women in *Femme dans une loge au theatre* appear to be in competition with each other, with one woman looking at the viewer and the other, somewhat suspiciously, at her companion.

For some at this time life itself was theatrical, with George Bernard Shaw commenting that 'public and private life become daily more theatrical'. People frequented the theatre and the music halls, where they watched each other as much as they looked at the performers on the stage. Images portraying men and women in theatre boxes were common. Artists as diverse as Mary Cassatt, Degas, **Spencer Gore**, **Walter Sickert** and Toulouse-Lautrec depicted theatre subjects through which they suggested the artifice of their daily lives.

23 *Elegant ladies by a garden pavilion*
painted in London, 1904
watercolour on silk, grisaille
74.0 x 135.2
National Gallery of Australia,
Canberra

24 *Pastoral (A river landscape with ladies and anglers)*
painted in London, 1904
watercolour on silk, grisaille
75.0 x 136.0
The Holmes à Court Collection,
Heytesbury Pty Ltd, Perth

25 *Maidens on a terrace by the sea*
painted in London, 1904
watercolour on silk, oval shaped
27.0 x 47.0
Barry Humphries Collection

Elegant ladies by a garden pavilion, *Pastoral (A river landscape with ladies and anglers)* and *Maidens on a terrace by the sea* belong to a group of watercolours commissioned by Sir Edmund Davis in 1904 for the decoration of rooms in his house at 11–13 Lansdowne Road, Holland Park.

T. Martin Wood wrote about Conder's decorations for Davis' house in *The Studio* in April 1905:

> the selection of no other artist to fill these panels could have been so successful as that of Mr Conder. His temperament has enabled him to enter the spirit of the scheme, for above everything else he is a decorator, in the sense that Watteau and his school were decorators … Beauty with him in these panels is light and decadent; they are full of fancy, crowded with images, pictures and memories of faded things.

He concluded:

> To know that we have amongst us a fine artist of sufficient courage to paint his fancies for their own sake, refusing to correct his art by any standard but that of the pleasure which it gives him and to have in him a fastidious exquisite who closes his lids to the ugly, and pretends that it does not exist, is, indeed, refreshing among the various artistic ideals of today.

Frank Gibson, in his monograph on Conder, maintained that Conder's decorations were his distinctive achievement, writing: 'He showed his genius in the decorative panels he designed, in his own distinctive style, for Mr. Bing, Mr. Edmund Davis, and others.

These were achievements which would have gained him in other ages constant employment in adorning public buildings or palaces.' He described Conder's decorations for Sir Edmund Davis:

> In the upper room, a bed-chamber, they form a frieze, fit decorations for such a place, for the sleeper awakes in an atmosphere filled with the beauty of dreams. They illustrate no particular story, but are just decorated panels which add grace and dignity to beautiful rooms exquisitely furnished. They are decorations which are not only the most pleasing in colour and design, but sensuous with the warmth of luxury. The decoration of these panels is full of fancy. (Gibson, 1914)

The two rooms that Conder decorated were the drawing room (the lower of the two rooms), which was decorated with a series of oval silk panels, painted in colour, set into satin-wood panelling, and an upper room, a bed-chamber, where rectangular grisailles formed a frieze (this second room has also been described as Davis' study).

The silks were removed from the rooms and sold through auction during the 1970s. About this time, facsimile photographs were made of the silks from both rooms and placed in a wood-panelled room which is now a bedroom in the house. This room includes both a frieze of photographs of rectangular silks and below this, a small group of photographs of oval silks that were painted in colour.

Elegant ladies by a garden pavilion and *Pastoral (A river landscape with ladies and anglers)* are two of the 10 rectangular panels for the monochrome frieze that was originally placed in the Davis' bed-chamber. *Maidens on a terrace by the sea* is possibly one of the oval silk panels that were originally placed in the Davis' drawing room but subsequently moved to the bedroom.

26 *Sonnet*
painted in London, 1904
watercolour on silk, grisaille
75.0 x 85.0
Philip Bacon Collection, Brisbane

Sonnet is the right-hand side of a larger rectangular composition, *Figures in a courtyard* (75.0 x 196.0 cm), formerly in Sir Edmund Davis' collection. *Figures in a courtyard* is most likely one of the 10 rectangular panels for the monochrome frieze that was originally placed in the Davis' bed-chamber at Lansdowne Road, Holland Park.

The left hand side of the composition (which was auctioned as an entire work in 1977) shows ladies and gentlemen with a sculpture. It is as if they are performers on a stage, which the right hand group is watching.

27 *A decoration*
painted in London, 1904
watercolour on silk, mounted
on cedar 224.0 x 127.0
signed 'CONDER' lower right
exhibited: 'Charles Conder', Leicester
Galleries, London, 1913 (16) ?
National Gallery of Australia,
Canberra

A decoration was described by Frank Gibson, Conder's biographer:

> Five [sic] ladies arrayed in summer costume assemble in a garden bathed in shimmering sunshine full of fragrant blossoms. The oval above this holds a composition showing two women exchanging confidences under twilight sky. The whole panel seems to be a painted summary of a summer's day. It is well named, for it is a perfect piece of decoration and fully reproduces the charm and poetry of such a day. (Gibson, 1914)

A decoration includes features that are typical of Conder's work, such as the oval medallion, wreaths and ribbons, and decorative borders. Inside the medallion, Conder depicted two women in elegant costume conversing, a variation on the theme of the two women in the oil painting, *Femme dans une loge au theatre*, and the lithograph, *Gossip*. In the lower half of the painting, the elegant ladies in the garden wearing fine outfits are variations on those in *Pastoral (A river landscape with ladies and anglers)* and *Elegant ladies by a garden pavilion*.

A decoration was once owned by Pickford Waller, a collector of Conder's work, as well as that of **Spencer Gore**, **George Lambert**, **William Nicholson** and **Charles Shannon**. In his house in Pimlico, Waller placed the large decorative piece in a room that was entirely hung with Conder's works. Waller commissioned **Nicholson** to paint an interior portrait group of himself and his daughter, Sybil. In the resultant painting, *The Conder room* 1910 (private collection), **Nicholson** portrayed Waller seated in front of *A decoration*, with Sybil standing beside it.

28 *Ladies at leisure*
painted in London, 1904
watercolour on silk, fan-shaped
20.5 x 47.0
signed and dated 'Conder 1904'
lower right
National Gallery of Australia,
Canberra

Conder began to paint fan designs in 1893, gaining a reputation for his work in this genre. He was indebted to French 18th-century fan designs, and to Japanese and Chinese art where the fan shape was common, but he developed his own unique approach. The fluidity of the wash and the fine surface of the silk enabled him to achieve subtle hues and delicate outlines, which suited his fanciful subjects. He could work quickly and with greater spontaneity in these works than he could when painting in oil on canvas. He was attracted to the challenge of placing his figures within the limited form of the fan shape, and he showed considerable inventiveness in his designs. His fans often include little oval panels, wreaths and ribbons, as in *Ladies at leisure,* while others have decorative lace-like borders. His subjects are varied, but are often idyllic themes of people at leisure, relaxing outdoors.

Streeton wrote to **Roberts** on 8 January 1901: 'I haven't seen [Conder] for near 2 years — but his fans — water color on silk I don't think *could* be more beautiful — its unrobust work — but beautiful.'

In his autobiography, *Chiaroscuro* (1952), **Augustus John** described Conder at work painting his fans:

> Seated in the village café with a bottle of Pernod at his elbow, used both for its refreshing properties and as a medium for his brush, he painted fans, filling the silken fabric before him with compositions illustrative of the Commedia dell'Arte or Verlaine's Fetes Galantes. His elegant figures, posturing in a moon-blue ambience, had recaptured from Watteau or St Aubin a romantic languor which owed nothing to the rusticity of his surroundings, nor recalled in any way his upbringing on an Australian sheep range.

Philip Connard
1875–1958

English painter Philip Connard was born on 24 March 1875 in Southport, Lancashire, the son of a house painter. He began work as a house painter and attended evening classes in art, which resulted in a scholarship to study textile design at the Royal College of Art from 1896 to 1898. In 1898, this led to another scholarship to study painting in Paris at the Académie Julian, under Jean-Paul Laurens. He worked for a short time as a designer in a carpet factory in Liège. On his return to London, he worked as an illustrator and taught at the Lambeth School of Art, where he met his wife, who was there as a student. Under the influence of **Philip Wilson Steer**, whom he accompanied on painting trips, Connard adopted a lively, impressionistic handling of paint. He painted family portrait groups, interior scenes and plein-air landscapes in London, Suffolk and Norfolk, focusing on the fleeting effects of light. From 1908 to 1915, he became friends with, and had an important influence on, **George Bell**, and the two artists went on painting trips together. In 1912, he gave up teaching to paint full time. From this time until the 1930s his chief reputation derived from romantic and decorative landscapes in oils. He was a faithful member of the Chelsea Arts Club, where he gathered with **William Orpen** and **Francis Derwent Wood**, and attained a reputation as a raconteur. **George Lambert** made a pencil portrait of him. During the First World War, he served in France until he was invalided out in 1916, when he became a British official war artist to the Royal Navy. In 1925, he was elected a full member of the Royal Academy. From 1932, he lived in Richmond, Surrey where he painted many riverside scenes. He was keeper of the Royal Academy Schools from 1945 to 1949. In later years he developed an interest in painting watercolours. His major commissions include a decorative panel on the subject of England for the dining room of the liner, *Queen Mary*. He painted a portrait of Rupert Murdoch and his sister Helen. He died at Twickenham Hospital, Middlesex, on 8 December 1958.

references: Frederick Wedmore, 'Philip Connard', *The Art Journal*, 1909; Marion Hepworth Dixon, 'The Paintings of Philip Connard', *The Studio*, vol. 57, January 1913; Jessica Walker Stephens, 'The Paintings of Phillip Connard', *The Studio*, vol. 85, June 1923; MaryAnne Stevens (ed.), *The Edwardians and after: The Royal Academy 1900–1950*, London: Royal Academy of Arts, 1988; Kenneth McConkey, *Impressionism in Britain*, London: Barbican Art Gallery, 1995.

29 *The guitar player*
painted in London, c.1909
oil on canvas 62.2 x 50.8
signed with monogram lower right
exhibited: New English Art Club, London, Spring 1909 (149); 'Third exhibition of Fair Women', International Society of Sculptors, Painters and Gravers, London 1910 (150); National Portrait Society, London, 1911 (4, as 'Woman playing a guitar')?; 'The Contemporary Art Society, First Public Exhibition in London', Goupil Gallery, London, 1-12 April 1913 (31, as 'The Guitar Player')
Art Gallery of South Australia, Adelaide, Morgan Thomas Bequest Fund in 1933

In *The guitar player*, Philip Connard depicted his daughters Jane and Helen, and the family cat James, who also feature in *Jane, Evelyn, James and Helen* 1913 (Tate, London). The woman seated on a couch playing the guitar is possibly the children's nursemaid, Evelyn, also represented in that painting. The standing woman at the back is Connard's wife, who features in *Woman on a balcony* 1909 (Tate, London), with the same black and white shawl draped over her shoulders. Connard portrayed himself at work, reflected in the mirror at the back of the room.

However, *The guitar player* is more than just a celebration of family life. Connard painted it using a kind of tonal impressionism derived from Velasquez in his painting *Las Meninas* 1656 (Prado, Madrid). In Connard's work, the guitar player is the main focus, in the place of Infanta in Velasquez's masterpiece, with his two daughters on either side of the musician in the places of the Infanta's companions.

In *The Studio*, vol. 57, January 1913, Marion Hepworth Dixon noted Connard's interest in the everyday world, and in the painterly aspects of his art:

> Life for him … is no impenetrable riddle. On the contrary, it is something to portray and enjoy. At the same time it should be said that Mr. Connard is a painters' painter in the sense that his manifest delight is in his pigments …With Mr. Connard it is not the fascination of the unknown, but rather the actual thing seen which haunts and preoccupies him.

Bessie Davidson
1879–1965

Australian painter Bessie Davidson was born on 22 May 1879 in Adelaide, the daughter of a Scottish immigrant father and an English mother. From 1899 to 1904 she studied painting with **Rose McPherson (Margaret Preston)**, who became a close friend. In 1904, she travelled overseas with her teacher, intending to study at the Künstlerinner Verein, a government-run women's art school in Munich, but spent only a short time there before moving to Paris. In Paris from 1904 to 1906, she studied at the Académie de la Grande Chaumière and developed a friendship with **Rupert Bunny**. She also became friendly with Lucien Simon and his family, spending summer holidays with them in Brittany, painting scenes of Breton life. She returned to Adelaide at the end of 1906, where she leased a studio and taught art with **McPherson** and where, in 1907, they held a combined exhibition. Davidson's style ranged from a more academic and sombrely tonal approach, as in the portrait of her friend, **Gladys Reynell**, to works in a lighter, more 'impressionistic' manner. In 1910, she returned to Europe and made her headquarters in Paris, but travelled widely in France, Britain and Europe. Between 1910 and 1914, she devoted herself increasingly to *portraits d'intérier*, depicting her friends and their children in light-filled interiors. In 1914, she visited Australia but, when war broke out, she returned to Paris to serve with the French Red Cross as a volunteer nurse. Afterwards, she was active in Parisian artistic life. In the 1920s, she painted landscapes and still lifes in a freer style, characterised by a vigorous handling of paint. In 1922, she was the first Australian woman to be made a *sociétaire* of the Société Nationale des Beaux-Arts, Paris. In 1930, she was vice-president of the Salon des Femmes Artistes Moderne and, in 1931, she was made a Chevalier of the Legion d'Honneur for her contribution to art and humanity. During the Second World War, she lived at Grenoble where she continued to paint. In 1944, she returned to her Montparnasse studio in Paris to live and work. She often stayed at her farm at Buchy, near Rouen, and every year she visited relatives in Scotland. Although she never relinquished her Australian citizenship, she made only one more trip to Adelaide, in 1951. She died in Paris on 22 February 1965, aged 85.

references: Roger Butler, *The prints of Margaret Preston*, Canberra: National Gallery of Australia, 1987; Jane Hylton, *South Australian women artists: Paintings from the 1890s to the 1940s*, Adelaide: Art Gallery of South Australia, 1994; Penelope Little, 'The beauty of common things: The rediscovery of Bessie Davidson', *Art and Australia*, vol. 36, no. 4, 1999; Penelope Little, *Bessie Davidson*, 2003.

30 *Le Livre vert*
painted in Paris, 1912
oil on canvas 92.0 x 73.0
signed 'Bessie Davidson' lower right
exhibited: Société Nationale des Beaux-Arts, Paris, 1912 (385)
private collection

Le Livre vert is typical of the 'portrait of an interior' genre that was fashionable in Paris at this time. Davidson's painting evokes an atmosphere of feminine domesticity and private reverie, while at the same time employing decorative elements to convey a certain sense of mystery and to hint at double entendre. The atmosphere becomes less serene than at first glance, the mood seems charged with tension, the hastily-arranged, vibrant red hair barely restrained and impatience emanating almost palpably from a body poised ready to spring to its feet. Forthrightness is in the nature of this sitter, but even so there is something enigmatic about this scene.

The young woman may well be **Rose McPherson** who visited Paris in 1912 and who, with **Gladys Reynell**, lodged in an apartment formerly occupied by Bessie Davidson.

Penelope Little

Malcolm Drummond
1880–1945

English painter Malcolm Drummond was born at Boyne Hill, Berkshire on 24 May 1880. He studied history at Christ Church, Oxford University, from 1889 to 1902, before attending the Slade School from 1903 to 1907, where he studied under **Philip Wilson Steer** and **Henry Tonks**; fellow students included **Hilda Fearon** and **Harold Gilman**. He also studied from 1908 to 1910 at the Westminster Technical Institute under **Walter Sickert**, with whom he formed a long-lasting friendship. He joined the Camden Town Group, sharing their interest in painting urban scenes and interiors with figures. He subsequently became a member of the London Group with **Henri Gaudier-Brzeska**, **Gilman**, **Spencer Gore**, **C.R.W. Nevinson** and **Sickert**. He painted a striking portrait of his friend Charles Ginner (1911), which reflects the two artists' sympathy with each other, and their shared interest in using strong colours and bold patterns. With the others, he observed what was happening in French art and considered how he might apply it in his own work. He used vivid colours and simplified forms to depict everyday subjects. During the First World War, he worked in munitions and in the War Office. He taught at the Westminster Technical Institute from 1925 to 1931. When his wife died in 1931, he settled in Moulsford in Berkshire. He lost his sight in 1943 and died on 10 April 1945, aged 64.

references: Henry James, 'London', *English hours*, [1905], London: Heinemann, 1960; Wendy Baron, *The Camden Town Group*, London: Scolar Press, 1979; Stephen Snoddy, *Pintura Británica Moderna*, Bilbao: Museo de Bellas Artes de Bilboa, 1997; Angus Trumble, *Bohemian London: Camden Town and Bloomsbury paintings in Adelaide*, Adelaide: Art Gallery of South Australia, 2001; Wendy Baron, *Perfect Moderns: A history of the Camden Town Group*, Aldershot: Ashgate, 2000.

31 *At the piano (The piano lesson)*
 painted in London, c.1912
 oil on canvas 89.5 x 60.6
 signed 'Drummond' lower right
 exhibited: 'Camden Town Group',
 London, 1912 (27)
 Art Gallery of South Australia,
 Adelaide Reproduced courtesy of
 Bridgeman Art Library 2004

In his book on Bohemian London, Angus
Trumble commented:

> *At the piano*, with its strong, deliberate
> technique and saturated colouring, takes
> us into a domestic world not unlike that
> of **Vanessa Bell** … The eyes of both
> women appear to concentrate on the
> invisible score — one woman playing,
> the other following. This mood of
> concentration extends throughout the
> picture … Drummond gathers into the
> space around them a cluster of detail
> which combines to suggest serious
> intellectual activities — reading, music-
> making and painting ... The colours
> are so vibrant that they almost destroy
> the illusion of closed space into which
> the artist pours them. (Angus Trumble,
> 1997)

It is likely that the pianist is Malcolm
Drummond's first wife Zina (née Ogilvie),
a book illustrator and, like her husband, an
accomplished musician. The standing figure
could be Mrs Bevan, a close friend of the
Drummonds. According to Wendy Baron, the
small picture above the seated figure is Charles
Ginner's *Neuville Lane*, a gift of the artist to
Drummond.

Other members of the Camden Town Group
painted images of women playing at the
piano, as did **James McNeill Whistler**,
Degas and Manet. In titling his painting,
At the piano, Drummond paid homage to
Whistler's painting from 1858–9 of the same
title. Drummond also drew from **Whistler**
his strong use of profile in this painting. The
bright colours reflect Drummond's admiration
for the work of the Post-Impressionists.

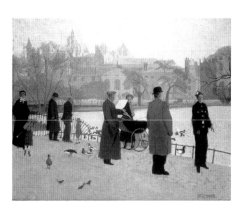

32 *In the Park (St James's Park)*
 painted in London, 1912
 oil on canvas 72.5 x 90.0
 signed 'Drummond' lower right
 exhibited: 'Camden Town Group',
 London, 1912 (29); Salon des
 Indépendants, Paris, 1913 (905);
 'English Post-Impressionists, Cubists
 and Others', Brighton Art Gallery,
 1913–14 (133)
 Southampton City Art Gallery
 Reproduced courtesy of Bridgeman
 Art Library 2004

Of all Drummond's views of London, *In the
Park* is the largest and most impressive, with
these silhouetted figures depicted as if arrested
in time. Drummond created a restrained
composition using a diagonal division of the
picture plane into land and water.

Reviewing the 1912 Camden Town Group
exhibition, *The Times* art critic commented on
the bright colours in Drummond's *In the Park*
and in paintings by other artists that had been
inspired by the 1910 exhibition, 'Manet and
the Post-Impressionists'. Drummond found
his inspiration for this picture in Seurat's
Un dimanche après-midi à l'Ile de la Grande Jatte
1884–6 (Art Institute of Chicago).

Henry James commented about this park in
The Century Magazine, December 1888:

> This popular resort has a great deal of
> character, but I am free to confess that
> much of its character comes from its
> nearness to the Westminster slums.
> It is a park of intimacy, and perhaps
> the most democratic corner of London,
> in spite of its being in the royal and
> military quarter and close to all kinds of
> stateliness. There are few hours of the
> day when a thousand smutty children
> are not sprawling over it, and the
> unemployed lie thick on the grass and
> cover the benches with a brotherhood of
> greasy corduroys. If the London parks
> are the drawing-rooms and clubs of the
> poor … these particular grass-plots and
> alleys may be said to constitute the very
> *salon* of the slums. (James, [1905], 1960)

Hilda Fearon
1878–1917

English painter Hilda Fearon was born on 14 September 1878 at Banstead, Surrey. She studied art in Dresden from 1897 to 1899, and at the Slade School from 1899 to 1904 under **Philip Wilson Steer** and **Henry Tonks**; fellow students included **Ethel Carrick**, **Malcolm Drummond** and **Harold Gilman**. She later worked under Algernon Talmage at St Ives, Cornwall, where she would have met up with **Carrick** and **E. Phillips Fox,** and where she painted many pictures in the open air. She lived in London where she painted figure subjects, landscapes and still lifes. Her subjects are often girls indoors, either at a table or in a ballet class. Her interiors are cool in colour and feeling, and she liked to depict the shine on china and glass. In her landscapes she conveyed the feeling of sun and wind. She died on 2 June 1917 from puerperal convulsions, aged 38.

references: Charles Marriott, 'The paintings of Miss Hilda Fearon', *The Studio*, vol. 63, no. 259, October 1914; 'Hilda Fearon', in Mary Chamot, Dennis Farr and Martin Butlin, *Tate Gallery: The modern British paintings, drawings and sculpture*, 2 vols, London: Oldbourne Press, 1964, "Hilda Fearon", in Penny Dunford, *A biographical dictionary of women artists in Europe and America since 1850,* Hemel Hempstead: Harvester Wheatsheaf, 1990.

33 *Studio interior*
painted in London, 1914
oil on canvas 99.3 x 84.4
Art Gallery of South Australia,
Adelaide, gift of Sir Will Ashton
in memory of his parents in 1945

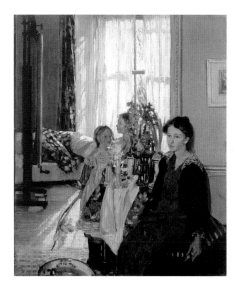

In *Studio interior*, the seated woman and two children do not seem to relate to each other; they sit and stand in this room like figures on a stage, posed for their portrait. But sunlight streams through a French window, suggesting a brighter, more energised world beyond this intimate interior.

The tall windows, high walls and deep cornices suggest this is a drawing room in a comfortable house. It is closer to the images of rooms filled with fine polished furniture, china and plants by Slade teachers, **Philip Wilson Steer** and **Henry Tonks**, than to the spare 'artistic' rooms depicted by artists like **Gwen John**. Yet the clothes of Hilda Fearon's woman and children have a simplicity that is more reminiscent of garments portrayed by **John** than the pretty, flouncy dresses depicted by **Steer** and **Tonks**.

J.D. Fergusson
1874–1961

Scottish painter and sculptor, John Duncan Fergusson was born on 9 March 1874 at Leith, Perthshire, into a farming family. He initially planned a medical career but abandoned this to pursue art, making frequent visits to Paris between 1895 and 1907, where he attended life classes at the Académie Colarossi. Visits to Normandy with the Scottish artist S.J. Peploe stimulated his interest in tone and design. Dividing his artistic life between France and Scotland, Fergusson's portraits of women at this time show the influence of **James McNeill Whistler** in composition and colour range. In 1907, he settled in Paris, teaching at **Jacques-Emile Blanche**'s atelier, and became a friend of **Rupert Bunny**. Already painting in the Fauve manner, he was inspired by Diaghilev's Ballets Russes to evolve a more modernist style, characterised by flat areas of vivid colour. By 1910 he was painting in a more rigorous manner, and he began to explore vitality and movement in his nude studies. He became art editor of John Middleton-Murry and Katherine Mansfield's *Rhythm* magazine in 1911. In the summers of 1910 and 1911 he painted scenes of Royan, near La Rochelle. In 1914 Fergusson and his wife, the dancer Margaret Morris, returned to London. In 1918, his experience of painting in the naval dockyards of Portsmouth was the catalyst for a new architectural vision that linked him to the Futurists and the Vorticists. Together with **F.C.B. Cadell**, Leslie Hunter and Peploe, he became known as one of the Scottish colourists. In 1929 he resettled in Paris, but in 1939 returned to Glasgow where he published *Modern Scottish painting* (1943). He died in Glasgow on 30 January 1961, aged 86.

references: Frank Rutter, *Some contemporary artists*, London: Leonard Parsons, 1922; Margaret Morris, *The art of J.D. Fergusson*, Glasgow: Blackie, 1974; Kenneth McConkey, *Edwardian portraits: Images of an age of opulence*, Woodbridge: Antique Collectors' Club, 1987; Roger Billcliffe, *The Scottish colourists*, London: John Murray, 1989; Philip Long, *The Scottish colourists 1900–1930*, London: Mainstream Publishing, 2001.

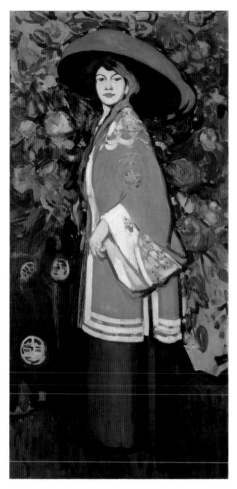

There could be no finer example of the flat decorative style of Fauve portraiture than *Le Manteau chinois*. Despite its title and oriental accoutrements, the picture is not a belated exercise in **Whistlerian** 'Japonisme'. On the contrary, Fergusson has painted his full-length portrait in a bold flat manner, emphasising basic shapes rather than modelling. The blue unmodulated 'manteau' contrasts with the reds of the roses and cartouches in the backdrop and these, in the words of Frank Rutter, 'accentuate and simplify the essential characteristics of the personality portrayed' (Rutter, 1922). In this instance, the features are those of Anne Estelle Rice (1877–1959), the Irish–American painter from Philadelphia. The two young artists had met in 1906 when Rice was sent to Paris by the proprietor of a Philadelphia department store to provide news and illustrations for his trade paper. She established herself quickly in Paris and in 1910 her *Danseuses Égyptiennes* was hailed at the Salon. From 1907 to 1909 she modelled regularly for Fergusson.

Kenneth McConkey, 1987

34 *Le Manteau chinois*
painted in Paris, 1909
oil on canvas 195.5 x 97.0
exhibited: Salon d'Automne, Paris, 1909 (547); 'Autumn Exhibition of Modern Art', Walker Art Gallery, Liverpool, 1912 (182)
The Fergusson Gallery, Perth and Kinross Council, Scotland

Stanhope Forbes
1857–1947

English painter Stanhope Forbes was born on 18 November 1857 in Dublin, the son of an English railway manager and a French mother. From 1874 to 1876, he attended the Lambeth School of Art and, from 1876 to 1878, the Royal Academy Schools. Whilst studying, he accepted portrait commissions as a source of income and continued to do so throughout his life. He studied in Paris with Léon Bonnat from 1880 to 1882. He became interested in the work of naturalist artists such as Jules Bastien-Lepage and painted outdoors in Brittany in the summer of 1881 with Henry La Thangue, a fellow student from the Royal Academy Schools. Using a plein-air realist approach, he continued to paint in Brittany, at Concarneau and at Quimperlé near Pont Aven. He returned to London in 1883 and then moved to Falmouth. In 1884, he discovered the Cornish fishing village of Newlyn, where the mild climate facilitated outdoor painting and, in 1889, with his wife Elizabeth, he settled there permanently. He painted images of fishermen and farm labourers at work. He believed that works should be completed in situ. In 1886, Forbes became a founding member of the New English Art Club, together with **George Clausen**, **Philip Wilson Steer** and **Henry Scott Tuke**. However, he did not remain a member for long, partly because he was critical of the work of **Walter Sickert** and his followers who also showed with the club, considering their choice of subject matter to be tawdry. In 1899, he and his wife opened the Newlyn School of Painting, which continued until 1938 and helped to foster a second generation of artists working in and around Newlyn, including **Ethel Carrick** (who attended the summer school in 1903). He became a friend of **Harold** and **Laura Knight** in 1907 when they moved to Newlyn, and of **Alfred Munnings** in 1911 when he moved to Lamorna, Cornwall. He would also have met the Australian artist, **George Bell**, who moved to St Ives at this time. Around 1910, he introduced a lighter and brighter colour range into his painting. That year, he was elected a full member of the Royal Academy. In 1912, his wife died and then, in the First World War, his son Alec died in action. On 2 March 1947, Forbes died at Newlyn, aged 90.

references: Mrs Lionel Birch, *Stanhope A. Forbes ARA and Elizabeth Stanhope Forbes ARWS*, London: Cassell & Co., 1906; Caroline Fox and Francis Greenacre, *Painting in Newlyn 1880–1930*, London: Barbican Art Gallery, 1985; MaryAnne Stevens (ed.), *The Edwardians and after: The Royal Academy 1900–1950*, London: Royal Academy of Arts, 1988; Caroline Fox, *Stanhope Forbes and the Newlyn School*, London: David & Charles, 1993; Kenneth McConkey, *Impressionism in Britain*, London: Barbican Art Gallery, 1995.

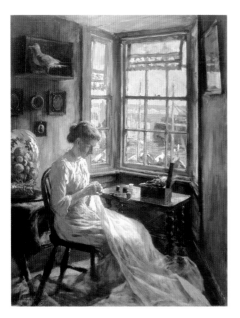

35 *The harbour window*
painted at Mousehole, Cornwall, England, 1910
oil on canvas 112.0 x 87.0
signed and dated 'Stanhope A. Forbes 1910' lower left
exhibited: Royal Academy, London, 1911 (264)
Royal Academy of Arts, London, diploma work, accepted in 1910

Dedicated though he was to depicting scenes of outdoor life, Stanhope Forbes also produced several paintings of interiors using a similar uncompromising attention to detail and tone as he used in his outdoor subjects. The people of Newlyn willingly sat for him. Forbes painted *The harbour window* at a time when he was experimenting with brighter colour and tonal contrast. He depicted a villager, Annie Blewett, in her home environment, the family's upstairs sitting room of the Ship Inn at Mousehole, a fishing village near Newlyn.

In Victorian genre painting, the image of a single needlewoman suggested industrial exploitation, but Forbes was less interested in social issues than in the pictorial possibilities of the figure in relation to the view of the harbour. In this respect, *The harbour window* is closer to **Margaret Preston**'s *The studio window* (cat.102) and **E. Phillips Fox**'s *The lesson* (cat. 41), which both show women seated in an interior before an open window and the garden beyond, than to **Albert Rutherston**'s image of a miserable needlewoman in *Song of the shirt* (cat. 116).

Gillian Ferguson

E. Phillips Fox
1865–1915

Australian painter and teacher, E. Phillips Fox was born in Melbourne on 12 March 1865, the son of a Jewish photographer and an artist mother. His father left home in 1866 and his mother remained central to an exceptionally closely knit family. He studied at the National Gallery School, Melbourne, from 1878 to 1886, where fellow students included **Rupert Bunny**, **Florence Fuller**, John Longstaff, Frederick McCubbin and **Tudor St George Tucker**. From 1881 to 1887, he taught evening classes at an artisans' school of design and, from 1885, he joined **Tom Roberts** on weekend painting excursions around Melbourne. In 1887 he left for Europe, where he studied in Paris from 1887 to 1889 at the Académie Julian and at the Ecole des Beaux-Arts from 1889 to 1890 under Jean-Léon Gérôme, supported by his brothers Joel and Philip. In 1889 Fox also joined the afternoon class of the American artist-teacher Alexander Harrison whose 'tendency' he wrote 'was towards the Impressionistic'(Zubans, 1995). He met up with **Bertram Mackennal**, Longstaff, **John Peter Russell** and **Tucker** and, in the summers, painted at the artists' communities at Etaples in Picardy with **Tucker** and Iso and Alison Rae, and also in Britanny. During 1890 and 1891, he moved to the artists' colony at St Ives, Cornwall. He copied Velasquez's works in Madrid in 1891 and visited the countryside near Paris. He returned to Melbourne in 1892, where he chiefly painted portraits and landscapes. In 1893, Fox and **Tucker** opened the Melbourne School of Art, where they introduced students to French teaching practices and promoted the plein-air painting approach at their outdoor summer school, held from about 1894 at Charterisville, near Eaglemont. In 1901, Fox left for London, having been commissioned to paint *The landing of Captain Cook at Botany Bay* (National Gallery of Victoria, Melbourne), which he was required to paint overseas. He spent time in London and revisited the artists' colony at St Ives, where he met **Ethel Carrick**, whom he married in 1905. In London he met up with **George Coates**, **George Lambert**, **Hugh Ramsay**, **Roberts**, **Arthur Streeton** and **Tucker**. Fox and **Carrick** lived in Paris until 1913, and became good friends with **Rupert Bunny** and his wife. He was elected

sociétaire of the Société Nationale des Beaux-Arts in 1910. Fox and **Carrick** travelled widely in Europe, and visited Algiers in 1911, where they painted Arab scenes. Fox mainly painted elegant women and family groups, in which he captured sunlight effects and conveyed the graceful languor of the Edwardian era. Fox and **Carrick** visited Australia in 1908 and again in 1913 when, at the outbreak of war, they cancelled their plans to return to Europe. Fox died of cancer in hospital in Melbourne on 8 October 1915, aged 50.

r e f e r e n c e s : Len Fox, *E. Philips Fox and his family*, Sydney: Len Fox, 1985; Ruth Zubans and Jane Clark, *E. Phillips Fox 1865–1915*, Melbourne: National Gallery of Victoria, 1994; Ruth Zubans, *E. Phillips Fox: His life and art*, Melbourne: The Miegunyah Press, 1995; Mary Eagle, *The oil paintings of E. Phillips Fox in the National Gallery of Australia*, Canberra: National Gallery of Australia, 1997; Virginia Spate, 'Nature and Artifice', in Lynne Seear and Julie Ewington (eds), *Brought to light: Australian Art 1850–1965*, Brisbane: Queensland Art Gallery, 1998.

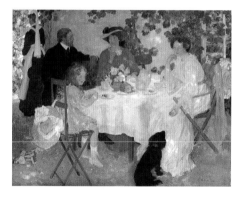

36 *Al fresco*
painted in Paris, c.1904
oil on canvas 153.6 x 195.6
signed 'E. Phillips Fox' lower right
exhibited: Royal Academy, London, 1906 (268); '36th Autumn Exhibition of Modern Art', Walker Art Gallery, Liverpool; Société Nationale des Beaux-Arts, Paris, 1907 (467); 'E.P. Fox', Guildhall, Melbourne, Feb – Mar 1908 (38); '11th Federal Art Exhibition', Adelaide, 1908 (51); Exhibition of Pictures by E. Phillips Fox, Sydney, June 1908 (28)
Art Gallery of South Australia, Adelaide, Morgan Thomas Bequest Fund in 1908

Al fresco is the first of E. Phillips Fox's paintings to depict a family meal in an outdoor setting, in which he expressed his delight in the contrasts of light and shade. The model for the woman in the light-coloured dress was probably his wife, **Ethel Carrick**.

This image of a family dining al fresco presents a vision of elegant, leisurely life in Europe that appealed to, and was recorded by, a number of artists at the turn of the century. The stylishly-dressed women, and the happy child who smiles at the dog about to be given a piece of fruitcake, create a view of an untroubled life.

The influence on Fox of the French Impressionists is evident in his use of small dabs of colour and in the dappled effects of light. But the way in which he created a flat pattern through the strong forms of the figures, and his use of bright colours and thickly textured paint, also suggests an understanding of the work of artists such as Pierre Bonnard, Maurice Denis and Edouard Vuillard, with whom Fox had been a fellow student at the Académie Julian and who also painted images of family groups dining in sunny settings. In this respect *Al fresco* is more 'modern' than Fox's later variations on this theme, such as *Déjeuner* c.1911 (cat. 40) where his approach was more impressionistic.

When *Al fresco* was exhibited in Melbourne, the critic for *Table Talk*, 5 March 1908, felt that 'somehow the work, excellent in every detail, has no appeal to Australians to whom out-of-door eating suggests abominable memories of flies and bull ants'. The *Age* reviewer was more sympathetic, appreciating Fox's ability to capture the contrasts of light and shade, writing on 29 February 1908:

> [Fox's] principal theme is that of the figure in the cool shade made by spreading trees or with a background of sunlight filtering through trailing vines, the general scheme being cool and low in tone, except for the bright spots falling on green grass or white drapery. A fine example is *Al Fresco*, four people seated at a table in the shade of vine covered tea house, a frequent sight in Paris, the black and scarlet costumes offering notes of distinction in what is quite an attainment as regards tone and color.

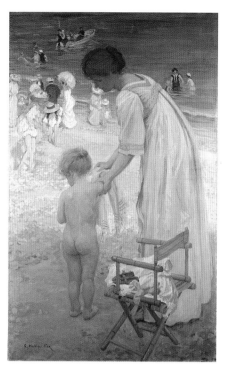

37 *Bathing hour*
painted in Paris, c.1909
oil on canvas 180.4 x 112.0
signed 'E. Phillips Fox' lower left
Castlemaine Art Gallery and Historical Museum, T.C. Stewart Bequest Fund in 1952

Fox made studies of the Chelsea Beach, near Melbourne, when picnicking there in 1908. He took these sketches to Paris to use as a basis for *Bathing hour*. On his return to France, he visited the northern beaches, in particular the fashionable beach resort of Trouville, where he made at least one sketch out of doors, in front of a sapphire blue sea, with a nurse drying a small child (*The beach at Trouville* c.1909 (private collection)).

Bathing hour is an image of leisure, of an ideal way of life. Fox captured sunlight and colour, the sun shimmering on the golden sand and quiet blue-green sea. He portrayed a scene of happy holiday-makers swimming in their neck-to-knee bathing costumes, or strolling along the shore in elegant dresses, with children building sandcastles. He showed a mother drying her young child, set apart in the intimacy of their domestic ritual. He stressed the closeness of the mother and child, emphasising the bond between them. Fox painted two versions of this subject, almost the same size, in this version working in a more spontaneous fashion, using broader brushstrokes.

As Virginia Spate has noted, at the time it was painted Fox's depiction of a naked child in such a setting was unconventional. Spate observed:

> Beach culture was, at the time, highly artificial, and particularly so on the fashionable resorts on the Channel coast where the work was conceived. Bathing was not yet a popular pastime and, as Fox's paintings show, it was very much the sphere of the upper middle classes — those who could afford holidays, the elegant summer fashions, and the nannies to look after the children. *Bathing hour* is unusual in showing a fashionable mother tending to her child … It is almost impossible to imagine that a child, particularly a girl child, would be seen naked on such a fashionable beach. (Spate, 1998)

Images of a mother and child were popular at this time, as evidenced in **Augustus John**'s *Family group (Decorative group)* 1908 (cat. 57), **George Lambert**'s *The holiday group (The bathers)* 1907 (cat. 69), **Charles Sims**' *By summer seas* c.1904 (cat. 128) and **Henry Tonks**' *After the bath* 1910–11 (cat. 136). **Lambert** depicted a bathing group, **Sims** showed figures on the beach, and **Lambert** and **Tonks** portrayed naked children. While critics attacked **Lambert**'s presentation of a naked woman among clothed figures in *The sonnet* c.1907 (cat. 68), they readily accepted his depiction of naked children in *The holiday group (The bathers)*. Likewise, *Bathing hour* was quite uncontroversial when shown at the Royal Academy. Spate concluded that the contemporary acceptance of the naked child in the *Bathing hour* could be because it had a symbolic value:

> One could … interpret *Bathing hour* as a discourse on the relationship between the natural and the artificial … Respectable middle-class women … had to be controlled, their bodies shaped by corsets and layers of fabric and constrained by elaborate social ritual. Little girls had to learn all this. (Spate, 1998)

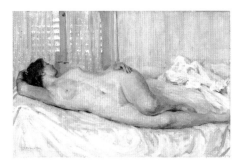

38 *Etude de nu*
painted in Paris, c.1910
oil on canvas 59.7 x 92.1
signed 'E. Phillips Fox' lower left
exhibited: Société Nationale des Beaux-Arts, Paris, 1910 (493); 'Pictures by E. Phillips Fox', Athenæum Hall, Melbourne, 17 June – 4 July 1913 (29); 'Pictures by E. Phillips Fox', Royal Art Society, Sydney, 13 October – 28 October 1913 (26)
Kerry Stokes Collection, Perth

Fox painted a number of nudes, mostly between 1909 and 1912. *Etude de nu* was his first exhibited nude in an interior setting. He depicted his subject lying on a bed with her face averted, with a typically French unselfconsciousness. He expressed delight in the female form, showing his nude's sensuous body fully exposed. Like **Walter Sickert** in his series of Camden Town nudes, Fox was concerned with capturing the effects of light, depicting the nude lying in front of a window, with light filtering through flimsy curtains and a slatted blind.

On 17 June 1913, the *Age*'s reviewer expressed his admiration of Fox's ability to capture beauty through the effects of light: 'With light and atmosphere always the ruling motive, there is revealed in his themes something of the infinite beauty discoverable in everyday things and natural effects.'

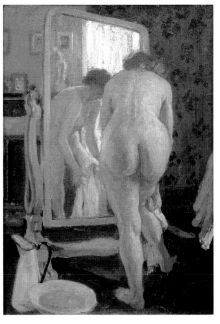

39 *After the bath*
painted in Paris, c.1911
oil on canvas laid on composition board 46.5 x 33.0
signed 'E. Phillips Fox' lower right
exhibited: 'Pictures by E. Phillips Fox', Athenæum Hall, Melbourne, 17 June – 4 July 1913 (26); 'Pictures by E. Phillips Fox', Royal Art Society, Sydney, 13 October – 28 October 1913 (22)
Art Gallery of South Australia, Adelaide, gift of Mrs Ailsa Osborne in 1980

In *After the bath*, Fox depicted a comfortable middle-class subject, a woman at her toilette. Like **Sickert**, he was interested in using thick touches of colour to capture the effects of light and wanted to paint everyday subjects, showing people caught in action, participating in their daily activities. However, rather than portraying the darker, shameful side of life as **Sickert** did, Fox turned to a more joyous one. His nude, drying her leg with a towel after her bath, has a sense of immediacy, of honesty and total absence of shame.

It is not known for certain who posed for this painting, but Fox's wife, **Ethel Carrick**, posed for some of his nudes and may well have been the model for this painting. Fox began painting nudes in 1909. On 10 September 1909 he wrote to Norman Carter, 'I have … been doing some small nudes lately'. And on 13 September 1911 he reported to Hans Heysen, 'we have been in Paris, painting nudes out of doors in our garden'. (Zubans, 1995)

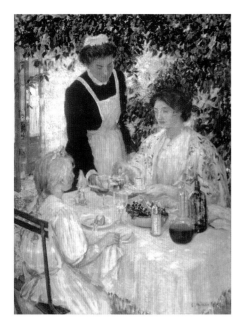

40 *Déjeuner*
painted in Paris, c.1911
oil on canvas 151.6 x 112.6
signed 'E. Phillips Fox' lower right
exhibited: Royal Academy, London,
1911 (162); Société Nationale des
Beaux-Arts, Paris, 1912 (542);
'Pictures by E. Phillips Fox',
Athenæum Hall, Melbourne,
17 June – 4 July 1913 (5);
'Pictures by E. Phillips Fox,
Royal Art Society, Sydney,
13 October – 28 October 1913 (5)
Lionel Lindsay Gallery and Library,
Collection of the Toowoomba
Regional Art Gallery

In *Déjeuner*, Fox painted a scene of a leisurely
luncheon, before the outbreak of the First
World War. The setting was his own Paris
garden, a shaded courtyard full of filtered
sunlight that he and his wife had devised
for their enjoyment and as a setting for
their paintings. It was a 'surprise of quaint
courtyards and creepers, twisting cobble paths,
wicket gates, and the loveliest little gardens on
to which open doors and windows of studios
and flats' (Eagle, 1997). Compared with Fox's
earlier images of outdoor eating, in *Déjeuner*
he adopted a closer and more intimate view
of his subjects, giving the figures a greater
sense of individuality and placing them in
a more enclosed setting, showing the bond
between a mother and her child.

Images of luncheons in the garden were
popular with European painters around the
turn of the century, including the French
Impressionists. Fox may well have seen
Monet's *Le Déjeuner* when it was shown at the
International Society of Sculptors, Painters
and Gravers in London early in 1904. The
English artist **Harold Knight** also depicted
the subject of relaxed outdoor eating in his
painting *In the spring* 1908 (cat. 63).

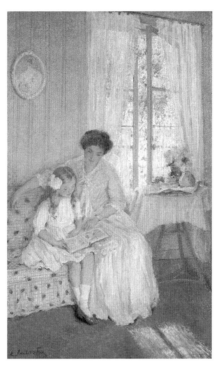

41 *The lesson*
painted in Paris, c.1912
oil on canvas 183.6 x 112.6
signed 'E. Phillips Fox' lower left
National Gallery of Victoria,
Melbourne, Felton Bequest in 1925

In *The lesson*, Fox portrayed a room filled
with sunlight and sweet pastel colours.
He showed the mother and child sharing
a moment of warmth and intimacy while
reading a storybook, their figures blended.
But the figures are only part of this middle-
class interior: the table, tea set and pink roses
beneath softly curtained French doors, the
view of the garden greenery through the open
doors, the striped wallpaper, the peacock-
covered divan, all contribute to the mood of
cosy domestic harmony.

George Clausen shared Fox's interest in
portraying an interior through atmospheric
light, as in his *Twilight: Interior* c.1909 (cat. 20).

George Frampton
1860–1928

English sculptor, goldsmith and designer,
George Frampton was born on 16 June 1860 in
London, the son of a stonemason. Apprenticed
first to a firm of architectural stone carvers,
he studied at the Lambeth School of Art
under W.S. Frith, and at the Royal Academy
Schools from 1881 to 1887, where fellow
students included **Tom Roberts**. From 1888
to 1889, Frampton studied sculpture in Paris
under Antonin Mercié, taking into his work
elements of French symbolism. From 1891,
he exhibited a number of idealised images
in which he blended his symbolist thinking
and technical experimentation with a formal
approach that was based in Italian Renaissance
sculpture. In the 1890s, he was drawn to the
Arts and Crafts Movement and, from 1893,
he and W.R. Lethaby were joint heads of the
Central Schools of Arts and Crafts. He was
closely associated with *The Studio* art magazine
from its inception in 1893, and he contributed
several articles on subjects such as enamelling,
wood carving and polychrome sculpture. His
own extensive use of polychromy, combining
different materials such as ivory and bronze in
one work, reflects his interest in merging art
and craft. Together with **Alfred Gilbert** and
Hamo Thornycroft, Frampton was among
those involved in the progressive school of
British sculpture known as the New Sculpture
movement. Rejecting the restrictive label
of sculptor, Frampton preferred to be
known as an art worker, stressing the
importance of versatility in many media.
He fulfilled commissions for medals, such as
the coronation medal of King Edward VII,
as well as designing household fittings and
jewellery. After 1900, he also produced a large
number of portrait busts. In 1902, he was
elected a full member of the Royal Academy
and was knighted in 1908. His best-known
monument is *Peter Pan* in Kensington Gardens,
London (1912). He was also responsible for the
bas-relief memorial to W.S. Gilbert near the
Victoria Embankment, two couchant stone
lions at the British Museum, London, in 1914
and the Edith Cavell Memorial in St Martin's
Place, London, in 1920. He died in London on
21 May 1928, aged 67.

references: Benedict Read, *Victorian sculpture*, New Haven: Yale University Press, 1982; Susan Beattie, *The New Sculpture*, New Haven: Yale University Press, 1983; John Christian (ed.), *The last Romantics: The Romantic tradition in British art*, London: Barbican Art Gallery, 1989; Timothy Stevens, 'George Frampton', in Penelope Curtis (ed.), *Patronage and practice: Sculpture on Merseyside*, Liverpool: National Museums and Galleries on Merseyside, 1989.

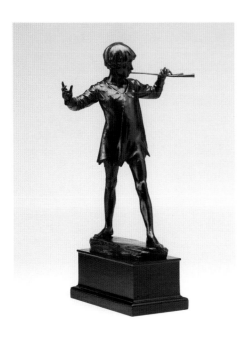

42　*Peter Pan*
modelled in London, 1912,
cast in London?, 1912
bronze 46.6 x 28.5 x 25.0
signed and dated 'Geo Frampton/
PP/ FIRST IMPRESSION 1912'
incised on base in front of foot on base
Art Gallery of New South Wales,
Sydney photograph : Jenni Carter
for AGNSW

Peter Pan is a small-scale version of the sculpture unveiled in Kensington Gardens in 1912, which presents the figure of Peter Pan on an elaborate tree trunk base, surrounded by fairies and elves, rabbits and mice. The Kensington Gardens sculpture was commissioned and paid for by J.M. Barrie, the author of the dramatic fantasy of the same name. This play grew from stories Barrie told the five Llewelyn Davies boys about Peter Pan, a motherless half-magical boy who taught the Darling children how to fly and took them to Never Never Land, where they encountered pirates. It was first performed in 1904 and was followed by a story, *Peter Pan in Kensington Gardens*, in 1906. The scenery for the first production of the play was designed by **William Nicholson**.

When the plaster of the Kensington Gardens sculpture was exhibited at the Royal Academy, P.G. Konody wrote in the *Observer* on 30 April 1911:

> Sir George has found a subject the quaintness of which is peculiarly suited to the personal character of his art with its strange blending of Gothic angularity and 'art nouveau' curves. Peter Pan is the idol of the young, and the monument is designed to delight the rising generation, without any sacrifice of artistry.

George Frampton produced many versions of *Peter Pan* on a reduced scale, reflecting the market for images of this magical child. The subject also reflects a contemporary fascination with paganism and a belief in the power of nature and natural forces (which in Frampton's sculpture are called up from their burrows by the music from Peter's pipes).

Florence Fuller
1867–1946

Australian painter and teacher, Florence Fuller was born in Port Elizabeth, South Africa in 1867. While she was still a child, she moved to Melbourne with her family. In 1883 and 1888, she attended the National Gallery School, Melbourne, where **Rupert Bunny, E. Phillips Fox** and **Arthur Streeton** were fellow students. She also studied with Jane Sutherland, who may have stimulated her interest in theosophy. From 1884 to 1886, she combined work as a governess with study with her uncle, the painter Robert Dowling. When Dowling returned to England, Fuller gave up her position and established herself as a portrait painter, completing his portrait of Lady Loch, the wife of the Governor of Victoria. In 1889, she won the Victorian Artists' Society prize for the best portrait painted by an artist under 25. In 1892, she travelled to the Cape of Good Hope to convalesce from an illness, staying with her married sister. She lived and worked in France and England from 1894 to 1904, apart from another trip to South Africa in 1899, when she painted a portrait of Cecil Rhodes. From 1904 to 1909, she lived in Perth, teaching privately and executing portrait commissions, where **Kathleen O'Connor** saw and admired her work. Fuller was an active member of the Perth Theosophical Society and, from 1909 to 1911, she lived in India at the Calcutta headquarters of the Theosophical Society. After revisiting England in June 1911, Fuller returned to New South Wales and settled in Mosman. She painted portraits, landscapes and miniatures, and taught life and figure classes, until she succumbed to mental illness. She died on 17 July 1946 in the Gladesville Mental Asylum, aged 81.

references: L.M. Mather, *Australians who count in London and who count in Western Australia*, London: Jas Truscott, 1913; Barbara Chapman, *The colonial eye*, Perth: Art Gallery of Western Australia, 1979; Jane Clark and Bridget Whitelaw, *Golden summers*, Melbourne: National Gallery of Victoria, 1985; Janda Gooding, *Western Australian art and artists 1900–1950*, Perth: Art Gallery of Western Australia, 1987; Victoria Hammond and Juliet Peers, *Completing the picture*, Melbourne: Artmoves, 1992; Joan Kerr, 'Florence Fuller' in Joan Kerr (ed.), *Heritage: The national women's art book*, Sydney: Craftsman House, 1995.

43 *Inseparables*
painted in London or Paris, c.1900
oil on canvas 90.2 x 68.5
signed 'F.A. Fuller' lower right
exhibited: 'The Third Federal
Exhibition', Adelaide 1900 (78)
Art Gallery of South Australia,
Adelaide, Elder Bequest Fund in 1900

Florence Fuller's subject was a popular
one for Edwardian artists: a girl sitting in
a comfortable drawing room reading or in
quiet contemplation. It was also the theme of
William Rothenstein's *The Browning readers*
1900 (cat. 114) and **Mary McEvoy**'s *Interior:
Girl reading* 1901 (cat. 82). Typically, these
artists portrayed women focused on their own
purposes rather than looking directly at the
viewer.

The title, *Inseparables*, would suggest that
Fuller's young woman had a considerable
thirst for knowledge and the imaginative life
of fiction. She is, however, isolated in a room
without a window or a view outside, and with
no access to the world beyond except through
her book.

Fuller commented in 1913: 'The hidden inner
life has not yet succeeded in expressing itself
on canvas, and I can only write myself as one
who aspires to a greater art' (Mather, 1913).

Henri Gaudier-Brzeska
1891–1915

French-born British sculptor, draughtsman
and printmaker, Henri Gaudier was born
on 4 October 1891 near Orléans, the son
of a carpenter. He won scholarships to
study English and Commerce in London
in 1906, and at Bristol and Cardiff from
1907 to 1908. Early in his artistic career he
produced architectural, animal and plant
studies, strongly influenced by John Ruskin.
In Paris, in 1910, he studied art in the St
Géneviève Library, looking at sculpture from
classical antiquity to 'primitive' and oriental
art, as well as the work of **Rodin**. He met
Sophie Brzeska, a Polish woman 20 years
his senior whose name he added to his own,
and by 1911 they were living in London,
where Gaudier-Brzeska obtained work as a
translator with Wulfsberg and Co. In London,
Gaudier-Brzeska encountered Jacob Epstein
and Wyndham Lewis, under whose influence
he assumed a geometrical simplification
in his sculpture. Although without formal
training, he made a number of innovative
carvings inspired by 'primitive' art and
modelled some more conventional works of
both figurative and animal subjects. In 1913,
he met the Australian-born artist and critic,
Horace Brodzky, who subsequently wrote
Gaudier-Brzeska's biography. His close friend
Nina Hamnett posed for several sculptures
and, through Nina, he met Roger Fry and
was briefly associated with Fry's **Omega
Workshops**. In 1915, he contributed to the
Vorticist's London exhibition and to their
magazine, *Blast*, writing that: 'Sculptural
energy is the mountain. Sculptural feeling
is the appreciation of masses in relation.
Sculptural ability is the defining of these
masses by planes.' He was killed in action
fighting for France on 5 June 1915, aged 23.

references: Ezra Pound, *Gaudier-
Brzeska: A memoir*, London: 1916; H.S. Ede,
Savage Messiah, New York: Literary Guild,
1931; Horace Brodsky, *Henri Gaudier-Brzeska*,
London: Faber and Faber, 1933; Richard
Cork, *Vorticism and abstract art in the first machine
age*, 2 vols, London: Gordon Fraser, 1976;
Roger Cole, *Burning to speak: The life and art
of Gaudier-Brzeska*, Oxford: Phaidon, 1978;
Michael Lloyd, 'Twentieth-century sculpture',
Art and Australia, vol. 20, no. 1, Spring 1982;
Jeremy Lewison (ed.), *Henri Gaudier-Brzeska,*

sculptor 1891–1915, Cambridge: Kettles Yard
Gallery, 1983; Roger Cole, *Gaudier -Brzeska:
Artist and myth*, Bristol: Sansom, 1995; Evelyn
Silber and David Finn, *Gaudier-Brzeska: Life
and art*, London: Thames and Hudson, 1996.

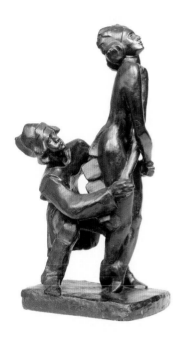

44 *The Firebird*
made in London, 1912
plaster with black paint
63.6 x 34.0 x 27.0
signed 'H. Gaudier/ Brzeska'
incised lower right on base
exhibited: Allied Artists
Association, London, 1913 (1212);
'Twentieth Century Art',
Whitechapel Art Gallery, London,
1914 (179)
National Gallery of Australia,
Canberra

For Henri Gaudier-Brzeska, making modern
sculpture meant conveying movement. In
November 1912, just after he had finished *The
Firebird*, he wrote: '

> Men today are not satisfied with one
> movement as in primitive sculpture,
> the movement is now composed as
> is a sequence of other uninterrupted
> movements which in their turn can be
> sub-divided, and different parts of the
> body can move in opposing directions
> with varying intensity.' *The Firebird* is
> the earliest surviving sculpture in which

Gaudier-Brzeska dealt with the subject of dance, a recurring theme in his brief career, and a *leit-motif* of Vorticist art.

In June 1912, *The Firebird* ballet was performed in London for the first time by Serge Diaghilev's Ballets Russes. Gaudier-Brzeska represented the moment in Scene One when Ivan the Tsarevich (Adolph Bolm) captures the Firebird (Tamara Karsavina). The translation of the figures into a series of simplified planes was Gaudier-Brzeska's first departure from **Rodin**. The spiral movement generated from the crouching figure of Bolm through linked arms with the upward thrust of Karsavina became his standard means for conveying movement.

Michael Lloyd, 1982

Mark Gertler
1891–1939

English painter Mark Gertler was born on 9 December 1891 at Spitalfields, East London, the son of a Jewish immigrant furrier from Poland. He attended evening classes at the Regent Street Polytechnic from 1906 to 1907 and worked as an apprentice at Clayton and Bell, glass painters. He also attended a series of talks on Dutch and Flemish painting that influenced his early work. In 1908, on the advice of **William Rothenstein**, the Jewish Educational Aid Society provided him with financial support to study at the Slade School, where, in 1909, he won a Slade scholarship. He was taught by **Henry Tonks** and **Philip Wilson Steer**, formed friendships with **C.R.W. Nevinson** and Stanley Spencer, and fell in love with Dora Carrington. He frequented the Café Royal, where he was known for his talents, vivacity and skills as a raconteur. Early patrons included Lady Ottoline Morrell and the civil servant Edward Marsh, who paid him £10 a month in return for first refusal on his paintings. Through Marsh he met Gilbert Cannan, who based his novel *Mendel* (1916) on the artist's life. In his early works, Gertler combined traditional and modernist techniques. He was a pacifist and conscientious objector during the First World War. In 1916, he commented on the futility of war in *The merry-go-round* (Tate, London), an image of soldiers and civilians trapped on an eternal roundabout. At Morrell's homes in London and Garsington, Oxfordshire, he met Lytton Strachey, **Vanessa Bell** and Roger Fry; in 1918 this resulted in his association with the **Omega Workshops**. During the 1920s, Gertler used subtler colour schemes, culminating with a series of nudes. In the 1930s, he painted a series of still lifes and figure pieces with intricate patterning. He began teaching at the Westminster Technical Institute in 1932. His haunting pictures were keenly collected by London society. However, having enjoyed early success and then been disappointed by lack of recognition for his art, suffering from tuberculosis and long-term depression, he committed suicide at Highgate, London, on 23 June 1939, aged 47.

r e f e r e n c e s : Noel Carrington (ed.), *Mark Gertler: Selected letters*, London: Rupert Hart-Davis, 1965; John Woodeson, *Mark Gertler: Biography of a painter 1891–1939*, London: Sidgwick & Jackson, 1972; *Mark Gertler: Fragments of a biography*, London: Arts Council/ BBC, 1981; Gerard Vaughan, *European masterpieces*, Melbourne: National Gallery of Victoria, 2001; Sarah Macdougall, *Mark Gertler*, London: John Murray, 2002.

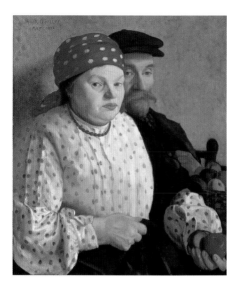

45 *The apple woman and her husband* painted in London, 1912
oil on canvas 66.0 x 56.0
signed and dated 'Mark Gertler/ May 1912' upper left
exhibited: New English Art Club, London, Summer 1912 (142)
National Gallery of Victoria, Melbourne

Mark Gertler painted *The apple woman and her husband* shortly after he left the Slade, creating an image of costumed figures, for which his parents, Golda and Louis Gertler, posed. It was loosely based on the theme of 'Apple gatherers' set by the Slade Sketch Club in 1912, which fellow student, Stanley Spencer, also depicted. It is linked to other early portraits and family groups in which Gertler suggested the deprivation and isolation experienced by Jewish emigrants in their ghettos. He once told his friend Dorothy Brett that his aim was to paint a work that expresses 'all the sorrow in life'. In its approach, *The apple woman and her husband* also reflects Gertler's admiration for Dutch and Flemish artists.

When *The apple woman and her husband* was shown at the New English Art Club, P.G. Konody praised it in the *Observer*, 2 June 1912, for its 'sureness of purpose, clear pure colour, a strong sense of pattern … notwithstanding the even light and absence of strong shadows'. He also praised its sense of style and knowledge of past art.

Alfred Gilbert
1854–1934

English sculptor, goldsmith and ornamental designer, Alfred Gilbert was born on 12 August 1854 in London, the son of musicians. He attended the Heatherley Schools in 1872 and the Royal Academy Schools from 1873 to 1874, while apprenticed to Edgar Boehm. Between 1875 and 1878 he studied at the Ecole des Beaux-Arts, Paris under P.J. Cavelier. He also lived in Italy between 1878 to 1884, and his visit to Florence around 1880 stimulated him to produce his first sculpture in bronze, *Perseus arming* 1882. Together with **George Frampton** and **Hamo Thornycroft**, Gilbert was at the forefront of the progressive school of British sculpture known as the New Sculpture movement. Like **Thornycroft**, Gilbert used the lost-wax method for casting his small bronzes. In 1893 he completed his best known work, the Shaftesbury memorial known as *Eros*, in Piccadilly Circus, London. In his *Tomb of Prince Albert Victor, Duke of Clarence*, commissioned by the Prince and Princess of Wales for their eldest son in 1892, he introduced oriental alloys to produce different coloured patinas and set the monument with semi-precious stones, enamel and ivory. In 1900, he became professor of sculpture at the Royal Academy Schools. The central thesis in his lectures of 1903 was 'the affinity and interdependence of the sister arts of sculpture, painting and architecture'. A tendency to take on too many commissions, which led to an inability to finish jobs, resulted in litigation with disgruntled patrons. Gilbert's extravagance, as well as the overwhelming costs of monuments such as *Eros*, caused his bankruptcy in 1901 and, from 1903, exile in Bruges. He returned to England in 1926 on the invitation of King George V, to complete the *Tomb of Prince Albert Victor, Duke of Clarence*, and to execute the *Queen Alexandra Memorial* 1926-32 at Marlborough Gate. His lifelong reverence for the ideals of Italian Renaissance craftsmanship led **Rodin** to describe him as the 'English Cellini'. In 1892, he was elected a full member of the Royal Academy and was knighted in 1932. He was the most famous and, briefly, the most successful, English sculptor of the late 19th century. He was interested in exploring the technical possibilities of his materials and in imbuing his work with a symbolic meaning. He died on 4 November 1934 in London, aged 80.

references: Benedict Read, *Victorian sculpture*, New Haven: Yale University Press, 1982; Susan Beattie, *The New Sculpture*, New Haven: Yale University Press, 1983; Richard Dorment, *Alfred Gilbert*, New Haven: Yale University Press, 1985; Richard Dorment, *Alfred Gilbert: Sculptor and goldsmith*, London: Royal Academy of Arts, 1986; John Christian (ed.), *The last Romantics: The Romantic tradition in British art*, London: Barbican Art Gallery, 1989.

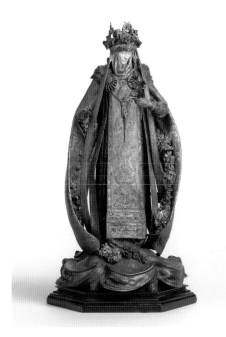

46 *St Elizabeth of Hungary* for the *Tomb of Prince Albert Victor, Duke of Clarence* modelled in London, 1899, this cast 1900 cast bronze and cloth stiffened with gesso plaster 54.6 x 29.2 x 25.4 exhibited: Fine Art Society, London, 1902 National Gallery of Victoria, Melbourne, Felton Bequest in 1909

The Prince and Princess of Wales (later King Edward VII and Queen Alexandra) commissioned Alfred Gilbert to create a memorial at Windsor for their first son, HRH Prince Albert Victor, the Duke of Clarence and heir to the throne of England, who died of pneumonia at Sandringham House on 14 January 1892. Gilbert created one of the most ornately detailed of all English royal tombs, surrounding the recumbent figure with a bronze grille punctuated by 12 polychromed figures (made with a combination of different coloured materials) of saints, including *St Elizabeth of Hungary, St George* and *St Michael*.

Gilbert made three casts of *St Elizabeth of Hungary*. The first, cast in Brussels in 1899, was sold to William Vivian, and the second was included on the tomb. This, the third cast, was made in 1900 and sold in 1902 for £300 through the Fine Art Society. Gilbert offended the mourning king and queen by putting on sale versions of four of the figures of the saints from their son's tomb, including *St Elizabeth of Hungary* and *St George*. When photographs of these 'working models' appeared in the *Magazine of Art*, Edward VII refused to see Gilbert again.

St Elizabeth of Hungary, an ancestor of Prince Albert, was born in 1207 in Hungary, the daughter of King Andrew II. She was sent to the court of Thuringia and married to Prince Ludwig at age 14. She tended the poor and the sick herself, despite the royal family's objections. Legend has it that one day she was carrying food hidden in her cloak to feed the poor. When her husband asked her what she had in her cloak, she replied, 'Only roses', whereupon her cloak fell open and, miraculously, roses fell about her feet. After her husband died in the Crusades, she lived a life of voluntary poverty, devoting herself to helping the destitute until her death, aged 24.

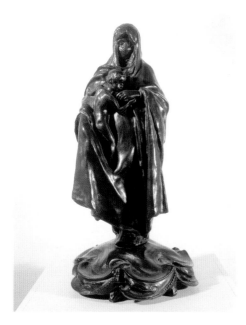

47 *St Catherine (The miraculous wedding)*
for the *Tomb of Prince Albert Victor,*
Duke of Clarence
modelled in London, c.1899,
cast c.1900
bronze 50.5 x 32.0 x 31.0
exhibited: 'Fair Women',
International Society of Sculptors,
Painters and Gravers, London,
1909 (302)
Schaeffer Collection

St Catherine was intended for the grille of the
Tomb of Prince Albert Victor, Duke of Clarence,
and a cast of it is recorded in Gilbert's studio
diary for October 1900. However, it was not
included in the plan of the tomb published
by *The Times*, 4 August 1898. *St Catherine of*
Egypt and *St Catherine of Siena* do appear in the
published plan and were included among the
figures modelled for the tomb by Gilbert.

Richard Dorment described *St Catherine* as 'a
fusion of the imagery of both St Catherine of
Egypt, represented as a heavily veiled Eastern
woman, and St Catherine of Siena, who
mystically wed the Christ Child'. (Dorment,
1986)

Harold Gilman
1876–1919

English painter Harold Gilman was born
at Rode, Somerset on 11 February 1876,
the son of a Church of England parson.
He attended Oxford University from 1894
to 1895 before studying at Hastings School of
Art in 1896 and then at the Slade School from
1897 to 1901. There he met **Spencer Gore,**
who became a lifelong friend and influence
and who subsequently introduced Gilman
to **Walter Sickert** and his circle. During
a visit to Spain from 1901 to 1903, Gilman
copied Velasquez's paintings in the Prado
and, on his return to England, he painted
works influenced by those of Velasquez.
He also painted images of intimate, domestic
scenes that reflected his interest in the work
of Manet and **James McNeill Whistler**. After
meeting with **Sickert** in 1907, he became part
of the Fitzroy Street Group, which included
Charles Ginner and **Gore**. In 1908, Gilman
moved to Letchworth, Hertfordshire, which
became the subject of his paintings. In 1909,
under the influence of **Gore**, he started to
use a lighter palette and to build up his
pictures with small touches of bright pigment.
Like others, he had considered the
implications of recent developments in French
art and, around 1910, he started to use flat
areas of brilliant colour. In 1911, he became
a member of the Camden Town Group, an
association of artists committed to workaday
subjects, which expanded in 1913 to become
the London Group. By then, members
included **Malcolm Drummond, Henri**
Gaudier-Brzeska and **C.R.W. Nevinson,**
in addition to **Gore** and **Sickert**. Gilman
visited Sweden in 1912 and Norway in 1913.
He taught at the Westminster Technical
Institute from 1912 to 1915, where **Norah**
Simpson was one of his students. In 1916,
he and Charles Ginner started an art school in
Soho, which folded when Ginner was called
to fight in the First World War. In 1917, he
coedited an art journal, *Art and Letters*, with
Ginner and Frank Rutter. He died on 12
February 1919 in a London hospital during
the Spanish influenza epidemic, aged 43.

references: Andrew Causey and
Richard Thomson, *Harold Gilman, 1876–1919,*
London: Arts Council of Great Britain, 1981;
Angus Trumble, *Bohemian London: Camden*
Town and Bloomsbury paintings in Adelaide,
Adelaide: Art Gallery of South Australia,
1997; Wendy Baron, *Perfect moderns: A history*
of the Camden Town Group, Aldershot: Ashgate,
2000; Esta Mion-Jones, *Harold Gilman and*
William Ratcliffe, Southampton: Southampton
City Art Gallery, 2002.

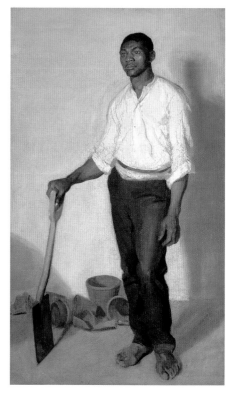

48 *The Negro gardener*
painted in London or Chicago,
USA, c.1905
oil on canvas 133.0 x 77.5
Langan's Restaurants, London
photograph: Prudence Cuming
Associates Ltd.

The Negro gardener reflects Harold Gilman's
admiration of Velasquez and the Spanish
tradition of portraiture. He saw the mundane
domestic chore of gardening as a subject
worthy of serious art. He depicted his subject
in the pose of a gentleman, with the gardener's
shovel replacing the gentleman's walking
cane. In portraying a servant with a sense
of nobility, as someone of social standing,
Gilman approached his subject in a similar
fashion to **Agnes Goodsir** when she depicted
a servant in *La Femme de ménage* (cat. 52).

Some of the Australian artists working in London at this time, such as **George Lambert** and **Hugh Ramsay**, were also influenced by Velasquez and the Spanish tradition, and in this respect Gilman's *The Negro gardener* has a direct connection with works such as **Ramsay**'s *A mountain shepherd* (cat. 106). Both Gilman and the Australians painted images with a natural but barely descriptive setting, and a normal but undemonstrative pose.

With its rare subject of a Negro gardener, this painting also reflects the changing attitudes in Edwardian society. Because of its subject it has been thought that this work was painted in America during Gilman's visit to meet his wife's family in 1905. However, it is also possible that it was painted earlier in London, under the influence of Velasquez, soon after his return from Spain.

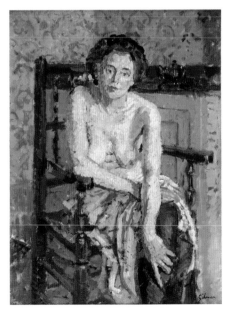

49 *Clarissa*
painted in London, c.1911
oil on canvas 59.0 x 44.0
inscribed 'H. Gilman' lower right
Queensland Art Gallery, Brisbane,
Beatrice Ethel Mallalieu Bequest,
purchased in 1956

Clarissa is a spontaneous and candid image of a seated woman leaning forward. In modelling the face and nude upper torso, Gilman used small, interlocking brushstrokes to build up surface, with looser and broader brushwork for Clarissa's clothes and the background dresser. The wallpaper background in this work is similar to that in Gilman's other works of around 1911 to 1912.

Despite the naturalism of the subject, Clarissa appears to be posing for the artist. A critic for *The Times*, 11 December 1911, observed that Gilman's very able nudes included in the Camden Town Group exhibition that year 'look as if they were sitting to be painted, not as if the artist had surprised them at some characteristic moment. You scarcely notice Mr. **Sickert**'s colour, it belongs so entirely to his subjects. But Mr. Gilman's colour seems rather to be imposed upon his subjects, though it surprises with its freshness and ingenuity.' Gilman's interest in the nude as a subject was restricted to the years 1911 to 1913, when he was involved with the Camden Town Group.

Aleksandr Golovin
1863–1930

Russian painter and stage designer, Aleksandr (Yakovlevich) Golovin was born on 1 March 1863 in Moscow, Russia. He studied architecture and painting under Vasily Polenov, Illarion Pryanishnikov and Vladimir Makovsky at the Moscow College of Painting, Sculpture and Architecture from 1881 to 1890, as well as in the studios of Raphaël Collin, Luc-Olivier Merson and Jacques-Emile Blanche in Paris from 1887 to 1989. He joined the Moscow Society of Painters in 1894, referencing the Art Nouveau style in his development of Russian nationalist themes for numerous projects, including a collaboration with Konstantin Korovin on the decoration of the Russian pavilion at the 1900 'Exposition Universelle' in Paris. He began designing for the stage in 1898, and, in his work as resident designer for the court productions of the St Petersburg Imperial Theatres from 1902, he gained a reputation for his use of large-scale architectural elements. In 1908, he began a long association with Serge Diaghilev, designing for his Ballets Russes productions in Paris, while continuing work as a painter until his death in Detskoye Selo, Russia on 17 April 1930, aged 67.

references: Robyn Healy and Michael Lloyd, *From studio to stage: Costumes and designs from the Russian Ballet in the Australian National Gallery*, Canberra: Australian National Gallery, 1990; Roger Leong et al., *From Russia with love: Costumes for the Ballets Russes 1909–1933*, Canberra: National Gallery of Australia, 1998; E. Fedosova (ed.), *Alexander Golovin: Album*, Leningrad: 1989.

50 *Costume for an attendant of the Immortal Koshchei*
in the Ballets Russes' production of *L'Oiseau de feu* (The Firebird), 1910
made in Paris?, 1910
tiered and hooped robe: white cotton with gold, black, blue and pink stencilling, metallic brocade ribbon, silver lamé, gold metallic fringe, pink rayon, red paint
belt: blue rayon, white cotton with blue stencilling, black rayon ribbon
height: 133.0, width at shoulders: 48.0, width at hem: 78.0
National Gallery of Australia, Canberra

This costume was designed for Serge Diaghilev's Ballets Russes' production of *L'Oiseau de feu* (The Firebird) which premiered at the Théâtre National de l'Opéra in Paris on 25 June 1910, with music by Igor Stravinsky, choreography by Michel Fokine and sets and costumes by Aleksandr Golovin and Léon Bakst.

Golovin's designs for this production were a stylised interpretation of Russian costume and folk art. His vivid abstraction of its traditional colours, patterns, materials and shapes moved the productions of the Ballets Russes towards a distinctly Modernist aesthetic. The tiered, hooped tunic design of this costume provided a sculptural canvas for Golovin's painted decoration based on Russian folk costume. Its design may have influenced the work of the French couturier, Paul Poiret, whose hooped and patterned short skirts and coats over slim-fitting dresses from around 1911 began to change the silhouette of women's clothing at the end of the Edwardian period.

Robert Bell

Natalia Goncharova
1881–1962

Russian painter and designer, Natalia Goncharova was born on 22 June (Old Style) or 4 July (New Style) 1881 at Nagaevo, near Tula, in Russia. In 1898 she enrolled at the Moscow Institute of Painting, Sculpture and Architecture, initially to study sculpture but, in 1900, she changed course to study painting. There she met Mikhail Larionov, who became her lifelong companion. In 1906, she contributed to the Russian section of the Salon d'Automne in Paris and, between 1908 and 1910, she contributed to the three exhibitions organised by Nikolai Riabushinsky, editor of the journal *Zolotoe runo* (The Golden Fleece). In 1912, Goncharova exhibited with the Blaue Reiter group in Munich and, in the same year, both she and Larionov were represented in the English critic Roger Fry's second Post-Impressionist exhibition at the Grafton Galleries, London. While initially active in fostering this liaison with the West, Goncharova and Larionov were also founding members of a number of renegade groups, notably Bubnovyi Valet (Jack of Diamonds) founded in 1910, Osliny Khvost (Donkey's Tail) in 1911, and Mishen (The Target) in 1913. These groups advocated an independent school of modern Russian painting and, for inspiration, looked not to the West but to the indigenous folk art of Russia and its roots in the East. In 1914, Goncharova was commissioned by Serge Diaghilev's Ballets Russes to design the sets and costumes for *Le Coq d'or* (The Golden Cockerel). The success of this production, which premiered in Paris in May 1914, led to a long association with the Ballets Russes. In 1915, Goncharova and Larionov left Russia and joined Diaghilev in Switzerland, and in 1917 they settled in Paris. During the war years, they designed numerous productions for the Ballets Russes and also acted as Diaghilev's chief artistic advisers, prompting him to commission stage designs from other well-known avant-garde artists. After the death of Diaghilev in 1929, and except for occasional contributions to exhibitions, Goncharova and Larionov lived virtually unrecognised and impoverished in Paris. In 1961 this neglect was partially redressed, when their work was shown in a large exhibition by the Arts Council of Great Britain. Goncharova died in Paris on 17 October 1962, aged 81.

references: Camilla Gray, *The Russian experiment in Art 1863–1922*, London: Thames and Hudson, 1962; John E. Bowlt, (ed.), *Russian art of the avant-garde: Theory and criticism 1902–1934*, New York: Viking, 1976; Mary Chamot, *Gontcharova*, Paris: La Bibliothéque des Arts, 1972; M.N. Yablonskaya, *Women artists of Russia's new age 1900–1935*, London: Thames and Hudson, 1990; Michael Lloyd and Michael Desmond, *European and American paintings and sculptures 1870–1970 in the Australian National Gallery*, Canberra: Australian National Gallery 1992; *Nathalie Goncharova, Michel Larionov*, Paris: Editions Georges Pompidou, 1995

51 *Peasants dancing*
painted in Moscow, 1910–11
oil on canvas 92.0 x 145.0
exhibited: 'Goncharova 1900–1913',
Mikailova Art Salon, Moscow,
August – October 1913,
(564, as one of a group of nine
paintings entitled 'Grape harvest')
National Gallery of Australia,
Canberra © Natalia Goncharova,
1910-11/ADAGP. Licensed by
VISCOPY, Sydney, 2004

The nine paintings comprising the 'Grape harvest' series were a centrepiece of Goncharova's 1913 retrospective. Painted on canvases measuring almost 1 x 1.5 metres, the compositions were paired vertically, as in *Women carrying baskets of grapes* (Musée Nationale d'Art Moderne, Paris) and *Men carrying baskets of grapes* (State Museum, St Petersburg), or horizontally, as in the *Wine drinkers* (Tretyakov Gallery, Moscow) and *Peasants dancing*. Together they must have stretched almost 12 metres along the wall. The paintings identified with this group all have a similar style; movements are angular and the extraordinarily rich colours are laid on rather flat with thick outlines in ochre. They are a prime example of Goncharova's so-called 'Neo-primitive' style, a mixture of

Fauve-inspired boldness of colour combined with a self-conscious nationalism that drew on folk and popular art forms, especially the cheap and popular printed images called *lubki*. 'At the beginning of my development l learned most of all from my French contemporaries', Goncharova wrote in the catalogue introduction to her 1913 retrospective. 'They stimulated my awareness and I realised the great significance and value of the art of my own country.' (Bowlt, 1976)

It might be ventured that *Peasants dancing* represents a particularly striking example of Goncharova's transposition of the influence of her French contemporaries. When painting this work she was undoubtedly aware of Henri Matisse's *Dance* 1910 which arrived in Moscow in December 1910 and, with its companion panel, *Music* 1910, was installed in the house of Sergei Shchukin who had commissioned the paintings from Matisse. The simple division of blue sky and green ground in *Dance* and *Music* is carried over to *Peasants dancing*, as is the application of paint in flat areas of brilliant colour. But whereas Matisse's dance is performed by athletic brown nudes from some Mediterranean arcadia, Goncharova chooses galumphing peasants, arranged in the flat frieze of folk embroidery, their contours edged by broad ochre lines that imitate in paint the gouged woodblock line of *lubki*.

Michael Lloyd and Michael Desmond, 1992

Agnes Goodsir
1864–1939

Australian painter Agnes Noyes Goodsir was born on 18 June 1864 in Portland, Victoria, the daughter of the Commissioner of Customs in Melbourne. She studied art at the Bendigo School of Mines under Arthur T. Woodward in 1898 and 1899. In 1900, she moved to Europe and lived in Paris with the financial support of her father until his death in 1906. She studied at the académies Julian, Delécluze and Colarossi and, like many others, during the summers she spent her time sketching outdoors in Brittany and Holland. She met up with **Hugh Ramsay** in Paris, and possibly **Rupert Bunny**. In 1905, during a five-month trip to Australia, she painted portraits of family and friends. On her return to Europe in 1906, she established herself in London where she remained until 1918. In 1909, her stepmother died and she inherited a portion of her father's estate, which improved her financial position. In the early 1920s she moved between Paris and London, exhibiting regularly in both cities before settling permanently in Paris in 1923. Goodsir's portraits are notable for their intensity of characterisation and simplicity of composition. Nellie Melba viewed her work in Paris and spoke about its 'beauty and sincerity'. Her subjects include the actress Ellen Terry, the philosopher Bertram Russell and, most frequently, her companion, Rachel Dunn. Her intimate images of domestic interiors, in which she focused on the patterns made by the wallpaper, pictures, fabrics, furniture and porcelain are typical of the time. Her paintings of beautifully dressed and sophisticated women often stress their androgynous qualities, as in *The Parisienne* c.1924 (National Gallery of Australia, Canberra) or *Type of the Latin Quarter* c.1926 (private collection). She also painted watercolours of Paris streetscapes. In 1926, she was elected *sociétaire* of the Société Nationale des Beaux-Arts, Paris, only the second Australian woman artist to receive this honour (the first being **Bessie Davidson**). The following year, Goodsir made a nine-month return visit to Australia. She died on 11 August 1939 in hospital in Paris, aged 75.

references: Janine Burke, *Australian women artists: 1840–1940*, Melbourne: Greenhouse Publications, 1980; Frank Cusack, 'Agnes Goodsir' in Joan Kerr (ed.), *Heritage: The national women's art book*, Sydney: Craftsman House, 1995; Karen Quinlan, *In a picture land over the sea: Agnes Goodsir 1864–1939*, Bendigo: Bendigo Art Gallery, 1998; Jane Hylton, *Modern Australian Women*, Adelaide: Art Gallery of South Australia, 2000.

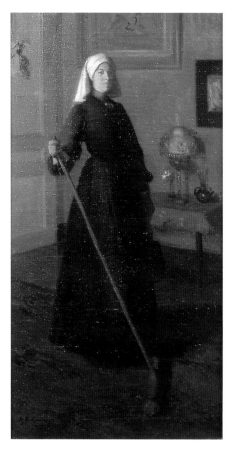

52 *La Femme de ménage*
painted in France, 1905
oil on canvas 91.5 x 48.0
signed and dated
'A.N. Goodsir 1905' lower left
private collection, courtesy of
Eva Breuer Art Dealer, Sydney
photographer: Greg Weight

In *La Femme de ménage*, Agnes Goodsir depicted a French housekeeper standing in a room and looking directly out of the picture with comfortable self-assurance. Her broom, dustpan, apron and head-scarf all indicate her role, but Goodsir portrayed her standing in an upright and assertive manner, like that of a lady holding a parasol. Goodsir's inspiration for this portrait might have been John Riley's *Bridget Holmes* 1686, a remarkable 17th-century image of a servant at work (Royal Collection, Windsor Castle). In this portrait, Riley made fun of the pretensions of Baroque portraiture, and Goodsir, with her image of the housekeeper in her simple, plain dress may likewise have been making a comment on the pomposity of some Edwardian portraits — although not at the expense of her subject. Indeed, in portraying the quiet dignity of a servant posed as if she were someone of social standing, Goodsir's approach to her subject resembles that of **Harold Gilman** in *The Negro gardener* c.1905 (cat. 48).

When Goodsir painted *La Femme de ménage*, she was in her early forties and had been in Paris for five years. She may have painted it in a guesthouse where she stayed during the summer vacation.

Spencer Gore
1878–1914

English painter Spencer Gore was born in Epsom, Surrey on 26 May 1878. He studied under **Henry Tonks** and **Philip Wilson Steer** at the Slade School from 1896 to 1899, where he formed friendships with **Harold Gilman**, **Augustus John**, Wyndham Lewis and **Albert Rutherston**. In the 1900s, he regularly spent holidays in France with **Rutherston**. During 1902 and 1903, he visited Spain with Lewis to study the Spanish masters. In 1904, in Dieppe, **Rutherston** introduced Gore to **Walter Sickert**, from whom he learned about aspects of modern French painting and the work of Degas. He became part of the Fitzroy Street Group in 1907, and began to produce modified neo-impressionist landscapes like those of Lucien Pissarro, as well as figure paintings, and music hall and ballet scenes inspired by **Sickert**. In 1910, he shared a studio with **Sickert** and with him became a guiding force in a circle of artists that included **Malcolm Drummond** and **Gilman**. From 1911, this association of artists became known as the Camden Town Group, which, in 1913, expanded to become the London Group. From 1911, Gore's style became more versatile, ranging from densely textured, strongly articulated window views in Camden Town to Gauguinesque landscapes and cityscapes with clearly defined areas of flat colour. In 1912, he directed a scheme for mural decorations for Madame Strindberg's nightclub, Cave of the Golden Calf. Gore died of pneumonia at Richmond, Surrey, on 27 March 1914, aged 35.

references: Frank Rutter, *Some contemporary artists*, London: Leonard Parsons, 1922; *Spencer Gore*, Oxford: Ashmolean Museum, 1970; Wendy Baron, *The Camden Town Group*, London: Scolar Press, 1979; Angus Trumble, *Bohemian London: Camden Town and Bloomsbury paintings in Adelaide*, Adelaide: Art Gallery of South Australia, 1997; Wendy Baron, *Perfect moderns: A history of the Camden Town Group*, Aldershot: Ashgate, 2000.

53 *'The mad Pierrot' ballet at the Alhambra*
painted in London, 1911
oil on canvas 49.4 x 51.2
signed 'S.F. Gore' lower right
exhibited: 'Camden Town Group',
London, 1911 (15); 'Paintings by
Spencer F. Gore and Harold Gilman',
Carfax Gallery, London, 1913 (14)
private collection

Equipped with a small notebook, Spencer
Gore spent every Monday and Thursday night
at the Alhambra Theatre, where he made
sketches of the stage and orchestra pit, always
from the same seat. In *'The mad Pierrot' ballet
at the Alhambra*, he created a dynamic image
by dividing the painting into three triangular
areas, with the line of footlights cutting
diagonally across the image, counterpoised
by the diagonals of the dancers' arms and the
sheets of music.

Gore started visiting music halls in 1906
with **Walter Sickert**, with whom he went to
the Bedford Music Hall in Camden Town.
However, he preferred the Alhambra in
Leicester Square for its ballets and spectaculars,
splendid backdrops and fancy costumes, and,
between 1903 and 1912, he made 30 to 40
paintings of theatre subjects.

The Alhambra was one of the main London
theatres, together with the Empire, the Palace
and the Coliseum. It was built on the east side
of Leicester Square in 1854 and converted to a
music hall in 1864. It was demolished in 1936.
It was known especially for its spectacular
ballets and acrobatic turns.

Gillian Fergusson

Nina Hamnett
1890–1956

British painter, designer and illustrator, Nina
Hamnett was born on 14 February 1890
at Tenby, Wales, the daughter of an army
officer. She studied under Arthur Cope at
his school in Pelham from 1906 to 1907, and
at the London School of Art from c.1907
to 1910, where she was taught by **Frank
Brangwyn**, **George Lambert** and **William
Nicholson**. With her extrovert personality,
Hamnett became a friend and model for many
artists and the lover of Roger Fry and **Henri
Gaudier-Brzeska**. Fry described her as 'the
most fascinating, exciting, tantalising, elusive,
beautiful exasperating creature in the world'.
Among her friends and supporters were
Augustus John, Wyndham Lewis and **Walter
Sickert**, who recognised her achievements as a
draughtswoman and praised the expressiveness
and virtuosity of her line. In 1914, she
attended drawing classes at Marie Wassilieff's
academy where Modigliani, Ossip Zadkine
and Australian artist and friend **Kathleen
O'Connor** were fellow students. Along with
many other artists, Hamnett left Paris for
London at the beginning of the First World
War, and rented a room in Bloomsbury near to
British artists **Vanessa Bell** and **Sickert**, and
Australian **O'Connor**. From 1914 to 1919 she
worked as a designer with Roger Fry's **Omega
Workshops**, where she associated with **Bell**
and **Gaudier-Brzeska**. Influenced by Fry
and modern French art, she painted strong,
spare still lifes, as well as portraits, landscapes
and interiors. In 1919, she returned to Paris,
where she mixed with the rich and titled like
Nancy Cunard, as well as with writers such as
Jean Cocteau, and composers Eric Satie and
Ivor Stravinsky. She became a friend of Ford
Madox Ford and Stella Bowen. By the 1930s,
her career had declined and she returned
to London where she was a well-known
bohemiènne, making studies of various figures
of London pub culture. She became something
of a mascot for a younger generation of
painters who treasured her connection with
avant-garde Paris but, by the 1950s, she had
become an alcoholic, perhaps succumbing
to the pressure of living as an independent
woman and finding paid work. She produced
two volumes of autobiography, *Laughing torso*
(1932) and *Is she a lady?* (1955). She died on
16 December 1956, following a fall from the
window of her London flat, aged 66.

references: Denise Hooker, *Nina
Hamnett: Queen of Bohemia,* London: Constable,
1986; Teresa Grimes, Judith Collins and Oriana
Baddeley, *Five women painters*, Oxford: Lennard
Publishing, 1989; Denise Hooker, 'Nina
Hamnett: Bloomsbury's Painted Lady', *Charleston
Magazine (U.K.)*, no. 20, Autumn/ Winter 1999.

54 *Ossip Zadkine*
painted in Paris, c.1914
oil on canvas 78.8 x 78.8
exhibited: 'Allied Artists Association',
London, 1914 (591, as 'Joe Zadkin')
private collection Reproduced
courtesy of Bridgeman Art Library
2004

Ossip Zadkine (1890–1967) was a sculptor of
Jewish–Russian descent who spent most of his
life in France. After studying art in London, he
settled in Paris in about 1910, where he became
part of the Cubist movement.

Nina Hamnett's declared ambition was 'to
paint psychological portraits that shall represent
accurately the spirit of the age' (Gordon-Stables,
1924, quoted in Hooker, 1986). Her portrait of
Zadkine is a strong statement of character, an
image of the artist in his studio beside one of his
sculptured heads. She used the contrast between
Zadkine's sensuous alert face and the angular
features of the sculpture to create a psychological
impact, to convey Zadkine's intensity and energy
and underlying melancholy, as well as her own
physical attraction to the subject.

Henri Gaudier-Brzeska wrote of this portrait in
The Egoist on 15 June 1914: 'It is very interesting
to see a portrait of Zadkine, the wood-carver.
In this work there are great technical qualities of
paint and drawing … The affinities of this artist
are coming nearer to a preference for abstract
design.'

Liz Wilson

Paul Iribe
1883–1935

French designer Paul Iribe was born at Angoulême in France on 8 June 1883, the son of an engineer. In 1901, he began work as an illustrator with the satirical newspaper, *Le Rire*. He also published satirical drawings in various other newspapers, including *Le Sourire, Canard sauvage, Le Cri de Paris, L'Illustré national* and *Le Journal*. He also provided material for the anarchist newspaper, *L'Assiette au beurre*. In 1906, he founded the magazine *Le Témoin*. In 1908, the couturier Paul Poirot employed Iribe to make ten images of Poiret gowns, which were reproduced in *Les Robes de Paul Poiret* in an edition of 250 copies. Poirot chose Iribe because his use of simple line and broad, flat, abstract expanses of bright colour perfectly captured the Empire dresses he was then making. *Les Robes de Paul Poiret* was the first of the 'new look' fashion publications that used modern art to represent the latest dresses; it redefined fashion illustration while also making a name for Iribe. He went on to a career in the graphic and decorative arts, working as a designer of furniture, decoration, stage design and theatre costumes. In 1914, he established the review *Le Mot* with Jean Cocteau, for which **Leon Bakst** provided drawings. He moved to New York in 1919 where he met Cecil B. de Mille and created a dress for Gloria Swanson in the film *Male and female*. He moved to Hollywood in 1920 and, in 1921, was artistic director of de Mille's film *Affaires d'Anatole* and eight other films. In 1926, he had a disagreement with de Mille and returned to France in 1927 where he worked with Gabriel Chanel. He died at Chanel's villa at Roquebrune, Cap Martin on 21 September 1935 from a heart attack, aged 52.

r e f e r e n c e s : Paul Iribe, *Les Robes de Paul Poiret*, Paris: Paul Poiret, 1908; Raymond Bachollet, Daniel Bordet and Anne-Claude Lelieur, *Paul Iribe*, Paris: Denoël, 1982; Raymond Bachollet, Daniel Bordet and Anne-Claude Lelieur, *Paul Iribe: Précurseur de l'art déco*, Paris: Bibliothèque Forney, 1983.

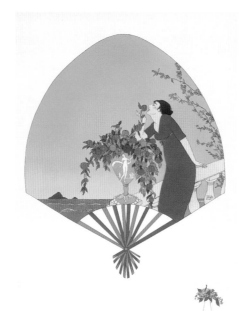

55 *A woman smelling a rose*
page from *L'Eventail et la fourrure chez Paquin* (Paris: Maquet for Paquin, 1911)
printed in Paris, 1911
stencil over lithograph,
fan-shaped, 48.0 x 34.0 (sheet)
National Gallery of Australia, Canberra, Julian Robinson Collection

The use of the pochoir printing technique, whereby colours were brushed onto paper through thin zinc or copper cut-out stencils, provided an important boost for fashion illustration.

L'Eventail et la fourrure chez Paquin consisted of seven pochoir illustrations by Paul Iribe, Georges Barbier and Georges Lepape. It contained fan designs by Iribe that captured the fashion and lifestyle of the Art Deco period. In this design of a woman smelling a rose, Iribe reduced the image to simple flat areas of red, blue, yellow, green and black. Iribe's use of bold forms and bright colours in his fan design resembles that of **Thea Proctor** in works such as *The song* (cat. 104).

Augustus John
1878–1961

British painter, draughtsman and printmaker, Augustus John was born on 4 January 1878 in Tenby, Wales, the son of a Welsh solicitor. He studied under **Henry Tonks** and **Philip Wilson Steer** at the Slade School from 1894 to 1898, where he was considered the most promising student of his generation with a remarkable talent for drawing. Fellow students included his sister **Gwen John**, **Spencer Gore**, **William Orpen**, and his future wife Ida Nettleship. He travelled to Paris with **Orpen** in 1899 to see the work of the old masters. In 1899, he painted at Vattetot-sur-mer with **Charles Conder**, **Orpen**, **William Rothenston** and **Albert Rutherston**. On a visit to Paris, he was impressed by the work of Puvis de Chavannes. From 1901 to 1902, he taught painting at the art school affiliated with University College, Liverpool and subsequently with **Orpen** at the Chelsea Art School, where **Henry Lamb** was a student. While in Liverpool, he became interested in the Romany people and subsequently took his extended family on trips in a gypsy caravan through Wales and England. At the Chelsea Arts Club and the Café Royal, he mixed with Australian artists such as **George Lambert**. He was one of the leading portrait painters of his time, using an expressive approach to achieve striking character portrayal. His sitters included many of the leading personalities of the time: authors, artists and musicians, such as James Joyce, Thomas Hardy, George Bernard Shaw, Madame Suggia, Dylan Thomas and W.B. Yeats. He also made many landscapes in bold colours and strong forms during his visits to North Wales with J.D. Innes and **Derwent Lees**, as well as in the south of France. During the First World War, he was an official war artist for the British and Canadian governments. John, a flamboyant character, had many amorous adventures and led an unconventional life. In 1928, he was elected a full member of the Royal Academy, but resigned in 1938 as a protest against the Selection Committee's rejection of Wyndham Lewis's portrait of T.S. Eliot, proclaiming that 'the Academy is stagnant-dead'. He was re-elected in 1940. He completed two volumes of autobiography, *Chiaroscuro* (1952) and *Finishing touches* (1964, published posthumously). He died on 31 October 1961 at his home, 'Fryern Court', near Fordingbridge, Hampshire, just before his 84th birthday.

references: John Rothenstein, *Augustus John*, London: Phaidon, 1944; Michael Holroyd, *Augustus John*, [1974], Harmondsworth: Penguin, 1976; Malcolm Easton and Michael Holroyd, *The art of Augustus John*, London: Secker & Warburg, 1974; Romilly John, *The seventh child*, London: Jonathan Cape, 1975; Richard Shone, *Augustus John*, London: Phaidon, 1979.

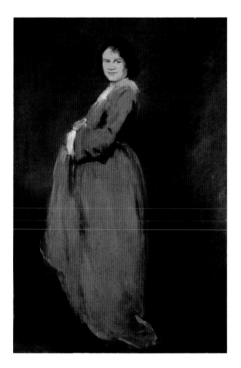

56 *Ida pregnant*
painted in Liverpool, England, 1901
oil on canvas 152.4 x 102.1
National Museums and Galleries of
Wales, Cardiff Reproduced courtesy
of Bridgeman Art Library 2004

In *Ida pregnant*, Augustus John portrayed
his first wife, Ida Nettleship (c.1877–1907),
pregnant with their first child, David, who
was born on 6 January 1902. John met Ida at
the Slade and they married in 1901. Ida and
Augustus had four further children, Caspar,
Robin, Edwin and Henry.

John painted *Ida pregnant* while he was living
in Liverpool; at this time he first became
interested in the Romany people. Showing Ida
dressed in the kind of loosely fitted garment
worn by 'artistic' women and by Romanies, it
is likely that he wanted to portray his wife in
the guise of a gypsy.

At first inflamed with an intense excitement,
a sense of power, massive tenderness and
fulfilment, John later felt confined and
restricted by Ida's pregnancy. He wrote to
William Rothenstein on 4 May 1901: 'I am
… about to become a *mother* — the question of
paternity must be left to the future. I suspect
at least 4 old masters' (Holroyd, 1976). Here,
in Ida's proudly smiling face, and the broad
expressive brush strokes, John paid homage
to the Dutch artist, Frans Hals. This full-
length, near life-size image placed in an
indeterminate setting also has similarities with
Manet's Velasquez-inspired, full-length figure
studies of the 1860s, such as the *The fifer* 1866
(Musée d'Orsay, Paris).

Ida pregnant is an excellent example of how
artists of this period made advances while
working within a continuing tradition. In *Art
in Australia*, August 1923, **George Lambert**
praised John's ability to use his knowledge
of past art in his work, his 'indefatigable
explorations of all periods and avenues of
Art' and his 'continuous effort to achieve
quickly, yet deliberately, the results which the
Masters brought into being'. This trend can
also be seen in Australian works such as **Hugh
Ramsay**'s *A mountain shepherd* (cat. 106).

John never exhibited this painting and the title
is not his, but was given to the work after his
death.

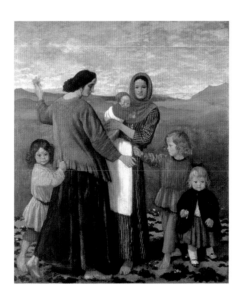

57 *Family group (Decorative group)*
painted in France or London, 1908
oil on canvas 203.0 x 177.0
exhibited: 'Chosen Pictures', Grafton
Galleries, London, 1909 (53, as
'Family Group'); New English Art
Club, London, Summer 1915,
(16, 'as 'Family Group');
Dublin City Gallery The Hugh Lane
Reproduced courtesy of Bridgeman
Art Library 2004

At the turn of the century, a number
of artists showed images of women and
children in the exhibitions of the Paris Salon
and the Royal Academy. More modern
painters, such as Maurice Denis and Picasso,
were also interested in this subject. The
women's movement promoted enlightened
motherhood, and advocated more exercise
for stronger and healthier bodies, in the
interests of child bearing and raising. John,
like **Lambert** in his *The holiday group* (cat. 69),
portrayed women in clothing that allowed
them to move freely, as recommended by these
'maternal feminists'.

In *Family group*, John depicted his first and
second wives, Ida and Dorelia (Dorothy
McNeill, 1881–1969), and four of his children
by them. Ida died on 14 March 1907 from
puerperal fever and peritonitis, five days after
her son Henry was born, but her influence
on John remained for many years. For a
period, the elder children were cared for by
their grandparents. In 1908, Augustus and
Dorelia took charge of the family, with the
exception of baby Henry who remained with
his grandparents. About this time, John started
to use his children as models. Summering
in France, he wrote to Ottoline Morrell, in
September 1908, that his children looked
'like healthy vagabonds'. On 20 September he
wrote to Ottoline that 'the days are wonderful
here … and I am working up to colour at last.
Do you know Cézanne's work? His colours
are more powerful than Titian's and searched
for with more intensity' (Holroyd, 1974).

Family group is more than a family portrait;
it is an image of an ideal family placed in a
fantastic landscape. It was inspired by the
decorative tradition of Puvis de Chavannes
and by certain works of Picasso, such as *La vie*
1903 (Cleveland Museum of Art) and *Family of
Saltimbanques* 1905 (Art Institute of Chicago).
The Times' critic on 27 April 1909 recognised

the decorative nature of this painting and commented:

> Mr. Augustus John has only one picture, but that a new one, and not easily passed over. The startling colour scheme and violent personality of his 'Family Group' only become intelligible or tolerable from the full distance of the Long Gallery. Seen from there the picture is found to be so brilliant and decorative as to suggest irresistibly that Mr. John could cover a large wall space in a superb and masterly manner.

58 *La Belle jardinière*
painted at 'Alderney Manor',
Dorset, England, c.1911
oil on canvas 188.6 x 77.7
National Gallery of Victoria,
Melbourne, Felton Bequest in 1946
Reproduced courtesy of Bridgeman
Art Library 2004

The model for *La Belle jardinière* was Dorelia, John's second wife, his ideal of feminine beauty. John met her in spring 1903 and their passionate relationship, which began soon afterwards, continued throughout his life. Dark-haired and olive-skinned, she became known for her free-flowing style of dress that was influenced by John's gypsy friends.

Dorelia was a passionate gardener. As Michael Holroyd has observed (1976):

> Flowers she loved. Almost every kind of tree and shrub flourished at Alderney with an abnormal vigour: ilex and pine, apple and cherry and chestnut, pink and white clematis, old-fashioned roses. the circular walled-in garden with its crescent-shaped flower-beds over which simmered the bees and butterflies became an enchanted place.

And Romilly John, in 1979, noted that:

> Dorelia, who had a passion for flowers, began to make something of the walled-in garden ... We seemed to have struck a paradise for children; an oasis where the ilex, the pine, the rhododendron and the chestnut proliferated as I have never seen them do elsewhere.

Gwen John
1876–1939

British painter Gwen John was born on 22 June 1876 in Havorfordwest, Wales, the daughter of a Welsh solicitor. She studied at the Slade School under **Philip Wilson Steer** and **Henry Tonks** from 1895 to 1898. The Slade was one of the first large art schools in Britain to allow women to enrol and was where her brother, **Augustus John**, her future sister-in-law, Ida Nettleship, **Mary Edwards** (**McEvoy**) and Ambrose McEvoy were also students. In 1898, she studied briefly at **James McNeill Whistler**'s Académie Carmen in Paris, where she learned to limit the range of tones in a painting. She returned to London in 1899 and, at this time, produced several remarkable self-portraits. Also about this time, she had a short-lived love affair with the painter Ambrose McEvoy. In 1903, she travelled to France with Dorelia McNeill, who would later become **Augustus John**'s mistress. She lived in Paris from 1904 where, except for occasional visits to London, she remained for the rest of her life, supporting herself by working as a model for British and American women artists. Her few friendships included the poet Rainer Maria Rilke and a passionate attachment to **Rodin**. In 1905, she modelled for **Rodin**'s *Monument à Whistler (Whistler's Muse)*. She worked slowly, often reworking the same composition, mostly painting self-portraits and images of women, children, cats and flowers. By 1908, she had replaced the warmer brown hues of her earlier work with a cooler palette of pink, blue, mauve and grey. In 1910, she met John Quinn, a New York lawyer and collector who, from 1912 until his death in 1924, sent her an annual allowance in return for paintings. In 1911, she moved to Meudon and, in 1913, she converted to Catholicism and began a series of portraits of nuns from the nearby convent. Despite **Augustus John**'s efforts to persuade her to return to Britain, she remained in France during the First World War and, from 1915, spent her summers in Brittany. She spent her last years as a recluse and died in the Hôpital de Dieppe on 18 September 1939, aged 63.

references: Augustus John, *Finishing touches*, London: Jonathan Cape, 1964; Susan Chitty, *Gwen John 1876–1931*, London: 1981; Cecily Langdale and David Fraser Jenkins, *Gwen John: An interior life*, London: Phaidon Press and Barbican Art Gallery, 1985; Mary Taubman, *Gwen John*, London: Scolar Press, 1985; Cecily Langdale, *Gwen John*, New Haven and London: Yale University Press, 1987; Alicia Foster, *Gwen John*, London: Tate, 1999; Sue Roe, *Gwen John: A painter's life*, London: Vintage, 2002.

59 *A lady reading*
painted in Paris, c.1909–11
oil on canvas 40.3 x 25.4
exhibited: 'Loan Exhibition',
Contemporary Art Society,
Manchester, 1911 (11); 'Loan
Collection of Modern Paintings',
Contemporary Art Society, Laing
Art Gallery, Newcastle, 1912 (128);
The Contemporary Art Society,
'First Public Exhibition in London',
Goupil Gallery, London 1-12 April
1913 (71, as 'Interior'); 'Purchases
and Gifts', Contemporary Art
Society, London, 1914 (11a); 'Modern
Paintings', Contemporary Art Society,
Belfast, 1914 (22)
Tate, London, presented by the
Contemporary Art Society in 1917
© Gwen John, c.1909-10/DACS.
Licensed by VISCOPY, Sydney 2004

Gwen John made two versions of *A lady reading*. In this painting, she gave the figure an idealised head, which she said was intended to resemble a painting of the Virgin Mary by Dürer. In the second version, *Girl reading at the window* 1911 (Museum of Modern Art, New York), the head painted is her own. However, John did not so much paint a descriptive portrait as create an expression of her interior life. In 1912, she wrote: 'I may never have anything to express, except this desire for a more interior life' (quoted in Langdale and Jenkins, 1985).

The room is John's own studio in Paris, showing two of her drawings of cats on the wall behind the figure and a wicker chair that appeared frequently in her paintings. However, she intended the composition to echo the private and intimate domestic spaces painted by Dutch artists such as Vermeer, with the window on the left throwing light onto the figure. A few years before John painted *A lady reading*, **Rodin** had given her money to move out of a sordid hotel room into an unfurnished room, and in this work she expressed her delight in having a room of her own.

A lady reading and *Girl reading at the window* are related to three other interior paintings by John: *La Chambre sur la cour* c.1907 (Mr and Mrs Paul Mellon, Upperville, Virginia), the earliest of her self-portraits in Parisian rooms, *The corner of the artist's room* c.1907–9 (Sheffield City Art Galleries) and *A corner of the artist's room in Paris* c.1907–9 (private collection), which also present similar decor and simple furniture, evoking the simplicity of her artistic lifestyle.

Liz Wilson

60 *The nun*
painted in Paris, during
the mid-1910s
oil on cardboard 71.2 x 52.0
National Gallery of Victoria,
Melbourne, Felton Bequest in 1947
© Gwen John, 1910s/DACS. Licensed
by VISCOPY, Sydney 2004

The nun is a portrait of Sister Marie Céline, one of the Dominican Sisters of Charity at Meudon. Gwen John was received into the Catholic Church in 1913 and she made drawings of the sisters while attending mass at Meudon. She met Mother Armand and agreed

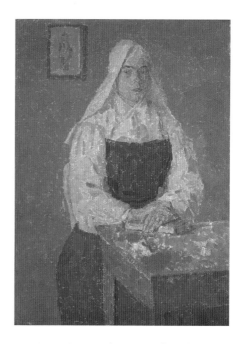

to paint an imagined portrait of Mother Marie Poussepin, who had founded the order in 1696. She based her portrait partly on an image on a prayer card and partly on a model, Sister Marie Céline, who sat for her in the same pose as on the prayer card. John took two years to paint the commissioned portrait, *Mère Poussepin* 1913-20 (private collection), and five other versions. She wrote to John Quinn in 1916, commenting that 'the nuns wanted so many, one for every room in the convent and I tried to do them all at the same time' (Langdale, 1987).

The nun is one of a group of eight images of Sister Marie Céline that may have been painted as preliminary studies for the commissioned portrait, *Mère Poussepin*. John painted it in the narrow tonal range and with the exquisite sensibility that is typical of her later work.

Augustus John wrote in *Finishing touches* (1964):

> she passed some time in Paris under the tutelage of **Whistler**. It was thus she arrived at that careful methodicity, selective taste and subtlety of tone which she never abandoned ... She said 'One accepts the Truth because it is the Truth, and not for any advantage; indeed, for the love of God one is prepared to lose everything, even life; as if that mattered!'

Liz Wilson

Gerald Kelly
1879–1972

English painter Gerald Kelly was born on 9 April 1879 in London, the son of a vicar. He read English at Trinity College, Cambridge. He studied art in Paris and continued to live there for some years, where he became friends with the writers Arnold Bennett and Somerset Maugham. About 1902, while in Paris, he met fellow artist Alan Beeton, who introduced Kelly to the Australian artists J.S. MacDonald and **Ambrose Patterson**, whose highly realistic paintings remained an inspiration to Kelly for much of his life. The Parisian art dealer Paul Durand-Ruel introduced Kelly to Cézanne, Degas, Monet, Renoir and **Rodin**, and he also met Clive Bell, **John Singer Sargent** and **Walter Sickert** there. Somerset Maugham encouraged Kelly to go to Burma in 1908 to recover from a disappointment in love, and the pictures he painted of Burmese temple dancers became some of his best known work. He returned to England in 1909. He was a member of the Modern Society of Portrait Painters together with **George Bell**, **George Lambert** and **Glyn Philpot**. His experiences in Intelligence during the First World War were incorporated in Maugham's book of spy stories, *Ashenden* (which Maugham dedicated to Kelly). He painted the state portraits of King George VI and Queen Elizabeth, as well as portraits of the conductor Malcolm Sargent and the composer, Ralph Vaughan Williams. He organised financial help for James Pryde when he was living in poverty in the last years of his life, and he arranged for **Sickert** to receive a Civil List pension. In 1930, he was elected a full member of the Royal Academy and he was knighted in 1945. While he was president of the Royal Academy from 1949 to 1954, his lively and enthusiastic comments on television helped to revitalise the Academy's public image. It was through his initiative that, in an effort to encourage the modern movement, the Royal Academy showed an exhibition of the *Ecole de Paris* 1900–1950 in 1951. He was also responsible for organising major retrospectives of Royal Academicians such as **Frank Brangwyn**, **Augustus John** and **Alfred Munnings**. He died in London on 5 January 1972, aged 92.

references: Derek Hudson, *For love of painting: The life of Sir Gerald Kelly*, London: Peter Davies, 1975; Clive Bell, *Old friends: Personal recollections*, London: Chatto and Windus, 1956; MaryAnne Stevens (ed.), *The Edwardians and after: The Royal Academy 1900–1950*, London: Royal Academy of Arts, 1988.

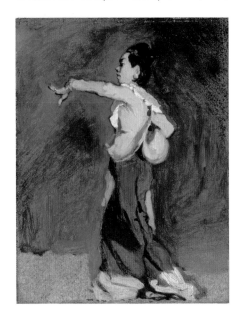

61 *Ma Seyn Mé, pose I (Burmese dancer)*
painted in Mandalay, Burma, 1909
oil on hardboard 34.7 x 27.0
inscribed and dated 'Mandalay/
Jan.13 1909' on verso
exhibited: Royal Hibernian Academy of Arts, Dublin, 1911 (98); Modern Society of Portrait Painters, London, 1912 (28, as 'Studies of Ma–Seyne–Me (a Dancer)')
Royal Academy of Arts, London, presented by the artist's widow in 1973

photograph: J. Hammond

Ma Seyn Mé was one of two dancers who posed regularly for the artist (the other being Ma Si Gyaw). Gerald Kelly commented: 'Ma Seyn Mé was so gay and full of zestful life that we had very lively sittings. I used to go — rather a gate-crasher — to any dance where she was performing' (Hudson, 1975). This painting is one of at least 15 studies that Kelly made of Ma Seyn Mé over three months. Smaller works such as this one were completed in Burma, while others were painted in two stages; the head of the dancer in Burma and the costume later in London, where Kelly returned in 1913.

P.G. Konody commented in the *Observer*, 18 February 1912: 'The three studies of Ma Seyn-Mé give us in a few swift strokes, set down with faultless sureness of purpose, the very essence of a Burmese dancer's sudden, jerky, angular movements.'

And Somerset Maugham said of these paintings:

> His Burmese dancers ... have a strange impenetrability, their gestures are enigmatic and yet significant, they are charming, and yet there is something curiously hieratic in their manner; with a sure instinct, and with a more definite feeling for decoration than is possible in a portrait, Mr Kelly has given us the character of the East as we of our generation see it. (Hudson, 1975)

Eric Kennington
1888–1960

English painter, printmaker and sculptor, Eric Kennington was born in London on 12 March 1888, the son of painter T.B. Kennington and a Swedish mother. Following his studies at the Lambeth School of Art from 1905 to 1907, he first gained recognition for his painting, *Costermongers*. Serving as a private in France and Flanders during 1914 and 1915, he was wounded and invalided out. His experiences in the army inspired his painting *Kensingtons at Laventie* 1915 (Imperial War Museum, London), a group portrait of battle-worn infantrymen, which is a testament to courage and sacrifice. Kennington also made pastel portraits of servicemen, as well as portraits of German prisoners. In 1920, Kennington met T.E. Lawrence. They became friends and Kennington went to Arabia to draw the portrait of Arab leaders for inclusion in Lawrence's *Seven pillars of wisdom* (1926). In the 1920s, he turned with success to monumental sculpture, carving a number of war memorials. He was one of a group of young British sculptors, which included Jacob Epstein, who sought to renew interest in the direct carving of stone. He worked for the acceptance of sculpture as decoration and ornament in architecture and, from 1930 to 1932, he made the carvings on the Shakespeare Memorial Theatre, Stratford on Avon. Between 1936 and 1939 he carved a recumbent effigy of T.E. Lawrence in Arab dress for St Martin's Church, Wareham. He again made portraits of servicemen during the Second World War. He also carved reliefs for schools, colleges and churches. In 1959, he was elected a full member of the Royal Academy. He died in Reading, Berkshire, on 14 April 1960, aged 72.

references: Campbell Dodgson and C.E. Montague, *British artists at the front IV: Eric Kennington*, London: Country Life, 1918; Olivier Meslay, 'Invitation à la visite: La collection de Sir Edmund Davis', *La revue du Musée d'Orsay*, no. 8, printemps 1999; Jonathan Black, *The sculpture of Eric Kennington*, London: Lund Humphries, 2002.

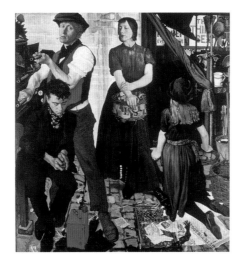

62 *Costermongers (La Cuisine ambulante)* painted in London, 1914
oil on canvas 131.0 x 122.0
signed and dated '1914/ Eric Kennington' lower right
exhibited: International Society of Sculptors, Painters and Gravers, London, Spring 1914 (3, as 'Coster-mongers')
Centre Pompidou, Musée national d'art moderne, Paris, presented by Sir Edmund Davis in 1915, on loan to Musée de Roubaix
Photo CNAC/MNAM Dist. RMN
© Family of the artist

In *Costermongers*, Eric Kennington painted an honest representation of London street life. He captured the individual characters of the hawkers using a hard-edge realism. He achieved a matter-of-fact honesty that is distinct from his father's rather sentimental images of the poor such as *The pinch of poverty* 1899 (Art Gallery of South Australia, Adelaide). The *Daily Telegraph* critic acknowledged this in his comments on 17 April 1914: 'There is strength of purpose, intensity of characterisation, with an almost pre-Raphaelite finish and downrightness, in Mr Eric H. Kennington's curiously hard yet, in its own way, very interesting group,

"Costermongers".'
Costermongers was exhibited in the International Society's 1914 exhibition, alongside **George Lambert**'s *Important people* (cat. 74). Contemporary critics observed that several of the artists in the exhibition had painted decorative groups with a similar viewpoint. On 20 April 1914, the *Daily Chronicle*'s critic placed Kennington's work amongst that of a group of artists that included **William Orpen** and **William Strang**, because these artists used a similar dramatic realism and strong colour, and commented: 'If it had not been for the **Strang** convention of intensive colour would Mr. Eric Kennington have painted his "Costermongers," an extraordinary clever piece of work, vivid, without a patch of atmosphere, a personal vision, unlike any earthly group of costermongers?' The reviewer for the *Daily Mail*, 24 April 1914, linked **Strang**, Kennington and **Lambert**, suggesting that their images broke away from the more traditional group portraits. He wrote:

> Three pictures which strike an unfamiliar note are **Strang**'s 'Picnic,' Mr Eric Kennington's 'Costers,' and Mr. G.W. **Lambert**'s 'Important People'. They must have been painted for pleasure, since one cannot imagine anyone buying and living with these huge staring groups of life-size people, represented in a brutal airless way, though with a great deal of technical cleverness. They must be protests against the namby-pambiness of the usual 'group'.

However, the Australian-born collector Sir Edmund Davis did purchase *Costermongers* for his private collection and, in 1915, presented it to the Musée Luxembourg along with a group of 37 British paintings and drawings from his collection, which included works by **Charles Conder**, **Augustus John**, **William Nicholson**, **Orpen**, **William Rothenstein**, **Charles Shannon**, **Walter Sickert**, **Strang** and **Henry Tonks**.

Harold Knight
1874–1961

English painter Harold Knight was born on
27 January 1874 in Nottingham, the son of
an architect and amateur painter, William
Knight. He attended the Nottingham School
of Art, where he met fellow student Laura
Johnson (**Laura Knight**) in 1890. In 1893,
he studied for a year in Paris at the Académie
Julian. On his return to Britain in 1894, he
moved with **Laura**, whom he married in 1903,
to the artists' community at Staithes,
a picturesque fishing village on the Yorkshire
coast. There he painted landscapes, seascapes
and the daily life of the local community.
Harold and **Laura** made several visits
to Holland to study the Dutch masters,
particularly Rembrandt and Vermeer. In 1907,
they moved to the artists' colony of Newlyn,
Cornwall, where **Stanhope Forbes** and
Alfred Munnings also worked. In Cornwall,
Knight painted outdoors and began to use
brighter colours, although he continued to
prefer indoor subjects and reflected light.
Around 1909, he began a series of paintings
of women in interiors, reflecting his interest in
the paintings of Vermeer. In 1913, Munnings
introduced Harold and **Laura** to **Augustus
John**. During the First World War, Knight
was a conscientious objector and worked on
the land as a farm labourer. At the end of the
war, the Knights moved to London, where
Harold established a reputation as a skilful,
meticulous portrait painter. In 1937, he was
elected a full member of the Royal Academy,
one year after his wife. He died at Colwall,
near Malvern, Herefordshire, on 3 October
1961, aged 87.

r e f e r e n c e s : Norman Garstin, 'The art
of Harold and Laura Knight', *The Studio*,
vol. 57, 1912; Janet Dunbar, *Laura Knight*,
London: Collins, 1975; Caroline Fox
and Francis Greenacre, *Painting in Newlyn
1880–1930*, London: Barbican Art Gallery,
1985; Caroline Fox, *Dame Laura Knight*,
Oxford: Phaidon, 1988; Kenneth McConkey,
Impressionism in Britain, London: Barbican Art
Gallery, 1995.

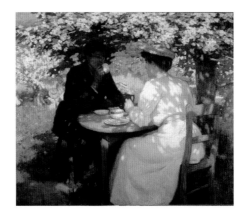

63 *In the Spring*
painted in Newlyn, Cornwall,
England, c.1908
oil on canvas 132.3 x 158.2
signed 'Harold Knight' lower left
Laing Art Gallery, Newcastle upon
Tyne, Tyne and Wear Museums
Reproduced courtesy of Curtis
Browne Law Firm © Harold Knight

Harold Knight painted *In the Spring* soon after
he moved with his wife **Laura** to Newlyn,
Cornwall, when he was experimenting with
painting out of doors, and using a lighter and
brighter colour. In this image of teatime,
Knight captured the dappled effect of light
under a shady tree.

Afternoon teas in the garden offered a break
from the customary rigid dining etiquette that
was an established part of Edwardian social
behaviour. Compared with the 12 highly
structured courses of the Edwardian dinner,
tea in the garden was a liberating experience.
Many artists were drawn to the subject of
outdoor eating, from the French Impressionists
to James Guthrie, **John Lavery** and Walter
Osborne, including **E. Phillips Fox** in *Al fresco*
(cat. 36) and *Déjeuner* (cat. 40).

Laura Knight
1877–1970

English painter, printmaker and designer,
Laura Johnson was born on 4 August 1877
in Long Eaton, Derbyshire, the daughter
of an art teacher mother. From 1890, she
studied at Nottingham School of Art, where
she met fellow student **Harold Knight**. In
1894, she moved with him to the artists'
community in Staithes, a fishing village in
north Yorkshire, and they married in 1903.
After their marriage, they made several visits
to Holland where they greatly admired work
by Dutch artists. In 1907, they moved to
Newlyn, Cornwall, where **Stanhope Forbes**
and **Alfred Munnings** also worked. After her
move to Cornwall, Laura worked outdoors,
using broader and more confident brushwork
and a lighter and more colourful palette in
order to capture the bright Cornish sunlight
in works such as *The beach* 1909 (Laing
Art Gallery, Newcastle upon Tyne). Her
subject matter was varied, although generally
narrative. She was consistently interested in
painting images of women and their lives.
She painted studies of women in the open air,
using London models who did not object to
posing or swimming in the nude, including
two versions of *Daughters of the sun* 1911
(now destroyed). In 1913, **Munnings**
introduced Laura and Harold to **Augustus
John**. At the end of the First World War,
Laura and Harold moved to London. She
gained permission to paint backstage during
the Diaghilev ballet seasons, and her paintings
of the ballet were popular during the 1920s
and early 1930s. Laura was also attracted to
circus life but her circus paintings, while
appreciated by the general public, were not a
critical success. She began to produce etchings
and aquatints in 1923. In 1929, she was
appointed Dame of the British Empire and,
in 1936, she became the first woman to be
elected a full member of the Royal Academy.
During the Second World War, she was
commissioned to paint portraits of women to
record their role in the war and, in 1946, she
was the official artist at the Nuremberg War
Crime Trials. She wrote three volumes of
autobiography, *Oil paint and grease paint* (1936),
A proper circus omie (1962), and *The magic of
a line* (1965). She died in London on 7 July
1970, aged 92.

references : Norman Garstin, 'The art of Harold and Laura Knight', *The Studio*, vol. 57, 1912; Laura Knight, *Oil paint and grease paint*, London: Ivor Nicholson and Watson, 1936; Alfred Munnings, *An artist's life*, London: Museum Press, 1950; Janet Dunbar, *Laura Knight*, London: Collins, 1975; Anne Kirker, *The first fifty years: British art of the 20th century*, Wellington: National Art Gallery of New Zealand, 1981; Caroline Fox and Francis Greenacre, *Painting in Newlyn 1880–1930*, London: Barbican Art Gallery, 1985; Caroline Fox, *Dame Laura Knight*, Oxford: Phaidon, 1988; Teresa Grimes, Judith Collins and Oriana Baddeley, *Five women painters*, Oxford: Lennard Publishing, 1989; Kenneth McConkey, *Impressionism in Britain*, London: Barbican Art Gallery, 1995.

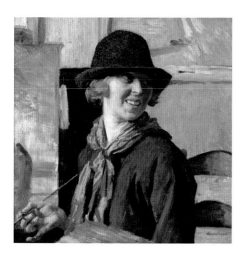

64 *Self-portrait*
painted in Newlyn, Cornwall, England, c.1913
oil on canvas 59.5 x 59.5
exhibited: National Portrait Society, London, 1914
(166, as 'Portrait of the painter')?
Museum of New Zealand Te Papa Tongarewa, Wellington, gift of Mr and Mrs D.A. Ewen in 1936
Reproduced courtesy of Curtis Browne Law Firm © Laura Knight

In her *Self-portrait*, Laura Knight used bright colours and energetic brushstrokes to convey her vivacious personality. She portrayed herself with palette and brush in hand as a sign of her commitment to paint. The black felt hat is the same one that she wore in her full-length self-portrait with a nude model, *Self and nude* 1913 (National Portrait Gallery, London).

In this self-portrait, Knight portrayed herself turning away from the canvas as if to welcome a friend. Her expression is open, joyous and inquisitive, as if she is looking to her companion for comment. In the first volume of his autobiography *An artist's life* (1950), her friend **Alfred Munnings** described the intensity of her passion for her art: 'Here was a great artist who never ceased working. She possessed the energy of six … Laura Knight could paint anything, be it a small watercolour or a nine foot canvas' (Munnings, 1950).

In her autobiography, Knight described how she was full of joie de vivre around this time and imbued her paintings with her sense of enjoyment:

> An ebullient vitality made me want to paint the whole world and say how glorious it was to be young and strong and able to splash with paint on canvas any old thing one saw, without stint of materials or oneself. (Knight, 1936)

Henry Lamb
1883–1960

English painter Henry Lamb was born on 21 June 1883 in Adelaide, South Australia, the son of a mathematician and physicist. In 1886, the family returned to England when Lamb's father was appointed Professor of Mathematics at the University of Manchester. Lamb studied medicine at the University of Manchester from 1901 to 1905, then moved to London. From 1906 to 1907, he attended the Chelsea School of Art in London, run by **William Orpen** and **Augustus John**, He became a follower of **John**, copying his dress and lifestyle as well as absorbing much of his approach to art. He studied with **Jacques-Emile Blanche** in Paris from 1907 to 1908. After returning to London, he spent the summers of 1910 and 1911 working in Brittany, and in Ireland from 1912 to 1913. His first distinctive works are of Breton subjects, rendered with a restrained realism in a flat decorative manner and muted colour range. Like others, he was conscious of the new movements in French art, including the work of Picasso, and in these early paintings he was influenced by Puvis de Chavannes and Gauguin. In 1911, he joined the Camden Town Group and was encouraged by **Walter Sickert**. During the prewar years, he was a close friend of Lady Ottoline Morrell and Lytton Strachey, and mixed with members of the Bloomsbury circle, learning Russian with Leonard Woolf. However, Lamb later severed ties with Bloomsbury members Clive Bell and Roger Fry, rejecting what he termed 'the false aesthetics of the Clive–Fry coalition'. At the beginning of the First World War, he resumed his study of medicine (at Guy's Hospital, London, 1914–16), then became a medical officer in France. He was invalided out of the army and returned to London with a heart condition and nervous debility. He was appointed a British official war artist in 1919. During the 1920s, he was friendly with Stanley Spencer, who used Lamb's Hampstead studio and was his guest in Dorset and Poole. His many portraits include those of Stanley Spencer, Evelyn Waugh, Leonard Woolf, and most importantly, Lytton Strachey — a psychologically perceptive image of the writer's awkward figure and general languor. Between 1940 and 1945, Lamb again worked as an official war artist and, in 1949, he was elected a full member of the Royal Academy. He died on 8 October 1960 in a hospital at Salisbury, aged 77.

references: Wendy Baron, *The Camden Town Group*, London: Scolar Press, 1979; Anne Gray, 'A portrait of Stanley Spencer — and Henry Lamb', *The Art Gallery of Western Australia Bulletin*, 1980; Keith Clements, *Henry Lamb: The artist and his friends*, Bristol: Redcliffe, 1985; Keith Clements and Sandra Martin, *Henry Lamb: 1883–1960*, Manchester: Manchester City Art Gallery, 1984; Stephen Snoddy, *Pintura Británica Moderna*, Bilbao: Museo de Bellas Artes de Bilbao, 1997; Wendy Baron, *Perfect Moderns: A history of the Camden Town Group*, Aldershot: Ashgate, 2000.

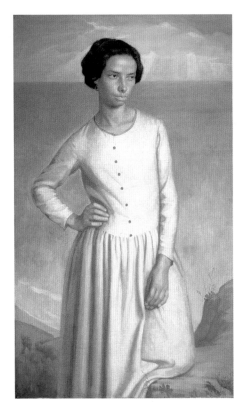

65 *Edie McNeill*
painted in Douélan,
Brittany, France, 1911
oil on canvas 127.5 x 76.2
signed and dated 'Lamb/ 1911'
lower right
exhibited: New English Art
Club, London, Winter 1911
(15, as 'Portrait')
Southampton City Art Gallery,
acquired through the Chipperfield
Bequest Fund in 1938

The model, Edie McNeill, was a sister of **Augustus John**'s second wife and favourite model, Dorelia. Like her sister, Edie was dark haired with a tanned complexion. She was later unhappily married to the Irish poet, Francis McNamara. Lamb painted her while he was in Douélan, Brittany, during July 1911.

Lamb, **John** and **Derwent Lees** all painted images of 'artistic' girls in romantic landscapes. Like **John**, Lamb drew inspiration from Puvis de Chavannes.

Generally, critics appreciated Lamb's use of colour and the simplicity of his design. For instance, the critic for the *Star* wrote on 23 November 1911: 'The colour is an exquisite and subtle harmony of greys, the only touch of positive colour in the picture being the narrow strip of red that borders the girl's neck.' The critic for *Bazaar*, 15 December 1911, remarked: 'how supple the plainly-clad figure, and how well its lines and shape fill the unbroken background'. The *Connoisseur*'s reviewer, January–April 1912, wrote: 'Mr. Henry Lamb, if he still showed the influence of Mr. John in his "portrait", did so not in the guise of an imitator, but rather as an original artist working upon parallel lines. His refined colour and delicate technique are all his own.' **Walter Sickert** wrote in the *New Age*, 4 June 1914:

> Lamb is not only a great talent, but a great talent under the guidance of a clear and educated brain. He has never been, for a moment, the dupe of technical pedantries. He knows, for instance, that it is a trivial thing to spend a lifetime in an effort after intrinsic brightness of paint … Lamb knows that, in a picture, design is the only thing that matters, and that its lucid expression is the whole of pictorial art … His people are individuals, each one unique.

George Lambert
1873–1930

Australian, painter, draughtsman, illustrator and sculptor, George Lambert was born on 13 September 1873 in St Petersburg, the posthumous son of an American railway engineer father and an English mother. He migrated to Australia with his mother and sisters in 1887 and worked briefly on his great-uncle's sheep station. From 1895 to 1899, he studied under Julian Ashton, who praised him for his draughtsmanship. In early paintings, such as *Across the black soil plains* 1899 (Art Gallery of New South Wales, Sydney), he expressed a nationalist sentiment. On the sea voyage to Europe in 1900, he became friends with **Hugh Ramsay**. He studied in Paris at the académies Colarossi and Delécluze where **Ramsay** and **Ambrose Patterson** were also students. Lambert was strongly influenced by the work of Velasquez and of near contemporaries such as **James McNeill Whistler** and Manet. From 1902 to 1921 he lived in London, working for the first two years in a studio in 'Lansdowne House', Holland Park, which was owned by Sir Edmund Davis (the top flat was occupied by Charles Ricketts and **Charles Shannon**). His principal work was in portraiture, in both pencil and oil, painting artist friends like **Thea Proctor**, **Ramsay**, **Francis Derwent Wood** and **Arthur Streeton**, as well as notables like King Edward VII and former Australian Prime Minister, Sir George Reid. In 1906, together with **George Bell** and **Gerald Kelly**, he became a foundation member of the Modern Society of Portrait Painters. He also painted large, stylised paintings of family and friends. At the Chelsea Arts Club and the Café Royal, he mixed with British artists such as **Augustus John** and **William Orpen** as well as Australians **James Quinn**, **Arthur Streeton** and **Tom Roberts**. In 1907, he taught at the London School of Art, when the school's founder, **Frank Brangwyn**, resigned. **William Nicholson** also taught there and **Kathleen O'Connor** and **Nina Hamnett** were both students. Around 1912, Lambert began to paint allegorical subjects in a high key. During the First World War, he was an Australian official war artist in Egypt and Gallipoli, where he painted a series of lyrical landscapes. He returned to Australia in 1921, in order to complete his commissions for large battle paintings for the

Australian government. He also painted works such as *The squatter's daughter* 1923–4 (National Gallery of Australia, Canberra), in which he created a new way of looking at the Australian landscape. In the 1920s, he turned to making sculpture and completed several important commissions. On 29 May 1930, he died of a heart attack at Cobbity, New South Wales, aged 56.

r e f e r e n c e s : George Lambert, 'Autobiography of George Lambert', *Lambert family papers*, [1924], Mitchell Library, Sydney, ML MS A1811; Amy Lambert, *G.W. Lambert: Thirty years of an artist's life*, Sydney: Society of Artists, 1938; Andrew Motion, *The Lamberts: George, Constant and Kit*, London: Chatto & Windus, 1986; Anne Gray, *Art and artifice: George Lambert 1873–1930*, Sydney: Craftsman House, 1996; Anne Gray, *George Lambert 1873–1930, Catalogue Raisonné*, Perth: Bonamy Press, 1996; Anne Gray (ed.), *Painted women: Australian artists in Europe at the turn of the century*, Perth: Lawrence Wilson Art Gallery, 1998.

In *Miss Thea Proctor*, George Lambert placed his sitter in an imaginary landscape, in the manner of earlier artists such as Thomas Gainsborough. He also worked in the tradition of prominent society portrait painter, Charles Furse, who created a vogue for airy, open-air portraits. Like Furse, Lambert uses billowing, rhythmical forms, in harmony with the rounded shapes of the figure and her dress. He superimposed dark shapes against light. He also idealised the image to achieve a sophisticated elegance, elongating the neck, torso and limbs.

Australian painter, printmaker and teacher, **Thea Proctor** (1879–1966) was significant in Lambert's life, as friend, colleague and model. She arrived in England in the summer of 1903 and sat for Lambert shortly after, during the autumn. For this portrait, **Proctor** wore her customary summer outfit for 1903, a softly flowing dark blue polka-dot dress. Throughout her life, **Proctor** presented herself as a woman who was aware of what was stylish, while adapting current trends to her own highly personal sense of elegance.

In *Lotty and a lady,* Lambert presented Lotty in command of her kitchen, looking out comfortably at the viewer. The lady, dressed for outdoors in hat and gloves, is more tenuously seated in the room; her body silhouetted against the door suggests her imminent escape. Lambert's painterly approach shows his desire to paint in the manner of Velasquez, and the image resembles Velasquez's *Christ at the house of Martha and Mary* 1618 (National Gallery, London). Lambert challenged the traditional Edwardian social roles and behaviours by portraying Lotty and the lady together.

The model for the lady was **Proctor**. The model for 'Lotty' was Lottie Stafford, a washerwoman living in the slum cottages of Paradise Walk, Chelsea. She also posed for **William Nicholson** and **Walter Sickert**, and was the model used by **Orpen** for a series of works painted around 1905, including *Resting* (cat. 93), that deal with working-class themes.

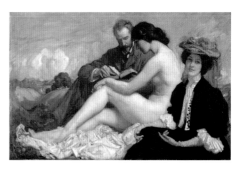

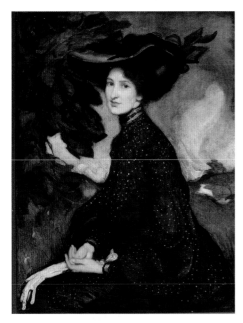

66 *Miss Thea Proctor*
painted in London, 1903
oil on canvas 91.5 x 71.0
signed 'G.W.L.' lower right
exhibited: Royal Academy, London, 1904 (531)
Art Gallery of New South Wales, Sydney, purchased under the terms of the Florence Turner Blake Bequest in 1961

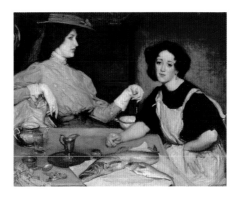

67 *Lotty and a lady*
painted in London, 1906
oil on canvas 103.0 x 128.3
signed and dated 'G.W. LAMBERT/ 1906' lower right
exhibited: Royal Academy, London, 1906 (160); 'Autumn Exhibition of Modern Art', Walker Art Gallery, Liverpool, 1906 (1); Société Nationale des Beaux-Arts, Paris, 1907 (703, as 'Lotty and Lady'); Franco-British exhibition, London, 1908 (368); 'Exhibition of Pictures & Drawings by Arthur Streeton, George Lambert, W. Hardy Wilson', Guild Hall, Melbourne, 30 August – 12 September 1910 (10)
National Gallery of Victoria, Melbourne, Felton Bequest in 1910

68 *The sonnet*
painted in London, c.1907
oil on canvas 113.3 x 177.4
signed 'G.W. LAMBERT' lower left
exhibited: International Society of Sculptors, Painters and Gravers, London, 1907 (225A); 'Streeton's Sydney Sunlight Exhibition', Bernard's Gallery, Melbourne, 1–5 October 1907; Exposición Internacional del Arte, Barcelona, 1911 (142); Royal Hibernian Academy, Dublin, 1912 (126)
National Gallery of Australia, Canberra, bequeathed by John B. Pye in 1963

In this allegorical image, a man reads a sonnet to his female companion who gazes contemplatively out of the painting. They seem unaware of the nude young woman who sits between them; she exists, as it were, on another plane, a metaphysical construct conjured up by the poet in the lines of the sonnet.

As in his other allegorical pictures, in *The sonnet* Lambert drew on well-known works by other artists — in this case the open-air idylls, Giorgione's *Fête champêtre* c.1509-10 (Louvre, Paris) and Manet's *Le déjeuner sur l'herbe* 1863 (Musée d'Orsay, Paris).

Despite the many precedents, critics objected to Lambert's juxtaposition of a nude with figures in modern dress in a landscape setting. They were more accustomed to the traditional practice of artists depicting the nude in classical themes, as in **Rupert Bunny**'s *An idyll* 1901 (cat. 9) and **Arthur Streeton**'s *Venus and Adonis* 1901 (cat. 132). They objected to Lambert's departure from the norm on the basis that the nude was too realistic to be proper. The *Observer* critic, P.G. Konody, wrote on 20 January 1907: 'At the "International" he aroused considerable comment by the insufficiently explained placing of the nude between fully-dressed figures.'

Kitty Powell was probably the model for the nude, **Streeton** for the man and **Proctor** for the lady. Lambert wrote: 'The model had been posing for my private classes. **Proctor** got instruction from me while she carried on professionally. **Streeton** was a frequent and honoured visitor to the studio. One day when I saw these three people together … it seemed to me a modernized version of Giorgione's "Fete Champetre".' (Lambert, A1811)

69 *The holiday group (The bathers)*
painted in London, 1907
oil on canvas 90.7 x 78.7
signed and dated 'G.W. LAMBERT 1907' lower left
exhibited: Modern Society of Portrait Painters 1907 (54, as 'Portrait Group'); Royal Hibernian Academy 1909 (38, as 'The Holiday group)?; 'Exhibition of Pictures & Drawings by Arthur Streeton, George Lambert, W. Hardy Wilson', Guild Hall, Melbourne, 30 August – 12 September 1910 (11, as 'The Holiday')
Art Gallery of South Australia, Adelaide, gift of Mrs A.O. Barrett in 1938

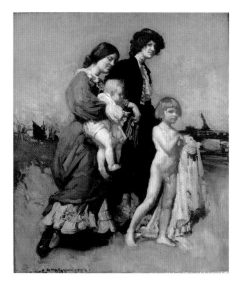

During the early 1900s, images of women and children were a favourite subject for traditional and more modern artists alike. At this time, the women's movement was encouraging women to exercise to give them healthier bodies to assist them in childbearing. In *The holiday group*, Lambert depicted women taking exercise with children, an image of health and wellbeing. He contrasted one woman (Amy Lambert) wearing the loose clothing of the maternal feminist, with the other (**Thea Proctor**) wearing the more restrictive but fashionable high necked blouse and waisted coat of a career woman.

Unlike the critical reactions to Lamberts' *The sonnet*, no objections were raised to the contrasted clothed and unclothed figures in *The holiday group*. The *Observer* critic, P.G. Konody, wrote on 20 January 1907:

> In the 'Portrait Group' he deals with the same artistic problem [as *The sonnet*] in a perfectly natural manner, his skill in stating the fleshiness and roundness of human limbs being given full scope by the two children, one of which is tripping and the other carried to the water's edge. Perhaps the black of the mother's dress is a little too heavy, but otherwise the out-door effect and breeziness of the sea air are as admirable as the forward movement of the figures.

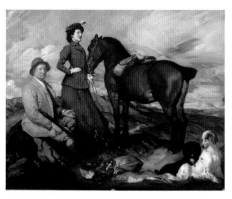

70 *Miss Alison Preston and John Proctor on Mearbeck Moor*
painted in London, 1909
oil on canvas 100.2 x 126.5
signed and dated 'GEO. W. LAMBERT/1909' lower right
exhibited: Royal Academy, London, 1909 (431, as 'Mearbeck Moor, Yorkshire')
The Wesfarmers Collection of Australian Art, Perth

In *Miss Alison Preston and John Proctor on Mearbeck Moor*, Lambert paid homage to Velasquez's *Philip IV as hunter* 1634 (Prado, Madrid), as well as to British sporting portraiture from the 18th century. In placing this group in a moorland setting, he was also influenced by the contemporary artist Charles Furse. By showing Proctor as if he were a sporting gentleman on a country estate, Lambert created a deliberate artifice. John Proctor was, in fact, not a member of the landed gentry but a barrister.

In this double portrait, Lambert portrayed John Proctor in pride of possession, with the spoils of the hunt at his feet, his gun resting against his knee, his dogs lying exhausted. Beside him stands his niece, his most loved 'possession' (this was a time when women had no legal rights of their own). Yet Lambert constructed the image so it told another story as well: that of the emerging role of women at that time. He showed Miss Alison Preston as not just another of John Proctor's assets but as a woman in her own right; he placed her standing at the apex of the composition, wearing a modern riding habit and confidently holding the reins of the horse.

Contemporary critics approved of this work, with Laurence Housman noting in the *Manchester Guardian*, 1 May 1909: 'the most interesting portraits of the year are, once more, the groups and single figures of private people which under the Furse influence, have found an open air setting on moorland or hill … Among these are … Mr. Lambert's human landmarks on a Yorkshire moor.'

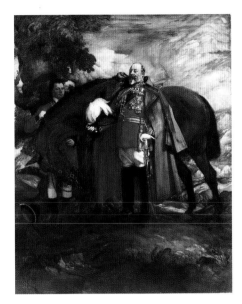

71 *King Edward VII*
painted in London, 1910
oil on canvas 303.5 x 243.0
signed and dated 'G.W. LAMBERT/ 1910' lower left
exhibited: Modern Society of Portrait Painters, London, 1910 (74, as 'His Majesty the King, Equestrian Portrait of King Edward VII')
Historic Memorials Collection, Parliament House Art Collection, Canberra, gift of Amy Lambert in 1930

Lambert depicted King Edward VII (1841–1910) in the uniform of a field-marshal, standing beside his favourite bay horse. The son of Queen Victoria and Albert, Prince Consort, Edward VII was christened Albert Edward Saxe-Coburg. In 1863, he married Alexandra Oldenburg of Denmark. He succeeded Queen Victoria to the throne in 1901 when he was nearly 60. Despite his colourful personal life, during his short reign

he was popular with the people for his good sense, tact and goodwill. He died, after a series of heart attacks, on 6 May 1910, aged 68, shortly after this portrait was completed.

Lambert worked from a few pencil sketches of the king, which he was given the opportunity to make, and then from a model who closely resembled the monarch, dressed in his uniform. One of the king's grooms brought the ceremonial harness to his studio to be placed on a model of a horse's head and shoulders.

This portrait was commissioned by the Imperial Colonial Club, London, but, shortly after Lambert received the commission, the club got into financial difficulties and was unable to pay for it, so it remained Lambert's property.

Critics pronounced this one of the best portraits of the king. Other portraits were painted by Luke Fildes (1902) and Arthur Cope (1907). Australian John Longstaff also painted a portrait of Edward VII (Art Gallery of New South Wales, Sydney). In the *Observer*, 6 February 1910, P.G. Konody referred to possible antecedents for the portrait:

> Perhaps it was the appalling list of failures which constitute the history of modern attempts at portraiture of royalty that made Mr. Lambert hark back to the past. No one will blame him for his intelligent study of Van Dyck's 'Le Roi à la Chasse,' which is here reflected without a hint of plagiarism. Perhaps he has also had a good look at Reynolds's 'Captain Orme' or Raeburn's 'Prof John Wilson' … Perhaps the composition would have been more effective if the figure of the King were placed a little lower on the canvas — a little further from the geometrical centre. But with all this, Mr. Lambert may be congratulated upon having produced the most — perhaps the only — satisfactory portrait of King Edward VII.

The *Studio* critic commented in March 1910: 'Mr. Lambert's portrait of the King is a wonderful piece of design, and the energy and precision of statement, the assurance and knowledge which his art displays, put his canvas, as court portraiture, on a plane above recent contemporary work of the kind.'

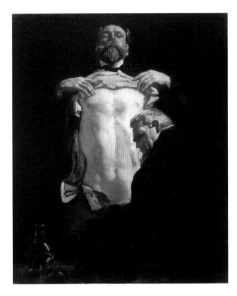

72 *Chesham Street*
painted in London, 1910
oil on canvas 62.0 x 51.5
signed 'G.W.L' lower centre
exhibited: New English Art Club, summer 1910 (264); International art exhibition, Rome, 27 March – October 1911 (?); '16th Annual International Exhibition', Carnegie Institute, Pittsburgh, 1912 (165); Australian Art Association, Melbourne, 7–30 May 1913 (1)
National Gallery of Australia, Canberra

Chesham Street is one of a group of 'puzzle pictures' painted by George Lambert between 1910 and 1914. These paintings appear to have a meaning and yet are not strictly narrative; they invite the viewer to provide their own interpretation. This is a bravura work that demonstrates Lambert's considerable technical prowess but, more than this, it is a challenging and demanding image which asks 'who is this man and what is going on?' The man sits boldly in front of the viewer, holding up his shirt and revealing his entire torso. His head is held high, his lips are closed and he looks down at the viewer, seeming somewhat superior. His pale flesh, with the play of light on it, gleams against the dark surroundings. The model is believed to be Lambert himself. Contemporary critics acknowledged the 'truly masterly painting of a male form' and, when later exhibited in Australia, Lambert's friends recognised that the subject provided a splendid opportunity for the representation of nudity. But this is not strictly a male nude; the figure is not naked, he is half clothed and

is intentionally shown in this way to give the image greater impact and to make it more sexually charged.

Contemporary critics read the image narratively, seeing it as a scene in a consulting room with a doctor examining the heart or lungs of his patient. Although Lambert did depict such a scene, this is not the subject of the painting but the excuse for the composition. Dramatically, the painting is not about a physical examination at a specialist's room in Chesham Street, London, but rather the psychological intrusiveness of that process. In 1901, Freud published his *Psychopathology of everyday life* and, during the decade, his ideas about exploring the psyche gained wider understanding. This painting is a metaphor: this man seems to have nothing to hide, to be literally and metaphorically baring his chest, exposing his heart and soul to the world.

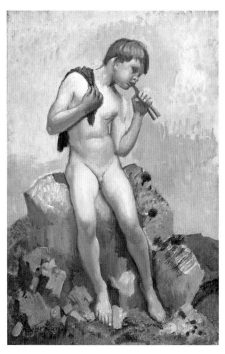

73 *Boy with pipes (The young shepherd)*
painted in London, c.1913
oil on canvas 58.5 x 38.5
signed 'G.W. Lambert' lower left
private collection, courtesy Philip
Bacon Galleries, Brisbane

The model for *Boy with pipes* was Lambert's son, Maurice. But the image is more than a painting of a nude boy playing a pipe. The title *Boy with pipes* is one which was given to the work after Lambert's death, and *The young shepherd* is more likely to be the title he gave it. This title suggests Lambert's idealised interest in simple country life and the virtues of native and natural forces. His youthful shepherd resembles **George Frampton**'s image of a young Peter Pan playing his pipes: about the time that Lambert painted *Boy with pipes*, **Frampton**'s sculpture *Peter Pan* was erected in Kensington Gardens, following the success of J.M. Barrie's famous play (1904).

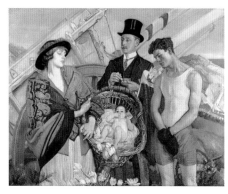

74 *Important people*
painted in London, 1914,
reworked 1921
oil on canvas 134.7 x 170.3
signed 'G.W. LAMBERT/
CHELSEA/ SYDNEY'
upper centre (on cart)
exhibited: International Society
of Sculptors, Painters and Gravers,
London, Spring 1914 (64); Royal
Academy, London, 1918 (56)
Art Gallery of New South Wales,
Sydney photograph: Ray Woodbury
for AGNSW

Who are important people? In his painting, Lambert presented a group of ordinary people at a time when the subjects of group portraits were often people with wealth or status in society. He mocked the assumption that importance is a matter of money or property. He created an allegorical image representing a range of qualities that are possessed by people in the world: motherhood, physical prowess, business acumen, and new life and energy. Lambert used a style that was influenced by the Italian primitives and Botticelli.

His realistic approach to portraying these working people and his strong characterisation appealed to his contemporaries, but they were puzzled about how they fitted together into one scene and would have preferred a more literal story to Lambert's allegorical one.

Lambert admired Bernard Shaw's insight into society and assimilated some of his socialist ideas. In Shaw's most famous play, *Pygmalion*, he ridiculed social snobbery and the reactions to an individual according to class definition. *Important people* was not an illustration of Shaw's writing, but it was a variation on his socialist ideas; it showed a flower girl and a prize-fighter posing with the authority of eminent citizens.

The woman who posed for the mother/ flower girl was a professional model, a young unmarried mother from Battersea whose baby, shown in the rush basket, died while the painting was in progress. The model for the boy was a boxer, Albert Broadrib, who was training for his first fight. The model for the businessman was William Marchant, the head of Goupil Gallery, who had retired to Hove but travelled to London for the sittings. Lambert made several pencil sketches of the various figures in this group.

When exhibited at the International Society's 1914 exhibition, *Important people* was a *succès de scandale*. It received greater critical attention than any of Lambert's previous works, with the reviewer from the *Daily Express* suggesting, on 16 April 1914, that the painting would 'provide dinner-table discussion for the next fortnight'.

Lambert's decorative and colourful arrangement of figures in fixed poses resembles that in the paintings of **Eric Kennington**, **William Strang** and other British realists with whom Lambert exhibited. It was shown in 1914 alongside **Kennington**'s *Costermongers* (cat. 62), and the reviewer for the *Daily Mail*, 24 April 1914, described these paintings as 'huge staring groups of life-size people, represented in a brutal airless way, though with a great deal of technical cleverness', and acknowledged that they were protests against the 'namby-pambiness' of the usual group compositions.

Raoul Larche
1860–1912

French sculptor Raoul Larche was born on 22 October 1860 in Saint-André-de-Cubzac, Gironde, France, the son of an ornamental sculptor. In 1878, he studied at the Ecole des Beaux-Arts in Paris under the sculptors François Jouffroy and Alexandre Falguière. He first exhibited in 1881 at the Salon of the Société des Artistes Français. He was awarded the second Grand Prix de Rome in 1886 and won a gold medal at the 1900 'Exposition Universelle' in Paris. He executed monumental sculptures, such as *Joan of Arc* at La Madeleine, Paris and the stone *St Anthony* at St Antoine, Paris and decorative works for Parisian facades. His fame, however, came with his small bronze lamp sculpture depicting the celebrated dancer, Loïe Fuller. This was the most popular of the small decorative figurative sculptures in the Art Nouveau style designed by Larche for casting in mass production. He produced other works in materials such as biscuit porcelain for the Sèvres factory, and in pewter and bronze for the Siot-Decauville foundry. He died on 2 June 1912 in a traffic accident in Paris, aged 41.

references: Loïe Fuller, *Quinze ans de ma vie [Fifteen years of my life]*, Paris: Juven, 1908; Dora Meeson Coates, *George Coates: His art and his life*, London: J.M. Dent, 1937; Alastair Duncan, *Art Nouveau and Art Deco lighting*, New York: Simon and Schuster, 1978; Gabriele Fahr-Becker, 'World expositions and the bourgeoisie: Paris' in *Art Nouveau*, Cologne: Könemann, 1997.

75 *Loïe Fuller lamp*
Raoul Larche, designer produced by Emile Decauville-Siot foundry, France, c.1900
hollow-cast gilt bronze, electric lamp and fittings 45.6 x 23.0 x 25.5
impressed 'RAOUL LARCHE' on front of base
National Gallery of Australia, Canberra

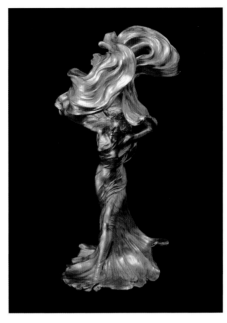

Larche's design for this decorative table lamp was inspired by the graceful movements of Loïe Fuller (1862–1928), one of the most celebrated dancers in Paris during the late 1890s. An American, Fuller had developed a style of dance based on the swirling and billowing movements of her diaphanous veiled costumes. She patented a choreographic style that was animated by the innovative use of coloured electric light bulbs in floor and back-lighting to dramatically illuminate her gestures and costumes. In her celebrated appearance at the 1900 'Exposition Universelle' in Paris, Fuller performed in a special theatre designed to enhance her innovative dance style and she became a symbol of Art Nouveau's sinuous eroticism and modernity. Inspired by her use of light, Raoul Larche designed his lamp with a concealed light source that replicated in miniature the effect of Fuller's sinuous dance. Mass-produced in several versions by the Siot-Decauville foundry, it became one of the most recognisable and widely-disseminated examples of the Art Nouveau style. The wide availability of this fashionable 'art edition', combined with its practical application of new technology, made it a desirable decorative element in the interiors of the Edwardian period.

Although Fuller is best remembered for her place in fin-de-siècle Paris, she also spent time performing in London. She made her London debut in 1889 at the Globe Theatre and returned to that city throughout her career, claiming that she enjoyed the warm welcome and support she found there. However, in her memoirs Fuller failed to mention this early period in her performing life and only made passing mention of her time in London. She was employed as one of the Gaiety Girls at the Gaiety Theatre on the Strand and may have wanted to distance herself from the 'naughty' reputation they gained. But she may also have wanted to avoid acknowledging the influence on her work of English female performers. Two of the Gaiety Girls, Kate Vaughan and Letty Lind, were known for their skirt dancing and they may well have influenced Fuller's serpentine dance — a fact she may have wanted to hide.

Dora Meeson Coates wrote about her husband **George Coates'** friendship with Loïe Fuller:

> In Paris George had made the acquaintance of Loïe Fuller, the American dancer, and had been invited to the home where she and her mother lived, full of mementoes from the many notable people who had been her friends. It was she who, among other original dances, had invented the 'Fire Dance', a wonderful effect of colour and movement produced by skilful motions of the arms extended with stilts and long, flying draperies and various changing lights. She was playing at Ealing when we were there, and came to the Mount Park Crescent house at our invitation, and we all liked her. Though stout and middle-aged, she was a real artist, and so homely and unspoilt and simple. She said she loved England for pleasure and Paris for work. I agreed with her, but not so George. He said he always felt an alien in Paris, whereas in London he could settle down to work, where the very smell of bacon and eggs in the morning gave him a sense of home and comfort.
> (Meeson Coates, 1937)

Robert Bell

Derwent Lees
1885–1931

Australian-born English painter, Derwent Lees was born on 14 November 1884 in Clarence, Tasmania, the son of an English-born bank manager. As a child he lived successively in Brisbane, Melbourne and Sydney. He fell from a horse when he was a teenager and damaged his right foot so severely that it had to be amputated and replaced with a prosthetic limb. He travelled to London to attend the Slade School from 1905 to 1907, where **Ethel Carrick**, **Hilda Fearon** and J.D. Innes were fellow students. While still studying, he was invited to join the academic staff and he taught drawing at the Slade for ten years from 1908 to 1918. His students included David Bomberg, **Mark Gertler**, **C.R.W. Nevinson** and Stanley Spencer. His close associates in London included J.D. Innes and **Augustus John** and, around the period from 1910 to 1913, he worked with Innes and **John** in Dorset and Wales, painting lyrical landscapes in vivid colours on small wooden panels. On 21 July 1913, he marries Edith Brice. He travelled widely in Europe and, during 1912 to 1914, visited the south of France with Innes and **John**. Using pure, strong colours, they painted similar subjects, landscapes of mountains and lakes. In 1918, he became incapacitated by schizophrenia and spent the rest of his life in a mental asylum. He died in hospital in Surrey on 28 March 1931, aged 46.

references: Alleyne Zander, 'Derwent Lees', *Art in Australia*, series 3, no. 48, February 1933; Eric Rowan, *Some miraculous promised land: J. D. Innes, Augustus John and Derwent Lees in North Wales 1910–13*, Llandudno: Mostyn Art Gallery, 1982; James Schoff (ed.), *The British collection at Carrick Hill*, Springfield: The Carrick Hill Trust, 1991; Henry Lew, *In search of Derwent Lees*, Melbourne: Forbes Laing, 1996; Angus Trumble, *Bohemian London: Camden Town and Bloomsbury paintings in Adelaide*, Adelaide: Art Gallery of South Australia, 1997; Henry Lew, 'J.D. Innes and Derwent Lees', *The Australasian Antique Collector*, December 1997–June 1998.

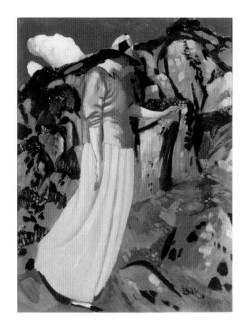

79 *The yellow skirt*
painted in France, 1914
oil on wood panel 50.7 x 38.3
signed and dated 'Lees/
14' lower right
Carrick Hill Trust, Hayward
Bequest, Adelaide

The model for *The yellow skirt* was most likely Derwent Lees' wife Edith Brice, known as Lyndra. Lees met Lyndra through **Augustus John**, for whom she had modelled. She is said to have had a calming and steadying effect on her husband. From 1913 to 1915, Lees painted many images of Lyndra against a landscape background. In *The yellow skirt* he used sharply defined forms and rich colours, as he did in many of his figurative images.

Lees' portraits of his wife have similarities with **John**'s paintings of his wife Dorelia standing or sitting in the landscape, but Lees' handling of paint is tighter. In its subject — a woman wearing 'artistic dress' communing with nature — *The yellow skirt* also resembles **John**'s *La Belle jardiniere* c.1911 (cat. 58) and **Henry Lamb**'s *Edie McNeill* 1911 (cat. 65).

Bertram Mackennal
1863–1931

Australian sculptor Bertram Mackennal was born on 12 June 1863 in Melbourne, the son of the architectural modeller and sculptor John Simpson Mackennal. He received his initial training from his father, before attending the National Gallery School, Melbourne, from 1878 to 1882, where fellow students included **Rupert Bunny**, Frederick McCubbin, Charles Douglas Richardson and **Tom Roberts**. In 1882, Mackennal travelled to London and, in 1883, studied for three months at the Royal Academy Schools where his tutor was **Hamo Thornycroft**. During this period, Mackennal shared a studio with **Roberts** and Richardson but, finding the teaching too rigid, he soon left for Paris and Rome. In Paris, **John Peter Russell** introduced him to **Rodin**, from whom he received instruction. On this trip, Mackennal also met British sculptor, **Alfred Gilbert**. In 1886, Mackennal returned to England and became head of modelling and design at the Coalport Potteries, Shropshire. In 1887, he won the competition for two relief panels for the facade of Parliament House, Melbourne, and the following year returned to Australia to set up a studio. However, disillusioned with his prospects for further work in Australia, Mackennal returned to Europe in 1891. In 1893, he had his first major success with *Circe* (National Gallery of Victoria, Melbourne), which was praised at the Paris Salon and the following year created attention at the Royal Academy. Combining both French and British New Sculpture influences, and causing a minor controversy about the perceived indecency of the intertwined figures surrounding the base, the work established Mackennal's reputation. A number of commissions followed, including that of *Dame Nellie Melba* 1899 (National Gallery of Victoria, Melbourne). He mixed with many of the Australian artists in London. In 1908, he designed the medals for the Olympic Games in London and in 1910 he designed the coronation medal, coinage, stamps and military honours for George V. Over the following decade, Mackennal enjoyed further royal patronage and was also awarded important public commissions, including the monumental *Apollo driving the horses of the Sun* 1915–24, for the facade of Australia House, London. He was knighted in 1921 and in

1922 he became the first and only Australian sculptor to be elected a full member of the Royal Academy. Mackennal visited Australia for the last time in 1926. He died on 10 October 1931 in Torquay, Devon, aged 68.

references: Noel Hutchison, *Bertram Mackennal*, Melbourne: Oxford University Press, 1973; Graeme Sturgeon, *The development of Australian sculpture, 1788–1975*, London: Thames and Hudson, 1978; Ken Scarlett, *Australian sculptors*, Melbourne: Thomas Nelson, 1980; Noel Hutchinson, 'Sir Edgar Bertram Mackennal', *Australian dictionary of biography*, vol. 10, Melbourne: Melbourne University Press, 1988; Robin Tranter, *Bertram Mackennal: A career*, MA thesis, University of Sydney, Department of Fine Arts, 1990.

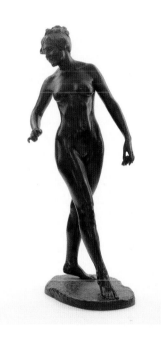

80 *The dancer*
modelled in London, 1904, cast in Paris, 1904
bronze 168.0 x 71.0 x 69.0
signed and dated 'B. Mackennal 1904' incised on edge of base, lower right
exhibited: Royal Academy, London, 1904 (1837), Société des Artistes Français, Paris, 1905 (3377, as 'La danseuse')
Art Gallery of New South Wales, Sydney

The dancer reflects Bertram Mackennal's increasing concern, from the turn of the century, with naturalism and movement.

He first came to prominence with *Circe*, his life-size female nude of 1893. Haughty, imperious and sexually charged, *Circe*'s pose is taut, static and rigidly symmetrical. Created just over a decade later, *The dancer* marks Mackennal's move away from the symbolism and intense psychological focus characteristic of the New Sculpture movement.

The dancer's pose is relaxed; she turns and bends to her right as she steps forward, her outstretched foot lightly touching the ground. Through the carefully balanced pose, the work expresses a sense of graceful movement and a relaxed sensuality, a marked contrast to the powerful and dangerous sexuality of the enchantress Circe. Mackennal has chosen not to clothe *The dancer* in allegory. This nude is not a mythological figure, or a personification of natural forces, rather she is presented as a woman who inhabits the contemporary world.

Elena Taylor

81 *Queen Victoria at her coronation*
modelled in London, 1897, cast in Paris, 1897
bronze 56.3 x 24.8 x 24.3
signed and dated 'BERTRAM. MACKENNAL' incised on rear of pedestal, 'LONDON 1897 BM', incised on left side of pedestal
National Gallery of Australia, Canberra

Although by the late 1890s Mackennal had achieved some measure of critical success, he was still not financially secure. His statuette of Queen Victoria, published in 1897 by Arthur Collie, was certainly intended to take advantage of the intense patriotism surrounding the celebration of the Monarch's Diamond Jubilee. Small in size, yet monumental in feeling, the work is an idealised image of the youthful queen at the time of her ascension to the throne. The surface of the figure of Queen Victoria is sensitively rendered, with Mackennal taking great care with the textures of her cloak and gown, and a sense of movement is given to the figure through the folds in the drapery. While clearly a commercial undertaking, this image of the young queen can also be considered alongside other images of women by Mackennal from this period, reflecting his fascination with feminine power and beauty.

Including the symbols of royal authority — sceptre, orb and crown — the work celebrates the reign of Queen Victoria and the British Empire. Victoria is shown standing on a four-sided pedestal with a cross-shaped base, into which four high-relief figures are set in shallow niches. These female figures represent the four corners of Empire; India shown as a warrior with shield and sword, Africa with miner's pick, Australia with shepherd's crook and sheep, and Canada with a scythe and field of grain. This relationship of main figure to subordinate pedestal figures can be seen as a succinct exposition of the contemporary ideology of Empire and the relationship of the colonies to the mother country.

Elena Taylor

Mary McEvoy
1870–1941

English painter Mary Edwards was born on 22 October 1870 in Freshford, Somerset, the daughter of an army officer. She studied at the Slade School in the 1890s under **Philip Wilson Steer** and **Henry Tonks**, where fellow students included **Augustus John**, Dora Meeson, Ambrose McEvoy and **William Orpen**. She married McEvoy in 1902 and they lived for a while at 10 Trafalgar Studios, Chelsea, neighbours of **George Coates** and Dora Meeson Coates. The latter remarked that McEvoy's 'nude studies at school were superb, and her small interiors, in their luminosity and golden harmonies and fine painting of details, were worthy of the best Dutch period'. In her sensitive paintings of women in interiors, she explored their inner life. She also painted portraits and flower studies. After her husband's death from pneumonia in 1927, McEvoy resumed painting while living in Somerset and London. On 4 November 1941, she died in London, aged 71.

references: Dora Meeson Coates, *George Coates: His art and his life*, London: J.M. Dent and Sons, 1937; 'Mary McEvoy', in Mary Chamot, Denis Farr and Martin Butlin, *Tate Gallery: The modern British paintings, drawings and sculpture*, 2 vols, London: Oldbourne Press, 1964; Maud Sulter, *Echo: Works by women artists 1850–1940*, London: Tate Publishing, 1991.

82 *Interior: Girl reading*
painted in London, 1901
oil on canvas 53.3 x 43.8
signed with monogram, lower right
exhibited: New English Art Club, London, Winter 1902 (102, as 'A girl reading'); 'International Society of Women Artists', Royal Institute, London, January 1908
Tate, London

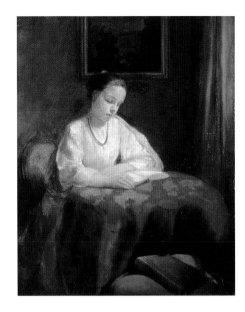

In *Interior: Girl reading*, a girl sits at a table reading in a private space within a comfortable setting; she is confined indoors, with only a hint of the outside world through the reflected light on the folds of the curtains. However, the girl is, indeed, reaching out beyond the limitations of this room, attaining new ideas and having delightful adventures through literature, if not through experience. Mary McEvoy achieved some of the qualities of Dutch masters such as Vermeer in the calm, spare quality of the picture, with each and every object arranged with precision to achieve an understated balance. Similar too is the slightly blurred picture on the wall and the heavy cloth on the table. Yet McEvoy's shy, pensive girl, absorbed in her book, is remarkably of her time. In its focus on the inner life, *Interior: Girl reading* is similar to a number of Edwardian images of middle-class women reading quietly in intimate interiors, such as **Florence Fuller**'s *Inseparables* (cat. 43) and **William Rothenstein**'s *The Browning readers* (cat. 114).

The *Observer*'s reviewer noted on 9 November 1902: 'McEvoy's pale "Reading Girl" is also interesting. Her features are homely and her wrists and hands positively ugly, but the face and attitude, as she sits at a table covered with a sort of red carpet stuff, are taking, and the incidence of the broad light very effective.'

Max Meldrum
1875–1955

Australian painter and teacher, Max Meldrum was born on 3 December 1875 in Edinburgh, the son of a chemist. In 1889, aged 14, he migrated to Australia with his family. He studied at the National Gallery School, Melbourne, from 1892 to 1899, where **George Bell**, **George Coates**, **Rose McPherson** (**Margaret Preston**) and **Hugh Ramsay** were fellow students. He sometimes assisted **Coates** at his painting and life classes. In 1900, he travelled to Europe with the assistance of the National Gallery Travelling Scholarship and, from 1900 to 1901, he studied at the Académie Julian and the Académie Colarossi in Paris. He found himself out of sympathy with the academic theories being taught and soon abandoned formal study. Like others at this time, he was influenced by Velasquez's paintings and approach to art. He visited his family in Edinburgh in 1901, returned to Paris in 1902 and subsequently moved to Pacé, a village in Brittany, to study in 'the school of nature'. In Paris he met Charles Nitsch, a painter from Pacé, and about 1907 he married Nitsch's sister, Jeanne, a singer who performed at the Opéra Comique. Among his best-known work is *Pitcherit's Farm* c.1910 (National Gallery of Victoria, Melbourne). He returned to Melbourne in 1911. From 1916 to 1926 he ran the Meldrum School of Painting. Here he advanced his theory of painting as a pure science, one of optical analysis, and his conviction that tone was the most important component of the art of painting, to the exclusion of all but the barest elements of drawing and colour. Among those influenced by his teaching were Clarice Beckett, Colin Colahan, Archibald Colquhoun, Percy Leason and Arnold Shore. From 1926 to 1931 he lived in France, apart from six months in the United States in 1928 to lecture on his theory and methods of painting. He returned to Australia in 1931 and, in 1937, he opened a new school in Collins Street, Melbourne. He became, and remained, a figure of controversy as he was uncompromising in the advocacy of his views. He published *The science of appearances as formulated and taught by Max Meldrum* (1950). He died on 6 June 1955 at Kew, Melbourne, aged 79.

references: Colin Colahan (ed.), *Max Meldrum: His art and views*, Melbourne: Alexander McCubbin, 1919; James Gleeson, *Aspects of Australian art: 1900–1940*, Canberra: Australian National Gallery, 1978; Peter and John Perry, *Max Meldrum and associates: Their art, lives and influences*, Castlemaine: Castlemaine Art Gallery and Historical Museum, 1996.

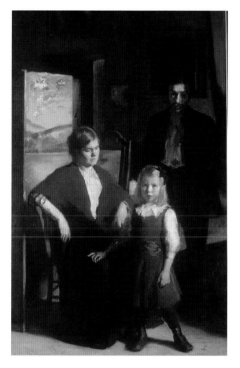

83 *The yellow screen (Family group)*
painted in Pacé, Brittany, France, 1910–11
oil on canvas mounted on composition board 217.5 x 140.0
exhibited: 'Max Meldrum', Athenæum Art Gallery, Melbourne, 22 July – 2 August 1913
(77, as 'Le Paravent Jaune')
National Gallery of Australia, Canberra

The figures represented in *The yellow screen (Family group)* are Max Meldrum (at the age of 35), his wife Jeanne and his eldest daughter Ida. His training had directed Meldrum towards the work of the Spanish artist Velasquez and his methods of arriving at visual truth through a searching study of tone, contrasting light and dark. Accepting this approach without question, Meldrum felt bound to record only what the eye saw at any particular moment. Forms existed only if they were defined by light; as they lost their substance in shadows, Meldrum refused to substitute conceptual forms to compensate for the visual loss. The result is a kind of tonal impressionism akin to that of Velasquez in his painting *Las Meninas* 1656 (Prado, Madrid). In Meldrum's work, the fair-haired daughter, Ida, stands looking out of the painting, with her right hand extended as a distinct echo of the flaxen-haired Infanta in Velasquez's masterpiece, and the artist depicted himself dramatically lit, directly related to Velasquez's own self-portrait in that painting. For all its visual objectivity and size, it is probably Meldrum's most intimate and personal work in this genre. Feeling has not yet been submerged by the clinical analysis and insistence on scientific method so characteristic of his later work.

James Gleeson, 1978

Paul Montford
1868–1938

British-born Australian artist, Paul Montford was born in London on 1 November 1868, the son of the sculptor, Horace Montford. He trained in his father's studio, at the Lambeth School of Art and at the Royal Academy Schools from 1887 to 1891. He was a highly talented student, winning the gold medal for his group *Jacob wrestling with an angel* c.1891, which, like his other early work, was influenced by the New Sculpture movement. In 1892, he spent a year in Europe. He was modelling master at South-Western Polytechnic, Chelsea from 1898 to 1903, while undertaking commissions for architectural sculptures, including reliefs on the Battersea Town Hall (1892), sculptural groups for the City Hall, Cardiff (1901–05) and the figures of Caxton and George Heriot on the Victoria and Albert Museum, London. He also made the bronze busts *Sir Campbell Bannerman* 1908 (Westminster Abbey, London) and *Sir William Randall Cramer* 1908 (Geoffrye Museum, London). In 1914, he won the competition for the four sculpture groups on Glasgow's Kelvin Way Bridge, but these were not erected until the 1920s. Montford migrated to Australia in 1923 and taught at the Gordon Institute of Technology at Geelong from 1923 to 1924. Montford's major public works are the granite figure groups for the exterior of the Shrine of Remembrance, Melbourne: *Patriotism, Peace and Goodwill, Justice, Sacrifice* 1929–34. Through his civic sculptures, he helped to revive public interest in sculpture in Melbourne. Other works produced in Australia include *Peter Pan* 1926 in the Alexandra Gardens, London, *Adam Lindsay Gordon Memorial* 1931 in Melbourne, and *Socrates* 1932 at the University of Western Australia, Perth. He died on 15 January 1938 in Melbourne, aged 69.

references: Basil Burdett, 'Paul Montford', *Art in Australia*, no. 70, March 1938; James Gleeson, *Aspects of Australian art 1900–1940*, Canberra: Australian National Gallery, 1978; Graeme Sturgeon, *The development of Australian sculpture, 1788–1975*, London: Thames and Hudson, 1978; Ken Scarlett, *Australian sculptors*, Melbourne: Thomas Nelson, 1980; Susan Beattie, *The New Sculpture*, New Haven: Yale University Press, 1983; Jenny Zimmer, *Australian dictionary of biography*, vol. 10, Melbourne: Melbourne University Press, 1988.

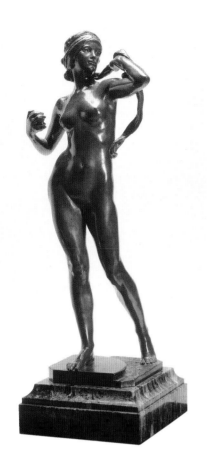

Alfred Munnings
1878–1959

English painter Alfred Munnings was born on 8 October 1878 at Mendham, Suffolk, the son of a miller. He was apprenticed to a Norwich lithographic firm from 1893 to 1898 and, at the same time, attended night classes at the Norwich School of Art under Walter Scott. He designed posters for Cayley's chocolates and crackers. In 1898, he lost the sight of his right eye as a result of an accident. A visit to the Lavenham horse fair sparked a lasting enthusiasm for painting horses and gypsies. In 1902 and 1903, he attended the Académie Julian, Paris, and became impressed by the work of Lucien Simon and Jules Bastien-Lepage. He moved to a farmhouse at Swainsthorp, near Norwich, where he continued to paint landscapes and rural themes and, according to **Gerald Kelly**, 'was never in a studio if he could be in the open air'. When he moved to Lamorna, Cornwall in 1911, his preference for painting from nature gave him common ground with the Newlyn Group of painters, particularly **Laura Knight**. Ineligible for active service during the First World War, he went to France as an official war artist for the Canadian government. The Australian artist **George Lambert** drew his portrait in 1918. In 1919, he took a studio in London and entered London's artistic social life, which was centred around the Chelsea Arts Club and the Café Royal. He also lived at 'Castle House', Dedham, Essex, which is now the Sir Alfred Munnings Art Museum. He received numerous commissions for paintings of racehorses, such as Hyperion (1921). In 1925, he was elected a full member of the Royal Academy and he was knighted in 1944. While president of the Royal Academy between 1944 and 1949, Munnings caused embarrassment and controversy by attacking modern art, particularly by criticising the work of Matisse and Picasso and the sculpture of Henry Moore. Munnings published a three-volume autobiography: *An artist's life* (1950), *The second burst* (1951), and *The finish* (1952). He died on 17 July 1959 at his home in Dedham, aged 80.

references: Reginald Pound, *The Englishman: A biography of Sir Alfred Munnings*, London: Heinemann, 1962; Gerald Kelly, 'Sir Alfred James Munnings', *Dictionary of national biography 1951–1960*, Oxford: Oxford University Press, 1971; Stanley Booth, *Sir Alfred Munnings, 1878–1959: An appreciation of the artist*, London: Sotheby Parke Bernet, 1981; Nicholas Usherwood, *Alfred Munnings 1878–1959*, Manchester: Manchester City Art Galleries, 1986; Jean Goodman, *What a go: The life of Alfred Munnings*, London: Collins, 1988; Kenneth McConkey, *An English idyll: Works from private and public collections and the Sir Alfred Munnings Art Museum*, London: Sotheby's, 2000.

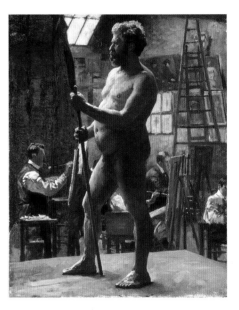

84 *Atalanta defeated (Atalanta and the golden apples)*
modelled in London, c.1900, date of cast unknown
bronze 54.9 x 23.2 x 18.5
signed 'Paul R Montford Sc' incised lower left on base
National Gallery of Australia, Canberra

In Greek mythology, Atalanta was the athletic huntress who promised to marry the first man who could outrun her. Those who lost the race also lost their lives. With the guidance of Aphrodite, Hippomenes won the race by dropping three golden apples in Atalanta's path during their contest. Unable to resist stopping to pick up the fruit, Atalanta lost the race.

Paul Montford depicted Atalanta after she had been defeated, in a static yet sensual pose. She still holds one of the golden apples that caused her defeat. Montford's static figure provides a striking contrast to Mackennal's striding *Atalanta* c.1925 (National Gallery of Australia, Canberra), who is portrayed running.

Steven Tonkin

85 *A study of a male nude in Julian's atelier, Paris*
painted in Paris, c.1902
oil on canvas 82.4 x 66.0
The Sir Alfred Munnings Art Museum, Dedham, Essex

A study of a male nude in Julian's atelier, Paris exemplifies studies produced at the Académie Julian by many artists of the period. Typically, the subject is observed against the light, *contre jour*, involving a close study of local colour.

George Bell, F.C.B. Caddell, George Clausen, Harold Knight, John Lavery, William Nicholson, Glyn Philpot, William Rothenstein, Charles Sims and Philip Wilson Steer all studied at the Académie Julian, and other artists attended similar ateliers in Paris, such as Colarossi's and Delécluze's.

Alfred Munnings described his time at the Académie Julian in the first volume of his autobiography, *An artist's life* (1950):

> Julian's in the Rue du Dragon soon became a second home … All were friends. Some advanced students were painting the most wonderful studies. Large canvases surprised us with their truth, drawing and colour. The enormous ground-floor atelier where I worked was visited then by two professors, M. Bachet and M. Schommer. Bouguereau came seldom, only to say, *'pas mal.'* At the far end the sculptors were at work … On certain Mondays models turned up to be chosen for the next fortnight. Each mounted the throne, one after the other, amid cries of approval or dissent. I felt sorry for the poor women who were too unattractive to pose … Ranging from aged and middle-aged to young, the students were from all countries. The Americans were the richer, and often occupied fine studios, living in state and luxury, while other fellows barely existed. Seventy odd pounds in Barclays Bank at Harleston filled me with all the confidence I needed. The Hotel Jacob cost little; we all ate our *déjeuner* at some place on the Boulevard St Germain. Youth, enthusiasm and small expenses bore us along week by week.

C.R.W. Nevinson
1889–1946

English painter and printmaker, C.R.W. Nevinson was born on 13 August 1889 in London. His father was the author and war correspondent, H.W. Nevinson, and his mother a suffragette and Poor Law reformist. Nevinson attended the St John's Wood Art Schools from 1907 to 1908 and the Slade School from 1909 to 1912, studying alongside **Mark Gertler** and Stanley Spencer. Between 1910 and 1913 he was associated with **Walter Sickert** and the Camden Town Group. He enthusiastically espoused modernism, identifying with the Italian Futurist movement's celebration of modernity and technology. He worked in Paris from 1912 to 1913 and, on his return to Britain, he became prominent in English Futurism, co-authoring with the leading theorist, Marinetti, *Vital English art: A Futurist manifesto*. This created a rift with the British avant-garde, leading to the formation of the Vorticist movement by Wyndham Lewis. In 1914, Nevinson volunteered as a Red Cross Ambulance driver in France but, in 1915, transferred to the Royal Army Medical Corps, serving at the 3rd London General Hospital, Wandsworth alongside **George Coates**, **Tom Roberts**, **Arthur Streeton**, and **Francis Derwent Wood**. In 1916, he was invalided out of the army with rheumatic fever. Adapting his Futurist style to depict life at the front, Nevinson produced some of the most striking paintings of the First World War. He was made a British official war artist in 1917, specialising in aerial views of planes and terrain. After the war, he painted city scenes from windows in London, Paris and New York, and produced more conventional landscapes, genre and flower pieces and satirical allegories. In the 1930s, Nevinson reacted to the spread of Fascism in Europe with a group of darkly allegorical pictures. He published an amusing and entertaining autobiography, *Paint and prejudice* (1937), which has been characterised as 'endless entertaining talk at a dinner party'. In 1942, he suffered a stroke which left him paralysed in his right hand and without the use of one eye. He died on 7 October 1946 in London, aged 57.

references: P.G. Konody, *Modern war: Paintings by C.R.W. Nevinson*, London: Grant Richards, 1917; Elizabeth Knowles, *C.R.W. Nevinson*, Cambridge: Kettles Yard Gallery, 1988; Richard Cork, *A bitter truth: Avant-garde art and the Great War*, New Haven: Yale University Press, 1994; Richard Ingleby et al., *C.R.W. Nevinson: The twentieth century*, London: Imperial War Museum, 1999; M.J.K. Walsh, *C.R.W. Nevinson. This cult of violence*, New Haven: Yale University Press, 2002.

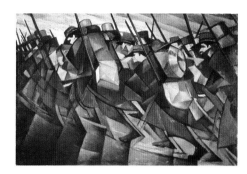

86 *Returning to the trenches*
painted in London, 1914
oil on canvas 51.2 x 76.8
signed 'C.R.W. NEVINSON'
lower left
exhibited: London Group,
London, 1915 (89)
National Gallery of Canada, Ottawa,
gift of the Massey Collection of
English Painting in 1946
Reproduced courtesy of Bridgeman
Art Library 2004

C.R.W. Nevinson witnessed the heavy casualties and widespread devastation of the first battles in Flanders. At the front, he made notes and sketches which he later worked up into drawings, paintings and drypoints. In *Returning to the trenches*, Nevinson captured, through angular lines and abstract blocks of colour, the movement of an army on the march. He showed the column of men marching as robots, caught up in a destiny over which they had no control.

Nevinson wrote in the *Daily Express*, 25 February 1915, that he had 'tried to express the emotion produced by the apparent ugliness and dullness of modern warfare'.
On 14 March 1915, P.G. Konody, the *Observer* critic, noted that Nevinson's *Returning to the trenches* conveyed the reality of men on the march through semi-abstract means:

[it] is really an uncommonly interesting picture, in which he has found a supremely expressive formula for the rhythmic march of a body of French infantrymen fully armed and laden with all the paraphernalia for a prolonged stay in the trenches. Whilst avoiding anything like literal representation of objects, he leaves the spectator in no manner of doubt concerning the meaning of every touch of the brush.

In 1916, **Walter Sickert** described one of Nevinson's war paintings, *La Mitrailleuse* 1915 (Tate, London; a close view of three French soldiers manning a machine gun, which has some resemblance to Sickert's own *The soldiers of King Albert* 1914, Graves Art Gallery, Sheffield) as 'the most authoritative and concentrated utterance on the war in the history of painting'.

Hilda Rix Nicholas
1884–1961

Australian painter Hilda Rix was born on 1 September 1884 in Ballarat, the daughter of a schoolteacher father and an artist mother. She studied at the National Gallery School, Melbourne from 1902 to 1905. In 1906, her father died unexpectedly and the following year she left Australia for Europe with her mother and sister. In London she admired the energetic brushwork of artists such as Charles Furse and **John Singer Sargent**. In 1907, Rix enrolled at the New Art School, London, under the illustrator and poster artist, John Hassall. Later that year, she studied in Paris at the Académie Colarossi, the Académie Delécluze and, in 1908, at the Académie de la Grande Chaumière, which strengthened her interest in figurative painting. While in Paris, she visited **Ethel Carrick** and **E. Phillips Fox**. Every summer from 1910 to 1914, she visited the artists' colony at Etaples in northern France, where she painted the local people in their traditional dress. There, she became friends with Henry Tanner and **Marie Tuck**. In 1912 and 1914, she visited Morocco where the colour and light refreshed her artistic vision. In 1913, the couturier **Jean-Philippe Worth** bought several of her pictures. At the start of the First World War, during evacuation from Etaples, her mother and sister contracted enteric fever; her sister died soon after their arrival in England and her mother in 1916. Later that year, she married Major George Matson Nicholas who returned to the Front three days later and was killed in action in November. Rix Nicholas expressed her grief in a group of emotional paintings. When she returned to Australia in 1918, she received critical acclaim for the range and versatility of her work, which included idealised images of soldiers. Almost immediately, however, she reformulated her approach to art, exchanging her European imagery for nationalistic images of Australian country life. She visited Britain and France between 1924 and 1926, and painted Breton subjects. In 1928 she married Edgar Wright, a grazier, and went to live with him at 'Knockalong', near Delegate. The landscape around this property provided her with subjects for her paintings for the rest of her life. She continued to exhibit her work throughout the 1930s and 1940s, but failing eyesight and ill health limited her output during the 1950s. She died on 3 August 1961 at Delegate Hospital, aged 76.

references: Bertram Stevens, *The art of Hilda Rix Nicholas*, Sydney: Anthony Horderns, 1919; John Pigot, *Hilda Rix Nicholas 1884–1961*, Melbourne: Ian Potter Gallery, 1990; John Pigot, *Capturing the Orient: Hilda Rix Nicholas & Ethel Carrick in the East*, Melbourne: Waverley City Gallery, 1993; John Pigot, *Hilda Rix Nicholas: Her life and art*, Melbourne: Miegunyah Press, 2000.

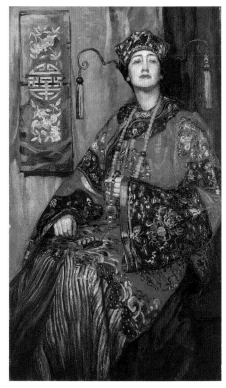

87 *La Robe chinoise*
painted in Paris, c.1913
oil on canvas 141.2 x 83.1
exhibited: Société des Peintres Orientalistes Français, Paris, February 1914; Société des Artists Français, Spring 1914 (1716)
Art Gallery of Western Australia, Perth, acquired with funds from the Sir Claude Hutchin Art Foundation in 1994

In *La Robe chinoise*, Hilda Rix depicted her sister, Elsie, dressed in a Chinese robe and headdress, enjoying the fun of 'dressing up' and acting the role of a haughty belle-dame. By creating an image of an occidental model clothed in a rich blue and red costume of oriental design and placing it in an ornamental frame, Rix playfully exploited the exoticism of the East and its cultural difference. The colourful costume and intricate frame allowed

her to play with the idea of cultural identity, limited by a western perspective.

La Robe chinoise complements works by other artists of occidental women in oriental dress painted in bright 'modernist' colours, such as **J.D. Fergusson**'s *Le Manteau chinois* 1909 (cat. 34).

William Nicholson
1872–1949

English painter and printmaker, William Nicholson was born on 5 February 1872 in Newark-on-Trent, the son of an engineer and politician. He attended the Herkomer Art School at Bushey from 1888 to 1891 and, also in 1891, studied life drawing at the Académie Julian, Paris. In 1893, he married Mabel Pryde and they moved to Denham with her brother, the Scottish artist James Pryde. As the 'Beggarstaff Brothers', Nicholson and Pryde collaborated in designing posters in a bold and simplified style. In 1896, Nicholson moved to London with his family. That year, **James McNeill Whistler** recommended him to the London publisher, William Heinemann, who commissioned *An alphabet*, a series of woodcut illustrations. Heinemann published more than 100 woodcuts by Nicholson over the next five years. His jubilee woodcut portrait, *Queen Victoria* 1897, was an immediate success. In 1898, he produced *An almanac of twelve sports* and *London types* for Heinemann. From 1901, Nicholson turned to portraiture, painting portraits of artists such as Max Beerbohm (1901) and Walter Greaves (1917), and notable people like Miss Gertrude Jekyll (1920). In about 1903, Max Beerbohm introduced Nicholson to **William Orpen** and they became firm friends. He also designed for the theatre, including the original costumes for J.M. Barrie's play, *Peter Pan* (1904). Nicholson later became known as a painter of still life and landscape. In these works, he confidently handled his low-keyed paint, using subdued tones and meticulously balanced design. He taught at **Frank Brangwyn**'s London School of Art with **George Lambert**, where **Kathleen O'Connor** and **Nina Hamnett** were both students. In 1918 his wife, Mabel, died during the Spanish 'flu epidemic, and his second son, Tony, was killed on active service. In 1919, he married Edith, the daughter of Sir Lionel and Florence Phillips. In 1933, Edith and William separated and, in 1935, Marguerite Steen became his companion for the rest of his life. He was knighted in 1936. In 1951, Lady Nicholson and her daughter presented to the National Gallery of Victoria 38 items of costume from Nicholson's collection, including five **Worth** dresses worn at the Coronation of Edward VII in 1902. William Nicholson died on 16 May 1949 in Blewbury, Berkshire, aged 67.

references: Marguerite Steen, *William Nicholson*, London: Collins, 1943; Robert Nichols, *William Nicholson*, Harmondsworth: Penguin, 1948; Lillian Browse, *William Nicholson*, London: Rupert Hart-Davis 1956; Duncan Robinson, *William Nicholson: Paintings, drawings and prints*, London: Arts Council of Great Britain, 1980; Andrew Nicholson (ed.), *William Nicholson painter*, London: de la Mare, 1996.

88 *La Belle chauffeuse*
painted in London, 1904
oil on canvas 76.3 x 63.8
signed and dated 'Nicholson 1904'
lower left
exhibited: International Society of Sculptors, Painters and Gravers, London, 1905 (239); Royal Scottish Academy, Edinburgh, 1906, (244); Royal Glasgow Institute of the Fine Arts, Glasgow, 1909 (120); 'Oil Paintings by William Nicholson', Goupil Gallery, London, April – May 1911 (17)
National Gallery of Victoria, Melbourne, Felton Bequest in 1926

La Belle chauffeuse is a portrait of the playwright Sylvia Bristowe, in motoring hat and gloves. Nicholson was interested in style and often included costume in his paintings. He reduced his image to its essentials and, under the influence of **James McNeill Whistler**, created a carefully balanced composition with an apparently effortless handling of paint.

Around the time that Nicholson painted this work, the *Motor Car Act 1903–04* introduced driving licences for the first time and raised the speed limit to a heady 20 miles per hour. The first charge under this new *Motor Car Act* was heard in 1903, as reported in *The Times*, 13 January 1904. Henry Smith was charged with being drunk while in charge of a motor car at 8.00 a.m. and with failing to produce his driver's licence when requested to do so. He was going at a slow pace but wandering from one side of the road to the other. When asked for his licence, he said he had left it at home and said he was not aware that he had to produce his licence whenever it was demanded by a police officer. As to the charge of drunkenness, he said he was more tired than drunk; he had been driving all night.

In depicting Sylvia Bristowe dressed in motoring outfit Nicholson suggested that she was a modern woman who had adopted the latest form of transport. He also indicated that she was sufficiently wealthy to be able to own and drive a car.

Kathleen O'Connor
1876–1968

Australian painter Kathleen O'Connor was born on 14 September 1876 at Hokitika, New Zealand, the daughter of an Irish-born civil engineer. In 1891, she moved with her family to Fremantle, Western Australia, where she studied art privately and at the Perth Technical College from 1901 to 1903. **Florence Fuller** and **Marie Tuck** were both working in Perth and they urged O'Connor to view European art at first hand so, in 1906, O'Connor travelled overseas with her mother and sister. She continued her studies at the London School of Art under **Frank Brangwyn** and Ernest Borough Johnson, and at the Bushey School of Art. Towards the end of 1908, she moved to Paris and started painting small intimate studies of the people she saw in the Luxembourg Gardens. In Paris, O'Connor met up with **Tuck** and, in 1909, she studied for a short time under **Rupert Bunny**. In 1911, she painted in Concarneau with New Zealander Frances Hodgkins and, later, helped Hodgkins to decorate her studio. In 1914, she and **Nina Hamnett** attended the classes of the Russian artist Marie Wassilieff in Paris. After the declaration of war in 1914, O'Connor left Paris for London and settled in Bloomsbury near British artists **Vanessa Bell**, **Hamnett** and **Walter Sickert**. At this time she met up with fellow expatriate **George Lambert**. She returned to Paris in 1917 and, during the 1920s, painted still lifes in tempera, exploring the possibilities of flat patterning and intense colours to construct her images. During this decade, she became involved in fashion and decorative arts, producing vividly painted fabrics for Paris shops and fashion houses. She visited Australia from 1926 to 1927, designing hand-painted plates, sunshades and fabrics for Grace Brothers and David Jones in Sydney. On her return to Paris, she painted still lifes using an expressive, energetic approach to applying paint, with strong colours. In 1940, she caught one of the last trains out of Paris before the Germans occupied the city. She lived in Britain throughout the war. In 1948, she tried to resettle in Perth but found it uncongenial and, in 1951, returned to Europe for four more years. However, in 1955, she finally settled back in Perth. She died on 25 August 1968 in Perth, Western Australia, aged 91.

references: Julie Lewis and Patrick Hutchings: *Kathleen O'Connor, artist in exile,* Fremantle: Fremantle Arts Press, 1987; Janda Gooding, 'Kathleen Laetitia (Kate) O'Connor', in Joan Kerr, *Heritage: The national women's art book,* Sydney: Craftsman House, 1995; Janda Gooding, *Chasing shadows: The art of Kathleen O'Connor,* Perth: Art Gallery of Western Australia, 1996; Anne Gray (ed.), *Painted women: Australian artists in Europe at the turn of the century,* Perth: Lawrence Wilson Art Gallery, 1998.

89 *Two café girls*
painted in Paris, c.1914
signed 'KLO'C' lower left and 'KLO'C' lower right
oil on canvas 60.0 x 47.5
private collection

Kathleen O'Connor was an objective recorder of Parisian life. Smoking in a public place was fashionable among young women in the 1910s and 1920s, who considered it to be a sign of liberation. O'Connor portrayed her two girls as modern misses, enjoying themselves smoking and drinking in a café.

In theme (women in hats leaning on a table) and in technique (lively free-flowing brushstrokes and restrained palette), *Two café girls* resembles Isaac Israels' painting, *A young girl* c.1913, which O'Connor advised the Art Gallery of Western Australia, Perth, to purchase in 1913. *Two café girls* is also in the tradition of Degas' *Absinthe drinkers* 1876 (Musée d'Orsay, Paris).

Liz Wilson

Omega Workshops
1913–1919

The Omega Workshops, one of the most distinctive achievements of the Bloomsbury artists, was a London applied arts company founded by Roger Fry and co-directed by **Vanessa Bell** and Duncan Grant. The name of the company first appeared in a financial appeal circulated by Fry, dated 11 December 1912, and was probably chosen to suggest that its products would be the 'last word' in design. Housed at 33 Fitzroy Square, the studios and showrooms opened to the public in July 1913 and stayed open until 1919. Fry's idea was to demonstrate that all life belongs to art. The workshops were interested in all forms of art: sculpture, screens, toys, murals and mosaics, and also modern design for furniture and for printed textiles, carpets, ceramics, embroideries. One of Fry's main objectives for the workshops was to provide a regular income for the artists. They tended to work as designers and decorators of utilitarian objects rather than as artisans, and other companies were involved in executing some of these designs to Omega's specifications. The workshops were a fluctuating community of about 20 artists including Henri Doucet, **Henri Gaudier-Brzeska**, Frederick and Jessie Etchells, Wyndham Lewis and **Nina Hamnett**. Pragmatically, the workshops provided these avant-garde artists with a subsidiary income. While interested in the idea of communal artistic activity, Fry's main interest was in aesthetic reform rather than social reform, in overcoming philistinism in Britain. He wished to apply the aesthetic of modernism — Post-Impressionism and Fauvism — to the decorative arts. Most of the workshops' products were sold anonymously. Objects were either bought from stock or commissioned. The workshops also undertook whole interiors. A broad clientele included 'ladies of fashion', and Fry's writer friends such as Arnold Bennett, George Bernard Shaw and W.B. Yeats. However, the Omega Workshops always struggled financially and by mid-1919 Fry was forced to close them down; they were officially liquidated on 24 July 1920.

references: Virginia Woolf, *Roger Fry*, London: Hogarth Press, 1940; Isabelle Anscombe, *Omega and after: Bloomsbury and the decorative arts*, London: Thames and Hudson, 1984; Judith Collins, *The Omega Workshops*, London: Secker and Warburg, 1984; *The Omega Workshops*, London: Craft Council Catalogue, 1984; Gillian Naylor (ed.), *Bloomsbury: The artists, authors and designers by themselves*, London: Octopus, 1990; Vanessa Bell, 'Notes on Bloomsbury' [1951] in *Sketches in pen and ink: A Bloomsbury notebook*, London: Hogarth Press, 1997; Angus Trumble, *Bohemian London: Camden Town and Bloomsbury paintings in Adelaide*, Adelaide: Art Gallery of South Australia, 1997; Richard Shone, *The art of Bloomsbury: Roger Fry, Vanessa Bell and Duncan Grant*, London: Tate Publishing, 1999.

arrangement in Roger Fry's painting *Still-life jug and eggs* 1911 (Art Gallery of South Australia, Adelaide).

Roger Fry wrote to George Bernard Shaw:
I am intending to start a workshop for decorative and applied art. I find that there are many young artists whose painting shows strong decorative feeling, who will be glad to use their talents on applied art both as a means of livelihood and as an advantage to their work as painters and sculptors. (Naylor, 1990)

90 Roger Fry, designer of fabric
Vanessa Bell, designer of garment
Dressing gown in Amenophis VI design
fabric designed in London, 1913,
printed in France, 1913
dressing gown designed and made in London, 1918
linen printed in pink, browns, blue
centre back: 131.0, cuff to cuff: 158.0
Art Gallery of South Australia, Adelaide

Amenophis was available in three colourways. Princess Lichnowsky, the wife of the German ambassador in London, is said to have named all the printed linens for the Omega Workshops. Amenophis was named after Egyptian kings of the New Kingdom. The design was based on the foreground

91 Roger Fry or Frederick Etchells, designer of fabric
Vanessa Bell, designer of garment
Pair of pyjamas in Mechtilde III design
fabric designed in London, 1913,
printed in France, 1913
pyjamas designed and made in London, 1918
linen printed in mauve, green, blue, brown,
trousers: 106.0, long outer leg: 120.0, circumference at waist; jacket: 84.0
long centre back, 150.0 cuff to cuff
Art Gallery of South Australia, Adelaide

Mechtilde was available in three colourways. It was named after the German ambassador's wife, whose name was Mechtilde.

Virginia Woolf wrote in her biography, *Roger Fry* (1940):

> It [the Omega] showed signs of immediately becoming a great success. Orders were coming in. The public was amused and interested. The papers devoted a great deal of space to the new venture ... [One] interviewer took himself off, prophesying that posterity would hold the Omega in honour because 'it had brought beauty and careful workmanship into the common things of life'.

Her sister, **Vanessa Bell** wrote:

> In 1913 the Omega Workshops were started by Roger Fry ... It was a difficult venture, with not enough money or experience behind it and temperamental artists to be driven the way they should go by Roger. All the same his pottery, lovely and perfect in its own way, would not have existed without it and many of the textiles, rugs, screens and painted furniture had character and beauty, too soon to be imitated and vulgarised by other shops. (Bell, [1951], 1997)

William Orpen
1878–1931

Irish painter William Orpen was born on 27 November 1878 in Stillorgan, County Dublin, the son of a solicitor. He studied at the Metropolitan School of Art, Dublin, from 1890 to 1897 and at the Slade School from 1897 to 1899 under **Philip Wilson Steer** and **Henry Tonks**, where he was one of the most outstanding students, excelling at drawing. He formed a friendship with fellow students **Augustus John** and Ambrose McEvoy, travelling with the former to Paris in 1899 to see the work of the old masters. In 1899, he painted at Vattetot-sur-mer with **Charles Conder**, **John**, **Albert Rutherston** and **William Rothenstein** and, in 1900, at Cany with **Conder** and **Rutherston**. In 1901, he married Grace Knewstub, daughter of John Knewstub, friend and assistant to Dante Gabriel Rossetti. He lived in London, but enjoyed visiting Ireland and, from 1902 to 1914, he was a teacher at the Metropolitan School of Art, Dublin, where he instructed a generation of students in sound principles of draughtsmanship and painting techniques. He played a part in the Irish cultural renascence that was led by the poet W.B. Yeats, the novelist and critic George Moore, and the art dealer and patron Hugh Lane. He taught with **John** at the Chelsea Art School from 1903 to 1905, where **Henry Lamb** was a pupil. In about 1903, Max Beerbohm introduced Orpen to **William Nicholson** and they became friends. Orpen was also an active member of the Chelsea Arts Club, where he became friends with **George Lambert**. He produced many sensitive paintings of women, including those of his wife, Grace, and his mistress, Mrs St George, and he enjoyed great success as a portraitist, painting notables such as Lloyd George. From 1913 to 1916, he produced three large-scale allegorical works in which he expressed his feelings and attitudes towards his Irish heritage. Orpen's experience as a British official war artist during the First World War deeply affected him. In 1918, he was knighted and in 1919 he was elected a full member of the Royal Academy. He became president of the International Society of Sculptors, Painters and Gravers in 1921. However, he became a sad figure during the 1920s; an alcoholic, separated from his family and friends. He wrote the autobiographical

An onlooker in France 1917–1919 (1921), and *Stories of old Ireland and myself* (1924), and edited *The outline of art* (1923). He died in London on 29 September 1931, at the age of 53.

references: R.P[ickle], *Sir William Orpen*, London: Benn, 1923; P.G. Konody and Sidney Dark, *Sir William Orpen, artist and man*, London: Seeley Service, 1932; Bruce Arnold, *Orpen: Mirror to an age*, London: Jonathan Cape, 1981; Bruce Arnold, *William Orpen 1878–1931*, Dublin: National Gallery of Ireland, 1991; Kenneth McConkey, *A free spirit: Irish art 1860–1960*, Woodbridge: Antique Collectors' Club, 1990; Brian Kennedy, *Irish painting*, Dublin: Town House, 1993; Alison Smith (ed.), *Exposed: The Victorian nude*, London: Tate Publishing, 2001.

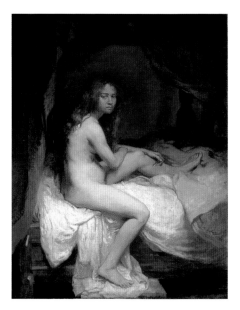

92 *The English nude*
painted in London, 1900
oil on panel 92.0 x 72.0
Mildura Arts Centre, Senator R.D. Elliott Bequest, presented to the city of Mildura by Mrs Hilda Elliott in 1956

During the first ten years of his working life, Orpen portrayed his nudes in daringly frank poses, while at the same time conveying the humanity of his subjects.

In *The English nude* he created a sensual image, depicting his nude sitting on crumpled sheets, tousled, relaxed and half asleep.

Orpen had the versatility to absorb the essence of other painters' work and revitalise their techniques. He particularly admired the way Rembrandt conveyed a sense of drama and feeling through his use of tone and texture, and in *The English nude* he paid homage to Rembrandt's *Hendrickje in bed* c.1648 (National Gallery of Scotland, Edinburgh) and *Bathsheba with King David's letter* 1654 (Louvre, Paris).

Bruce Arnold (1981) recorded that Orpen painted *The English nude* in his dank, dark basement-cellar room in Fitzroy Street, London, where rats sometimes gnawed at his canvases. Emily Scobel was the model for this picture, as well as for *The mirror* (Tate, London) and *The bedroom* (private collection), all painted in 1900. Orpen never exhibited or sold this painting during his lifetime, which may have been because he thought it too forthright in its sensuality for contemporary viewers. He may also have wanted to keep this painting because of his attachment to his model. He had been engaged to Emily but, according to her daughter, she broke it off because she thought him too ambitious, and instead married Orpen's Slade contemporary, Max West.

In *Resting*, Orpen portrayed a washerwoman at rest, with a companion visible through an open doorway or window, busily hanging out clothes on the line. In both his approach and subject, Orpen was influenced by Velasquez, whose work he had viewed on a trip to Madrid in 1904 with his Irish patron, Hugh Lane.

Lottie Stafford, the model for this painting, was a Cockney washerwoman from the slum cottages of Paradise Walk in Chelsea. She was popular as a model on account of her naturalness, total self-assurance and subtle sensuality, despite the fact that she declined to pose in the nude. She had a 'swan-neck' which greatly appealed to Orpen, and which he emphasised in *Resting*. Orpen also employed her as the model for other paintings, including *The wash house* 1905 (National Gallery of Ireland, Dublin) and *Lottie of Paradise Walk* 1905 (Leeds City Art Gallery).

Lottie Stafford was also the model for **George Lambert**'s *Lotty and a lady* 1906 (cat. 67), another Velasquez-inspired image.

Night (no. 2) depicts the sitting room of Orpen's house in London, looking out through a tall window into the night sky. It shows Orpen's wife, Grace, in an armchair, arching back towards her husband who leans over her, to meet him in an embrace. In 1901, Orpen had married Grace Knewstub, and *Night (no. 2)* conveys the happiness of the early years of their marriage.

Night (no. 2) is one of at least six domestic nocturnes that Orpen painted in 1907 showing this room and this window. Grace appears in most of these paintings. They are variations on a theme, and all portray the comfortable, familiar warmth of Orpen's home.

Bruce Arnold (1981) observed that, although a number of images have a metaphysical aspect, this was not something that Orpen consciously put into his painting but was something that his imagery evoked:

> If there is a metaphysical content, then it is in the images themselves. The artist, particularly when he is so firmly set against all attempts to put into words his feelings about art, as Orpen was, must be assumed to be unconscious of what he is 'saying' except in terms of paint, tone, composition … In this group of works he does not know why … he cannot realistically justify the repetition … perhaps not even the starkly objective portrayal of Grace, the sombre shadows of night which hang behind and over her, the pensive stillness which is powerfully present in the works.

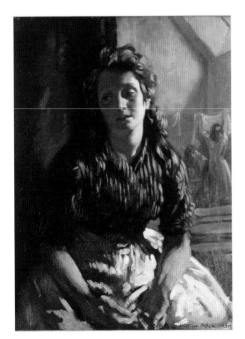

93 *Resting*
painted in London, 1905
oil on canvas 76.2 x 55.8
signed 'William Orpen' lower right
Museums and Galleries of Northern Ireland, Ulster Museum, Belfast

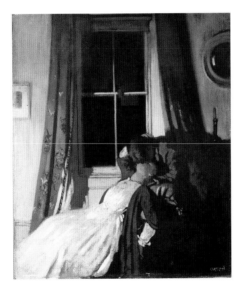

94 *Night (no. 2)*
painted in London, 1907
oil on canvas 76.5 x 64.0
exhibited: Goupil Gallery Salon, London, 1907 (91)?
National Gallery of Victoria, Melbourne, Felton Bequest in 1929

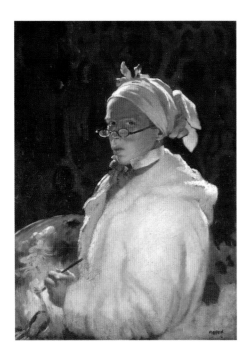

95 *Self-portrait with glasses*
painted in London, 1907
oil on canvas 77.0 x 56.0
signed 'ORPEN' lower right
Mildura Arts Centre, Senator R.D.
Elliott Bequest, presented to the city
of Mildura by Mrs Hilda Elliott in
1956

Orpen produced a number of fine self-portraits. He used his own face as subject matter in his art, despite having grave reservations about the attractiveness of his appearance. He made a joke about this, and claimed that the reservation had been there since his extreme youth. Yet photographs do not bear out his argument, and it seems more likely that it was an attitude adopted deliberately by Orpen, who was in fact very attractive. Self-portraiture for Orpen fulfilled a very complex and deep personal need; essentially inarticulate in expressing matters relating to his spiritual and creative nature — though he was highly articulate and witty at the level of lighter issues — Orpen studied himself in order to understand what art was about, which direction he should be taking with his life, and what point of achievement he had reached at any of the frequent occasions of such self-analysis. The many self-portraits throughout his career are in part puzzled examinations of his nature and purpose. They represent a kind of visual 'diary', the pouring forth, in pencil, wash or oil-paint, of himself.

Orpen once dressed up as the French painter Jean-Baptiste Simeon Chardin for a Covent Garden ball: he wore a white dressing gown, high collar and cravat, white and blue kerchief around his head with the ends sticking up on top, and with a quaint pair of spectacles at the end of his nose. In this *Self-portrait with glasses*, Orpen paid homage to Chardin and his *Self-portrait with pince-nez* 1771 (Louvre, Paris).

Bruce Arnold, 1991

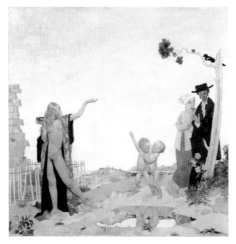

96 *Sowing new seed (for the Board of Agriculture and Technical Instruction for Ireland)*
painted in London, c.1913
oil on canvas 137.0 x 137.0
signed 'ORPEN' lower right
exhibited: New English Art Club,
London, Winter 1913 (28)
Mildura Arts Centre, Senator R.D.
Elliott Bequest, presented to the city
of Mildura by Mrs Hilda Elliott in
1956

Sowing new seed was one of three large-scale allegorical works that Orpen painted between 1913 and 1916, expressing his feelings towards his Irish heritage. *Sowing new seed* is about the arts in Ireland, while *The western wedding* 1914 and *The holy well* 1916 (National Gallery of Ireland, Dublin), are about the Irish peasant.

The scene of *Sowing new seed* is Dublin Bay, painted from Howth. The full-frontal female nude sprinkling seeds symbolises Orpen's attempts to modernise Irish ideas about art. The two naked infants represent the receptive youth of Ireland, open to the new ideas. The man in black represents the

several heads of the Board of Agriculture and Technical Instruction and the lady on his arm the wives of these men. The bare tree represents the members of the board and the magpie stands for bad luck. Orpen painted this work after years of frustration teaching at the Metropolitan School of Art, Dublin (1902–14) and trying to introduce change.

In painting *Sowing new seed* and the other two works, Orpen used a decorative, two-dimensional, fresco-like approach. He adopted a 'marble' medium, developed at that time by Windsor and Newton, which produced a flat opaque quality, something like tempera.

Sowing new seed was selected for purchase by the Art Gallery of South Australia, Adelaide, by **Rose McPherson** (**Margaret Preston**) and Will Ashton, acting as overseas agents for the gallery. It was hung in the gallery in the summer of 1914 and viewed by a record number of people. However, conservative reaction to the explicit nudity led a vandal to deface the pubic area of the nude with acid. The gallery removed the painting for restoration and eventually exchanged it for a mediocre copy of the artist's portrait of Marshall Foch. In 1927, Orpen sold the painting to the Australian collector, R.D. Elliott, who eventually bequeathed it to Mildura.

Harold Parker
1873–1962

Australian sculptor and painter, Harold Parker was born on 27 August 1873 at Aylesbury, Buckinghamshire, England, the son of a carpenter. In 1876, the family migrated to Brisbane. Parker attended night classes in drawing, design and modelling at the Brisbane School of Arts Technical College from 1889 to 1892 and worked in Sydney for a year between 1892 and 1893, carving floral designs for furniture. He travelled to London in 1896 to work as a woodcarver, but instead studied sculpture under W.S. Frith at the City and Guilds South London Technical Art School from 1897 to 1902. During these years, and until 1908, he assisted established sculptors, including Thomas Brock, **Hamo Thornycroft** and Goscombe John. By 1903 he had begun to produce portraits, figures and commemorative works from his own studio in Chelsea. He was commissioned to portray Queensland expatriates and became a rival of the Australian sculptor, **Bertram Mackennal**. He was a member of the Chelsea Arts Club and a friend of fellow Australians **Tom Roberts**, **James Quinn** (who painted his portrait in 1907) and **Arthur Streeton**, whose bust he modelled. At the pinnacle of his artistic career, in 1908, his marble sculpture *Ariadne* was displayed at the Royal Academy as one of the leading works of the year and subsequently acquired for the Tate. That year, he moved his studio to the fashionable area of Kensington. From 1915 to 1918, he worked on his most important public commission, two large allegorical groups to flank the main entrance to Australia House, London: *Peace and prosperity* 1915–18 and *The awakening of Australia* 1915–18. During a visit to Brisbane in 1921, he experimented with Queensland marble. As he was working in a manner different from current trends in sculpture, British critics began to respond unfavourably to his work. Having visited Australia in 1911 and from 1921 to 1922, Parker returned to Australia to settle in 1930. He lived at first in Sydney and Melbourne and in Brisbane from 1934. Unable to secure major sculptural commissions in his home state, he turned more and more to painting. He died in Brisbane on 23 April 1962, aged 88.

references: Ken Scarlett, *Australian sculptors*, Melbourne: Thomas Nelson, 1980; Judith McKay, 'Harold Parker', *Australian dictionary of biography*, vol. 11, Melbourne: Melbourne University Press, 1988; Judith McKay, *Harold Parker: Sculptor*, Brisbane: Queensland Art Gallery, 1993; Christopher Wray, *Arthur Streeton: Painter of light*, Wilton: Jacaranda Wiley, 1993.

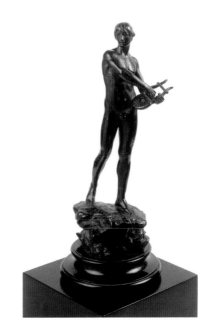

97 *Orpheus*
modelled in London, 1904, cast in London?, c.1909
bronze 43.6 x 15.0 x 17.5
signed and dated 'Harold Parker/ 1904' incised between the feet of Orpheus on base
exhibited: Royal Academy, London, 1909 (1662); Royal Glasgow Institute of Fine Arts, Glasgow, 1910 (621)
National Gallery of Australia, Canberra, gift of William Richard Cumming in 1984

In the 1880s, the New Sculpture movement revitalised British sculpture with the introduction of 'art bronzes', or small-scale sculptures, which became a well-established genre by the 1890s. The aim was to democratise sculpture, to make it an affordable domestic ornament for the increasingly affluent Victorian and later Edwardian middle classes, and to provide a vital source of income for the sculptor.

In Greek mythology, Orpheus is the legendary musician who accompanied Jason and the Argonauts on their quest for the Golden Fleece. He later descended to the Underworld in an attempt to retrieve his love, Eurydice, after her untimely death. Mesmerised by Orpheus' music, Hades, ruler of the Underworld, gave him a chance to lead Eurydice back to the living on condition that he did not look back at her during their journey. Despite this warning, in a fateful moment of self-doubt he stole a glance and lost her forever. Harold Parker's *Orpheus* plucks his lyre, a symbol of his divine talent, yet his melancholic gaze foreshadows his human vulnerability and the ultimately tragic end to his heart's quest.

Orpheus, first modelled in clay in 1904, is Parker's earliest known statuette; his somewhat tentative experiment in working on this type of small-scale figure is perhaps evident by the absence of detail in *Orpheus*' features and instrument. The work was probably not cast in bronze until 1909, when it was exhibited at the Royal Academy as an accompaniment to his more ambitious near life-size sculpture of *Prometheus chained* 1909. In 1908, Parker's marble sculpture *Ariadne* had been acquired through the Chantrey Bequest by the Tate Gallery, London, for the substantial sum of £1,000. This financial, as well as critical, success may have encouraged Parker to cast his earlier statuette of *Orpheus* as an 'art bronze', so as to secure a wider market for his work among private collectors.

Steven Tonkin

98 *Arthur Streeton*
modelled in London, 1906,
cast in London?, 1906
bronze 24.5 x 15.0 x 9.5
signed and dated 'Harold Parker/
1906' incised on base
exhibited: 'An exhibition of paintings
by Arthur Streeton', Market
Buildings, Sydney, July 1907
(45, 'Bronze bust (by Harold Parker)')
private collection
photograph: Brenton McGeachie
for NGA

This bust of the Australian landscape painter
Arthur Streeton points to the connections
between Australian expatriate artists in
London.

In 1906, **Streeton** was 39 and had been living
in London for eight years. In an interview
with the *Sydney Morning Herald*, 31 December
1906, he commented: 'Every man has to
undergo an apprenticeship in London. I
don't care who he is.' As with many of the
expatriates, he had found it difficult to
establish himself in Britain, and was sustained
by his relationship with his future wife, the
violinist, Nora Clench. **Streeton** made a
return journey to Australia at the end of 1906
where he was received like a prodigal son
and secured sufficient sales of his work and
the necessary funds to marry Nora in January
1908.

Grace Joel remarked in *Art and Architecture*,
January–February 1906, a little before this
bust was made, that she found **Streeton** to be
'as simple as of yore in his manner of greeting
and conversation, but his intensely sensitive
nature has suffered from London life'.

The serious expression that Parker captured in
this portrait reflects **Streeton**'s rather earnest
character and may also imply the difficulties
he had in establishing himself in London at
this time.

Ambrose Patterson
1877–1966

Australian-born American painter, printmaker
and teacher, Ambrose Patterson was born on
29 June 1877 at Daylesford, Victoria, the son
of an English-born auctioneer and his Irish
wife. From 1895 to 1898 Patterson attended
the National Gallery School, Melbourne,
where fellow students included **George
Bell**, **Max Meldrum**, **Rose McPherson
(Margaret Preston)** and **Hugh Ramsay**.
He also studied with **E. Phillips Fox** and
Tudor St George Tucker at the Melbourne
School of Art. On receiving an inheritance
in 1898, he took **Fox**'s advice and travelled
to Paris to study at the Académie Julian. As
a result of financial difficulties, in 1899 he
travelled to Montreal and to New York, where
he worked as a cartoonist for newspapers.
In 1901, his brother's sister-in-law, Nellie
Melba, financed his return to Paris. He studied
at the Académies Colarossi and Delécluze,
where **George Lambert** and **Ramsay** were
also students. He became friends with
English artist Alan Beeton, who introduced
him to **Gerald Kelly**. Initially a follower of
Velasquez, around 1904 he started to paint
in a more impressionist manner, inspired
by the work of Manet, Monet, Renoir and
Pissarro. He suffered a breakdown in 1905,
recuperating first in the south of England and
subsequently Ireland. In 1909, while on a trip
to Venice, he suffered a further breakdown.
Returning to Australia in 1910, he received
several significant portrait commissions, and
also depicted Melbourne streetscapes and
rural landscapes. He received support from
Frederick McCubbin, with whom he was
one of the founders of the Australian Art
Association. He moved to Hawaii in 1916,
where he mastered the art of woodblock
printing. In 1918 he moved to Seattle, and
was Professor of Art at the University of
Washington from 1919 to 1947. He became an
American citizen in 1928. Between 1929 and
1930, he studied in France under André Lhote,
adopting a moderate form of Cubism and,
in 1934, he went to Mexico to study fresco
painting. He died on 27 December 1966 in
Seattle, aged 89.

references: Laura Brunsman and Spencer Moseley, *Ambrose Patterson: Modernist painter and printmaker*, Seattle: Carolyn Staley Fine Arts, 1989; Jane Alexander, *Portrait of an artist: Ambrose Patterson (1877–1966): From the Latin Quarter to the pot pourri of Palamadom*, Melbourne: McClelland Regional Gallery, 1992.

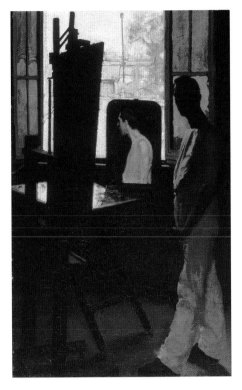

99 *Self-portrait (La Fenêtre de l'atelier)*
painted in Paris, c.1902
oil on canvas 130.5 x 81.5
signed 'Patterson' lower right
exhibited: 'British Colonial Art
Exhibition', Royal Institute of
Painters, London, June–July 1902
(6, as 'Portrait of the artist');
American Art Association exhibition,
Paris, December 1902; Salon
d'Automne, Paris, 1903 (433, as 'Par
la Fenêtre')
National Gallery of Australia,
Canberra

Artists have often painted their own portraits because of the ready availability of the model — themselves — and also as a means of self-enquiry. At the time he painted this portrait, Ambrose Patterson was feeling insecure and experiencing self-doubt because his work had been rejected from the 1902 Société Nationale des Beaux-Arts exhibition

in Paris. Furthermore, Nellie Melba had withdrawn her patronage in favour of his friend, **Hugh Ramsay**. Patterson expressed his inner darkness by portraying himself as a dark silhouette seen against the frame of the open window, but revealed his hopes for a more positive future by showing a brighter image of himself reflected in the mirror. He also painted a work that is based on formalist principles, using strong vertical and horizontal grid and bold shapes.

Patterson admired the work of earlier artists, including Velasquez's group portrait, *Las Meninas* 1656 (Prado, Madrid). The mirror image in the centre of *Self-portrait (La Fenêtre de l'atelier)*, the light coming in from outside, the artist's pose and the painting on the easel are all devices that Patterson adapted from Velasquez's painting and worked into a new and original image.

The critic for the *British Australasian* pointed to the Velasquez influence in his article on 19 June 1902: 'Mr. Ambrose Patterson, who dates from Paris, sends some capital interiors of a studio. In one the artist himself is standing at his easel. The pose is reminiscent of Velazquez, and the simple studio furniture is cleverly suggested.'

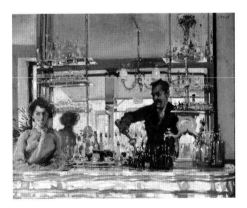

100 *The Pewter Bar, St Leger en Yvelines*
painted in Paris, c.1904
oil on canvas 49.5 x 61.0
signed 'A. Patterson' upper right
exhibited: Baillie Gallery, London,
January? 1905?
Art Gallery of South Australia,
Adelaide, gift of Mrs A. McCarthy
Patterson in 1913

In *The Pewter Bar, St Leger en Yvelines*, Patterson paid homage to Manet's last great masterpiece, *A bar at the Folies-Bergère* 1881–82 (Courtauld Institute Galleries, London), an image set in the bar of one of the most fashionable café concerts in Paris. Manet's painting is a careful formal arrangement of figures and setting, with every area full of interest and observation, whereas Patterson's is a more loosely composed and painted work. Patterson's bar scene, nonetheless, is an interesting variation on Manet's theme. Instead of a bar at the most Parisian of all variety theatres, Patterson chose a bar outside Paris in the village of St Leger en Yvelines in the Ile de France. Instead of the reflection of a crowded auditorium, Patterson presented the mirror image of a spacious room. Instead of a barmaid talking to a client on the other side of the bar, Patterson included a barman pouring a drink. In contrast with the iconic pose of Manet's barmaid, who stares out of the picture in an inscrutable but impassive fashion, Patterson presented the more naturalistic image of a cosmopolitan couple enjoying their work. Manet depicted a bored but servile working class, Patterson a happier and more liberated one.

Glyn Philpot
1884–1937

English painter and sculptor, Glyn Philpot was born on 5 October 1884 in London, the son of a surveyor. From 1900 to 1903, he studied under **Philip Connard** at the South London Technical Art School, Lambeth, and in 1905 at the Académie Julian, Paris. After a visit to Spain in 1906, his work showed the influence of Velasquez. In 1906, he took a studio in Chelsea, where he established himself as a portrait painter, working in the style of **John Singer Sargent**. About 1911, he met Charles Ricketts and **Charles Shannon**, and they introduced him to Robert Ross who helped him gain portrait commissions. He became a member of the Modern Society of Portrait Painters together with **George Bell**, **Gerald Kelly** and **George Lambert**. Philpot admired Serge Diaghilev's Ballets Russes, and **Léon Bakst**'s designs influenced his style and his use of colour. He enlisted in the army in 1914 and was invalided out in 1917. After the First World War, he became one of the most financially successful portrait painters of his generation, painting portraits of Siegfried Sassoon, Dame Nellie Melba and Lady Melchett. However, he exhibited most flair when painting portraits of African men, which he did throughout his life. He lived elegantly, surrounding himself with beautiful furniture, elaborate oriental screens and objets d'art. He first achieved public success for his sculpture in 1923. From 1923 to 1935, Philpot lived in the studio flat at Sir Edmund Davis' 'Lansdowne House', Holland Park which had previously been Ricketts and **Shannon**'s. From 1924, he taught for several years at the Royal Academy Schools, but became dissatisfied with his success and, from about 1930, he turned away from portraiture, producing mythological and allegorical paintings and religious subjects. The tensions between his public and personal lives led him to spend long periods outside Britain. In 1931, he visited Berlin where he was profoundly affected by his encounter with that city's homosexual underworld. He adopted a new style in a lighter and brighter palette, using simplified decorative cubist forms and surrealist ideas. In 1923, he was elected a full member of the Royal Academy; however, in 1933, when he submitted *The great Pan* to the Royal Academy, it was rejected on moral grounds because of its explicit homosexual references. Although he acquired a new, more progressive circle of admirers, his modern approach nearly led to financial hardship. He died suddenly in London from heart failure on 16 December 1937, aged 53.

references: A.C. Sewter, *Glyn Philpot 1884–1937*, London: B.T. Batsford, 1951; Anne Kirker, *The first fifty years: British art of the 20th century*, Wellington: National Art Gallery of New Zealand, 1981; Robin Gibson, *Glyn Philpot 1884–1937*, London: National Portrait Gallery, 1984; John Christian (ed.), *The last Romantics: The Romantic tradition in British art*, London: Barbican Art Gallery, 1989; Gabrielle Cross, *Glyn Philpot*, London: Fine Art Society, 1998; J.G.P. Delaney, *Glyn Philpot: His life and art*, London: Lund Humphries, 1999.

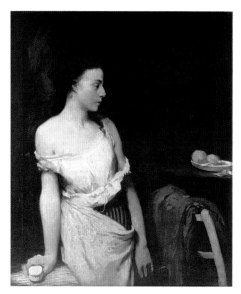

101

Girl at her toilet
painted in London, c.1908
oil on canvas 100.0 x 85.0
signed 'G.W. Philpot' lower right
exhibited: 'Institute of Oil Painters', London, October 1908; 'Paintings by Glyn W. Philpot', Baillie Gallery, London, 30 April – 21 May 1910 (16)
Museum of New Zealand Te Papa Tongarewa, Wellington

In *Girl at her toilet*, Glyn Philpot expressed his admiration of **John Singer Sargent**. He painted his subject in profile, with the stylised pose and emphasis on her neck that **Sargent** had used in his notorious *Madame X* 1884 (Museum of Modern Art, New York). This girl's shift remains provocatively off her shoulder, a feature that in *Madame X* was thought to indicate moral laxity. However, while **Sargent** depicted his subject with tension in every muscle, Philpot portrayed the girl as relaxed and natural. P.G. Konody noted in the *Observer* on 25 October 1908 that *Girl at her toilet* was striking at first sight for the brilliancy of the flesh tones and the bold turn of the bare arm and shoulder ('not unlike Mr. **Sargent**'s famous "Mme. Gautrian" [*sic*]'). In his reference to **Sargent**'s best known painting, Philpot ennobled his model, showing her as if she were someone of social standing.

The model was Philpot's sister, Daisy, whom he depicted in a similar pose in his painting, *The stage box* 1909 (private collection). When young, she saved up her allowance to buy paints for him, and she remained his devoted friend, secretary and housekeeper throughout his life.

Margaret Preston (Rose McPherson)
1875–1963

Australian painter, printmaker and teacher, Margaret Rose McPherson was born on 29 April 1875 at Port Adelaide, the daughter of a marine engineer. She studied at the National Gallery School, Melbourne, in 1893 and from 1896 to 1898, where **George Bell**, **George Coates**, **Max Meldrum** and **Hugh Ramsay** were fellow students. Returning to Adelaide, she attended the School of Design under H.P. Gill in 1898, and taught at her city studio from 1899 to 1904. From 1904 to 1906, she travelled to Europe with **Bessie Davidson**. After only a short time in Munich, McPherson and **Davidson** moved to Paris where **Rupert Bunny** was helpful to them. In 1905, they left Paris for an extensive tour of England, Scotland and Europe. Back in Adelaide, McPherson leased a studio and taught art with **Davidson**. Her pupils included **Gladys Reynell**, with whom she shared a studio from 1911 and with whom she travelled to Europe in 1912. McPherson renewed contact with **Bunny**, and through him she met **J.D. Fergusson** and admired his use of modernist colour and simplified form. McPherson and **Reynell** travelled to London in 1913, where McPherson became an advisor to the Art Gallery of South Australia, Adelaide, recommending the purchase of **William Orpen**'s *Sowing new seed* (cat. 96) and **Frank Brangwyn**'s *Bridge at Avignon* 1913–14. In 1914, McPherson began teaching in London and, in the summers of 1914 and 1915, she continued to teach at the picturesque seaside village of Bonmahon, Ireland. McPherson and **Reynell** studied pottery at the Camberwell School of Arts and Crafts from 1916 to 1917 and, during 1917 and 1918, they started a small pottery in Cornwall. As part of the war effort, they worked in a canteen for soldiers and sailors, where McPherson first met William Preston. From 1918 to 1919, they taught pottery, basketry and printmaking to soldiers at the Seale Hayne Neurological Hospital, Devon. In 1919, McPherson returned to Australia on board the same ship as Preston, whom she married at the end of that year, thereafter exhibiting under the name of Margaret Preston. In Sydney, she concentrated mainly on still lifes in a simplified, geometric style, which reflected her knowledge of modern European art, and

she played a major role in fostering an interest in printmaking. In the late 1930s and 1940s, her painting also reflected her interest in Chinese and Aboriginal art and she produced many landscapes. She contributed articles to *Art in Australia* and *Manuscripts*, including her autobiographical 'From eggs to Electrolux' (1927). She died on 28 May 1963 in Sydney, aged 88.

references: Ian North, *The art of Margaret Preston*, Adelaide: Art Gallery of South Australia, 1980; Elizabeth Butel, *Margaret Preston*, Ringwood: Penguin Books, 1985; Roger Butler, *The prints of Margaret Preston*, Canberra: National Gallery of Australia, 1987; Jane Hylton, *South Australian women artists: Paintings from the 1890s to the 1940s*, Adelaide: Art Gallery of South Australia, 1994; Elizabeth Butel (ed.), *Art and Australia by Margaret Preston, selected writings 1920–1950*, Sydney: ETT Imprint, 2003.

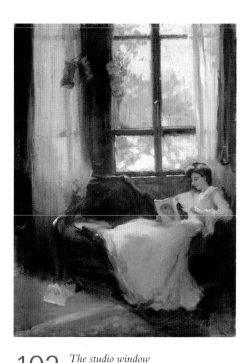

102 *The studio window*
painted in Paris, 1906
oil on canvas 81.5 x 60.0
signed and dated 'M.RM/06'
lower right
exhibited: 'Studio Exhibition, Misses Rose McPherson and Bessie Davidson', Adelaide, March 1907;
'South Australian Society of Arts', Adelaide, 13 June – 6 July 1907 (64)
National Gallery of Australia, Canberra © Margaret Preston, 1906. Licensed by VISCOPY, Sydney 2004

In *The studio window*, Margaret Preston depicted the sitting room of the Paris studio apartment that she shared with fellow Australian artist **Bessie Davidson** in 1906. The view looks out, past decorative lanterns hanging against the curtains, through tall French windows to the gardens of the neighbouring monastery. She portrayed a young woman lying on a sofa wearing the flouncy kind of dress worn by the women in paintings by **Rupert Bunny**, **Philip Wilson Steer** and **Henry Tonks**. This young woman, however, does not relax idly, dream languorously, or focus on her self image in a mirror, as do the subjects in those artists' paintings; Preston depicted her looking at what appears to be an adventurous, modern illustrated magazine or exhibition catalogue. Nonetheless, Preston painted a typically Edwardian scene of stillness and quiet reflection, of a woman enjoying a relaxed moment of quiet reading while soaking in the sunlight streaming through the window.

In 1907, the critic for *The Register* (Adelaide) described *The studio window* as 'delightfully dreamy and delicate in treatment. A pretty girl engrossed in a magazine is reclining on an old-fashioned French seat at the studio window. The figure is most gracefully posed and the pale pink dress is fascinatingly depicted.'

Thea Proctor
1879–1966

Australian painter, printmaker, designer and teacher, Alethea Proctor was born on 2 October 1879 in Armidale, New South Wales, the daughter of a solicitor. Her mother was a cousin of the artist, **John Peter Russell**. From 1896, Proctor studied with Julian Ashton in Sydney, where fellow students included **George Lambert** and Sydney Long. In 1903, chaperoned by her mother, she travelled to London where, on the advice of **Tom Roberts**, she studied briefly at the St John's Wood Art Schools and then privately with **Lambert**. Viewing exhibitions in London, she admired work by **Giovanni Boldini**, **John Lavery**, **Charles Shannon** and **James McNeill Whistler**. She posed regularly for **Lambert** to supplement her income. She also associated with **Charles Conder**, John Longstaff, **Roberts** and **Arthur Streeton**. At Sir Edmund Davis' house, she met **Shannon** and Charles Ricketts. She concentrated on drawing and painting in watercolours, frequently depicting dreamy figures leading apparently idle lives. She also created a number of fan designs which reflected her interest in contemporary fashion. She studied lithography with F. Ernest Jackson and, between 1915 and 1921, made 12 lithographs, one of which shows the influence of **C.R.W. Nevinson** and another the influence of **William Orpen**. Along with other contemporaries, she looked to **Augustus John**'s expression of modern life. She was influenced by the drawings of Ingres, Japanese prints and Diaghilev's Ballets Russes. Proctor visited Australia between 1912 and 1914 and returned to Australia in 1921. She tried to popularise lithography in Melbourne, but found little interest there and moved to Sydney where she became well known for her taste, stylishness and her impeccable dress sense in the clothes she designed herself. In 1924, she produced a tableau vivant at the Theatre Royal, Sydney, with her cousin Hera Roberts. She taught design at Ashton's Sydney Art School with Adelaide Perry, and also privately, introducing many artists to linocut and woodcut printing. She showed her first woodcuts in an exhibition with **Rose McPherson** (**Margaret Preston**) in 1925. In 1926, with **Lambert**, she founded the Contemporary Group, to encourage and support the work of younger avant-garde artists. She designed many elegant covers for the *Home* magazine and wrote on fashion, interior decoration and flower arrangement. The many subjects of her works include images of topical, flapper-type women living a modern, independent lifestyle similar to her own. She also produced original theatre designs for Noel Coward's *Tonight at 8.30*, which reflected her understanding of fashionable society. She died on 29 July 1966 at Potts Point, aged 86.

references: Roger Butler and Jan Minchin, *Thea Proctor: The prints*, Sydney: Resolution Press, 1980; Joan Kerr, *Heritage: The national women's art book*, Sydney: Craftsman House, 1995; Hendrik Kolenberg, *Australian watercolours from the gallery's collection*, Sydney: Art Gallery of New South Wales, 1995; Helen Morgan, 'Thea Proctor in London 1910–11', *Art Bulletin of Victoria*, 36, 1995; Anne Gray (ed.), *Painted women: Australian artists in Europe at the turn of the century*, Perth: Lawrence Wilson Art Gallery, 1998; Bridget Elliott and Janice Helland (eds), *Women artists and the decorative arts*, Aldershot: Ashgate, 2002.

103 *Fan design*
painted in London, c.1908
pencil, watercolour, chinese white on silk, fan-shaped, 20.5 x 32.2
signed 'THEA PROCTOR' lower right
Art Gallery of New South Wales, Sydney, bequest of Florence Turner Blake in 1959
© Thea Waddell, 2004
photograph: Brenton McGeachie for AGNSW

Thea Proctor was inspired by French 18th-century fan designs, and by Japanese and Chinese art in which the fan shape was also common. Proctor later acknowledged **Conder**'s influence on her watercolours on silk and her decorative fan designs, which she painted for over 20 years. A reviewer for the *Onlooker*, 25 March 1911, observed the influence of **Conder** on Proctor, noting that her fan designs were 'done for the most in soft pastel tones of **Conder**. She is prone to look upon a world of romantic fancy through the spectacles of **Conder**.'

Proctor gained aesthetic pleasure from painting on silk, and enjoyed the challenge of creating an image within the restricted form of the fan shape. In this *Fan design*, Proctor excelled herself in the arrangement of the interlocking figures within the space, showing them leaning forward with outstretched arms and flowing dress. In her placement of figures in this fan design, she may even have bettered her master, **Conder**.

104 *The song*
painted in London, c.1909
watercolour, gouache and gold paint on card, fan-shaped,
23.0 x 23.5
signed 'Alethea Proctor' centre right
exhibited: Goupil Gallery Salon, London, 1909 (201, as 'The song (fan)')?; New English Art Club, London, Summer 1912 (81, as 'Fan design: "The song"')
National Gallery of Australia, Canberra
© Thea Waddell, 2004

Proctor used clean lines, simple forms and bold colours in *The song*, foreshadowing her later woodcuts and her teaching of the modernist principles of rhythm, design and colour. She depicted a singer dressed in the latest fashion, 'the tango' dress with its beaded fringe, and wearing a turbaned feathered headdress. Proctor painted *The song* using a thick gouache on card shaped like a Japanese-style fixed fan. In her use of strong colour and dramatic design, as well as in her fan shape, Proctor created a very different image from the majority of her fan paintings which, like *Fan design*, are in pastel colours on silk. Given Proctor's interest in fashion, she may well have known of **Paul Iribe**'s *Les Robes de Paul Poiret*, published in 1908 in an edition of 250 copies. It was a pioneer fashion publication, in which **Iribe** used a decorative approach to depict Poiret's latest dresses, creating an effect somewhat similar to that of Proctor's *The song*.

James Quinn
1869–1951

Australian painter James Quinn was born on 4 December 1869 in Melbourne, the son of a restaurateur. He studied at the National Gallery School, Melbourne, from 1886 to 1893, where fellow students included **George Coates**, **Charles Conder** and **Arthur Streeton**. In 1894, he went to Europe with the assistance of the National Gallery Travelling Scholarship and, in Paris, he studied at the Académie Julian, the Ecole des Beaux-Arts, the Académie Colarossi and the Académie Delécluze. In 1902, Quinn moved to London, where he married fellow art student Blanche Guernier and established a reputation as a portrait painter. He painted many studies of his family, such as *Mother and sons* 1910 (Art Gallery of New South Wales, Sydney), as well as portraits of fellow Australian artists **Tom Roberts** and **George Bell**. His portraits of notable people include the Queen Mother when she was Duchess of York. A lover of good food, wine and conversation, he frequented the Chelsea Arts Club and the Café Royal, where he mixed with Australians **George Lambert**, **Streeton** and **Roberts**. During the First World War, he was an Australian official war artist in France, responsible for portraits of distinguished Australian servicemen and, in 1919, he was an artist for the Canadian War Records. After the war, he continued to paint portraits in London but in 1935, on the death of his artist son René, he returned to Melbourne. He lived a bohemian life of genteel poverty, teaching for a short while in the mid-1940s at the National Gallery School. Though no modernist himself, Quinn publicly opposed Sir Robert Menzies when, in 1941, Menzies opened an exhibition with derogatory remarks about modern art. Quinn died of cancer on 18 February 1951 in Melbourne, aged 81.

references: Kineton Parkes, 'The paintings of James Quinn', *Drawing and Design*, March 1922; Alison Fraser, *James Quinn*, Melbourne: Victorian College of the Arts Gallery, 1980; Alison Fraser, 'James Quinn', *Australian dictionary of biography 1891–1939*, vol. 11, Melbourne: Melbourne University Press, 1988.

105 *A Japanese lady (Madame J. Takeuchi)* painted in London, 1911 oil on canvas 97.2 x 76.5 signed 'J. Quinn' lower right exhibited: Royal Academy, London, 1911?; 'Autumn Exhibition of Modern Art', Walker Art Gallery, Liverpool, 1914 (1062); National Portrait Society, 1914 (150, as 'A Japanese lady') National Museums Liverpool, the Walker Art Gallery

Quinn shared the Edwardian interest in the Japanese people and their culture, as is evident in this serene portrait of a Japanese lady, dressed in a kimono, holding a fan and seated in front of an embroidered screen. In selecting the pose and the position of his subject's head and eyes, as well as through his use of a subtle and restrained palette, Quinn suggested Madame Takeuchi's reserved character and inner peace.

Quinn differed from others who turned to orientalist themes at this time in that he portrayed, with cultural sensitivity, a Japanese lady rather than a European woman posing in oriental costume, as is seen in **James McNeill Whistler**'s work, as well as that of **J.D. Fergusson** in *Le Manteau chinois* 1909 (cat. 34) and **Hilda Rix Nicholas** in *La Robe chinoise* 1913 (cat. 87). To this extent, Quinn's portrait is closer to **Rupert Bunny**'s portrait, *Madame Sadayakko as Kesa* c.1907 (cat.12), than to these other orientalist works.

Kineton Parkes wrote in 1922: 'The portrait of Madame J. Takeuchi, which was seen at the 1911 Academy, is a sympathetic study.'

Hugh Ramsay
1877–1906

Australian painter of portraits and genre subjects, Hugh Ramsay was born on 25 May 1877 in Glasgow, Scotland, the son of a businessman and lay preacher. When he was aged one, his family migrated to Melbourne. From 1894 to 1899, he studied at the National Gallery School, Melbourne, where fellow students included **George Bell**, **George Coates**, **Max Meldrum**, **Rose McPherson** (**Margaret Preston**) and **Ambrose Patterson**. He also studied with **E. Phillips Fox** and **Tudor St George Tucker** at the Melbourne School of Art. Ramsay's promise was recognised by John Longstaff , who remained a friend and mentor throughout his life. Ramsay travelled to Europe in 1900, meeting **George** and Amy **Lambert**, with whom he became friends on board ship. In Paris he shared the studio of the Australian artist, James MacDonald, in a building which housed other artists including **Patterson**. In 1901, he studied at the Académie Colarossi, where **Lambert** and **Patterson** were also students. He admired the work of Velasquez and other old masters as well as that of near contemporaries such as **James McNeill Whistler** and Manet. In Paris, he moved in the same circles as other Australian artists including **Rupert Bunny**, **Agnes Goodsir** and **Meldrum** and the American artist Frederick Friescke. **Patterson** arranged for Ramsay to meet his brother's sister-in-law, Nellie Melba, and she commissioned him to paint her portrait (unfinished) in London, where he moved to in April 1902. He was impressed by the bold, vigorous brushwork of **John Singer Sargent**'s work exhibited at the Royal Academy. In London, he met up with **Fox** and, while staying with Longstaff, he discovered that he had contracted tuberculosis, probably in his studio in Paris. On medical advice, Ramsay returned to Australia in June 1902. Melba helped to finance his return and she also commissioned him to paint a portrait of her father, David Mitchell and her niece, Nellie Patterson. Ramsay defied orders to rest and continued to paint, producing works with a new vigour and breadth of style inspired by **Sargent**, such as *Two girls in white* (*The sisters*) 1904 (Art Gallery of New South Wales, Sydney). He died on 5 March 1906 at his family home, 'Clydebank', in Essendon, Melbourne, aged 28.

references: Patricia Fullerton, 'Hugh Ramsay in Paris, 1901–1902', *Art and Australia*, vol. 25, no. 1, 1987; Patricia Fullerton, *Hugh Ramsay*, Melbourne: Hudson Publishing, 1988; Patricia Fullerton, *Hugh Ramsay 1877–1906*, Melbourne: National Gallery of Victoria, 1992.

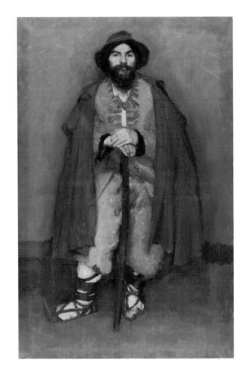

106 *A mountain shepherd* (*An Italian dwarf*)
painted in Paris, 1901
oil on canvas 167.5 x 110.8
exhibited: 'Myoora', Melbourne, 1902 (24, as 'An Italian dwarf')
National Gallery of Australia, Canberra, gift of Nell Fullerton, niece of the artist, in memory of her parents, Sir John and Lady Ramsay in 1980

Hugh Ramsay wrote to his father from his Paris studio on 24 December 1901, describing his subject as 'A mountain shepherd':

> I am painting a brigand or something. Supposed to be an Italian Mountain Shepherd, but looks more like a gnome or hobgoblin. He's a little nuggety dwarflike fierce little cuss, so I keep me 'verolver' in my hip pocket, ready. It's awfully interesting both the man and the costume. I've nearly finished. (Fullerton, 1988)

In *A mountain shepherd*, Ramsay painted a bearded character from the sidewalks of the bohemian Latin Quarter, wearing a hat and cloak and leather-bound alpine sandals, clutching a walking staff and gazing squarely out at the viewer with a simple dignity. Ramsay admired the work of Velasquez and Rubens, and in his choice of subject, his use of an uncompromising realism and his use of light and dark to define space and form, he made reference to these Spanish masters.

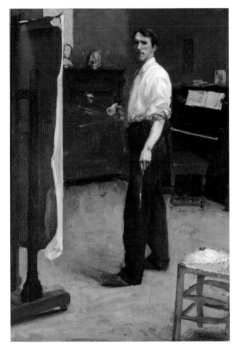

107 *Portrait of the artist standing before easel*
painted in Paris, 1901–02
oil on canvas 128.0 x 86.4
National Gallery of Victoria, Melbourne, bequest of the executors on behalf of Miss E.D. Ramsay in 1943

Ramsay painted a large number of self-portraits, often as private works, not Salon pictures. In *Portrait of the artist standing before easel*, he depicted himself in the studio he shared with J.S. MacDonald at 51 Boulevard St Jacques, Montparnasse, Paris. He showed himself in the act of painting, brush and palette in hand, at the moment of standing back from the easel to look at his work. Behind him is the hired piano which he and MacDonald played to entertain friends such as **Rupert Bunny**, **George Lambert** and **Max Meldrum**. The room, which Amy Lambert

described as being insanitary, served as the artists' studio, sitting room, bedroom and kitchen.

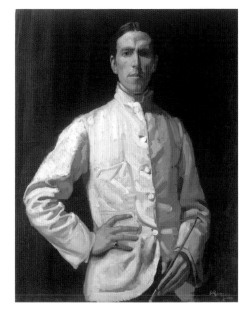

108 *Self-portrait in white jacket*
painted in Paris, 1901–02
oil on canvas 92.3 x 73.5
signed 'H. Ramsay' lower right
exhibited: 'Myoora', Melbourne
1902 (18)
National Gallery of Victoria,
Melbourne, presented through
the NGV Foundation by Mrs Nell
Turnbull, niece of the artist, and
by her children, John Fullerton,
Patricia Fullerton and Fiona
Fullerton, Founder Benefactors in
2002

In this self-portrait, with its superb handling of paint, Ramsay paid homage to his contemporary **John Singer Sargent** and his paintings like *The Earl of Dalhousie* 1900 (exhibited at the Royal Academy in 1900 and reproduced in *The Magazine of Art* and *Royal Academy Pictures*). Ramsay's painting, like **Sargent**'s, exhibits brilliant handling of light on white. Ramsay depicted himself in a formal pose, self-assured, wearing a white jacket, hand on hip. In 1902, the *Argus*'s critic wrote of *Self-portrait in white jacket*: 'the pose is excellent, and the picture impressive'. (Fullerton, 1988)

109 *The lady in blue*
(Mr and Mrs J.S. MacDonald)
painted in Paris, 1902
oil on canvas 172.0 x 112.0
signed 'Hugh Ramsay' lower left
exhibited: 'British Colonial
Exhibition', Royal Institute
Galleries, Piccadilly, 1902;
'Myoora', Melbourne, 1902
(7); Victorian Artists Society,
Melbourne, 1904 (16)
Art Gallery of New South Wales,
Sydney, presented by the family
of Hugh Ramsay in 1943
photograph: Ray Woodbury
for AGNSW

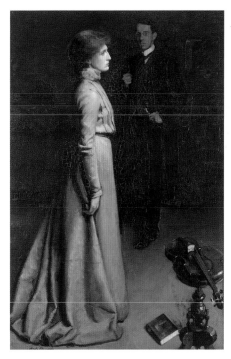

'I've just finished three more pictures; a big one of Jimmy Mac and Miss Keller (best thing I've done) ... So that's my Paris work finished.' (Hugh Ramsay, 25 April 1902)

The painting described as the 'best thing I've done' is the double portrait of James MacDonald and his American fiancée Maud Keller, which shows how Ramsay was beginning to intellectualise his portraiture. No longer content with depicting only the dress, character and pose of his sitter, Ramsay's concern for the overall harmony and balance of the composition led him to depersonalise his subjects and treat them more as poetical props. Following perhaps the example of **James McNeill Whistler** who, in a conscious

reaction against giving his pictures subject titles, had named the portrait of his mother *Arrangement in grey and black* 1871 (Musée d'Orsay, Paris) Ramsay called this painting *The lady in blue*. The simplified geometrical lines of the composition are reminiscent of **Whistler**, as is the harmonious colouring. The transition from the dark blue book on the floor to the softer blue of Miss Keller's dress leads the eye upwards from the bottom right of the picture. By placing MacDonald as a pictorial foil in the background — rather like a piece of furniture — and taking an unusually high viewpoint (like **Whistler** again), Ramsay made the focus of the picture the still-life collection of the book, table and violin at the lower right of the canvas, and conceived his composition more as a still life than a portrait. A high viewpoint was used by Puvis de Chavannes, **Whistler** and **Sargent** and was not new to Ramsay's work.

When the painting was shown at 'Myoora' in 1902, the reviewer for the *Sun* noted that: 'the portrait that will attract the average person is ... most graceful, and in a charming soft harmony of colour, and should encourage a number of our women to sit to Mr Ramsay'.

Patricia Fullerton, 1998

Gladys Reynell
1881–1956

Australian painter, potter and printmaker, Gladys Reynell was born in Adelaide on 4 September 1881, the daughter of a land agent and vigneron. She studied medicine at the University of Adelaide from c.1907 to 1910 and, from 1910 to 1912, she studied painting with **Rose McPherson (Margaret Preston)**, who became a close friend. At this time, **Bessie Davidson** painted her portrait. Reynell and **McPherson** travelled to Europe in 1912, staying in an apartment which had previously belonged to their Adelaide friend **Davidson**, and later that year visited Basle and Brittany. Reynell made friends with **Rupert Bunny,** who gave her lessons and suggested that she study with George Oberteuffer at the Ecole des Beaux-Arts, Paris. Reynell and **McPherson** studied pottery at the Camberwell School of Arts and Crafts from 1916 to 1917 and during 1917 and 1918 they started a small pottery in Cornwall. As part of the war effort, they worked in a canteen for soldiers and sailors, and, from 1918 to 1919, Reynell and **McPherson** taught pottery, basketry, and printmaking to soldiers at the Seale Hayne Neurological Hospital, Devon. Reynell realised that her future lay in pottery and, upon returning to Adelaide in 1919, she established the Reynella Pottery on the family property, south of Adelaide. She found and used local clays, built and fired her own kiln, and threw robust forms based on European folk pottery. She was helped by the family gardener, George Osborne, and in 1922 she married him and moved to Ballarat, Victoria where they started the Osrey Pottery. They found a market for their work in Adelaide, Melbourne and Sydney but, in 1926, George contracted lead poisoning from the glazes and they abandoned this craft, Reynell resuming painting and printmaking. She was employed in the army pay corps, in the Taxation Office and as a translator of French during the Second World War. She worked in a bold, modernist style, painting still-life and genre studies, and cutting wood and lino prints but, unlike **McPherson**, she seldom exhibited in later life. Her article, 'Knowledge or feeling in art' in *Art in Australia*, 15 August 1935, explained her approach to art. She died of cancer in Melbourne on 16 November 1956, aged 75.

references: Roger Butler, *The prints of Margaret Preston*, Canberra: National Gallery of Australia, 1987; Noris Ioannou, 'Gladys Reynell', *Australian dictionary of biography 1891–1939*, vol. 11, Melbourne: Melbourne University Press, 1988; Jane Hylton, *South Australian women artists: Paintings from the 1890s to the 1940s*, Adelaide: Art Gallery of South Australia, 1994.

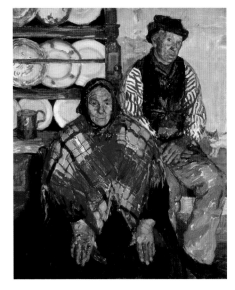

110 *Old Irish couple*
painted in Bonmahon, Waterford County, Ireland, c.1915
oil on canvas 65.3 x 54.0
signed 'G. Reynell' lower left
exhibited: Royal Academy, London, 1916 (161)
Art Gallery of South Australia, Adelaide

In the summers of 1914 and 1915, Gladys Reynell and **Rose McPherson** went to Bonmahon, Ireland. Reynell probably painted *Old Irish couple* during their second visit. She depicted the old couple in a homely kitchen, sitting with their toil-worn hands in their laps, their faces revealing great strength of character.

The New Zealand artist Edith Collier, who worked with Reynell and **McPherson** in Ireland, wrote about the Irish subjects: 'There are grand models here and very cheap. They think it is wonderful to be painted … Bonmahon is a grand place for painting models of all sorts' (quoted in Butler, 1987). **McPherson** commented on the poverty they experienced in Ireland: 'It is almost inconceivable the poverty here — A family of nine in the ordinary course of events, and the father never hopes to earn more than seven shillings a week, how they feed them I don't know' (quoted in Butler, 1987).

While Irish families could be living on something like seven shillings a week, **McPherson** charged five shillings for her private lessons in art. Nonetheless, in *Old Irish couple* Reynell expressed the quiet dignity of these people and suggested their resilience against all odds.

Tom Roberts
1856–1931

Australian painter Tom Roberts was born on 9 March 1856 in Dorchester, England, the son of a journalist. Following the death of his father, he migrated to Australia with his family in 1869, aged 13. He worked for a photographer and, in 1873, attended weekly drawing classes at the Schools of Design at Collingwood and Carlton where he was influenced by Louis Buvelot. He studied at the National Gallery School, Melbourne, from 1874 to 1880, where fellow students included **E. Phillips Fox**, Frederick McCubbin and **Bertram Mackennal**. In 1881, he travelled to London on the same ship as **John Peter Russell**. He attended the Royal Academy Schools from 1881 to 1883, where **George Frampton** was also a student, and to help finance his studies he contributed illustrations to the *Graphic* magazine. In the summer of 1883, Roberts visited Spain with **Russell** and William Maloney, where they met the Spanish art students Laureano Barrau and Ramon Casas, who inspired them to paint directly in front of the motif. Roberts returned to Melbourne in 1885, where he promoted plein-air painting and, together with McCubbin, established the famous painting camps around Heidelberg. **Arthur Streeton** and **Charles Conder** later joined these camps. Roberts was a major instigator along with **Conder** and **Streeton** of the '9 by 5 Impressions' exhibition of 1889. Between 1889 and 1898, Roberts spent much of his time visiting outback stations in New South Wales, painting rural works of a national character such as *Shearing the rams* 1890 (National Gallery of Victoria, Melbourne). He also established a reputation for portraits, including those of public figures such as Sir Henry Parkes and a series of 23 informal panel portraits of Australian types. In 1891, he moved to Sydney and worked at Sirius Cove with **Streeton**. In 1901, he was commissioned to make a vast representation of the opening of the first Federal Parliament in Melbourne and, in 1903, he returned to England to complete it. He was vice-president of the Chelsea Arts Club when **George Clausen** was president. During the First World War, he served as an orderly at the 3rd London General Hospital, Wandsworth, alongside **George Coates**, **C.R.W. Nevinson**, **Streeton** and **Francis Derwent Wood**. He visited Australia during 1919 and 1920, and in 1923 he returned to Australia permanently where he painted landscapes in a low-key palette. He died from cancer on 14 September 1931 at Kallista, Victoria, aged 75.

references: R.H. Croll, *Tom Roberts: Father of Australian landscape painting*, Melbourne: Robertson & Mullens, 1935; Virginia Spate, *Tom Roberts*, Melbourne: Lansdowne Press, 1972, revised 1978; Chris Cuneen, 'John Adrian Louis Hope', *Australian dictionary of biography 1891–1939*, vol. 9, Melbourne: Melbourne University Press, 1983; Helen Topliss, *Tom Roberts 1856–1931, a catalogue raisonné*, 2 vols, Melbourne: Oxford University Press, 1985; Humphrey McQueen, *Tom Roberts*, Melbourne: Macmillan, 1996; Ron Radford, *Tom Roberts*, Adelaide: Art Gallery of South Australia, 1996; Mary Eagle, *The oil paintings of Tom Roberts in the National Gallery of Australia*, Canberra: National Gallery of Australia, 1997.

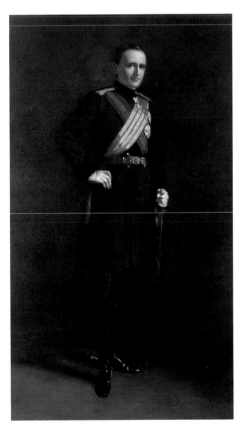

111 *Marquis of Linlithgow* painted in Fürtzburg, Bavaria, Germany?, and London, 1904–05 oil on canvas 213.3 x 122.0 Art Gallery of South Australia, Adelaide, gift of Sir J. Langdon Bonython in 1905

John Adrian Louis Hope (1860–1908) was the 7th Earl of Hopetoun and the 1st Marquis of Linlithgow. He was born at 'Hopetoun House', near South Queensferry, Scotland and was educated at Eton and the Royal Military College, Sandhurst. His responsibilities on the family estate and his poor health prevented him from joining the army. He was governor of Victoria from 1889 to 1895, and the first governor-general of the Commonwealth of Australia from 1901 to 1902. He was humiliated when the government refused to agree to the prime minister's proposal that the governor-general's salary be increased, and he asked to be recalled. On his return to Britain in 1902 he was created Marquis of Linlithgow. He served as secretary of state for Scotland in Arthur Balfour's ministry, but was already seriously ill. A press clipping from the *British Australasian*, 16 June 1904, mentions that Roberts had gone to Fürtzburg to paint Lord Linlithgow's portrait while Linlithgow was taking the cure there. He died of pernicious anaemia while wintering in France.

Tom Roberts painted this portrait after Linlithgow had returned to Britain, showing him wearing full dress uniform, looking directly and benignly at the viewer. Roberts captured Linlithgow's slight build and what the *Bulletin* described as his 'willowy stoop and cat like, Lord Chamberlain's tread'.

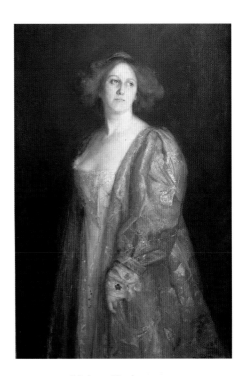

112

Madame Hartl
painted in London, c.1909
frame carved by Lillie Williamson,
the artist's wife
oil on canvas 114.5 x 76.4
signed 'Tom Roberts' lower right
exhibited: Royal Academy,
London, 1910 (1); British Colonial
Society of Artists, London, 1911
National Gallery of Australia,
Canberra

Madame Ruby Hartl (née Assafrey) wore
the spectacular Italianate costume of La
Tornabuoni to the Chelsea Arts Club Annual
Costume Ball at the Royal Opera House,
Covent Garden, on 18 February 1909. Nancy
Elmhurst Goode, an opera singer from
Melbourne, who attended the ball in the same
party as Ruby Hartl, Roberts and his wife,
remembered years later that the Australians
gathered 'at the sign of the Kangaroo'.
Bertram Mackennal wore 'the rich dress of
a Chinese mandarin'. **George Lambert** 'with
pointed beard and curled moustache, doublet
and hose', styled himself on Rubens. His wife
came as 'an Indian squaw'. Roberts appeared
as 'a sundowner, true to his beloved Australia'.

Towards the end of 1909, Roberts asked
whether Hartl would pose for him in her
costume. After years of self-doubt he had
taken specific steps to cope with long-standing
problems of style. On the advice of **James
Quinn**, he reduced his palette to a limited
range of colours which would read as tones
as well as colours. 'Quinn helped me very
much by suggesting a simple range of y[ellow]
ochre Lt Red [mixed with] white so that one
isn't deceived by the brilliance of the pigment
into thinking you've got light & Black.' He
used that palette, and specifically the graded
red tones, for *Madame Hartl*. Roberts' other
exercise was to overhaul his manner of putting
on paint. 'Coates & I have been doing copies
of the Phillip IV head [*Philip IV in brown and
silver* c.1634 by Velasquez] I have the same
experience each week[ly copying session at the
National Gallery, London] … the subtlety of
it & the way the pigments have been floated &
flickered on, I grasp all that the painter meant,
no brush work, no cleverness!'

Madame Hartl benefited not only from these
lessons in paint application but also from the
composition and elaborate costume of the
Velasquez portrait. Conception and effect
is refined, conservative and assured. We are
told that for portraits at this time Roberts
'demanded many sittings and spared no labour
to satisfy himself'.

In 1910, the portrait of Madame Hartl was
shown at the Royal Academy. Jubilant,
the artist wrote to a Melbourne friend:
'The portrait of Madame Ruby Hartl as La
Tornabuoni is No. 1 in the first room, just one
above the line, and looks as well as it did in
the studio.'

Shortly after acquiring her portrait, Ruby
Hartl married Fielding Nalder and went to
live in 'Passalacqua', on Lake Como, Italy,
where Roberts visited them in 1913.

Mary Eagle, 1997

Auguste Rodin
1840–1917

French sculptor, draughtsman and printmaker,
Auguste Rodin was born on 12 November
1840 in Paris, the son of a police clerk. He
studied at the Ecole Impériale Spéciale de
Dessin et de Mathématiques from 1854 to
1857 but failed the entrance examinations
for the Ecole des Beaux-Arts. He worked as
an ornamental mason, becoming, in 1864,
a studio assistant to Albert-Ernest Carrier-
Belleuse, one of the most prolific 19th-
century sculptors. Between 1871 and 1877
he worked in Brussels, visiting Italy from
1875 to 1876 and studying the sculpture of
Michelangelo and Donatello. In 1877, he
exhibited *The age of bronze* in Brussels and
Paris, where the anatomical accuracy of this
work led to accusations that he had made a cast
from a living person. *St John the Baptist* 1878–80
was his next major sculpture. In 1880, he was
invited to design an ornamental doorway
for the proposed Musée des Arts Décoratifs
(which was never installed but which occupied
him for many years). Known as *The gates
of hell* 1880-1917, it incorporated many of
his best-known independent works, such as
his passionate *The kiss* c.1881-82. Although
French, Rodin had strong connections with
London and the artists working there; he first
visited London in 1881 and exhibited work
in the Royal Academy exhibition of 1882.
Rodin carried out a number of prestigious
commissions, notably the monuments to
creative men such as Victor Hugo, Claude
Lorrain and Honoré de Balzac. In 1884 he
received the commission for *The burghers of
Calais*, which was exhibited in its final form in
1889. A retrospective of Rodin's work, held in
Paris in conjunction with the 1900 'Exposition
Universelle', confirmed his reputation. In
1903, he succeeded **James McNeill Whistler**
as the president of the International Society
of Sculptors, Painters and Gravers, where
he worked closely with **John Lavery**, his
vice-president. In 1911, the National Art
Collections Fund purchased *The burghers of
Calais* for the gardens at Westminster and, in
1914, Rodin presented 18 of his sculptures to
the Victoria and Albert Museum, London.
During the First World War, he moved to
England and spent some time at Cheltenham.
During his last years he was occupied with
creating a museum of his sculpture and, in

1916, the French government finally endorsed the establishment of the Musée Rodin in Paris, based on his substantial gift of sculpture and other works. His working methods were traditional; he conceived his works in clay, and left to his assistants the casting in bronze and carving in marble. His style, however, was revolutionary; aiming to imitate not only form, but also life, dramatising his forms and surfaces to make use of the effects of light. He achieved expressive effects through portraying fragmented or incomplete figures and contorted poses. Rodin died in Meudon on 17 November 1917, aged 77.

references: Auguste Rodin, *Art: From the French of Paul Gsell*, London: Hodder and Stoughton, 1912; Alan Bowness, *Rodin*, London: The Hayward Gallery, 1970; Joy Newton and Margaret MacDonald, 'Rodin: The Whistler Monument', *Gazette des Beaux-Arts*, vol. VI, no. 92, December 1978; Albert Elsen, *Rodin rediscovered*, Washington: National Gallery of Art, 1981.

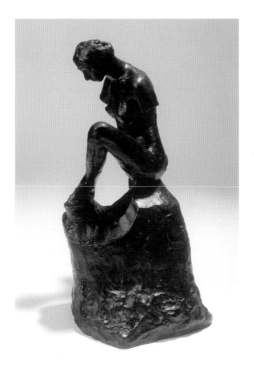

113 *Study for* Monument à Whistler
modelled in Paris, 1910,
cast in Paris, 1983
bronze 65.5 x 33.0 x 34.0
Art Gallery of New South Wales,
Sydney, gift of David Jones Ltd
in 2001 photograph: Jenni Carter
for AGNSW

In 1905, at a meeting of the International Society of Sculptors, Painters and Gravers, Joseph Pennell, **Whistler**'s biographer, suggested that Rodin be asked to make a monument to the painter, who had died on 17 July 1903. It was to be erected at the western end of Chelsea Embankment, near where **Whistler** had lived. Rodin was **Whistler**'s successor as president of the International Society and the two artists had known each other for many years. Rodin was the obvious choice, although he had never made a portrait of **Whistler**.

Rodin was asked to create a 'Winged Victory', symbolising **Whistler**'s successes and the victory of art over its enemies. However, when he exhibited a model for this memorial at the Salon in 1908, he did not show a 'Winged Victory' but a 'Muse, climbing the mountain of fame'. Joseph Pennell commented in the *Christian Science Monitor*, 30 June 1916:

> M. Rodin … has told us perfectly freely … that it is to be a heroic figure of fame, or the triumph of art and of one man over the artlessness of the world. M. Rodin refused absolutely to make a portrait … but that it should be purely symbolic & decorative.

Gwen John posed for the working drawings and the sculpture, creating an image of a muse in meditation, bending down, listening to her inner self. Rodin used **John**'s withdrawn expression to convey a solemnity tinged with uncertainty. Rodin was 65 in 1905, when he began to work on the commission, and subject to long spells of ill health. In 1910 he began working on a small scale version of this work. He continued to make changes on the work over many years and never completed it. This bronze is cast from the surviving plaster maquette of the small version, which is in the collection of the Musée Rodin, Paris.

William Rothenstein
1872–1945

English painter, draughtsman, printmaker, teacher and writer, William Rothenstein was born on 29 January 1872 in Bradford, Yorkshire, the son of a German–Jewish cloth merchant, and the elder brother of **Albert Rutherston**. He studied at the Slade School from 1888 to 1889 under Alphonse Legros, and at the Académie Julian, Paris, from 1889 to 1893. He became enthusiastic about French painting and came under the influence of Degas, Fantin-Latour and **James McNeill Whistler**. He held a joint exhibition with **Charles Conder** in Paris in 1891. On returning to England in 1893, and until 1925, he worked on a series of more than 750 contemporary portrait drawings and 135 lithographs of subjects as varied as Einstein, Henry James, T.E. Lawrence, Charles Ricketts and **Charles Shannon**, **John Singer Sargent** and Verlaine. Rothenstein made drawings and lithographs of **Rodin** while a guest at his home in Meudon in 1897. In 1899, he painted at Vattetot-sur-mer with **Conder**, **Augustus John**, **William Orpen** (who subsequently became his brother-in-law) and **Rutherston**. As artistic manager of the Carfax Gallery, he promoted the work of **Conder**, **John**, **Orpen**, **Walter Sickert**, **Shannon** and others. He produced a succession of realistic interiors, ranging from straightforward domestic scenes to somewhat menacing works like *The dolls house* 1899 (Tate, London). Between 1904 and 1907, he painted a series of works on Jewish themes, including *Aliens at prayer* 1905 (National Gallery of Victoria, Melbourne), and provided advice and support to the young aspiring Jewish artist **Mark Gertler**. In 1910, he travelled to India, assisting with exhibitions of Indian art and acquiring Indian miniatures and, in 1912, he visited the United States. A war artist during both world wars, he was principal of the Royal College of Art from 1920 to 1935, when pupils included Henry Moore and Barbara Hepworth. He was knighted in 1931. He published *Goya* (1900), *A plea for the wider use of artists and craftsmen* (1917) and three volumes of memoirs: *Men and memories* (2 vols, 1931–2) and *Since fifty* (1939). He died on 14 February 1945, aged 73, at Far Oakridge, Gloucestershire, where he had lived since 1912.

references: H. Wellington, *William Rothenstein*, London: Ernest Benn, 1923; Robert Speaight, *William Rothenstein: The portrait of an artist in his time*, London: Eyre and Spottiswoode, 1962; John Thompson (ed.), *Sir William Rothenstein 1872–1945: A centenary exhibition*, Bradford: Cartwright Hall, 1972; Robert Rosenblum, MaryAnne Stevens and Anne Dumas, *1900: Art at the crossroads*, London: Royal Academy, 2000.

114 *The Browning readers*
painted in London, 1900
oil on canvas 76.0 x 96.5
exhibited: New English Art Club, London, Winter 1900 (101)
Bradford Art Galleries and Museums, presented by Moritz Rothenstein in 1911
reproduced courtesy of Bridgeman Art Library 2004

In *The Browning readers*, William Rothenstein was strongly influenced by **James McNeill Whistler**'s tonal restraint and his orderly composition. The girl sitting resembles the pose of **Whistler**'s *Arrangement in grey and black: Portrait of the artist's mother* 1871 (Musée d'Orsay, Paris) and the pose of the girl taking down a book from the bookcase echoes that of a woman in Puvis de Chavanne's *Le Ballon* 1870 (Musée d'Orsay, Paris). The models for the picture were the artist's wife, Alice, and her sister, Grace, wife of **William Orpen**. Rothenstein depicted them in a softly-lit domestic parlour, decorated in an artistic 'oriental' style with sculpture, china, pictures and a wicker chair.

In 1899, Rothenstein married Alice Knewstub, daughter of John Knewstub, friend and assistant of Dante Gabriel Rossetti. As an actress, she was known as Alice Kingsley. Alice appeared in a number of Rothenstein's interiors at this time. He wrote in *Men and memories* (vol. 2):

I had already painted Grace Knewstub in a picture *The Browning Readers*; she had then worn a dress belonging to my wife. I disliked the high collars, and *gigot* sleeves which women wore, and my wife dressed in a way that pleased us both, somewhat after the style of the Pre-Raphaelite ladies … I think **Orpen** would have agreed that at this period he was somewhat influenced by my 'interiors'.

Robert Browning's poetry, particularly his dramatic lyrics and monologues, was admired and widely read by the Edwardians, including Rothenstein and his friend, **Charles Conder**. Browning's reflections on an individual's search for a place in the universe might have had a particular meaning for middle-class women of the era, who were portrayed by a number of artists as if in a gilded cage of quiet domesticity.

This is one of a number of portraits of his family and his close friends that Rothenstein painted in which the interior is as significant as the figures depicted. The setting was Rothenstein's house at 1 Pembroke Cottages, Edwardes Square, Kensington.

The painting was popular and was remarkably influential on contemporary interior decoration. The simplicity of the decoration shown in this painting — the brass plate and the blue and white vase with branches of spring blossom — started a fashion for uncluttered interiors.

John Peter Russell
1858–1930

Australian painter John Peter Russell was born on 16 June 1858 in Darlinghurst, Sydney, the son of a Scottish engineer. In 1880, his father died and he received an inheritance that enabled him to travel to Europe to study art. Initially, he studied at the Slade School, London, under Alphonse Legros, and admired the work of **James McNeill Whistler**, Jules Bastien-Lepage and the neo-classicists Albert Moore and Frederick Leighton. In the summer of 1883, Russell visited Spain with his brother Percy, William Maloney and **Tom Roberts**, where they met the Spanish art students Laureano Barrau and Ramon Casas, who inspired them to paint directly in front of the subject. The following year Russell moved to Paris, where he studied with Fernand Cormon and became friends with fellow students Emile Bernard and van Gogh, as well as with **Rodin**. He joined van Gogh on a painting trip to Belgium and, in 1886, painted a portrait of him. In Paris, in 1887, he met up with **E. Phillips Fox**. In 1886, Russell visited Belle-Ile and met Monet; the two artists painted together during the summer and, in 1888, Russell moved to Belle-Ile and lived there for over 20 years with his wife Marianna (who had been one of **Rodin**'s favourite models). During the summers of 1896 and 1897, he met Matisse at Belle-Ile. Russell had an extensive knowledge of colours and their properties, and he encouraged Matisse to exchange his earthy Flemish palette for intense, pure colours. After his wife's death in 1908, Russell left Belle-Ile and from that time mainly painted in watercolour. He travelled with his daughter, Jeanne, through the south of France and, in 1912, married his daughter's friend, the American singer Caroline de Witt Merrill. They settled for a time in Italy and Switzerland and, in 1915, moved to England where his five sons were serving in the Allied forces. In 1921, he returned to Australia, and the following year he travelled to New Zealand where he established his son on a citrus farm. He returned to Sydney two years later to live in a fisherman's cottage at Watson's Bay on Sydney Harbour. He died of a heart attack brought on by lifting rocks, on 22 April 1930 in Sydney, aged 71.

references: Elizabeth Salter, *The lost Impressionist*, London: Angus and Robertson, 1976; Ann Galbally, *The art of John Peter Russell*, Melbourne: Sun Books, 1977; Hilary Spurling, *The unknown Matisse*, Harmondsworth: Penguin Books, 1998.

115 *Mon ami Polite (Père Polyte)*
painted in Belle-Ile, France, 1900
oil on canvas 54.6 x 65.4
signed and dated 'JOHN RUSSELL/...1900' lower left
Art Gallery of New South Wales, Sydney photograph: Diana Panuccio for AGNSW

In 1886, Russell visited Belle-Ile, a small island in the Bay of Biscay off the coast of Brittany. Russell and Monet painted here together during the summer and a local fisherman, Hippolyte Guillaume (Père Polyte), became Monet's porter and a model for both artists. In *Mon ami Polite*, Russell depicted Père Polyte dressed in a blue shirt and trousers, holding a basket, striding towards us on top of a cliff by the sea.

In his letters to **Tom Roberts**, Russell repeatedly returned to the subject of his search for colour. On 26 December 1887 he wrote, 'I have for the past two years been chasing color, been floored again and again.' Around 1890 he wrote:

> two years alone with (as far as art influences are concerned) nature had so changed my ideas particularly as regards color that I could not look at my stuff ... Since that time have been chasing after broken color ... I now put the colors in as pure as I can without stirring them up on the palette, so that they are without the protective influence of the body white ... I have been experimenting. Making my own color with more or less success. (quoted in Galbally, 1977)

It is possible that van Gogh's interest in the work of Jean-François Millet and in peasant subjects inspired Russell to paint works that portray the dignity of working life such as in *Mon ami Polite*. But there were many models that Russell could have followed in painting such subjects; towards the end of the 19th century a number of artists, such as Emile Bernard and Gauguin, left the city for a simpler life in the country and there painted peasant subjects. Furthermore, when Russell moved to Belle-Ile he had such subjects in mind, writing to **Roberts** on 5 October 1887 that he intended to paint 'a picture of the folks threshing' and 'tall girls bring[ing] corn to [the] barn in baskets' (quoted in Galbally, 1977).

Albert Rutherston
1881–1953

English painter Albert Rothenstein (Albert Rutherston) was born on 5 December 1881 in Bradford, Yorkshire, the son of a German–Jewish cloth merchant, and the younger brother of **William Rothenstein**. He and his brother Charles changed their names to Rutherston in 1916 to show their allegiance to Britain; William retained his original name. Albert studied at the Slade School between 1898 and 1902 under **Philip Wilson Steer** and **Henry Tonks**, and fellow students included **Harold Gilman**, **Spencer Gore** and **William Orpen**. In 1899, Rutherston painted at Vattetot-sur-mer with **Charles Conder**, **Augustus John**, **Orpen** and **Rothenstein** and, in 1900, at Cany with **Conder** and **Orpen**, where he first met **Walter Sickert**. In the early 1900s, he regularly spent holidays in France with **Gore**. In 1907, he took a studio in Fitzroy Street, London with **Gore**, **Gilman** and others, and participated in Sickert's Fitzroy Street Group. At first a realist painter, from around 1910 Rutherston adopted a more decorative approach and began experimenting in murals and book illustration; he also designed costumes and scenery for the theatre and ballet in the period from 1912 to 1914. In 1920, he taught at the Camberwell School of Art; from 1922, at the Ruskin School of Drawing, Oxford, and from 1929 to 1949 he was Ruskin Master of Drawing at Oxford. In 1936, he founded the Pottery Group with **Vanessa Bell**, **Duncan Grant**, Paul Nash, Ben Nicholson and Graham Sutherland. He illustrated plays by Laurence Housman and poems by Edmund Blunden, Thomas Hardy and Walter de la Mare. In August 1943 he wrote an article for the *Burlington Magazine* about his friendship with **Gore** and others. He died on 14 July 1953, while on holiday in Ouchy-Lausanne, Switzerland, aged 71.

references: R.M.Y. Gleadlowe, *Albert Rutherston*, London: Ernest Benn, 1925; Max Rutherston, *Albert Rutherston*, London: 180 New Bond Street, 1988; Robert Rosenblum, MaryAnne Stevens and Anne Dumas, *1900: Art at the crossroads*, London: Royal Academy, 2000.

116

Song of the shirt
painted in London, 1902
oil on canvas 76.0 x 58.5
signed and dated 'A.R. 1902'
lower right
exhibited: New English
Art Club, Winter 1902 (49)
Bradford Art Galleries and
Museums

Song of the shirt is a carefully observed and
scrupulously realised picture. As an image of a
woman seated against an empty space, it pays
homage to **James McNeill Whistler**'s portrait
of his mother, which had by this time attained
iconic status. With its meticulous rendering
and carefully structured composition, it is
somewhat similar to **William Rothenstein**'s
more genteel arrangements of women in
interior settings, such as *The Browning readers*
(cat. 114). Albert Rutherston's solitary
seamstress, however, portrays the deprivation
and harshness of working-class life.

The force of Rutherston's realistic approach
was recognised by the art reviewers, who
were disturbed by this image of poverty,
an unpleasant reality that they would
have preferred to ignore. *The Times*' critic
commented on 8 November 1902 that,
'though a powerful study of a type, [*Song of
the shirt*] is almost savage in its realism'. The
Observer's critic commented on 9 November
1902 that 'Mr. Rothenstein … in his "Song of
the Shirt," lays far too much emphasis on the
hideousness of the bony, half-starved woman,
who plies her needle "in poverty," but not in
"rage and dirt," for the room is painfully bare
and clean.'

Like the Camden Town artists **Harold
Gilman, Spencer Gore** and **Walter Sickert**,
Rutherston appears to have believed that
'serious' art should avoid the drawing room
and take as its subject the scullery or the
kitchen. But Rutherston went further to
make a clear social comment; his seamstress
is poor, hungry and worn out. In *Song of the
shirt* Rutherston drew attention to the fact
that Edwardian society depended upon 'the
masses', many of whom, like this woman,
worked quietly and unobtrusively for absurdly
small wages.

Like a range of other artists, including
G.F. Watts in the period 1848 to 1850 and
Frank Holl in 1874, Rutherston was possibly
inspired by Thomas Hood's poem, 'Song of
the shirt', published in 1843:

With fingers weary and worn,
With eyelids heavy and red,
A woman sat, in unwomanly rags,
Plying her needle and thread —
Stitch! Stitch! Stitch!
In poverty, hunger, and dirt,
And still with a voice of dolorous pitch,
She sang the 'Song of the Shirt' …

John Singer Sargent
1856–1925

American painter and draughtsman, John
Singer Sargent was born in Florence, Italy
on 12 January 1856, of American parents.
He spent his childhood living and travelling
in Europe. From 1874 to 1878, he worked
as student and assistant in the Paris studio
of Carolus-Duran, where he gained an
understanding of tonal values, while also
studying drawing at the Ecole des Beaux-
Arts. He regularly went on sketching
trips. He visited America in 1876 and then
travelled in Europe, copying the work of
Velasquez in Spain in 1879 and Frans Hals
in Holland in 1880. During the 1880s he
became a friend of Monet and assimilated
aspects of Impressionism. Through Monet he
met **Rodin**. He also became a friend of the
portrait painters **Giovanni Boldini** and Paul
Helleu. After the controversial reception of his
painting *Madame X* (Metropolitan Museum
of Art, New York) at the Paris Salon in 1884,
he moved to London in 1886. Between
1885 and 1889, he produced a number of
impressionist interiors and open-air studies
of the English countryside. His painting of
children, *Carnation, Lily, Lily, Rose* 1885–6
(Tate, London), was his first notable success in
London. On two successive trips to America
(1887–8 and 1889–90), he was welcomed as a
celebrity and offered many commissions. After
1893, with his sensuously painted portrait,
Lady Agnew of Lochnaw 1892 (National Gallery
of Scotland, Edinburgh), he established his
reputation in Britain and became a highly
fashionable portrait painter. In 1897, he was
elected a full member of the Royal Academy.
He painted with insight and sympathy many
distinguished personalities, including the
actress Ellen Terry and the novelist Henry
James. His style ranged from studiedly formal
to boldly experimental, using a repertoire
of poses inspired by van Dyck and Joshua
Reynolds, which led **Rodin** to call him the
'van Dyck of our times'. He reinvigorated
portraiture by intensifying the illusion of
reality and by capturing a sense of shimmering
light. From 1897, he was a visiting teacher at
the Royal Academy Schools, where he taught
Vanessa Bell. Australian artists, such as **Hugh
Ramsay** and **George Lambert**, viewed his
works enthusiastically in London exhibitions.
After 1900, Sargent spent his summer holidays
painting plein-air works in Europe with his

sister and painter friends, recording the vivid light and the atmosphere of place. Eventually Sargent tired of portraiture and focused, from 1907, on landscapes, and murals such as those for the Boston Public Library. He regarded these murals as his major work. He gradually withdrew from fashionable society, preferring the company of family and close friends such as **Philip Wilson Steer** and **Henry Tonks**. In 1918, he visited the battlefields in France in the company of **Tonks** and saw soldiers blinded by mustard gas, which provided him with the subject for his monumental painting, *Gassed* 1919 (Imperial War Museum, London). Sargent died in his sleep from a heart attack in his London house on 15 April 1925, aged 69.

r e f e r e n c e s : Evan Charteris, *John Sargent*, London: William Heinemann, 1927; Stanley Olson, *John Singer Sargent: His portrait*, London: Macmillan, 1986; Kenneth McConkey, *Edwardian portraits: Images of an age of opulence*, Woodbridge: Antique Collectors' Club, 1987; Patricia Fullerton, *Hugh Ramsay*, Melbourne: Hudson Publishing, 1988; H.S. Barlow, *Swettenham*, Kuala Lumpur: Southdene, 1995; Julia Rayer Rolfe et al., *The portrait of a lady: Sargent and Lady Agnew*, Edinburgh: National Gallery of Scotland, 1997; Elaine Kilmurray and Richard Ormond, *John Singer Sargent*, London: Tate Publishing, 1998; Richard Ormond and Elaine Kilmurray, *John Singer Sargent: The early portraits, complete paintings 1*, New Haven: Yale University Press, 1998.

117 *Lord Ribblesdale*
painted in London, 1902
oil on canvas 258.5 x 143.5
signed and dated 'John Sargent 1902' lower right
exhibited: Royal Academy, London, 1902 (175); Société Nationale des Beaux-Arts, Paris, 1904 (1134); Venice Biennale 1907 (?)
The National Gallery, London, presented by Lord Ribblesdale in 1916, in memory of Lady Ribblesdale and his sons, Captain the Hon. Thomas Lister and Lieutenant the Hon. Charles Lister

This portrait of Thomas Lister, 4th Baron Ribblesdale, came to epitomise the Edwardian aristocrat: a sportsman, soldier, courtier and landowner. John Singer Sargent depicted him wearing his hunting clothes, with Chesterfield overcoat, black riding boots and holding a riding whip. He is alert and upright, a man with a strong physical presence, immaculately dressed, but with an expression that suggests he may have been stubborn at times. While Sargent revealed everything about his subject, in another sense he gave nothing away — he presented Ribblesdale's public face and not his private life. Nonetheless, when Ribblesdale went to view his portrait when it was exhibited in Paris in 1904, he found himself the centre of attention, pursued by a fascinated crowd who were keen to view the English aristocrat.

Ribblesdale (1854–1925) was a dedicated sportsman; in the 1890s he served in the Royal Household as Master of the Buckhounds and, in 1892, he wrote *The Queen's hounds* and *Stag hunting recollections*. A Liberal peer, a lord-in-waiting at court, and a trustee of the National Gallery, London, he was also involved through his wife, Charlotte Tennant, in an artistic and aristocratic circle of friends known as 'the

Souls', renowned for their brilliance and wit. When, in 1911, Ribblesdale's wife died of tuberculosis, he moved to the Cavendish Hotel run by Rosa Lewis (the 'Duchess of Duke Street'), and lived there for at least eight years. Both his sons were killed in action, Thomas in Somaliland in 1904 and Charles at Gallipoli in 1915. In 1919, Ribblesdale married Ava Willings, the widow of Jacob Astor.

The Australian artist **Hugh Ramsay** viewed this painting at the Royal Academy in 1902, and wrote:

> Sargent dominates the Academy, and absolutely convinces me as to what a great, a really great painter he is … Ignorant people say, 'Oh Sargent's too clever'. But it isn't cleverness, its absolute mastery. Seeing his canvases at the proper distance, the truth in them is absolutely convincing … The *Lord Ribblesdale*, a fine old chap in a long riding cloak, drab riding pants and black boots, standing in full blaze of light against a creamy white wall, is quite suggestive of Velasquez. The way the figure stands up is remarkable, and the character, and the decorative shape of the figure, and the whole thing bathed in silver light — oh it is splendid. (Fullerton, 1988)

118 *Evelyn, Duchess of Devonshire*
painted in London, 1902
oil on canvas 147.3 x 91.4
signed and dated 'John S. Sargent
1902' upper left
exhibited: Royal Academy,
London, 1903 (19, as 'Lady Evelyn
Cavendish')
Chatsworth House Trust,
Derbyshire

Lady Evelyn Fitzmaurice (1870–1960),
daughter of the 5th Marquess of Lansdowne,
the Viceroy of India, was the wife of the Hon.
Victor Cavendish, who succeeded his uncle as
9th Duke of Devonshire in 1908. It is said that
'preferring inanimate objects to humans', she
was ever critical of her family and her servants.
Her brother-in-law (the Duke of St Albans)
called her 'an unpleasant woman accustomed
to authority'. However, when the Duke and
Duchess moved to Chatsworth in 1908 the
Devonshire collections benefited greatly
from her care. Her favourite occupation was
mending the antique tapestries at Hardwick
and Chatsworth, and she regarded herself as a
textile conservator on a par with professionals.

In *Evelyn, Duchess of Devonshire* Sargent
portrayed the formidable Duchess turning a
pensive gaze towards the viewer. Verticals, in
the panelling behind her, the table leg, and in
the line of her left arm, reinforce the formality
of the portrait. Sargent relieved the generally
sombre impression by the reflected gleam of
silver on the table top, the sparkle of jewellery
and the filmy texture of her sleeves. He may
have looked to van Dyck in painting this
portrait, and to works such as *Queen Henrietta
Maria* 1632 (Royal Collection, Windsor), in
which van Dyck placed the figure in a similar
three-quarter view with one hand on a table
and the other at her side with a handkerchief
in her hand.

The portrait was commissioned by the Duke
of Devonshire. He wrote of the finished
picture in his unpublished diaries: 'Think it
looks alright but it is rather stern.'

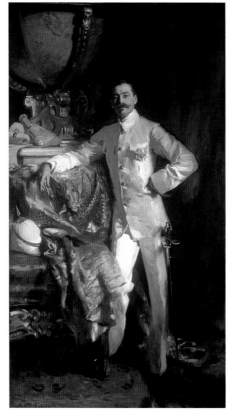

119 *Sir Frank Swettenham*
painted in London, 1904
oil on canvas 259.0 x 143.0
signed 'John S. Sargent' lower left
and dated '1904' lower right
Singapore History Museum

Frank Athelstane Swettenham (1850–1946)
was an outstandingly able and effective
colonial administrator, ending his career as
Governor of the Straits Colony and High
Commissioner for the Federated Malay States.
To commemorate Swettenham's service, the
Straits Association commissioned this portrait
after the sitter's retirement and gave it to the
colony.

Sargent portrayed his subject as a powerful
proconsul, dressed in an immaculate white
uniform with the KCMG star on his chest,
surrounded by the emblems of Empire: his
white helmet and the ivory baton, his badge
of office. He showed Swettenham's right arm
resting on a richly carved piece of furniture
draped with a rug and a spectacular length of
Malaysian silk, and placed an immense globe
behind him, turned to display the Malay
States. But Sargent also revealed Swettenham's
vanity, showing him standing with casual
confidence, weight on one leg, left arm on hip,
and head turned to the viewer in authoritative
contemplation. Through the arrogant thrust of
Swettenham's chin and chest, Sargent captured
his proud confidence.

H.S. Barlow described Swettenham thus:
> Of his personal characteristics, cynicism,
> irony and sarcasm were striking features
> … He allowed nothing to stand in his
> way, whether it was professional scruples
> … financial probity, or most tragically,
> his marriage. This was the blight of
> his life. It revealed him as cruel, cold-
> hearted and deceitful. Moreover, the
> deceit seems to have placed him in a
> position where he was for several years
> exposed to blackmail. Add to this a
> macabre and perhaps sexually-associated
> fascination with death. The result was
> an outstandingly able and effective man:
> but scarcely a nice one. (Barlow, 1995).

120 *The fountain, Villa Torlonia, Frascati, Italy*
painted in Frascati, Italy, 1907
oil on canvas 71.4 x 56.5
signed 'John S. Sargent' lower left
exhibited: New English Art Club, London, Winter 1907
(63, as 'The fountain')
The Art Institute of Chicago, American Art Collection

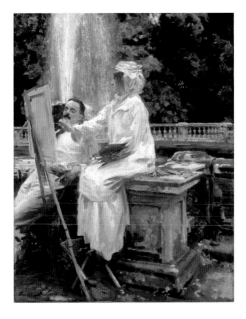

In *The fountain, Villa Torlonia, Frascati, Italy*, Sargent depicted the villa's sunlit gardens stretching up the hillside at Frascati, near Rome. He portrayed the artist Jane de Glehn (1873–1961) perched on the corner of a balustrade sketching the scene in front of her, watched by her artist husband Wilfrid (1870–1951).

Jane described sitting for the picture in a letter to Lydia Field Emmet on 6 October 1907:

> Sargent is doing a most amusing and killingly funny picture in oils of me perched on a balustrade painting. It is the very 'spit' of me. He has stuck Wilfrid in looking at my sketch with rather a contemptuous expression … I am all in white with a white painting blouse and a pale blue veil around my hat. I look rather like a pierrot, but have rather a worried expression as every painter should have who isn't a perfect fool, says Sargent. Wilfrid is in short sleeves, very idle and good for nothing. (quoted in Kilmurray and Ormond, 1988)

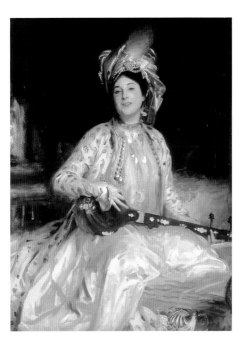

121 *Almina, daughter of Asher Wertheimer*
painted in London, 1908
oil on canvas 134.0 x 101.0
signed 'John S. Sargent' upper left and dated '1908' upper right
exhibited: 'Third exhibition of Fair Women', International Society of Sculptors, Painters and Gravers, London, 1910 (26, as 'Almina')
Tate, London, presented by the widow and family of Asher Wertheimer in accordance with his wishes in 1922

Almina, daughter of Asher Wertheimer is a portrait of Almina (1886–c.1928), the fifth daughter of the Bond Street dealer, Asher Wertheimer. This was the last of Sargent's portraits of the Wertheimer family and the most fanciful. Sargent portrayed Almina dressed in an exotic costume, an ivory-white Persian dress and a white and green jacket (a studio prop), wearing a turban entwined with pearls on her head and holding a musical instrument (the *sarod* from northern India, owned by the artist).

The practice of portraying European women as alluring 'orientals' was highly fashionable at the turn of the 20th century. *Almina, daughter of Asher Wertheimer* has been compared to van Dyck's portrait of Lady Shirley of 1622 (National Trust, Petworth House, Sussex) and the figure of the musician in Ingres' *Odalisque with slave* 1842 (Walters Art Gallery, Baltimore).

Charles Shannon
1863–1937

English painter and printmaker, Charles Shannon was born on 26 April 1863 at Quarington, Lincolnshire, the son of a country parson. He studied wood engraving from 1881 to 1885 at the City and Guilds Technical Art School at Lambeth. There, he met Charles Ricketts, his companion in work and life for 50 years. He exhibited oil paintings and pastels in the 1880s, while teaching at the Croydon School of Art. He visited Puvis de Chavannes in 1887 and sought to attain in his own work a similar imaginative and romantic vision to that of Puvis. From 1888 to 1897, he concentrated chiefly on exploring lithographic and woodcut techniques, becoming one of the leading exponents of lithography in Britain. In 1889, Shannon and Ricketts founded *The Dial* (a magazine which ran until 1897), through which they fostered a revival in the art of original wood engraving and lithography. They established the Vale Press in 1896, which operated until 1904 and was one of the most significant private presses of its time. They advised the Australian patrons Sir Edmund and Lady Davis in building their collection. In exchange, from 1902 to 1923, Shannon and Ricketts lived and worked in the top flat at 'Lansdowne House', Holland Park, in the London studios built by Sir Edmund Davis. Between 1902 and 1904, **George Lambert** had a studio in the same building and when Shannon and Ricketts left their flat in 1923 it was taken over by **Glyn Philpot**. They met **Rodin** at a dinner at the Davis' house when the sculptor visited London. Their friends included literary figures like Oscar Wilde, as well as artists such as **Charles Conder**, **William Rothenstein** and **William Strang** (with whom they shared a love of the Venetian masters). Not unaware of contemporary art movements, they regarded them as irrelevant to their work. However, they admired Diaghilev's Russian Ballet, and **Léon Bakst**, Diaghilev and Nijinsky were visitors to their home. In 1923, they moved to a house in Regent's Park and a cottage at Sir Edmund Davis' country house, 'Chilham Castle'. In a fall from a ladder while hanging a picture in 1929, Shannon suffered concussion and never fully recovered his senses. He died on 18 March 1937 at Kew, Surrey, aged 73.

references: George Derry, 'The lithographs of Charles Hazelwood Shannon', *Print Collectors Quarterly*, vol. 4, 1914; Paul Delaney, *The lithographs of Charles Shannon*, London: Taraman, 1978; Stephen Calloway and Paul Delaney, *Charles Ricketts and Charles Shannon: An aesthetic partnership*, Twickenham: Orleans House Gallery, 1979; Joseph Darracott, *All for art: The Ricketts and Shannon collection*, Cambridge: Fitzwilliam Museum, 1979; Keith Spencer, *At the sign of the dial: Charles Hazelwood Shannon and his circle*, Lincoln, 1987–8; John Christian (ed.), *The last Romantics: The Romantic tradition in British art*, London: Barbican Art Gallery, 1989.

122 *The snow, Winter*
printed in London, in 1907
published in *The Neolith*,
No. 2, February 1908
lithograph in green ink
21.0 x 42.8
signed 'Charles Shannon/ R73.
The Snow, Winter (a Fan)'
lower left
National Gallery of Australia,
Canberra

One of the strengths of Charles Shannon's work is his sense of design, which led him to experiment with unusual shapes, including circular and fan-shaped lithographs. He designed and printed seven lithographic fans between 1906 and 1909, enjoying the compositional challenge they presented. He showed ingenuity in adapting the design to the fan shape, even though his figures are usually larger than one might expect in relation to the space.

Shannon was possibly inspired by the success of his younger friend **Charles Conder**, whose painted fans in watercolour on silk were highly sought after in the 1890s and early 1900s. Mary Davis, the wife of Shannon's patron, Sir Edmund Davis, who was taught painting by Shannon and was influenced by **Conder**, also made fan designs.

Like many others of his time Shannon was influenced by Puvis de Chavannes. In 1892, Puvis had painted two murals for the reception room of the Hôtel de Ville, Paris: *Summer* and *Winter*, a snow scene with peasants carrying wood. The National Gallery of Victoria purchased a small version of Puvis's *Winter* in 1910.

Walter Sickert
1860–1942

English painter, printmaker, art critic and teacher, Walter Sickert was born on 31 May 1860 in Munich, the son of an Anglo–Irish mother and Oswald Sickert, a painter and illustrator of Danish descent. In 1868, the family moved to England. For a time, Sickert worked as an actor playing small roles in Henry Irving's company, and a love of theatre stayed with him throughout his life. He attended the Slade School from 1881 to 1882, studying under Alphonse Legros, before becoming the pupil and assistant to **James McNeill Whistler**, learning his preference for the use of subdued colours. He also assisted **Whistler** with printing his etchings and, in 1883, delivered **Whistler**'s portrait of his mother to the Paris Salon. Sickert visited Manet's studio and also met Degas, under whose influence he developed his skill as a draughtsman. From 1885, he began making regular summer visits to Dieppe, living there from 1898 to 1905, and producing evocative townscapes. During this time, he met Monet, Pissarro and Renoir, as well as **Jacques-Emile Blanche**. He was one of the first in Britain to appreciate modern French art; however, Sickert's techniques were not those of the French Impressionists: he explored the nuances of shadows as opposed to sunlight, and carefully constructed his works from drawings in separate studio sittings. In 1893, he opened the first of his seven private art schools. After several visits to Venice, Sickert returned to London in 1905 to settle in Fitzroy Street. This move coincided with a change of direction in his subject and technique, with a greater emphasis on suburban interiors, painted in patches almost like mosaic. With **Spencer Gore**, he became the leader of a group of painters committed to painting interiors and urban scenes. This circle of artists, which included **Malcolm Drummond** and **Harold Gilman**, became known as the Camden Town Group and, subsequently, the London Group. Sickert taught part-time at the Westminster Technical Institute from c.1908 to 1918, where **Norah Simpson** was one of his students and, in 1910, he founded Rowlandson House, the longest surviving of his private art schools. During the First World War, he lived in Bath. He returned to Dieppe in 1919, but went back to England in 1926. From about 1927, he painted brightly

toned 'English Echoes', relying increasingly for his pictorial themes upon photographs from newspapers and magazines, as well as Victorian engravings. Virginia Woolf regarded his paintings as novels without words. In 1934 he was elected a full member of the Royal Academy, but he resigned in 1935 as a protest against the Academy's refusal to support the fight to save Jacob Epstein's sculptures on the British Medical Association's headquarters on the Strand. He was also a prolific writer for the *Burlington Magazine*, the *Daily Telegraph*, the *English Review*, and the *New Age*. A compilation of his writings was published posthumously as *A free house!* (1947). Sickert died in Bath, Somerset, on 22 January 1942, aged 81.

references: Virginia Woolf, *Walter Sickert, a conversation*, London: Hogarth Press, 1934; Robert Emmons, *The life and opinions of Walter Richard Sickert*, London: Faber and Faber, 1941; Lillian Browse, *Sickert*, London: Rupert Hart-Davis, 1960; Marjorie Lilly, *Sickert. The painter and his circle*, London: Elek, 1971; Wendy Baron, *Sickert*, London: Phaidon, 1973; Denys Sutton, *Walter Sickert*, London: Michael Joseph, 1976; Penelope Curtis and Richard Shone, *W.R. Sickert: Drawings and paintings 1890–1942*, Liverpool: Tate Publishing, 1988; Wendy Baron and Richard Shone, *Sickert paintings*, London: Royal Academy, 1992; Angus Trumble, *Bohemian London: Camden Town and Bloomsbury paintings in Adelaide*, Adelaide: Art Gallery of South Australia, 1997; Wendy Baron, *Perfect Moderns: A history of the Camden Town Group*, Aldershot: Ashgate, 2000.

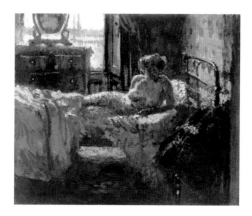

123 *Mornington Crescent nude, contre-jour* painted in Camden Town, London, 1907
oil on canvas 50.8 x 61.1
signed 'Sickert' lower left
Art Gallery of South Australia, Adelaide, A.R. Ragless Bequest Fund in 1963
© Walter Sickert, 1907/DACS. Licensed by VISCOPY, Sydney 2004

This is one of a series of works that Walter Sickert painted following the murder of a prostitute in Camden Town, the rough North London neighbourhood where he lived and had a studio.

Sickert projected into the gloom of a cheap bed-sitter a kind of sordidness: *Mornington Crescent nude, contre-jour* assembles with relish the tawdry elements of an implicit narrative of afternoon sex — the narrow iron bed with its sagging mattress, squashed pillow and crumpled sheets. The frank pose of the woman suggests that she is *in* bed and not merely posing on it. Her hair is still up, and her clothes are discarded in a frowzy heap on a chair in the foreground. It has been argued that the real subject is natural light — afternoon sunlight slanting through the glass of a dirty window, yellowed by a grimy London sky.

The French term *contre-jour*, sometimes used in connection with cinematography, means lit from behind, that is, almost producing the effect of a silhouette.

Angus Trumble, 1997

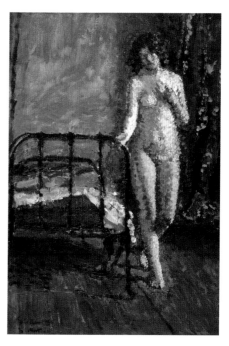

124 *Nude standing by an iron bedstead* painted in Camden Town, London, 1909
oil on canvas 50.8 x 34.5
signed 'Sickert' twice, lower left
private collection
© Walter Sickert, 1909/DACS. Licensed by VISCOPY, Sydney 2004

Sickert's paintings of modern life, such as *Nude standing by an iron bedstead*, were essentially essays in paint, not anecdotal pictures — the titles often came afterwards. The so-called Camden Town murder paintings were in reality a series of interior studies of figures, clothed and unclothed. Inevitably these subjects went against the prevailing morality of the day.

The model for *Nude standing by an iron bedstead* was Sally, who posed for a number of Sickert's important Camden Town nudes between 1909 and 1911.

In the early 1900s, Henry Tonks was interested in painting poetic images of beautiful and elegant women engaged in wistful reverie. In *The pearl necklace*, he depicted such a young woman absorbed in thought, enveloped in sunlight. Writing in *The Studio*, vol. 49, 15 February 1910, the critic, C.H. Collins Baker praised Tonks' ability to convey the inner tensions and humanity of his figures, and the way 'the implication of their complexities and mysteries' made them beautiful. He observed that there is in these pictures 'an atmosphere of sub-conscious expectancy of and wonder at we know not what.'

The pearl necklace was included in the 'French and British Modern Art' exhibition, brought to Australia by the Melbourne *Herald* in 1939, and was purchased from this exhibition by the Art Gallery of New South Wales, Sydney, in 1943.

Tender, domestic interiors appealed to Tonks. In *After the bath* he created a modern-day Madonna and child in an everyday setting, with a lively baby and adoring sisters. Tonks replaced the traditional shepherd with a young girl presenting a toy sheep to the baby. The central mother figure in this painting has a similar strength and presence to the female archetypes of **Augustus John** in works such as *Family group* (cat. 57).

In 1909, Tonks painted a related work, *The baby's bath*, depicting two women with a baby which was reproduced in *The Studio*, 15 February 1910. He also made a large pastel drawing for *After the bath*, 1910-11 which is in the collection of the Museum of New Zealand Te Papa Tongarewa, Wellington.

Marie Tuck
1866–1947

Australian painter, printmaker and teacher, Marie Tuck was born on 5 September 1866 at Mount Torrens, South Australia, the daughter of a schoolteacher. She studied in the evenings under James Ashton at his Norwood School of Art from 1886 to 1896, and worked for a garden nursery by day. In 1896, she moved to Perth where she set up the Perth Art School for private students of drawing and painting. There she became a role model for **Kathleen O'Connor**. She left for France in 1904, where she remained for ten years. In the winter months she studied with the Australian artist **Rupert Bunny**, whom she greatly admired, in exchange for cleaning his Paris studio. **O'Connor** was also one of **Bunny**'s students. Tuck spent her summers in Normandy and Flanders and lived with a peasant family in Etaples, Picardy, where she encountered **Ethel Carrick**, **E. Phillips Fox** and **Hilda Rix Nicholas**, as well as Iso and Alison Rae. She was fascinated by French culture and particularly enjoyed rural France, painting many landscapes, portraits and scenes of daily life. She returned to Australia at the outbreak of the First World War and, from 1919 to 1939, was an influential teacher of life drawing and painting at the South Australia School of Arts and Crafts. She introduced the practice of using nude models and provided her students with an understanding of French artistic life. At Frewville, she built a small live-in studio set in a garden, where her students would come on Saturdays to eat, drink and talk of Paris. In 1940, Tuck suffered a stroke and, although handicapped, she continued to paint until her death on 3 September 1947, just before her 81st birthday.

references: Ruth Tuck, 'Marie Anne Tuck', *Australian dictionary of biography 1891–1939*, vol. 12, Melbourne: Melbourne University Press, 1990; Jane Hylton, *South Australian women artists: Paintings from the 1890s to the 1940s*, Adelaide: Art Gallery of South Australia, 1994; Betty Snowdon, 'Marie Anne Tuck' in Joan Kerr, *Heritage: The national women's art book*, Sydney: Craftsman House, 1995.

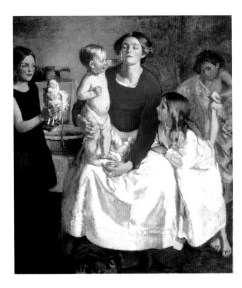

136 *After the bath*
painted in London, 1910–11
oil on canvas 106.7 x 96.5
inscribed 'Henry Tonks 1910/ 11'
lower right
exhibited: New English Art Club,
London, Summer 1913 (93)
private collection

137 *The red geranium*
painted in Etaples, Picardy,
France, c.1912
oil on composition board
86.0 x 71.0
signed 'M. Tuck' lower right
Adelaide Casino
photograph: Clayton Glen
for NGA

The red geranium is one of Tuck's many Etaples
paintings that show local people and their
daily life. The woman, concentrating on
her tatting, is clad traditionally in a pinafore
over a black dress. Almost silhouetted by the
light coming through the lace curtain, the
geraniums on the window sill balance the
composition of this intimate interior.

Tuck's interest in the customs and dress of
the local people in Picardy was shared by
other artists of her time, such as **Hilda Rix
Nicholas**, with whom Tuck associated at
Etaples.

Tudor St George Tucker
1862–1906

English-born Australian painter and teacher,
Tudor St George Tucker was born on 28
April 1862 in Finchley, Middlesex, England,
the son of an army officer. He migrated to
Melbourne in 1881 for the good of his health.
He studied at the National Gallery School,
Melbourne, from 1883 to 1887, where fellow
students included **Rupert Bunny**, **E. Phillips
Fox**, **Florence Fuller**, John Longstaff and
Arthur Streeton, and he joined plein-air
painting excursions with **Fox**, Longstaff,
Frederick McCubbin and others. In 1887, he
left for Europe, studying in Paris alongside
Fox at the Académie Julian and, in 1889, at
the Ecole des Beaux-Arts. In 1890, **Charles
Conder** wrote to friends in Melbourne that
Fox and Tucker were thought to be the
leading Australian artists in Paris. Tucker
joined the artists' colony at Etaples in 1891,
where he painted his first major picture, *Une
Pêcheuse de crevettes*. He returned to Australia
in 1892. In 1893, Tucker and **Fox** began
the Melbourne School of Art, based on the
French atelier system. From 1894, they ran a
summer school at Charterisville where, with
an emphasis on drawing from a live model and
painting outdoors, Tucker and Fox provided a
popular alternative to the traditional approach
offered at the National Gallery School. Their
students included **Ambrose Patterson**. In his
own work, Tucker demonstrated a sensitive
appreciation of the effects of light and the use
of colour. He returned to Europe in 1899, and
settled in Chelsea. He died of tuberculosis on
21 December 1906, aged 44.

reference: Jane Clark and Bridget
Whitelaw, *Golden Summers*, Melbourne:
National Gallery of Victoria, 1985;
Ruth Zubans, 'Tudor St George Tucker',
Australian dictionary of biography 1891–1939,
vol. 12, Melbourne: Melbourne University
Press, 1990; Ruth Zubans, *E. Phillips Fox*,
Melbourne: Miegunyah Press, 1995.

138 *Nasturtiums*
painted in London, c.1903
oil on canvas 101.0 x 71.6
signed 'T.S.G. Tucker' lower right
National Gallery of Australia,
Canberra

Painted around 1903, *Nasturtiums* is decidedly
non-Australian in its colour. Tudor St
George Tucker used white paint freely, while
employing a gestural technique to define
the textures of different forms. He captured
the effects of light and shade on a homely,
domestic scene. The enclosed courtyard
garden's towering cream walls cut out the sky,
and are in contrast with the round clumps of
vivid green nasturtiums and climbing plants.
Sunlight dapples through the unseen foliage
of the tree, adding movement and immediacy
to the composition. The brightly lit diagonal
path leads the eye to the two figures, placed
in the middle distance, each defined by their
own space.

Jenny Manning

references: *Ethel Walker, Frances Hodgkins, Gwen John: A memorial exhibition*, London: Tate Publishing, 1952; *Distinguished British paintings 1875–1950: An accent on Ethel Walker*, London: Roland, Browse and Delbanco, 1974; *Dame Ethel Walker*, London: Blond Fine Art, 1979; Maud Sulter, *Echo: Works by women artists 1850–1940*, London: Tate Gallery Publishing, 1991.

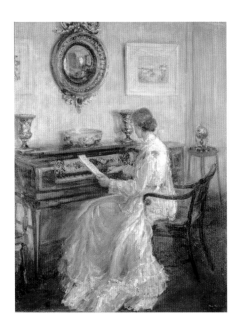

141 *The forgotten melody*
painted in London, 1902
oil on canvas 113.5 x 88.5
signed and dated 'Ethel Walker/ 1902' lower right
Laing Art Gallery, Newcastle upon Tyne, Tyne and Wear Museums

In *The forgotten melody*, Walker adopted **James McNeill Whistler**'s subject of a woman in a white dress, and his subdued, harmonious colour scheme. However, she painted this work impressionistically, with energetic touches of paint, capturing the soft light on the back of the neck, the shimmer on the woman's dress and the reflected light in a mirror. Walker created an image of a gracious woman set in a solidly Edwardian interior, immersed in a kind of reverie. However, she placed this woman as if encaged in this environment, with no window opening out onto a wider world.

Gillian Ferguson

James McNeill Whistler
1834–1903

American painter, printmaker, designer and collector, James McNeill Whistler was born on 11 July 1834 in Lowell, Massachusetts, the son of a railway engineer. He spent his childhood in Russia. From 1851 to 1854, he studied at the West Point Military Academy and, from 1854 to 1955, worked as a cartographer and learned to etch. He left America in 1855 and, in 1856, studied in Paris in Charles Gleyre's studio. In Paris, he met Courbet, Henri Fantin-Latour, George du Maurier and Edward Poynter. From 1858 to 1859 he painted his first major oil, *At the piano* (Taft Museum, Cincinnati). He moved to England the following year, took lodgings at Wapping and began to paint and etch scenes of the London docks, which established his reputation as an etcher. In the 1860s, he painted a number of Japanese-inspired figure pieces, in which he included Japanese porcelain, fans and other objets d'art and used simplified, asymmetrical compositions. He admired Velasquez's paintings and paid tribute to them in works such as *Harmony in grey and green: Miss Cicely Alexander* 1872–74 (Tate, London). In the 1870s, he began to produce his 'Nocturnes' and other works with musical titles. These were studies of tone, colour and atmosphere, which he regarded as tone poems in paint, and which emphasised his interest in art for its own sake rather than for its subject. In 1876, he began the major decorative scheme in the dining room of F.R. Leyland's London house, the 'Peacock Room', but fell out with his patron over the cost. When he submitted *Nocturne in black and gold: The falling rocket* 1875 (Detroit Institute of Arts) to the Grosvenor Gallery in 1877, John Ruskin accused him of 'flinging a pot of paint in the public's face'. Whistler sued him for libel and was awarded a derisory farthing for damages. In 1879, he was declared bankrupt and the following year he went to Venice, where he regained his reputation through his etchings and pastels of unsurpassed delicacy. After his return to London in 1880, Whistler concentrated more on portraiture, and his sitters included close friends like Theodore Duret. With these subjects he was able to experiment with costume, pose and gesture. In 1882, **Walter Sickert** became his pupil and assistant, helping him to print his etchings. He had a reputation as a controversial pamphleteer and acerbic wit, and his views on art were as influential as his art itself. In his *Ten o'clock lecture* (1885), he explained his aesthetic creed, claiming that 'the artist is born to pick, and choose, and group ... that the result may be beautiful — as the musician gathers his notes, and forms his chords, until he bring forth from chaos glorious harmony'. In 1890 he wrote *The gentle art of making enemies,* a clever selection of snippets from the critics, accompanied by acerbic rejoinders from Whistler. In 1891, *Arrangement in grey and black: Portrait of the artist's mother* 1871 (Musée d'Orsay, Paris) was purchased for the Musée du Luxembourg and *Arrangement in grey and black no. 2: Portrait of Thomas Carlyle* 1872–3 (Glasgow Museums: Kelvingrove Art Gallery and Museum) was purchased by the Glasgow Corporation. In the following year the Goupil Gallery retrospective, 'Nocturnes, Marines and Chevalet Pieces', helped to re-establish his London reputation. From 1892 to 1895, he lived in Paris. In 1898, he established the Académie Carmen in Paris, where **Gwen John** was a student. That year, he was elected president of the International Society of Sculptors, Painters and Gravers and, aided by **John Lavery**, played a key role in its affairs over the next two years. His friends Monet and **Rodin** sent work to the International Society's exhibitions. Throughout the last years of his life, he worked intermittently on portraits of his family and favourite models. His art had a powerful influence on the generation of artists that followed. He died on 17 July 1903 in London, aged 69.

references: Andrew McLaren Young, Margaret MacDonald, Robin Spencer and Hamish Miles, *The paintings of James McNeill Whistler*, 2 vols, New Haven: Yale University Press, 1980; Kenneth McConkey, *Edwardian portraits: Images of an age of opulence*, Woodbridge: Antique Collectors' Club, 1987; Barbara Dawson, *Images and insights*, Dublin: Hugh Lane Municipal Gallery of Modern Art, 1993; Richard Dorment and Margaret MacDonald, *James McNeill Whistler*, London: Tate Publishing, 1994; Susan Galassi, Margaret MacDonald and Aileen Ribero, *Whistler, women and fashion*, New Haven: Yale University Press, 2003.

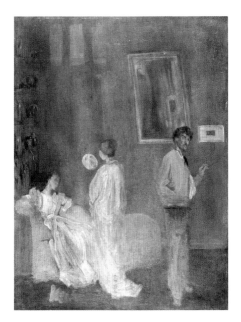

142 *The artist's studio*
painted in London, 1865
oil on cardboard 62.5 x 47.0
exhibited: Royal Hibernian
Academy, Dublin, 1904 (77);
'Memorial Exhibition', New
Gallery London, 1905 (15);
'First Exhibition of Modern
Paintings', Municipal Art Gallery,
Belfast, 1906 (142); 'Exposición
Internacional del Arte', Barcelona,
1907; Municipal Gallery of
Modern Art, Dublin, 1908 (70);
'Whistler', Tate, London, 1912 (3)
Dublin City Gallery The Hugh
Lane

The artist's studio is one of Whistler's first
Japanese-inspired compositions. He portrayed
elongated figures dressed in oriental costume,
and included blue and white porcelain
shimmering in the shadows on the left. His
models were Joanna Heffernan, who posed for
many of his paintings, and himself, wearing
the long-sleeved waistcoat in which he usually
painted, holding the small palette with raised
edges he sometimes used to keep the liquid
pigment from running off.

The artist's studio is one of two preliminary
sketches made for a large painting that
Whistler planned to submit to the Paris Salon
in 1866. He intended to include his friends
Albert Moore and Henri Fantin-Latour, but
he never painted this large work, and did not
include his friends in his studies.

143 *Arrangement in black no. 5:*
Lady Meux
painted in London, 1881
oil on canvas 194.2 x 130.2
signed with butterfly centre left
exhibited: Salon, Paris 1882
(2687); 'College for Working
Men and Women', London 1889;
Grafton Galleries, London,
1893 (46)
Honolulu Academy of Arts,
Hawaii, purchased with donations
from the community and Robert
Allerton Fund in 1967

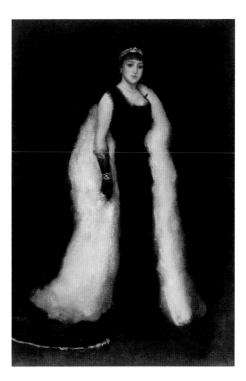

Whistler depicted Lady Meux in a figure-
hugging black velvet evening dress, with
a lavish white sable stole, glittering with
diamonds, unashamedly displaying her
sex appeal and flaunting her wealth. In the
Independent, vol. 52, 2 November 1899, Mrs
Julian Hawthorne recalled Whistler painting
this portrait: Lady Meux stood on a dais about
20 feet away from the artist, who 'held in his
left hand a sheaf of brushes, with monstrous
long handles; in his right the brush he was at
the moment using. His movements were those
of a duellist fencing actively and cautiously
with the small sword.'

Valerie Susan Langdon (1847–1910) caused
a scandal in 1878 when she married in secret
Henry Meux, the heir to a brewery fortune.
Valerie said she was an actress before her
marriage, but others suggested that she had
worked under the name of Val Reece at the
Casino de Venise in Holburn, a dance hall
frequented by prostitutes. The magazine,
Truth, claimed that she had cohabited with a
certain Corporal Reece. Henry's mother, a
daughter of Lord Bruce and granddaughter
of the Marquess of Ailesbury, was indignant.
Valerie defended herself by writing, 'I
can very honestly say that my sins were
committed before marriage and not after',
without realising that a lady should not admit
to having any sins at all. Henry bought his
wife the diamonds that Whistler portrayed
in *Arrangement in black no. 5: Lady Meux*, but
neither the jewels, nor her Egyptian antiquities
collection, nor even Henry's succession to the
title in 1883 could gain Lady Meux the place
in polite Victorian society that she desired. In
her will she exacted revenge by excluding the
family.

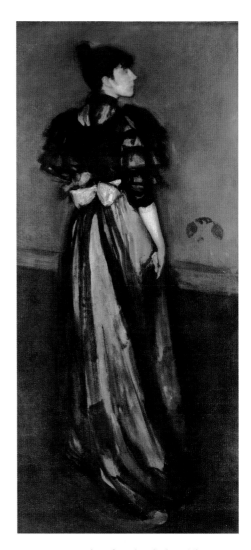

mood by asking his model to pose with a haughty backward swerve.

Mother of pearl and silver: The Andalusian is one of the most finished of Whistler's portraits of his sister-in-law, Ethel Birnie Philip (1861–1920), daughter of the sculptor, John Birnie Philip. Nicknamed 'Bunnie' by the artist, she was his favourite model in the 1890s and the subject of at least five paintings. From 1893 to 1894, she worked as his secretary and, in 1895, married the American journalist and writer, Charles Whibley.

The title, *The Andalusian*, refers to Ethel's silk evening dress, the transparent layered sleeves of the bolero jacket resembling traditional Andalusian costume. Ethel was particularly interested in clothes and, although not a wealthy woman, liked to dress in the latest Parisian fashions. At this time, couturiers gave their dresses names so that customers could ask to view the 'Andalusian' or the 'Tulipe' design, and then request their dressmakers to make replicas from images in fashion magazines. It is possible that 'The Andalusian' in *Mother of pearl and silver: The Andalusian* and 'La Tulipe' in *Rose et or: La Tulipe* 1894–96 (Hunterian Art Gallery, Glasgow) refer to the style of Ethel's attire, and that the paintings are, to this extent, as much portraits of dresses as of a person.

144

Mother of pearl and silver: The Andalusian
painted in Paris?, 1888(?)–1900
oil on canvas 191.5 x 89.8
signed with butterfly centre right
exhibited: 'Exposition Universelle', Paris, 1900 (103); '71st Annual Exhibition', Philadelphia, 1902 (49); 'Ouvres de James McNeill Whistler', Palais de l'Ecole des Beaux-Arts, Paris, 1905 (25)
National Gallery of Art, Washington, Harris Whittemore Collection

In *Mother of pearl and silver: The Andalusion*, Whistler used fluid oil paint, brushing it onto the canvas almost as if it were watercolour. He gently understated Ethel's striking profile and soft features, and, in the way he portrayed the swish of her gown and the expanse of the floor, created the sense of someone slowly turning, about to move away. He used cool greys and warm tans, and created a Spanish

However, Whistler wanted his art principally to be looked at 'for art's sake' and firmly stated, 'Art should be independent of clap-trap — should stand alone, and appeal to the artistic sense of eye or ear, without confounding this with emotions entirely foreign to it, as devotion, pity, love, patriotism and the like.' (*Ten o'clock lecture*, 1885) He also wrote, in his *Ten o'clock lecture*:

> The people have been harassed with Art in every guise, and vexed with many methods as to its endurance. They have been told how they shall love Art, and live with it. Their homes have been invaded, their walls covered with paper, their very dress taken to task — until, roused at last, bewildered and filled with the doubts and discomforts of senseless suggestion, they resent such intrusion, and cast forth the false prophets, who have brought the very name of the beautiful into disrepute, and derision upon themselves.

Francis Derwent Wood
1871–1926

English sculptor, draughtsman and painter, Francis Derwent Wood was born on 15 October 1871 in Keswick, the son of an American. He was educated in Switzerland and began his art studies in Karlsruhe. He returned to England in 1887 and worked as a modeller for Maw and Co. Pottery and for Coalbrookdale Iron Co. foundry. In 1889, he studied under Edouard Lantéri at the National Art Training Schools in South Kensington (later Royal College of Art) and then worked as an assistant to Alphonse Legros at the Slade School from 1890 to 1892. From 1894 to 1895, while working as an assistant to Thomas Brock, he studied at the Royal Academy Schools, where **Hamo Thornycroft** was a teacher. While he was modelling master at the Glasgow School of Art from 1897 to 1901, he designed many figures for public buildings in Glasgow. He returned to London in 1901 and produced a number of portrait busts, such as those of Henry James, **Augustus John**, T.E. Lawrence and **Walter Sickert**. He also made sculptures of mythological subjects such as *Daedalus and Icarus* 1895 (Bristol Museum and Art Gallery) and *Psyche* c.1908–19 (Tate, London). His wife, Florence Schmidt, was an expatriate Australian singer from Rockhampton, Queensland. He associated with Australian artists at the Chelsea Arts Club, where **Tom Roberts** was vice-president. **George Lambert** painted his portrait in 1906 (National Portrait Gallery, London) and, that year, Wood held a farewell dinner for **Arthur Streeton** when Streeton made a brief trip to Australia. Wood sculpted portraits of the Australians Billie Hughes and Bess Norris Tait. During the First World War he was responsible for making masks for plastic surgery for soldiers with facial wounds at the 3rd London General Hospital, Wandsworth, working there alongside **George Coates**, **C.R.W. Nevinson**, **Roberts** and **Streeton**. He succeeded his teacher, Lantéri, as professor of sculpture at the Royal College of Art from 1918 to 1923, during which time **Lambert**'s son, Maurice, was his apprentice. In 1920, he was elected a full member of the Royal Academy. After the war he was commissioned to make several public monuments including the figure of *David* for the *Machine Gun Corps Memorial* 1925 at Hyde Park Corner, London. On 19 February 1926, he died in London after an operation, aged 54.

references: T. Borenius, 'Francis Derwent Wood', *Dictionary of national biography: 1922–1930*, London: Oxford University Press, 1937; Benedict Read, *Victorian sculpture*, New Haven: Yale University Press, 1982; Susan Beattie, *The New Sculpture*, New Haven: Yale University Press, 1983; John Christian (ed.), *The last Romantics: The Romantic tradition in British art*, London: Barbican Art Gallery, 1989.

145 *Tom Roberts*
modelled in London, 1910
plaster with bronze-coloured paint
55.9 x 34.0 x 26.0
signed and dated 'F. Derwent Wood/1910' incised on lapel
Art Gallery of New South Wales, Sydney, gift of Tom Roberts in 1929 photograph: Jenni Carter for AGNSW

Francis Derwent Wood's privately produced bust of his friend, the Australian painter **Tom Roberts**, is an affectionate and insightful portrait of the older artist. Roberts' expression is alert and inquisitive and he is depicted as though momentarily turning his head, to listen or to look at something closely. The lively feel of this work is further enhanced by Wood's animated treatment of the surface and expressive modelling of form, particularly evident in the lapels and coat of his subject.

Elena Taylor

House of Worth

Charles Frederick Worth
1825–1895

English-born French couturier Charles Worth was born on 13 October 1825 in Bourne, Lincolnshire, the son of a solicitor. He went to Paris in 1845 after an apprenticeship at Swan and Edgar and a brief period as a shop assistant at Lewis and Allenby, both London drapers. In Paris, Worth worked for Maison Gagelin as a salesman, at a time when it was considered far more advantageous to sell fabrics than to be a dressmaker. Women would order fabrics to have female dressmakers — normally referred to as milliners — make their own designs. Worth proposed to his employers that he be allowed to make up dresses in some of their silks to be sold on their premises. Whilst there was initial opposition, Gagelin's doubts were soon dispelled and Worth's design skills were discovered by the ladies of the court of Napoleon III. The cut and finish of Worth's gowns was so unparalleled in quality that his approach came to have another name. It was not dressmaking, it was *haute-couture*. Denied a partnership by his employers, Worth left Gagelin in 1858 to start his own business. Forming a business partnership with a Swede, Otto Bobergh, the two pooled their resources and opened as Worth et Bobergh at 7 Rue de la Paix in 1858. Their gowns of this time are the first to contain a label with the couturier's name. In 1871, following Bobergh's return to Sweden, the House of Worth continued to flourish. France's Second Empire provided the opportunity for lavish costumes and, through the generous support of European royalty as well as wealthy Americans, Worth was producing between 6,000 and 7,000 gowns annually. He was appointed court couturier to Empress Eugénie and held a royal warrant. Worth embraced new techniques, such as machine-made lace and silks woven on looms of great complexity and sophistication, and had an ingenious method of garment construction using interchangeable parts so that one pattern could be utilised for innumerable designs. One of Worth's innovations was the 'Princess Line', named after Alexandra, Princess of Wales. This one-piece dress had a fitted waist but no waist seam, the fit being achieved by long darts from bust to hip. This simple idea was taken up by other dressmakers; it became the fundamental dress construction throughout the late 1880s and is a classic form which endures today. Two important streams of business for the House of Worth were the result of the excesses of the period. The competition for opulence and the limits sometimes placed upon society when attending royal events, and the popularity of fancy dress, enabled the House of Worth to design the most creative and extraordinary costumes. A continuum of this fantasy world was the interest in the theatre, which provided Worth with another constant source of additional income. Actresses such as Sarah Bernhardt and Lillie Langtry and opera singers Nellie Melba, Adelina Putti and Emma Albani had Worth and his son design gowns for them. When Worth died, his obituary in *Harpers Bazaar* stated: 'no painter, no sculptor, no poet, no actor, no novelist of the past three decades has achieved so widespread a fame as that of this dressmaker of the Rue de la Paix'. Charles Worth died in Paris on 10 March 1895 aged 69.

Jean-Philippe Worth
1856–1926

In 1879, Charles Worth's two sons started full-time work at the House of Worth. Jean-Philippe, who had studied art under Corot, assisted with design while his brother, Gaston, helped with management and finance. In the 1880s a relative newcomer to the opera stage, Nellie Melba, started dressing at the House of Worth. As a rising star she did not qualify for the attention of the master 'but was handed to Jean-Philippe', although anything Jean-Philippe suggested for her had to be approved by and, if necessary, corrected by his father Charles. Some beautiful clothes came out of this partnership and Melba became indebted to Jean-Philippe for his constant help and advice. Whilst Melba later went to Jacques Doucet and others in Paris and London, Worth remained the name most associated with her stage, as well as her personal, wardrobe. Jean-Philippe died in 1926, aged 70.

references: *The House of Worth*, New York: The Brooklyn Museum, 1962; Diana de Marly, *Worth, father of haute couture*, New York: Holmes and Meier, 1980; Jo Anne Olian, *The House of Worth: The gilded age 1860–1918,* The Museum of the City of New York, 1982; Roger Leong: *Dressed to kill: 100 years of fashion*, Canberra: National Gallery of Australia, 1993.

146 *The Lohengrin cloak*
Jean-Philippe Worth, designer,
for House of Worth, Paris,
commissioned by Dame
Nellie Melba
made in Paris, c.1890
cloak: green silk shot with gold
and lined with flesh satin and tulle;
bordered with a band of gold braid,
cream silk chiffon and pearls,
sequins and beads; nine hand-
painted angels set in a circle of
velvet with beads and gold ruche;
centre back: length 223.52,
width at hem: 406.4
The Arts Centre, Performing
Arts Collection, Melbourne, Gift
of Pamela, Lady Vestey in 1978

Dame Nellie Melba is believed to have spent about 8,700 French francs on this cloak. She valued it so highly that, long after her singing career, she carefully laid it out upon her bed at her home, 'Coombe Cottage' in Victoria. When away travelling she would ask that it be turned regularly. The cloak is in very good condition, due to Melba's care, its original construction and the fact that Melba ceased singing Wagnerian roles after 1897.

Wagner's opera *Lohengrin* was first performed in Weimar in 1850 with Franz Liszt as the conductor. Forty years later, Melba made her first appearance as Elsa, her performance meeting with great acclaim. In February 1891, Melba was invited by Tsar Alexander III to perform in St Petersburg and she noted the following incident relating to the cloak which occurred en route from Paris:

> I considered why we were waiting so long and then realised that it was because of the searching examinations of passengers' luggage by the dark, fiery-eyed customs officers who were stamping their feet in the snow outside. A closer inspection revealed to my horror an exquisite cloak which I had brought especially for *Lohengrin*, lying on the ground, perilously near the soldiers' feet. I dashed outside and tried to explain in a mixture of four languages, that the cloak was for Opera that it was a very beautiful thing and that no account must it be spoilt.

Melba also wrote in her memoirs of her great debt to Jean-Philippe Worth for his help and advice 'in making me realise how important it was to look as well as I sang'. Elsa remained part of Melba's repertoire until the American season of 1894–5. Following Melba's first appearance as Elsa at the Metropolitan, the critic in the *New York Tribune* remarked, 'the magnificence of her wardrobe was without a parallel as far as the local stage is concerned'. Melba always wore her own costumes, not those belonging to the theatre as had been the standard practice.

The greatest compliment given to Melba regarding her cloak was in St Petersburg when, following the Second Act, the Tsar and Tsarina sent for her. The Tsarina Maria Feodorovna, whose coronation robes were designed by Charles Worth, bent over and took the cloak in her hands, stating how perfectly lovely it was.

The cloak is made from green silk shot with gold and lined with flesh-coloured silk satin. The shoulder has a plaited tie attached to the inside and hooks for attaching the cloak on to a dress. There is also a hand-written label identifying the garment. Both centre front seams of the cloak and the lower section are decorated with gold braid encasing a cream silk chiffon band of pearls, sequins and beads all in colour sequence. Arranged centrally are five appliquéd flowers and below this is the chiffon band. The lower part of the cloak has gold leaves formed by using a fine gold band. This also surrounds the nine hand-painted angels set in a circle of velvet with beads and gold ruschia decoration. The hem of the cloak has a pearl trim set on chiffon between gold braid and a pink bias dirt trap. The decoration on the cloak has all been sewn by hand but the joins in the silk and lining are machined. The lining has been sewn on to the silk

Ron Ramsey

This dress belonged to Mary Crowninshield Endicott Chamberlain, wife of Joseph Chamberlain, English statesman, politician, businessman and social reformer. She was the mother of the British Prime Minister, Neville Chamberlain. **John Singer Sargent** painted her portrait in 1902 (National Gallery of Art, Washington), around the time this dress was made.

The 'slashed' sleeves, possibly a historic reference to earlier fashion trends (the Worths often used paintings and historical references in their designing). The smoothly fitted five-panel skirt, which was a feature of the House of Worth, has an inverted pleat at the back, forming a train.

Ron Ramsey

147 *Afternoon dress*
Jean-Philippe Worth, designer,
for House of Worth, Paris
made in Paris, c.1902
raspberry pink silk satin two piece
dress: bodice has a handmade
bobbin lace collar, machine tulle
trim at neck, handmade tulle
along front edge, black silk rosettes
on front and on 'slashed' sleeves
trimmed with machine tulle;
trained five-panel skirt; centre
back bodice: 51.0,
length of sleeves: 35.0,
centre back of skirt: 154.0
National Gallery of Australia,
Canberra

Chronology

The events which are listed are intended as a rough chronological guide to the Edwardian period;
inevitably there are many events which are not included.

Arts events	Historical events

1900

	Arts events	Historical events
7 February		British Labour Party is formed.
February – April	Claude Monet visits London.	
15 April– 12 November		Exposition Universelle, Paris.
29 July		Edward, Prince of Wales opens the Central Line Underground as a cross-London route from Bank to Shepherd's Bush. The initial adoption of the universal fare of twopence immediately gives the line the nickname 'The Two-penny Tube'.
25 August	Friedrich Nietzsche, German philosopher and writer, dies.	
17 September		Queen Victoria proclaims that the Commonwealth of Australia, comprising all six colonies, will come into existence on 1 January 1901.
21 September		Queen Victoria officially appoints John Adrian Louis Hope, Seventh Earl of Hopetoun, as Australia's first governor-general.
3 October	Edward Elgar's oratorio *Dream of Gerontius* is first performed in Birmingham Town Hall.	
October		British general election gives victory to the Conservative Party.
30 November	Oscar Wilde, author and playwright, dies in Paris.	
23 December		Reginald Fessenden, a Canadian, transmits his own voice over the first wireless telephone from a site on Cobb Island in the middle of the Potomac River near Washington. Radio broadcasting is born.
	L. Frank Baum's *The wonderful wizard of Oz* is published.	
	Joseph Conrad's *Lord Jim* is published.	

1901

	Arts events	Historical events
1 January		The proclamation of the Commonwealth of Australia in Centennial Park, Sydney. Lord Hopetoun officially assumes his duties as the first governor-general. The interim federal ministry, with Sir Edmund Barton as prime minister, is sworn in.
		Advance Australia Fair, written by Amicus (P. D. McCormick), is sung at the inauguration ceremony, but does not become Australia's national anthem until 19 April 1984.
22 January		Queen Victoria dies; Edward VII becomes king.
27 January	Giuseppe Verdi, Italian composer, dies.	
31 January	Anton Chekhov's play *Three sisters* is first performed at the Moscow Art Theatre.	
29 March		The first Australian federal elections are held. Prime Minister Sir Edmund Barton selects the first Federal Cabinet.
9 May		The first Australian Commonwealth Parliament is declared open by the Duke of Cornwall and York (later George V) at the Exhibition Building in Melbourne.

1901 cont.

10 July		London United Tramways begin London's first electric tram service, running between Shepherd's Bush and Kew Bridge.
7 September		The Boxer Rebellion in China ends.
9 September	Henri de Toulouse-Lautrec, French painter, dies.	
27 October	Sergei Rachmaninov's *Second piano concerto* is first performed, with the composer as the soloist.	
10 December		The first Nobel Prize ceremony is held in Stockholm.
12 December		Marconi transmits a radio signal from England to Newfoundland — the first transatlantic telegraph.
		The first electric typewriter, the Blickensderfer, is introduced.
	Edward Elgar composes the first of his *Pomp and circumstance* marches, which became better known as the music for 'Land of Hope and Glory'.	
	Miles Franklin's *My brilliant career* is published.	
	Sigmund Freud's *Psychopathology of everyday life* is published.	
	Rudyard Kipling's *Kim* is published.	

1902

17 January		*The Times Literary Supplement* is first published.
11 April	Enrico Caruso records 10 arias in Milan for Britain's Gramophone Company. He is paid a fee of £100 for the session.	
1 May	The first science fiction film, *A trip to the moon*, opens in Paris.	
14 May	Nellie Melba sings with Enrico Caruso in *Rigoletto* at Covent Garden.	
31 May		The Boer War ends.
May		Miller Reese Hutchinson, the inventor of the first battery-powered hearing aid, is asked to go to England to exhibit the device to the deaf Queen Alexandra.
12 June		*Commonwealth Franchise Act* comes into being, giving all women the right to vote in Australian federal elections but excluding 'aboriginal natives of Australia'.
17 July		Lord Hopetoun, Australia's first governor-general, leaves Australia.
9 August		Coronation of King Edward VII and Queen Alexandra.
29 September	Emile Zola, French author, dies.	
3 November		The empire cable, the submarine telegraph cable from Vancouver, Canada to Southport, Queensland is opened.
	Joseph Conrad's *Heart of darkness* is published.	
	Arthur Conan Doyle's *The hound of the Baskervilles* is published.	
	Henry James' *Wings of the dove* is published.	
	Beatrix Potter's *Tale of Peter Rabbit* is published.	
	Rodin's *St John the Baptist* is bought by public subscription in England and donated to the present Victoria and Albert Museum. Rodin makes a triumphal visit to London.	

1903

1 January		Edward VII is proclaimed Emperor of India.
9 January		Lord Tennyson is confirmed as Australia's second governor-general. He was acting governor-general from 17 July 1902 when Lord Hopetoun left Australia. Lord Tennyson remains in office until 21 January 1904.
15 February		Morris Michtom makes the first official toy bear. It is called the teddy bear after Theodore (Teddy) Roosevelt, the 26th president of the United States of America.
9 May	Paul Gauguin, French painter, dies.	
After April	Cecil Hepworth's film *Alice in wonderland* is produced.	
17 July	**James McNeill Whistler, painter, dies.**	
	On the death of Whistler, Auguste Rodin is elected President of the International Society of Sculptors, Painters and Gravers.	
24 September		When Edmund Barton resigns to become a judge of the High Court, his friend and deputy Prime Minister Alfred Deakin succeeds him as prime minister.
10 October		Emmeline Pankhurst, together with her daughter Christabel, help found the Women's Social and Political Union (WSPU).
2 November		Alfred Harmsworth founds the *Daily Mirror* in London as a women's paper costing one penny.
13 November	Camille Pissarro, French painter, dies.	
1 December	Edwin Porter's film *The great train robbery* is copyrighted. It is regarded as the first classic Western.	
17 December		At Kitty Hawk, first Orville Wright and then Wilbur Wright make the first powered airplane flights in history.
28 December	George Gissing, English author, dies.	
		The first petrol driven cab, the Prunel, is licensed for use in London.
	Samuel Butler's *The way of all flesh* is published.	
	Joseph Furphy's *Such is life* is published.	
	Josef Hoffman and Koloman Moser co-found the Weiner Werkstätte, to integrate the fine and applied arts.	
	Henry James' *The ambassadors* is published.	
	G.E. Moore's *Principia Ethica* is published.	

1904

17 January	Anton Chekhov's play *The cherry orchard* is first performed at the Moscow Art Theatre in a production directed by Stanislavsky.	
21 January		Lord Northcote serves as Australia's third governor-general until 9 September 1908.
1 Feburary	Enrico Caruso records selections from Leoncavallo's opera, *Pagliacci*, for Victor Records — the first million-selling record. Caruso is paid $4,000.	
17 February	Giacomo Puccini's opera *Madame Butterfly* is first performed at the Teatro alla Scala, Milan.	
17 March	Nellie Melba makes her first recordings in her own home at 30 Great Cumberland Place, with extracts from *Lucia di Lammermoor* and *La Traviata*.	
8 April		The Entente Cordiale, an agreement between Britain and France, resolves a number of longstanding colonial disputes, and establishes a diplomatic understanding between the two countries.

1904 cont.

30 April – 1 December		The ice cream cone is introduced at the St. Louis World's Fair, coinciding with the third Olympic Games in that city.
May		The Rolls-Royce car manufacturing company is formed.
9 May – 4 June	Claude Monet exhibits 37 views of London at Galerie Durand-Ruel, Paris.	
May–June	Exhibition of Irish Art is shown at the Guildhall, London, organised by Hugh Lane.	
1 July	G.F. Watts, English painter, dies.	
14 July	Anton Chekhov, Russian playwright and short story writer, dies.	
25 August	Henri Fantin-Latour, French painter, dies.	
16 October	Charles Furse, English painter, dies.	
15 November		A patent is granted to K.C. Gillette for a safety razor with a safe, inexpensive and disposable blade.
19 November	'Modern French Art' exhibition opens at the Royal Hibernian Academy, Dublin, organised by Hugh Lane.	
27 December	J.M. Barrie's play *Peter Pan* is first performed at the Duke of York's Theatre, London.	
	The opening of the Abbey Theatre, Dublin, the Irish theatre company devoted primarily to national drama. The Abbey Players present a double bill, *On Baile's Strand* by W.B. Yeats and *Spreading the news* by Lady Gregory.	
28 December		In New York, merchant Thomas Sullivan packages loose tea in small cloth and silk bags; his customers brew tea using the bags and the tea-bag is born.
	Joseph Conrad's *Nostromo* is published.	
	Henry James' *The golden bowl* is published.	
	Edith Nesbitt's *New treasure seekers* is published.	

1905

22 January		The massacre of Russian demonstrators at the Winter Palace in Saint Petersburg is one of the triggers of the abortive Russian Revolution of 1905.
January - February	Paul Durand-Ruel organises an exhibition of Impressionist paintings at the Grafton Galleries, London (315 works exhibited).	
	Frank Rutter starts a fund to buy an Impressionist painting for the National Gallery, London. He wants to purchase a painting by Monet, but has to settle for Boudin's *The harbour at Trouville*.	
22 February - 15 April	The Whistler Memorial Exhibition is organised by the International Society of Sculptors, Painters and Gravers at the New Gallery, Regent Street, London.	
24 March	Jules Verne, French author, dies.	
23 May	George Bernard Shaw's play *Man and superman* is first performed at the Royal Court Theatre.	
30 June		Albert Einstein's *Special theory of relativity* breaks away from the Newtonian reliance on space and time as immutable frames of reference.
3 October		*HMS Dreadnought* is laid down, revolutionising battleship design.
15 October	Claude Debussy's *La Mer* is first performed in Paris.	
31 October	George Bernard Shaw's play *Mrs Warren's profession* opens in New York, and is assailed by critics for making light of prostitution and incest, and closes after one performance.	
October	Salon d'Automne includes works by the Fauves.	

1905 cont.

November	Die Brücke group of Expressionist artists in Dresden exhibit their work for the first time. This work marks the beginning of modern art in Germany.	
28 November		The first political party to be known as 'Sinn Fein' is founded, declaring itself as working for the right of Irish people as a whole to attain self-determination.
30 December	Franz Lehar's operetta *The merry widow* is first performed in Vienna.	
		'Cadbury's Dairy Milk' chocolate is first released, with a 'glass and a half of full cream milk'.
	Thomas Beecham makes his debut as a conductor.	
	E.M. Forster's *Where angels fear to tread* is published.	
	Baroness Orczy's *The Scarlet Pimpernel* is published.	
	H.G. Wells' *Kipps* is published.	
	Edith Wharton's *The house of mirth* is published.	

1906

15 January		The British general election gives the Liberal Party a landslide victory.
February	'Pictures from the 1905 Salon d'Automne' are shown at the Lafayette Gallery, London.	
5 March	**Hugh Ramsay, Australian painter, dies.**	
April	Walter Booth makes first UK animated film, *The hand of the artist*.	
23 May	Henrik Ibsen, Norwegian playwright, dies.	
12 June		After protracted litigation, the highest court in France reverses the 1899 treason conviction and exonerates Alfred Dreyfus of all charges.
Summer	Percy Grainger collects folk songs in Lincolnshire with a phonograph.	
23 October	Paul Cézanne, French painter, dies.	
16 December	*The story of the Kelly Gang*, directed by Charles Tait, is premiered at the Athanæum Hall, Melbourne. It is said to be the first film to last more than an hour.	
21 December	**Tudor St George Tucker, Australian painter, dies.**	
24 December		Reginald Fessenden presents radio's first program from Boston. Wireless operators on ships across the Atlantic hear the inventor play *O Holy Night* on his violin and his wife Helen and her friend sing Christmas carols.
		British Labour politician, Fred Jowett, makes his maiden speech on the subject of school meals and eventually manages to convince Parliament that hungry children have trouble learning and the *Provision of School Meals Act* is passed, permitting local authorities to provide school meals.
	The first volume of John Galsworthy's *The Forsyte saga* is published.	
	Edith Nesbit's *The railway children* is published.	

1907

January – February	First exhibition of the Modern Society of Portrait Painters.
26 January	At the premiere of J.M. Synge's play *The playboy of the western world* at the Abbey Theatre, Dublin, riots break out, supposedly incited by Synge's use of the word 'shift'. Summoned from Scotland by Lady Gregory, W.B. Yeats attempts to quell the riots by addressing the audience from the stage.
Spring	Walter Sickert, Spencer Gore and Harold Gilman found the Fitzroy Street Group, an informal association; membership fluctuates over the years.
10 June	
September	
4 September	Edvard Grieg, Norwegian composer, dies.
26 September	

Louis Lumière markets the Autochrome plate, the first practical colour photography process — which he patented in 1903.

Emily Dimmock, a part time prostitute, is found murdered in her bed in Camden Town. The press refers to the murder as 'The Camden Town Murder'.

New Zealand becomes a dominion.

The British Education (Administrative Provision) Act is passed making a system of medical inspection of children in British public elementary schools a statutory obligation on every local education authority.

Joseph Conrad's *The secret agent* is published.

E.M. Forster's *The longest journey* is published.

Charles Rennie Mackintosh designs the Glasgow School of Art.

Pablo Picasso paints *Les Demoiselles d'Avignon*, one of the most important works in the genesis of modern art.

1908

27 April – 31 October	
16 May	The Commonwealth Literary Fund is established as a pension fund for Australian writers in poverty.
July	First exhibition of the Allied Artists' Association, (a non-jury exhibiting body conceived by Frank Rutter as the English equivalent to the Salon des Indépendants).
9 September	
1 October	
15 December	

Fifth Olympic Games, held in London, are officially opened by Edward VII.

Lord Dudley serves as Australia's fourth governor-general, until 31 July 1911.

Henry Ford produces his first Model T automobile. The price: $850.

The Invalid and Old Age Pensions Act becomes law in Australia and sets up a national aged pension scheme. The scheme begins in July 1909 for men aged 65. Women aged 60 have to wait until December 1910, when invalid pensions are also introduced.

E. M. Forster's *A room with a view* is published.

Kenneth Grahame's *The wind in the willows* is published.

Somerset Maugham's *The magician* is published.

Lucy Montgomery's *Anne of Green Gables* is published.

Henry Handel Richardson's *Maurice Guest* is published.

1909

1 January		State pensions become payable to persons in Britain of the age of 70 years and over as a result of the *Old Age Pensions Act* passed in 1908.
16 January		Ernest Shackleton and team reach the magnetic South Pole.
8 February		In a speech delivered to the American Chemical Society, the discovery of Bakelite is formally announced. Leo Baekeland obtained a patent for it in 1906, and bakelite, the first synthetic plastic, was produced in 1907.
9 February	Charles Conder, British-Australian painter, dies.	
20 Feburary	Filippo Marinetti's *Futurist manifesto* is published by the journal *Le Figaro* in Paris.	
12 April	Algernon Charles Swinburne, English poet, dies.	
15 March		Selfridges department store opens in Oxford Street, London.
19 May	Serge Diaghilev's Ballets Russes give their first public performance at the Théâtre du Châtelet, Paris with *Armida's pavilion* and *The Polovtsian dances from Prince Igor.*	
25 July		Louis Bleriot is the first man to fly across the English Channel in an aeroplane (in 43 minutes).
July		An imprisoned suffragette, Marion Dunlop, refuses to eat. Afraid that she might die and become a martyr, it is decided to release her. Soon afterwards other imprisoned suffragettes adopt the same strategy. Unwilling to release all the imprisoned suffragettes, the prison authorities force-feed these women on hunger strike.
11 September		Halley's Comet is photographed nearing the sun.
21 October	First issue of *The Art News.*	
13 December		The Act establishing an Australian High Commission in London becomes law and Australia's first overseas office is established. A month later George Reid becomes Australia's first high commissioner. During his term the building of Australia House commences.
	Maurice Maeterlinck's most famous play, *The blue bird,* is first produced in London at the Haymarket Theatre.	
	H.G. Wells' *Ann Veronica* is published.	

1910

January		British general election gives victory to the Liberal Party.
March	Herwarth Walden founds his magazine *Der Sturm* in Berlin, introducing the readership to important aspects of Cubism, Expressionism, Constructivism, Futurism.	
21 April	Mark Twain, American author, dies.	
6 May		Edward VII dies; George V becomes king.
4 June	*Schéhérazade* ballet, with choreography by Michel Fokine, music by Nikolai Rimsky-Korsakov, and scenery and costumes by Léon Bakst, premieres at the Paris Opera.	
25 June	*The Firebird* ballet, with choreography by Fokine and music by Stravinsky, and scenery and costumes by Golovin and Bakst, premieres at the Paris Opera.	
July		'Dr Crippen' is arrested at sea for the murder of his wife, the first criminal suspect to be caught as a result of radio messaging. He was travelling with his mistress Ethel Le Neve, who was disguised as a boy.
9 August		A patent is issued for the first electric-powered washing machine (the Thor).
20 August		Florence Nightingale dies.

1910 cont.

27 August	Thomas Edison demonstrates his 'kinetophone' which combines the sound of the phonograph and the images of the motion picture.
8 November– 15 January	'Manet and the Post Impressionists' exhibition at Grafton Galleries, London.
20 November	Leo Tolstoy, Russian novelist, dies.
11 December	Georges Claude, Paris inventor, shows to the public the first neon light.
December	British general election gives victory to the Liberal Party.

E.M. Forster's *Howards end* is published.

Colette's *La Vagabonde* is published.

Henry Handel Richardson's *Getting of wisdom* is published.

Rodin visits London to discuss the site for the cast of *The burghers of Calais*, purchased by the British Government in 1911, and set up next to the Houses of Parliament in 1913.

H.G.Wells' *History of Mr Polly* is published.

1911

1 January	The Northern Territory and the Australian Capital Territory are formally transferred to the Commonwealth of Australia.
20 January – 18 February	Inaugural exhibition of the National Portrait Society, London.
May	W.S. Gilbert, English dramatist, dies
22 June	Coronation of King George V and Queen Mary.
June	First exhibition of the Camden Town Group
31 July	Lord Denman is Australia's fifth governor-general (until 18 May 1914).
4 October	First escalators installed in a London Underground station, at Earl's Court.
14 December	Roald Amundsen, Norwegian explorer, first to reach the South Pole.
December	*Der Blaue Reiter*, organisation of Expressionist artists, is formed in Munich by Wassily Kandinsky and Franz Marc.

Max Beerbohm's *Zuleika Dobson* is published.

Arnold Bennett's *The card* is published.

Frances Hodgson Burnett's *The secret garden* is published.

G. K. Chesterton's *The innocence of Father Brown* is published.

Serge Diaghilev presents the Ballets Russes for the first time at Covent Garden in London.

Walter Sickert, Spencer Gore, Harold Gilman and others form the Camden Town Group.

Edith Wharton's *Ethan Frome* is published.

Summer	*Rhythm*, a quarterly journal on the arts, is launched by Middleton Murray and Katherine Mansfield, with J.D. Fergusson as art editor.

Curator's Acknowledgements

Many, many people have assisted with this exhibition. For their superb contributions I am indebted to Dr Ann Galbally, University of Melbourne; Professor Kenneth McConkey, University of Northumbria, Newcastle-upon-Tyne; Benedict Read, University of Leeds; and Christine Riding, Tate, London. They have not only enriched the treatment of the subject by discussing important aspects of Edwardian art in detail, but have guided me in areas where I have needed guidance. MaryAnne Stevens from the Royal Academy, London and Angus Trumble from the Yale Centre for British Art, New Haven, Connecticut have provided invaluable support and advice. So too has Stephen Coppel, Assistant Keeper, Department of Prints and Drawings, British Museum. Brian Allan and Frank Salmon from the Paul Mellon Centre for British Art, London, Carl Bridge and Ian Henderson from the Menzies Centre, London and Ian Donaldson and Caroline Turner from the Humanities Research Centre, ANU, Canberra have also provided valuable support.

I would like to extend my warmest and most sincere thanks to all who have given their knowledge, advice and assistance over the last three years. In addition to those already mentioned, I would particularly like to thank the following: Bruce Arnold; Stephanie D'Allessandro; Philip Athill; Philip Bacon; Robert Bell; Laurie Benson; Bruce Beresford; Richard Beresford; Frances Borzello; Tony Bradshaw; Ann Bukantas; Roger Butler; Sighle Breathnach-Lynch; Eva Breuer; Helen Campbell; Mungo Campbell; Belinda Carrigan; Helen Carroll; Jane Clark; Natasha Conland; Lyn Conybeare; Glenn Cooke; Tim Craven; Albert Davia; Stephen Deuchar; Diana Dethloff; Christine Dixon; Jeff Dunn; Dinah Dysart; Mary Eagle; Tony Ellwood; Julie Ewington; Simon Ford; David Fraser Jenkins; Adam Free; Patricia Fullerton; Peter Funnell; James Gleeson; Paul Goldman; Janda Gooding; Ted Gott; Sasha Grishin; Colin Harrison; Gloria Groom; Deborah Hart; Mark Henshaw; Alan Hobart; Christine Hopper; Gordon Hudson; Barry Humphries; Claudia Hyles; Alison Inglis; David Jaffé; Christina Kennedy; Joan Kerr; Jenny Kinnear; Jane Kinsman; Anne Kirker; Lou Klepac; Hendrik Kolenberg; Roger Leong; Frances Lindsay; Penelope Little; Samantha Littley; Catherine Lomas; Philip Long; Pamela Luhrs; Humphrey McQueen; Sasha Menz; Anne Meredith; Julie Milne; Andrew Montana; Gael Newton, Pamela Gerrish Nunn; Charles Noble; David O'Connor; Tim Pate; Barry Pearce; Peter Perry; Ron Radford; Sarah Richardson; Brett Rogers; Anne Ryan; Andrew Sayers; Margaret Seares; John Schaeffer; Richard Shepherd; Geoffrey Smith; Peyton Skipwith; Howard Smith; Paul Spencer-Longhurst; Sasha Smith; Kathleen Soriano; Peter Stanley;

Chris Stephens; Hugh Stevenson; John Stringer; Ann Sumner; Sharon Tassicker; Daniel Thomas; Sarah Thomas; Julia Toffolo; Steven Tonkin; Julian Treuherz; Lady Vestey; Dr Ernst Vegelin van Claerbergen; Lucina Ward; Nick Winterbotham; Claire Woodage; Jenny Wright and Ruth Zubans.

I am also grateful to the following copyright holders for permission to reproduce works, and for the information they have provided on the artists: Mrs V. Bevis; Donald Brown; Henrietta Garnett; Luke Gertler; Tom Hewlett; Jessica Ivanovic; Chris Kennington; Antoinette Niven; Yvonne Patterson; Henrietta Phipps; Rosamund Shepherd; Jane Smith; Oliver Streeton; Thea Waddell of Australia; and Rix Wright.

At the National Gallery, my warm thanks go to every member of staff who has been involved in the planning, coordination and promotion of the exhibition. I particularly thank Liz Wilson, who has worked closely with me on all stages of the exhibition, for her considerable assistance with the research for this exhibition and administration of a large and complex project; to Gillian Ferguson for her assistance with writing the biographies and picture texts; and to Susan Hall for her meticulous and sympathetic editing. Elena Taylor provided essential support through her thorough attention to detail on the catalogue entries and picture texts. My thanks also go to Rebecca Chandler for her assistance with the exhibition labels and Melanie Beggs-Murray for her typing assistance. Kirsty Morrison guided the publication through every stage and Sarah Robinson provided the splendid and sumptuous catalogue design. I would also like to thank Pauline Green, Alistair McGhie, Carla Da Silva, Eve Sullivan and Bev Swifte in Publications for their support.

Adam Worrall and Beatrice Gralton in Exhibitions have provided invaluable and enthusiastic support, and Adam is responsible for the splendid environment for the exhibition. They have both been a joy to work with. Jenny Blake and Elizabeth Malone have done so much for the promotion of the exhibition and have shown great confidence in it. Susan Herbert, Head of Education and Public Programs, and her team, Robyn Daw, Ben Divall, Sylvia Jordan, Jo Krabman, Michel Fensom-Lavender, Jenny Manning, Andrew Powrie, José Robertson, Daryl Shires and Annette Tapp have provided invaluable support.

I thank Leanne Handreck in Publications for her splendid work in obtaining the photographs and rights and permissions. Bruce Moore, Steve Nebauer and Wilhemina Kemperman have provided invaluable assistance with the photography for the exhibition.Charlotte Galloway, Katrina Power and Peta Hendricks in Registration together

with Lesley Arjonilla should be congratulated for the skill they have brought to organising and administering such a complicated loan process. Kim Brunoro, Allan Byrne, Micheline Ford, Greg Howard, Sheridan Roberts, Solitaire Sani, Debbie Ward and Stefanie Woodruff have undertaken the conservation of works with their usual care and thoroughness. Margaret Shaw, Chief Librarian, together with Kate Brennand, Kathleen Collins, Gillian Currie, Helen Hyland and Vicki Marsh have answered numerous queries and requests with characteristic efficiency and zeal.

I am grateful to the Director Brian Kennedy who has given me free rein to fulfil my vision for this exhibition along with his unbounded encouragement and support. I also thank Deputy Director Alan Froud who has managed the funds; to my fellow Assistant Directors — Ruth Patterson, who has enthusiastically overseen the promotion of this exhibition; Erica Persak, who has provided support and guidance in the management of the loans and indemnification; Ron Ramsey, who has enthusiastically taken on board the writing of an Edwardian cookbook to accompany this exhibition and Jörg Zutter, who has provided advice and support. Mary Lou Lyon has also provided ongoing enthusiasm, and assistance in a great many ways.

I also wish to acknowledge the many authors and curators who in recent years, through the books they have published and the exhibitions they have organised, have deepened my enjoyment and knowledge of the art of this period. Reference to their work can be found in the bibliography or in the references under the individual artists' biographies. Without their work this exhibition would be a very different one indeed.

Anne Gray
Assistant Director, Australian art
National Gallery of Australia,
Canberra

List of Lenders

Australia

Adelaide Casino 137

Art Gallery of New South Wales, Sydney 11, 42, 66, 74, 80, 103, 109, 113, 115, 127, 130, 135, 145

Art Gallery of South Australia, Adelaide 9, 29, 31, 33, 36, 39, 43, 69, 90, 91, 100, 110, 111, 123

Art Gallery of Western Australia, Perth 3, 87

The Arts Centre, Performing Arts Collection, Melbourne 146

Philip Bacon Collection, Brisbane 12, 26

Carrick Hill Trust, Hayward Bequest, Adelaide 79

Castlemaine Art Gallery and Historical Museum 37

Fosters Group, Melbourne 17

Geelong Gallery 2

Grainger Museum, The University of Melbourne 6

Historical Memorials Collection, Parliament House Art Collection, Canberra 71

The Holmes à Court Collection, Heytesbury Pty Ltd, Perth 22, 24

Barry Humphries Collection 25

Mildura Arts Centre 8, 92, 95, 96

National Gallery of Australia, Canberra 1, 13, 15, 23, 27, 28, 44, 50, 51, 55, 72, 75, 83, 84, 97, 99, 102, 104, 106, 112, 122, 133, 138, 147

National Gallery of Victoria, Melbourne 10, 18, 21, 41, 45, 46, 58, 60, 66, 78, 88, 94, 107, 108

Newcastle Region Art Gallery 14

Queensland Art Gallery, Brisbane 49

Schaeffer Collection 47, 134

Kerry Stokes Collection, Perth 38

Toowoomba Regional Art Gallery 40

The Wesfarmers Collection of Australian Art, Perth 70

Wollongong City Gallery 132

Canada

National Gallery of Canada, Ottawa 86

England

Ashmolean Museum, Oxford 125

Bradford Art Galleries and Museums 114, 116

Chatsworth House Trust, Derbyshire 118

Government Art Collection of the United Kingdom, London 126, 140

Laing Art Gallery, Newcastle Upon Tyne, Tyne and Wear Museums 63, 141

Langan's Restaurants, London 48

Leeds Museums and Galleries, City Art Gallery 20

The Sir Alfred Munnings Art Museum, Dedham, Essex 85

The National Gallery, London 117

National Museums Liverpool, the Walker Art Gallery 105

National Portrait Gallery, London 4

Royal Academy of Arts, London 35, 61, 139

Southampton City Art Gallery 32, 65

Tate, London 5, 59, 82, 121, 129, 131

France

Centre Pompidou, Musée National d'Art Moderne and Musée de Roubaix 62

New Zealand

Museum of New Zealand Te Papa Tongarewa, Wellington 19, 64, 101, 128

Northern Ireland

Museums and Galleries of Northern Ireland, Ulster Museum, Belfast 93

Republic of Ireland

Dublin City Gallery The Hugh Lane 7, 57, 76, 142

Scotland

The Fergusson Gallery, Perth and Kinross Council 34

Glasgow Museums: Kelvingrove Art Gallery and Museum 16, 77

Singapore

Singapore History Museum 119

United States of America

The Art Institute of Chicago 120

Honolulu Academy of Arts, Hawaii 143

National Gallery of Art, Washington 144

Wales

National Museums and Galleries of Wales, Cardiff 56

Private collections

30, 52, 53, 54, 73, 89, 98, 124, 136

(Lenders are listed with catalogue numbers)

General Bibliography

Anscombe, Isabelle, *Omega and after: Bloomsbury and the decorative arts*, [1981], London: Thames and Hudson, 1984

Baile de Laperriere, Charles (ed.), *The Society of Women Artists exhibitors 1885–1996*, 4 vols, Calne: Hilmarton Manor, 1996

Banks, Olive, *Faces of Feminism: A study of Feminism as a social movement*, Oxford: Basil Blackwell, 1986

Baron, Wendy, *The Camden Town Group*, London: Scolar Press, 1979

Baron, Wendy and Cormack, Malcolm, *The Camden Town Group*, New Haven: Yale Centre for British Art, 1980

Baron, Wendy (ed.), *Government Art Collection of the United Kingdom: The twentieth century*, London: Government Art Collection, 1997

Baron, Wendy, *Perfect moderns: A history of the Camden Town Group*, Aldershot: Ashgate, 2000

Beattie, Susan, *The New Sculpture*, New Haven: Yale University Press, 1983

Beckett, Jane and Cherry, Deborah (eds), *The Edwardian era*, Oxford: Phaidon, 1987

Bell, Clive, *Old friends: Personal recollections*, London: Chatto and Windus, 1956

Bell, Vanessa, *Sketches in pen and ink: A Bloomsbury notebook*, London: Hogarth Press/Chatto and Windus, 1997

Benjamin, Roger (ed.), *Orientalism: Delacroix to Klee*, Sydney: Art Gallery of New South Wales, 1997

Bertram, Anthony, *A century of British painting 1851–1951*, London: Studio Publications, 1951

Billcliffe, Roger (ed.), *The Royal Glasgow Institute of the Fine Arts 1861–1989*, 4 vols, Glasgow: Woodend Press, 1990–92

Bindman, David (ed.), *The Thames and Hudson encyclopaedia of British art*, London: Thames and Hudson, 1985

Borzello, Frances, *A world of our own*, London: Thames and Hudson, 2000

Bowness, Alan (ed.), *Post-Impressionism: Cross-currents in European and American painting 1880–1906*, London: Royal Academy of Arts, 1979

Brendon, Piers, *Eminent Edwardians*, London: Secker and Warburg, 1979

Brettell, Richard, *Modern Art 1851–1929*, Oxford: Oxford University Press, 1999

Brothers, Ann, *A studio portrait: The marketing of art and taste 1893–1918*, Melbourne: University of Melbourne, 1993

Brough, James, *The prince and the lily*, [1975], London: Coronet Books, 1978

Brown, Oliver, *Exhibition: The memoirs of Oliver Brown*, London: Evelyn, Adams and Mackay, 1968

Chamot, Mary, Farr, Dennis and Butlin, Martin, *Tate Gallery: The modern British paintings, drawings and sculpture*, 2 vols, London: Oldbourne Press, 1964

Carey, Frances and Griffiths, Antony, *Avant-garde British printmaking 1914–1960*, London: British Museum, 1990

Christian, John (ed.), *The last Romantics: The Romantic tradition in British art*, London: Barbican Art Gallery, 1989

Corbett, David Peters and Perry, Lara (eds), *English art 1860–1914: Modern artists and identity*, Manchester: Manchester University Press, 2000

Corbett, David Peters, Holt, Ysanne and Russell, Fiona (eds), *The geographies of Englishness: Landscape and the national past 1880–1940*, New Haven: Yale University Press, 2002

Cork, Richard, *Vorticism and its allies*, London: Hayward Gallery, 1974

Cork, Richard, *Vorticism and abstract art in the first machine age*, 2 vols, London: Gordon Fraser, 1976

Cross, Tom, *Artists and bohemians: 100 Years with the Chelsea Arts Club*, London: Quiller Press, 1992

Curtis, Penelope, *Sculpture 1900–1945: After Rodin*, Oxford: Oxford University Press, 1999

Dawson, Barbara, *Images and insights*, Dublin: Hugh Lane Municipal Gallery of Modern Art, 1993

Edwardian reflections, Bradford: Bradford Art Galleries and Museums, 1975

Edwards, Deborah, *Presence and absence: Portrait sculpture in Australia*, Canberra: National Portrait Gallery, 2003

Ellman, Richard (ed.), *Edwardians and late Victorians*, [1960], New York: Columbia University Press, 1967

Farr, Dennis, *English Art 1870–1940*, Oxford: Clarendon Press, 1978

Fisher, John, *The world of the Forsytes*, London: Secker and Warburg, 1976

Forster, E.M., *Collected short stories*, [1947], Harmondsworth: Penguin, 1977

Fox, Caroline and Greenacre, Francis, *Artists of the Newlyn school 1880–1900*, Newlyn: Newlyn Orion Galleries, 1979

Fox, Caroline and Greenacre, Francis, *Painting in Newlyn 1880–1930*, London: Barbican Art Gallery, 1985

Free, Renee, *Art Gallery of New South Wales catalogue of British paintings*, Sydney: Art Gallery of New South Wales, 1987

Galbally, Ann, 'Australian artists abroad, 1880–1914', in Galbally, Ann and Plant, Margaret (eds), *Studies in Australian Art*, Melbourne: University of Melbourne, 1978, pp. 57–66

Galbally, Ann, *The collections of the National Gallery of Victoria*, Melbourne: Oxford University Press, 1987

Garner, Philippe, *The world of Edwardiana*, London: Hamlyn, 1974

Gaunt, William, *The aesthetic adventure*, [1945], Harmondsworth: Penguin, 1957

Gaunt, William, *A concise history of English painting*, London: Thames and Hudson, 1964

Gaze, Delia (ed.), *Dictionary of women artists*, London: Fitzroy Dearborn, 1997

General indices to the first forty-two volumes of "The Studio": 1893–1908, London: Sims and Reed, 1979

Gooding, Janda, *Western Australian art and artists 1900–1950*, Perth: Art Gallery of Western Australia, 1987

Graves, Algernon, *The Royal Academy of Arts: A complete dictionary of contributors and their work from its foundation in 1769 to 1904*, [1905–06], 8 vols, New York: Burt Franklin, 1972

Gray, Anne (ed.), *Painted Women: Australian artists in Europe at the turn of the century*, Perth: Lawrence Wilson Art Gallery, 1998

Gray, Anne (ed.), *Australian art in the National Gallery of Australia*, Canberra: National Gallery of Australia, 2002

Green, Christopher (ed.), *Art made modern, Roger Fry's vision of art*, London: Merrell Holberton, 1999

Green, Jeffrey, *Black Edwardians: Black people in Britain, 1901–14*, London: Frank Cass, 1998

Gruetzner Robins, Anna, *Modern art in Britain 1910–1914*, London: Merrell Holberton, 1997

Hammond, Victoria and Peers, Juliet, *Completing the picture: Women artists and the Heidelberg era*, Melbourne: Artmoves, 1992

Hardie, William, *Scottish painting 1837–1939*, [1976], London: Studio Vista, 1990

Harries, Meirion and Susie, *The war artists*, London: Michael Joseph, 1983

Harrison, Charles, *English art and Modernism, 1900–1939*, London: Allen Lane, 1981

Harrison, Michael, *Rosa*, [1962], London: Corgi, 1977

Hartley, Keith, *Scottish art since 1900*, Edinburgh: National Galleries of Scotland, 1989

Hayward, Edward, *Upstairs and downstairs: Life in an English country house*, Andover: Pitkin, 1998

Holme, Bryan, intro., *The Studio: A bibliography: The first fifty years: 1893–1943*, London: Sims and Reed, 1978

Holt, Ysanne, *British artists and the modernist landscape*, Aldershot: Ashgate, 2003

Hylton, Jane, *South Australian women artists: Paintings from the 1890s to the 1940s*, Adelaide: Art Gallery of South Australia, 1994

Hynes, Samuel, *The Edwardian turn of mind*, Princeton: Princeton University Press, 1968

Jackson, Holbrook, *The eighteen nineties*, [1913], London: Jonathan Cape, 1931

James, Henry, *English hours*, [1905], London: Heinemann, 1960

James, Henry, *The outcry*, [1911], London: Penguin, 2001

James, Henry, *Parisian sketches*: New York: Collier Books, 1961

Johnson, Jane, *Works exhibited at the Royal Society of British Artists, 1824–1893*, Woodbridge: Antique Collectors' Club, 1975

Kennedy, Brian, *Irish painting*, Dublin: Town House, 1993

Kirker, Anne and Tomory, Peter, *British painting 1800–1990*, Sydney: Beagle Press, 1997

Laver, James, *Portraits in oil and vinegar*, London: John Castle, 1925

Leong, Roger, *Dressed to kill: 100 years of fashion*, Canberra: National Gallery of Australia, 1993

Leong, Roger et al., *From Russia with love: Costumes from the Ballets Russes 1909–1933*, Canberra: National Gallery of Australia, 1998

Lesage, Jean-Claude, *Peintres Australiens à Etaples*, Etaples: A.M.M.E. éditions, 2000

Leslie, Anita, *Edwardians in love*, [1974], London: Arrow Books, 1974

Lloyd, Michael and Desmond, Michael, *European and American paintings and sculptures 1870–1970 in the Australian National Gallery*, Canberra: Australian National Gallery, 1992

Long, Philip and Cumming, Elizabeth, *The Scottish colourists 1900–1930*, Edinburgh: National Galleries of Scotland, 2000

McConkey, Kenneth, *Edwardian portraits: Images of an age of opulence*, Woodbridge: Antique Collectors' Club, 1987

McConkey, Kenneth, *British Impressionism*, Oxford: Phaidon, 1989

McConkey, Kenneth, *Impressionism in Britain*, London: Barbican Art Gallery, 1995

McConkey, Kenneth, *Memory and desire: Painting in Britain and Ireland at the turn of the twentieth century*, Aldershot: Ashgate, 2002

Martin, Christopher, *Spotlight on the Edwardian era*, Hove: Wayland, 1987

Maugham, Somerset, *The magician*, [1908], Harmondsworth: Penguin, 1967

Maugham, Somerset, *Ashenden, or The British agent*, [1928], London: Pan, 1952

Milner, John, *A dictionary of Russian and Soviet artists 1420–1970*, Woodbridge: Antique Collectors' Club, 1993

Nairn, Bede, Serle, Geoffrey and Ritchie, John (eds), *Australian dictionary of biography*, vols 7–12, Melbourne: Melbourne University Press, 1979–1990

National Gallery of Victoria, *European masterpieces: Six centuries of paintings from the National Gallery of Victoria*, Melbourne: National Gallery of Victoria, 2000

Nowell-Smith, Simon (ed.), *Edwardian England 1901–1914*, London: Oxford University Press, 1964

Paterson, John, *Edwardians: London life and letters 1901–1914*, Chicago: Ivan Dee, 1996

Pearce, Barry, *Australian art in the Art Gallery of New South Wales*, Sydney: Art Gallery of New South Wales, 2000

Pearce, Barry, *Parallel visions: Works from the Australian collection*, Sydney: Art Gallery of New South Wales, 2002

Priestley, J. B., *The Edwardians*, [1970], Harmondsworth: Penguin, 2000

Radford, Ron, et al., *Treasures from the Art Gallery of South Australia*, Adelaide: Art Gallery of South Australia, 1998

Read, Benedict, *Victorian sculpture*, New Haven: Yale University Press, 1982

Read, Herbert, *Contemporary British art*, Harmondsworth: Penguin, 1951

Rosenblum, Robert, Stevens, MaryAnne and Dumas, Ann, *1900: Art at the crossroads*, London: Royal Academy, 2000

Rothenstein, John, *The artists of the 1890's*, London: Routledge, 1928

Rothenstein, John, *British art since 1900*, Oxford: Phaidon, 1962

Rothenstein, John, *Modern English painters*, 3 vols, [1952], London: Macdonald and Jane's, 1976

Royal Academy of Arts (Great Britain), *Royal Academy exhibitors 1905–1970*, Calne: Hilmarton Manor Press, 1985–87

Rutter, Frank, *Some contemporary artists*, London: Leonard Parsons, 1922

Rutter, Frank, *Evolution in modern art: A study of modern painting, 1870–1925*, London: Harrap, 1926

Rutter, Frank, *Art in my time*, London: Rich and Cowan, 1933

Rutter, Frank, *Modern masterpieces: An outline of modern art*, [1940], London: George Newnes, 1942

Sackville-West, Vita, *The Edwardians*, [1930], London: Virago, 1983

Sato, Tomoko and Lambourne, Lionel, *The Wilde years: Oscar Wilde and the art of his time*, London: Barbican Art Gallery, 2000

Schoff, James (ed.), *The British collection at Carrick Hill*, Springfield: The Carrick Hill Trust, 1991

Seear, Lynne and Ewington, Julie (eds), *Brought to light — Australian Art 1850–1965*, Brisbane: Queensland Art Gallery, 1998

Shone, Richard, *The century of change: British painting since 1900*, Oxford: Phaidon, 1977

Shone, Richard, *The art of Bloomsbury: Roger Fry, Vanessa Bell and Duncan Grant*, London: Tate Publishing, 1999

Simon, Robin, *The portrait in Britain and America*, Oxford: Phaidon, 1987

Sitwell, Osbert (ed.), *A free house! or, the artist as craftsman: being the writings of Walter Richard Sickert*, London: Macmillan, 1947

Sitwell, Osbert, *Great morning*, [1948], London: Quartet Books, 1977

Sitwell, Osbert, *Laughter in the next room*, [1949], London: Quartet Books, 1977

Skipwith, Peyton, *Gibson to Gilbert: British sculpture 1840–1914*, London: Fine Art Society, 1992

Skipwith, Peyton, *Peter Pan and Eros: Sir George Frampton and Sir Alfred Gilbert, public and private sculpture in Britain, 1880–1940*, London: Fine Art Society, 2002

Smith, Alison (ed.), *Exposed: The Victorian nude*, London: Tate Publishing, 2001

Snoddy, Stephen, *Pintura Británica Moderna*, Bilbao: Museo de Bellas Artes de Bilbao, 1997

Société des Artistes Français, *Catalogue illustré du salon des artistes français*, Paris: Société des Artistes Français, 1900–1914

Société du Salon d'Automne, *Société du salon d'automne, Paris, Catalogue (Musée des Beaux-Arts)*, Paris: Société Nationale des Beaux-Arts, 1900–1914

Société du Salon d'Automne, *Exposition de l'art russe*, Paris: Moreau Freres, 1906

Société Nationale des Beaux-Arts, *Catalogue illustré du salon*, Paris: Baschet, 1900–1914

Spalding, Frances, *British art since 1900*, London: Thames and Hudson, 1986

Standen, John, *The Edwardians*, London: Faber and Faber, 1968

Stevens, MaryAnne (ed.), *The Edwardians and after: The Royal Academy 1900–1950*, London: Royal Academy of Arts, 1988

Stevenson, R.A.M., *Velasquez*, [1895], London: George Bell, 1900

Stewart, Ann M., *Royal Hibernian Academy of Arts: Index of exhibitors and their works, 1826–1979*, 3 vols, Dublin: Manton, 1985–87

Sulter, Maud, *Echo: Works by women artists 1850–1940*, London: Tate Publishing, 1991

The Studio: An illustrated magazine of fine and applied art, nos 1–201, London: The Studio, 1893–1909

Thompson, Paul, *The Edwardians: The remaking of British society*, [1975], London: Routledge, 1992

Thomson, Belinda, *Post-Impressionism*, London: Tate Publishing, 1998

Thornton, Alfred, *Fifty years of the New English Art Club, 1886–1935*, London: New English Art Club, 1935

Tickner, Lisa, *Modern life and modern subjects: British art in the early twentieth century*, London: Yale University Press, 2000

Tillyard, S.K., *The impact of modernism, 1900–1920: Early modernism and the Arts and Crafts movement in Edwardian England*, London: Routledge, 1988

Topliss, Helen, *Modernism and Feminism: Australian women artists 1900–1940*, Sydney: Craftsman House, 1996

Trumble, Angus, *Bohemian London: Camden Town and Bloomsbury paintings in Adelaide*, Adelaide: Art Gallery of South Australia, 1997

Trumble, Angus, *Love and death: Art in the age of Queen Victoria*, Adelaide: Art Gallery of South Australia, 2001

Turner, Jane (ed.), *The dictionary of art*, 34 vols, London: Macmillan, 1996

Valentine, Helen (ed.), *Art in the age of Queen Victoria, treasures from the Royal Academy of Arts permanent collection*, London: Royal Academy of Arts, 1999

Watney, Simon, *English Post-Impressionism*, London: Studio Vista, 1980

Wedmore, Frederick, *Some of the moderns*, London: Virtue, 1909

Weintraub, Stanley, *Edward the caresser*, New York: Free Press, 2001

Wilcox, Denys J., *The London Group 1913–1939: The artists and their works*, London: Scolar Press, 1995

Wilton, Andrew, *The swagger portrait: Grand manner portraiture in Britain from van Dyck to Augustus John, 1630–1930*, London: Tate Publishing, 1992

Windschuttle, Elizabeth (ed.), *Women, class and history*, Sydney: Fontana/Collins, 1980

Wood, Sydney, *The Edwardians*, Edinburgh: Oliver and Boyd, 1981

Woolf, Virginia, *A room of one's own*, [1928], Harmondsworth: Penguin, 1963